MMO

AN MODERN **BOOKS**

THE
Contact
Sheet

William Claxton

Lucien Clergue

Danny Clinch

Chuck Close

Michel Comte

Anton Corbijn

Imogen Cunningham

Carl De Keyzer

Robert Doisneau

David Doubilet

Elliott Erwitt

Joakim Eskildsen

Paul Fusco

George Georgiou

Nan Goldin

Adam Jeppesen

Nadav Kander

Art Kane

David Hume Kennerly

Dorothea Lange

Saul Leiter

Mark Leong

Peter Lindbergh

Steve McCurry

Jerry McMillan

Joel Meyerowitz

Richard Misrach

Joseph Mougel

Arnold Newman

Paul Outerbridge

Martin Parr

Melissa Ann Pinney

Mark Power

Alex Prager

Ed Ruscha

Julius Shulman

Jeanloup Sieff

Edmund Teske

Pete Turner

Jerry Uelsmann

Peter van Agtmael

Hellen van Meene

Julian Wasser

William Wegman

Photographers

A contact sheet is a window into the thought process of a photographer. It is a photographer's sketchbook, not often seen by others.

Years ago, when I started to work with other photographers' archives, I had the opportunity to get to know those artists on a deeper level than I ever imagined I could. Editing their work helped me understand how they perceived things, how they pondered and considered the subject matter they saw through their lenses, and it often gave me deeper insight as to what they were all about—as artists and often as people. Sometimes I had the privilege of discussing their works with the photographers, who explained their vision; sometimes I never had a chance to meet the photographers other than through the legacy they'd left behind. Regardless, I learned a lot from the journey, and sharing that editing process was the idea behind this book.

Each photographer sees so very differently from every other, it is almost impossible to compare them. Photographers are like musicians who play similar notes on their instruments, and yet the sounds they create are unique. It's also very enlightening to see these artists' individual sensibilities come through even more so in the selection process. By choosing a single image that to them resonated most within the context of the overall contact sheet, the photographer has granted the reader access into his or her creative editing process. Much like scenes that have been cut out of a film, the competing images of a contact sheet are rarely shared with the viewer.

My hope is that the reader will gain a deeper understanding of these artists and of their work. A great variety of contact sheets are presented here, from some of the masters of the last century, as well as from some inspiring new artists.

Steve Crist
Los Angeles, California
July 2009

Introduction

Une planche contact est une fenêtre ouverte sur le processus de création d'un photographe, c'est un cahier d'esquisse personnel qui reste souvent hors de portée du plus grand nombre.

C'est par mon travail sur les archives d'autres photographes que j'ai approfondi ma connaissance de ces artistes à un degré que je n'aurais jamais cru imaginable. L'édition de leur œuvre m'a aidé à apprécier leur perception du monde, leur démarche réflexive et leur regard face aux sujets saisis par l'objectif. Ce travail m'a souvent permis de mieux les connaître, à la fois en tant qu'artiste et sur un plan personnel. J'ai eu parfois le privilège de discuter de leur œuvre avec des photographes qui m'ont fait part de leur vision. Il m'est aussi arrivé de ne connaître un photographe que par l'intermédiaire du corpus d'images qu'il a réalisées. Ce cheminement fut dans les deux cas très enrichissant et ce livre est l'occasion de partager mon expérience avec le lecteur.

Chaque photographe se distingue par un point de vue individualisé et il serait illusoire d'établir des comparaisons entre eux. Le photographe est semblable au musicien qui joue une mélodie sur un instrument et en obtient une sonorité qui lui est propre. Il est de même fascinant d'observer la sensibilité individuelle de chaque artiste s'affirmer au cours du processus de sélection des photographies. En choisissant l'image qui, à son sens, a le plus de résonance dans le contexte de la planche contact, le photographe donne au lecteur accès à son processus créatif. A l'instar des scènes supprimées lors du montage d'un film, les images d'une planche contact sont rarement portées à la connaissance du spectateur.

J'espère que le lecteur trouvera un intérêt à la découverte de ces artistes et de leur œuvre. Ce livre recueille une grande variété de planches contact, certaines furent créées par de grands noms du siècle dernier et d'autres réalisées par de jeunes artistes d'avenir.

Steve Crist
Los Angeles, Californie
Juillet 2009

Introduction

Ein Kontaktbogen ist ein Fenster zum Denkprozess eines Fotografen. Es ist ein Skizzenbuch eines Fotografen, das nicht oft von anderen gesehen wird.

Vor Jahren, als ich mit den Archiven von anderen Fotografen zu arbeiten begann, hatte ich die Möglichkeit, diese Künstler auf einer tieferen Ebene als ich mir das jemals vorstellen konnte, kennenzulernen. Das Editieren ihrer Arbeit half mir, zu verstehen, wie sie Dinge wahrnahmen, wie sie die Materie, die sie durch ihre Linsen sahen, abschätzten und betrachteten, und es gab mir oft einen tieferen Einblick in das, was sie waren – als Künstler und oft als Menschen. Manchmal hatte ich das Privileg, die Werke mit den Fotografen, die ihre Vision erklärten, zu diskutieren; manchmal hatte ich nie eine Chance, die Fotografen zu treffen, ausser durch das Erbe, das sie hinterlassen hatten. Trotzdem, ich lernte viel von der Reise, und diesen Editierprozess zu teilen, war die Idee hinter diesem Buch.

Jeder Fotograf sieht so verschieden von jedem anderen, es ist fast unmöglich, sie zu vergleichen. Fotografen sind wie Musiker, die ähnliche Noten auf ihren Instrumenten spielen, und doch sind die Laute, die sie erzeugen, einzigartig. Es ist auch sehr erleuchtend zu sehen, dass diese künstlerischen Sensibilitäten sogar mehr in diesem Auswahlprozess durchscheinen. Durch das Auswählen eines einzelnes Bild, das mit ihnen im Kontext des gesamten Kontaktbogens am meisten resoniert hat, hat der Fotograf dem Leser Zugang zu seinem oder ihrem kreativen Editierprozess gewährt. So wie Szenen, die aus einem Film herausgeschnitten wurden, werden die konkurrierenden Bilder eines Kontaktbogens selten mit dem Zuschauer geteilt.

Meine Hoffnung ist, dass der Leser ein tieferes Verständnis in diese Künstler und deren Werke gewinnt. Eine grosse Auswahl an Kontaktbögen ist hier präsentiert, von einigen der Meister des letzten Jahrhunderts, sowie von einigen inspirierenden neuen Künstlern.

Steve Crist
Los Angeles, Kalifornien
Juli 2009

Einleitung

Una hoja de contactos es una ventana abierta al proceso de pensamiento de un fotógrafo. Se trata del cuaderno de bocetos del fotógrafo, al que pocos suelen tener acceso.

Hace años, cuando comencé a trabajar con los archivos de otros fotógrafos, tuve la oportunidad de conocer a esos artistas hasta alcanzar un nivel al que jamás había imaginado que llegaría. Editar su trabajo me ha ayudado a comprender cómo percibían las cosas, cómo sopesaban y consideraban el tema que veían a través de sus lentes, y con frecuencia me proporcionó la posibilidad de conocer cómo eran, como artistas y, a menudo, como personas. En ocasiones tuve el privilegio de hablar de los trabajos con sus fotógrafos, quienes me explicaron su visión; otras tan sólo tuve la oportunidad de conocer a los fotógrafos a través del legado que habían dejado tras de sí. Aún así, aprendí mucho en el recorrido, y compartir ese proceso de edición ha sido la idea tras este libro.

Cada fotógrafo ve las cosas de una manera muy diferente al resto por lo que resulta prácticamente imposible compararlos. Los fotógrafos son como músicos que tocan notas similares en sus instrumentos y a pesar de ello los sonidos que crean son únicos. Resulta muy enriquecedor ver cómo las sensibilidades individuales de estos artistas resultan aún más evidentes en el proceso de selección. Al escoger una sola imagen que para él o ella fuese más significativa dentro del contexto de la hoja de contactos general, el fotógrafo ha proporcionado al lector acceso a su proceso de edición creativa. De forma muy parecida a lo que ocurre con las escenas cortadas de una película, las imágenes que compiten entre sí en la hoja de contactos pocas veces se comparten con el espectador.

Tengo la esperanza de que el lector llegue a comprender aún mejor a estos artistas y su trabajo. Presentamos aquí una gran variedad de hojas de contacto de algunos de los maestros del siglo pasado, así como de algunos prometedores artistas nuevos.

Steve Crist
Los Ángeles, California
Julio de 2009

Introducción

In the early 1950s, while a student at UCLA, William Claxton began to photograph a young and then-unknown trumpet player named Chet Baker. The resulting collection of images from those sessions has become known throughout the jazz world and is largely credited as defining both Baker's initial fame and legacy. In a career that spanned more than fifty years, Claxton was long considered the preeminent photographer of the jazz genre.

In the '60s, Claxton collaborated with his wife, the noted fashion model Peggy Moffitt, to create a collection of iconic fashion images featuring the revolutionary designs of Rudi Gernreich. The select image from this 1964 contact sheet is one of Claxton's most well-known Gernreich photographs— of Moffitt posing in what was dubbed the first topless swimsuit. Moffitt had been reluctant to model the daring swimsuit but eventually did it under the condition that Claxton photograph her. Moffitt said,

"One of the things that I thought of during this session was the idea of pearl divers in Japan. They're all women and wear sort of a loincloth, and are topless when they dive into the ocean to collect pearls. So one of my thoughts was to wear a diver's mask, as an athletic kind of thing. We did some pictures with the diving mask on, and after we did some of those, I thought it would be good to be wet. So I had a pan of water and a great big sponge and was just standing there on a bath mat while I took the sponge and squeezed it over my head.

"At the time that the picture was taken, most everybody in fashion thought the most elegant woman in America was Barbara 'Babe' Paley. She was just the nth degree of elegance. I thought to myself, *I'm Mrs. Paley on my private beach on Long Island in my new bathing suit. And I hope you all like it.* And it was a very cool kind of thought— elegant and cool and dripping wet."

Au début des années 1950, encore étudiant à UCLA, William Claxton commença à photographier un trompettiste alors inconnu nommé Chet Baker. Le corpus d'images rassemblées au cours de ces sessions devint célèbre dans le monde du jazz et fut déterminant pour la reconnaissance initiale de Chet Baker et pour sa renommée. Au long de sa carrière qui s'étend sur cinquante ans, William Claxton fut souvent considéré comme le portraitiste vedette des légendes du jazz.

En collaboration avec sa femme, le célèbre modèle Peggy Moffitt, Claxton créa dans les années 1960 une collection de photographies mythiques des designs révolutionnaires de Rudi Gernreich. Cette image tirée d'une planche contact créée en 1964 est l'une des photographies les plus célèbres prise par Claxton pour Gernreich, Peggy Moffitt et est le premier modèle à porter le célèbre « monokini. » Peggy Moffitt montrait une certaine réticence à se laisser photographier dans cette tenue mais accepta à la condition que Claxton soit le photographe. Peggy Moffitt décrit la séance en ces termes :

« Pour cette session, j'avais dans l'idée de faire une allusion aux pêcheurs de perles du Japon. Ce sont toutes des femmes, elles portent seulement une sorte de pagne fixé à la taille quand elles plongent dans l'océan pour chercher les perles. J'avais donc pensé porter un masque de plongée, pour donner une impression athlétique. On a prit quelques photos avec le masque, et je me suis dit qu'il serait intéressant d'être mouillée. On m'a apporté une bassine d'eau et une grosse éponge, je me suis mise debout sur un tapis de bain et je me suis aspergée d'eau avec l'éponge.

A l'époque où la photo a été prise, le monde de la mode pensait que la femme la plus élégante d'Amérique était Barbara « Babe » Paley. Elle représentait le Nième degré de l'élégance. Je me suis dit *je suis Mme Paley sur ma plage privée de Long Island avec mon nouveau maillot de bain — élégante et distinguée, et détrempée.* »

In den frühen Fünfzigern, als Student an der UCLA, begann William Claxton einen jungen und damals unbekannten trompetenspieler namens Chet Baker zu fotografieren. Die resultierende Kollektion von Bildern von diesen Sitzungen ist durch die ganze Welt der Jazzmusik bekannt geworden, und wird zum Grossteil als definierendes Element von Bakers anfänglichem Ruhm und Vermächtnis angerechnet. In einer Karriere, die mehr als fünfzig Jahre umspannte, wurde Claxton lange als der hervorstechende Fotograf von Jazzmusik anerkannt.

In den 1960ern kollaborierte Claxton mit seiner Frau, dem bekanntnenen Fotomodell Peggy Moffitt, um eine Kollektion von ikonischen Modefotos der revolutionären Entwürfe von Rudi Gernreich zu erzeugen. Das ausgewählte Bild von diesem Kontaktbogen von 1964 ist eines von Claxtons bekanntesten Gernreich-Fotografien – von Moffitt in einem Badeanzug posierend, der als erster oberteilloser Badeanzug tituliert wurde. Moffitt war widerwillig gewesen, den verwegenen Badeanzug vorzuführen, doch schliesslich tat sie es unter der Bedingung, dass Claxton sie fotografierte. Moffitt sagt:

„Eines der Dinge, an die ich während dieser Session dachte, war die Idee von Perlentauchern in Japan. Es sind alles Frauen und sie tragen eine Art Lendenschutz, und sind oben ohne, wenn sie in den Ozean tauchen, um Perlen zu sammeln. So einer meiner Gedanken war es, eine Tauchmaske zu tragen, als Art athletisches Ding. Wir machten ein paar Fotos mit der Tauchmaske, und nachdem wir einige von denen gemacht hatten, dachte ich, es wäre gut, nass zu sein. So hatte ich eine Wanne mit Wasser und einen tollen grossen Schwamm und ich stand da nur auf der Badematte, während ich den Schwamm nahm und ihn über meinem Kopf ausdrückte.

Zu der Zeit, als das Foto genommen wurde, fand fast jeder in der Modebranche, dass die eleganteste Mrs. in Amerika Barbara 'Babe' Paley war. Sie war das zigste Mass von Eleganz. Ich dachte mir, *Ich bin Mrs. Paley auf einem privaten Strand auf Long Island in meinem neuen Badeanzug. Und ich hoffe, er gefällt euch allen.* Und es war ein sehr cooler Gedanke – elegant und cool und tropfnass."

A comienzos de la década de los cincuenta, mientras estudiaba en UCLA, William Claxton comenzó a fotografiar a un joven y entonces desconocido trompetista llamado Chet Baker. La colección de imágenes resultante de estas sesiones es conocida en el mundo de la música jazz y debe a ésta la definición del legado y fama inicial de Baker. En una carrera profesional de más de cincuenta años, Claxton fue considerado durante mucho tiempo un eminente fotógrafo de música jazz.

En la década de 1960, Claxton colaboró con su esposa, la afamada modelo Peggy Moffitt, para crear una colección de imágenes de moda icónicas con los revolucionarios diseños de Rudi Gernreich. La imagen seleccionada de esta hoja de contactos de 1964 es una de las fotografías de Gernreich más conocidas, en la que Moffitt posaba en lo que se calificó como el primer bañador topless. Moffitt se había resistido a posar en el atrevido traje de baño, pero acabaría haciéndolo bajo la condición de que Claxton la fotografiara. Moffitt dice:

"Una de las cosas en las que pensé durante esta sesión fue en las buceadoras de perlas de Japón. Son mujeres y llevan algo así como un taparrabo, y no llevan nada puesto en la parte de arriba cuando se sumergen en el océano para recoger perlas. Así que uno de mis pensamientos fue ponerme unas gafas de buceo, como si se tratase de algo deportivo. Hicimos algunas fotos magníficas con las gafas de buceo puestas y después de hacerlas pensé que sería una buena idea mojarse. Así que tenía un barreño con agua y una estupenda esponja grande y estaba allí, de pie sobre una alfombra de baño mientras cogía la esponja y la estrujaba sobre mi cabeza.

Cuando se hizo aquella fotografía, prácticamente todo el mundo de la moda pensó que la mujer más elegante de América era Barbara 'Babe' Paley. Era la quintaesencia de la elegancia. Pensé para mis adentros, *Soy Mrs. Paley en mi playa privada en Long Island con mi bañador nuevo. Espero que le guste a todos.* Y fue un pensamiento muy cool, elegante y cool, empapada de arriba abajo".

William Claxton

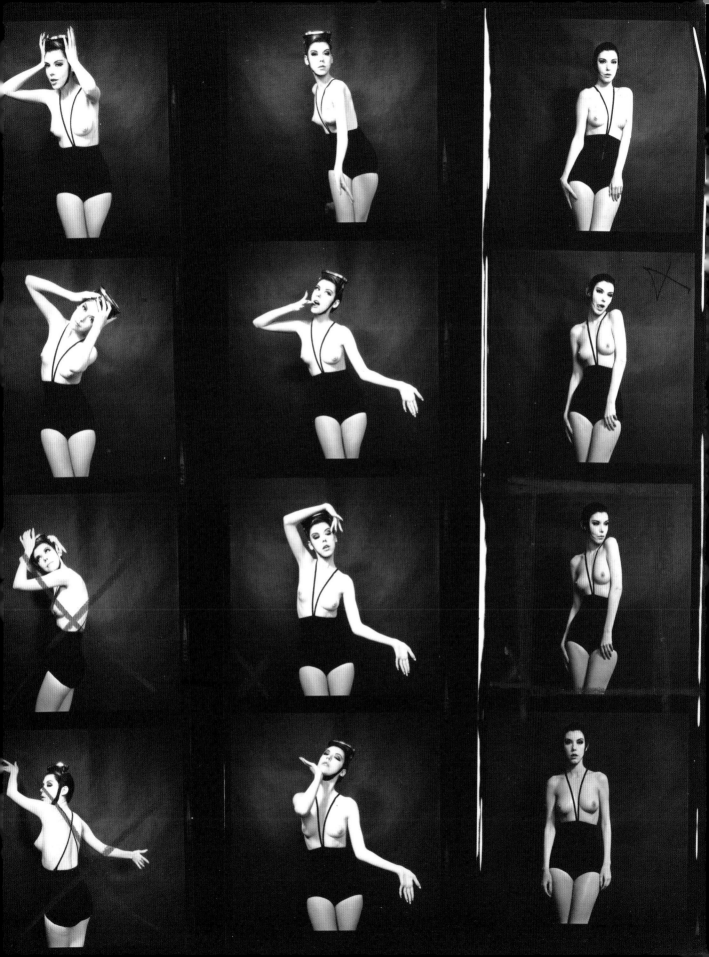

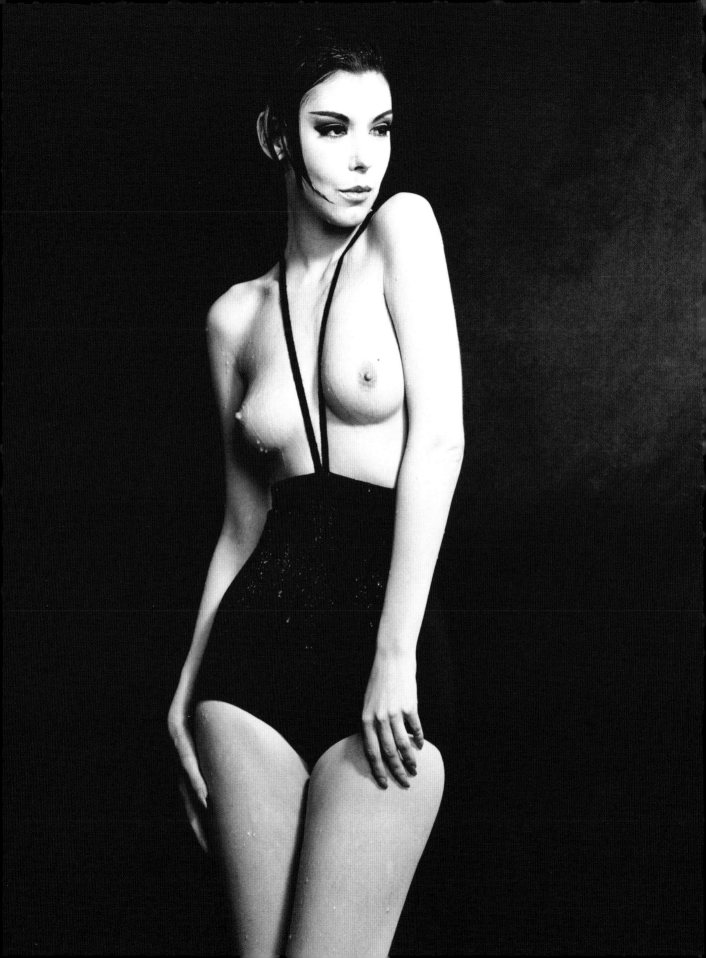

Lucien Clergue learned photography in his adolescence in Arles, France, during World War II. As a teenager, he witnessed the bombing of his family's home and the death of his mother. His work reflects this harrowing period—often suggesting themes of loss, death, and decay. In the early 1950s, Clergue met Pablo Picasso at a bullfight in Arles, sparking a friendship and mutual professional admiration that would span the next thirty years.

During the '50s through the '70s, Clergue was known for his beautiful female nude works and bullfight images from the Arles arena. It was during this period that he also extensively photographed the gypsies of southern France.

"My actual work is more concentrated on color double exposure: shooting a girl on a nude in soft light, then keeping the film unprocessed and redoing it in front of a museum painting. The results are sometimes so unexpected that it does not look possible."

The contact sheet was made in 1998 in New York City.

"The girl was Liz, a charming secretary friend of mine, who has been modeling only for me and is now in Los Angeles. She was one of the best models I ever had! The most difficult aspect was using existing light from the sun. I do not use anything else like reflectors or flashes, et cetera. You have to also check the light on her skin, even underexpose it a little. Distortions on the body are best even though it is not so comfortable while we were shooting. But she loves to do it, and there was a good exchange between us. She often brought her own ideas, and had an attitude that inspired me.

"The idea came about because of this venetian blind, but it has been done before me by Man Ray in particular, but visiting New York ten years ago was very exciting and inspiring because of the season and the change of position of the sun in the sky. There is no philosophy behind it, it was just playing with the human body and the sun, and I reorganized the design made by the shadows of the venetian blinds on her skin."

Lucien Clergue s'initia à la photographie pendant son adolescence passée à Arles, avec pour toile de fond la France de la deuxième guerre mondiale, le bombardement de la maison familiale et le décès de sa mère. Il sera durablement influencé par cette période douloureuse et les thèmes de la perte, de la mort et de la décrépitude ressurgissent souvent dans son œuvre. Au début des années 1950, Lucien Clergue fit la connaissance de Picasso lors d'une corrida à Arles, cette rencontre marqua le début d'une amitié et d'une admiration mutuelle qui devaient durer près de trente ans.

Des années 1950 à 1970, Lucien Clergue accéda à la célébrité pour son magnifique travail sur les nus féminins et pour ses séries consacrées à la tauromachie dans les arènes d'Arles. C'est aussi durant cette période qu'il entreprit un long travail sur les saltimbanques du sud de la France et de sa ville d'Arles. Décrivant sa méthode de travail, Lucien Clergue déclare « mon travail est en fait centré sur la double exposition couleur : on prend un nu féminin avec une lumière diffuse, on garde la pellicule non développée et on photographie en surimpression un tableau classique pris sur la cimaise d'un musée. Le résultat est parfois si surprenant qu'il paraît impossible à réaliser ».

Cette planche contact fut réalisée en 1988 à New York.

« J'ai travaillé sur ces photos avec Liz, une amie charmante qui était secrétaire et qui posait pour moi ; elle vit maintenant à Los Angeles. C'est le meilleur modèle que je n'ai jamais eu ! Le plus difficile fut de composer avec la lumière du soleil, car je n'utilise pas de réflecteurs ou de flash. Il fallut aussi être attentif à l'intensité de la lumière sur la peau et même la sous-exposer un peu. Les distorsions du corps favorisaient le jeu de la lumière même si ce n'était pas très confortable pour Liz, mais elle adorait poser et un bon contact s'était établi entre nous deux. Elle me faisait souvent part de ses propres idées et son attitude était source d'inspiration.

L'idée m'est venue à cause d'un store vénitien, et, même si Man Ray notamment avait déjà pris ce type de clichés, ma visite à New York était très stimulante et je me sentais inspiré par la saison et par la course du soleil dans le ciel. Il n'y a pas de concept derrière ces clichés, c'est simplement un jeu entre le soleil et le corps humain et j'ai ensuite réorganisé les motifs créés par l'ombre portée des stores vénitiens sur les courbes de Liz. »

Clergue lernte während seiner Adoleszenz in Arles, Frankreich, im Zweiten Weltkrieg zu fotografieren, inmitten der Erlebnisse der Bombardierung seines Familienhauses und dem Tod seiner Mutter. Sein Werk reflektiert oft diese qualvolle Periode – oft werden Themen von Verlust, Tod, und Zerfall suggeriert. In den frühen Fünfzigern traf Clergue Pablo Picasso bei einem Stierkampf in Arles, was eine Freundschaft und gegenseitige professionelle Bewunderung entfachte, die die nächsten dreissig Jahre umspannte.

Während der 1950er bis in die 1970er war Clergue für seine wunderbaren weiblichen Akte und die Stierkampfbilder der Arles-Arena bekannt. Es war während dieser Periode, dass er auch extensiv die Zigeuner des südlichen Frankreichs fotografierte. Von seinem eigenen Werk meint Clergue, „Meine richtige Arbeit ist mehr auf die doppelte Farbbelichtung konzentriert: ein Mädchen als Akt in sanftem Licht zu fotografieren, dann den Film unentwickelt zu lassen und es noch einmal vor einem Museumsbild zu fotografieren. Die Resultate sind manchmal so unerwartet, dass es nicht möglich zu sein scheint."

Der Kontaktbogen wurde in 1998 in New York City gemacht.

„Das Mädchen war Liz, eine charmante Sekretärin und Freundin von mir, die nur für mich Modell stand und die nun in Los Angeles ist. Sie war eines der besten Modelle, die ich jemals hatte! Der schwierigste Aspekt war es, das existierende Sonnenlicht zu verwenden. Ich benutze keine Reflektoren oder Blitze, etc. Man muss auch das Licht auf ihrer Haut prüfen, sogar ein wenig unterbelichten. Verzerrungen auf dem Körper sind am besten, auch wenn das nicht angenehm ist, während wir filmen. Aber sie liebt es zu tun, und es war ein guter Austausch zwischen uns. Sie brachte oft ihre eigenen Ideen, und sie hatte eine Einstellung, die mich inspirierte.

Die Idee entstand wegen der Jalousien, aber das wurde schon vor mir gemacht, vor allem von Man Ray, aber als ich New York vor zehn Jahren besuchte, war es sehr aufregend und inspirierend wegen der Saison und dem Wechsel der Sonne am Himmel. Da ist keine Philosophie dahinter, es war nur ein Spiel mit dem menschlichen Körper und der Sonne, und ich reorganisierte das Design, das die Schatten der Jalousien auf ihrer Haut gemacht hatten."

Clergue estudió fotografía en su adolescencia en Arles, Francia, durante la Segunda Guerra Mundial, al tiempo que era testigo del bombardeo del hogar de su familia y del fallecimiento de su madre. Su trabajo refleja el horror de esa época, y sugiere a menudo temas de pérdida, muerte y decadencia. A principios de los años cincuenta, Clergue conoció a Pablo Picasso en una corrida de toros en Arles, y de ahí surgiría una amistad y una mutua admiración profesional que se prolongaría a lo largo de los siguientes treinta años.

Durante los años 50 hasta los 70, Clergue era conocido por sus hermosos desnudos femeninos y las imágenes taurinas de la plaza de toros de Arles. En ese período también realizó múltiples fotografías de los gitanos del sur de Francia. Acerca de su propia obra, Clergue opina: "Mi trabajo actual está más concentrado en dobles exposiciones en color: tomo una instantánea de una chica desnuda con una iluminación suave, mantengo la película sin procesar y vuelvo a tomar una foto delante del cuadro de un museo. Los resultados son a veces tan inesperados que no parecen posibles".

La hoja de contactos se realizó en 1998 en la ciudad de Nueva York.

"La chica es Liz, la encantadora secretaria de un amigo mío, que ha posado sólo para mí y que ahora vive en Los Ángeles. Ha sido una de las mejores modelos que he tenido. El aspecto más difícil era emplear la luz solar existente, no utilizo nada más, como reflectores o flash, etc. También hay que comprobar la luz sobre la piel, incluso subexponerla un poco. Las distorsiones del cuerpo son mejores aunque no sea tan cómodo durante la sesión fotográfica. Pero a ella le encantaba, y había una buena relación entre nosotros. A menudo, ella aportaba sus propias ideas, y tenía una actitud que me inspiraba.

La idea se me ocurrió a causa de una persiana veneciana, aunque ya se había hecho antes, en concreto por Man Ray, pero visitar Nueva York hace diez años resultaba muy emocionante y sugerente debido a la estación y al cambio de posición del sol en el cielo. No hay ninguna filosofía en ello, sólo estaba jugando con el cuerpo humano y el sol, y reorganicé el diseño creado por las sombras de la persiana sobre su piel".

Lucien Clergue

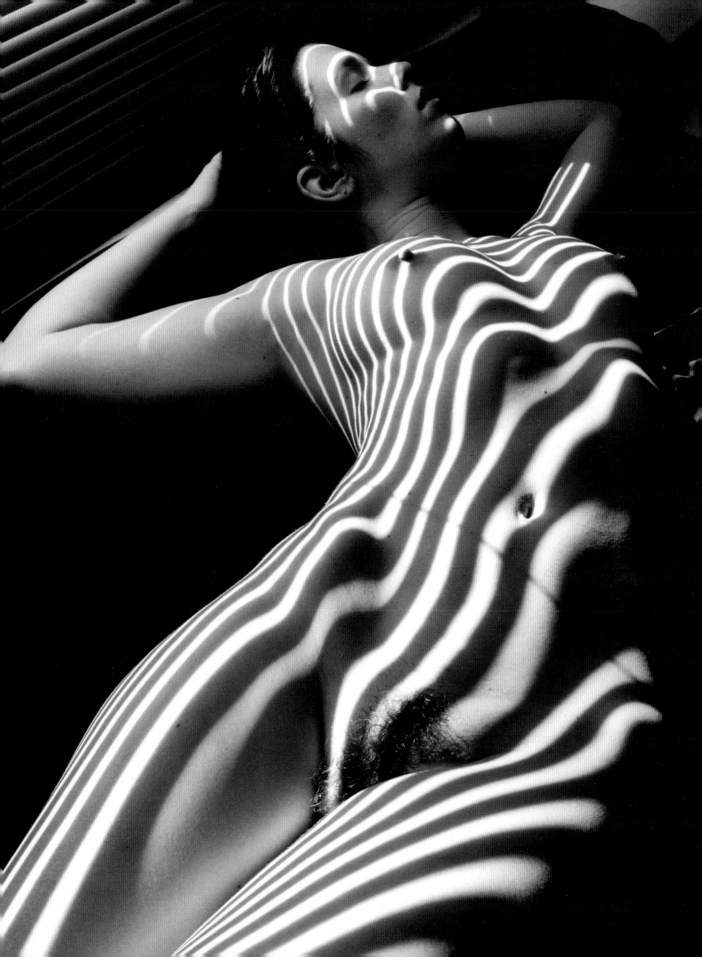

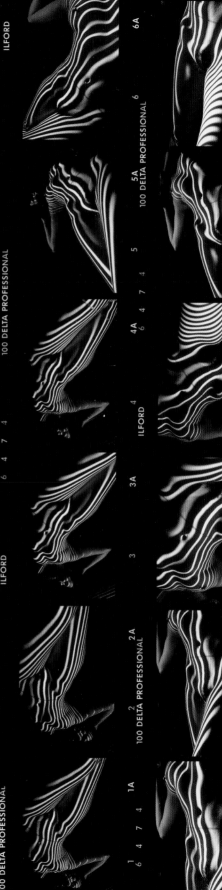
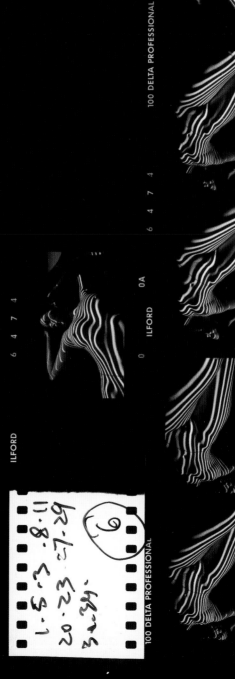

98051 — NZCY Rasset och 98 —
30×40 6-8

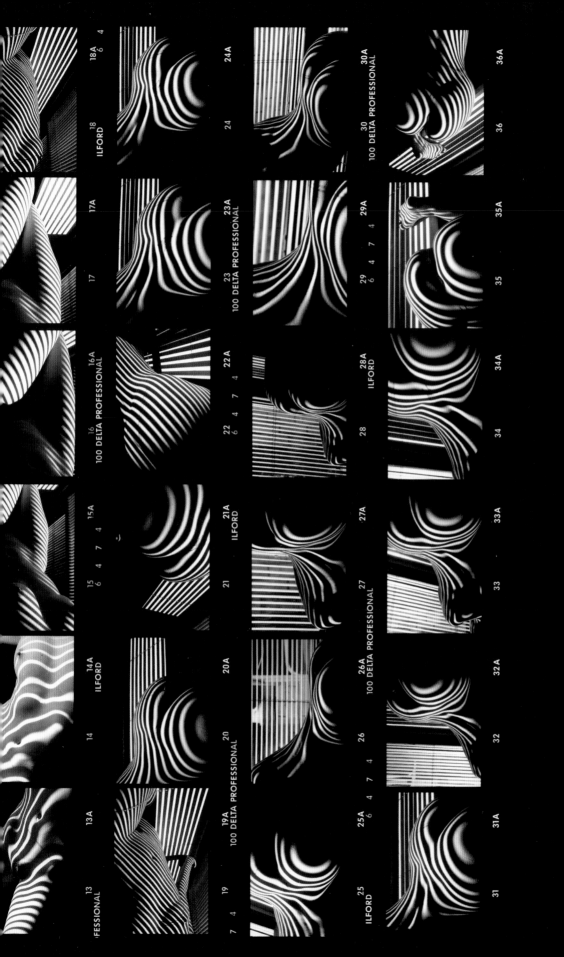

Documenting the music industry for more than a decade, Danny Clinch has photographed a wide range of subjects in his work—from hip-hop superstars to monks at Free Tibet concerts. Clinch has established himself as an insider in the music world, capturing rare glimpses into the youthful spontaneity and energy behind musicians and their lives.

Born in New Jersey in 1964, Clinch grew interested in photography while attending community college. After graduating, Annie Leibovitz offered Clinch an internship when they met at the Ansel Adams Gallery workshops. He eventually became her assistant—traveling and working with other photographers such as Mary Ellen Mark, Timothy White, and Steven Meisel.

Clinch started shooting for *Spin* in the 1990s, but photographing musicians was nothing new for Clinch. While living in Boston, he documented local band Rick Berlin: *The Movie*, fueling his love of photojournalism and music. Shooting for musicians was a great way for Clinch to work spontaneously, especially in settings such as concerts. This spontaneous approach helped musicians feel comfortable with Clinch and has since become a trademark style in his photography.

The contact sheet is a series of photos taken while Clinch was in Austin, Texas, for the South by Southwest Music Conference and Festival in 2003. The subject is the late musician Chris Whitley, who was playing the festival at the time.

"I had become friends with Chris after photographing him several times and going to a lot of his concerts. He was playing at the festival, and I ran into him at a show. He was on a small label at the time, and I suggested we spend a little time together and shoot some photographs. So I picked him up in my rental car and we roamed around Austin, looking for some interesting locations. We came across this old church with severely cracked walls, and the visual really struck me. So we got out and started shooting. As modest and shy as Chris often seemed, he always seemed very present when I photographed him. I don't think he minded. Some musicians don't enjoy this process, but Chris was a natural … very honest and one of the most intelligent and interesting people I have met through my photography and love of music."

L'œuvre de Danny Clinch présente un large panorama de l'industrie de la musique des dix dernières années et s'étend sur une large palette de sujets – des superstars du hip-hop aux moines bouddhistes des concerts au profit du tibet libre. Danny Clinch s'est trouvé une place privilégiée dans le monde de la musique, ses clichés ont su saisir quelques instants rares de spontanéité et d'énergie de la vie intime des musiciens.

Né dans le New Jersey, Danny développa un intérêt pour la photographie à l'université. Après avoir passé son diplôme, Danny Clinch se vit proposer un stage par Annie Leibovitz après leur rencontre à la Ansel Adams Workshop. Il devint son assistant, voyageant et travaillant aux côtés d'autres grands noms de la photographie tels que Mary Ellen Mark, Timothy White, et Stephen Meisel.

Danny Clinch commença à collaborer avec le magazine *Spin* dans les années 1990 avec déjà une solide expérience dans la photographie de musiciens. A Boston, il réalisa un film sur le groupe Rick Berlin: *The Movie*, alimentant son amour du photojournalisme et de la musique. Photographier des musiciens a privilégié la spontanéité du travail de Danny Clinch, notamment dans le cadre de spectacles ou de concerts. Cette approche spontanée a aussi favorisé ses relations avec les musiciens qui se sentent à l'aise avec lui et elle est devenue caractéristique de son style de photographie.

Cette planche-contact présente une série de photos prises à Austin, Texas, où avait lieu le festival de musique South by Southwest Conference and Festival 2003. Chris Whitley, musicien aujourd'hui décédé qui se produisait en concert pendant ce festival, est le sujet de ces photographies.

« J'étais devenu ami avec Chris après l'avoir photographié à de nombreuses reprises et avoir assisté à beaucoup de ses concerts. Il participait à ce festival et je suis tombé sur lui pendant un concert. Il travaillait pour un petit label de production à l'époque et je lui ai suggéré de passer un peu de temps avec moi pour prendre des photos. Je suis allé le chercher et on a roulé dans Austin pour trouver des endroits intéressants. On est passé devant cette vieille église et l'image de ces murs fissurés m'a vraiment frappé. On a garé la voiture et on a commencé à prendre des photos. Chris parait souvent modeste et timide, mais il est toujours très présent sur les photographies. Je pense que ça ne le gênait pas d'être devant l'objectif. Certains musiciens n'aiment pas trop ces séances de poses, mais Chris était très naturel … très honnête et l'une des personnes les plus intelligentes que j'ai eu l'occasion de rencontrer dans mon travail et grâce à mon intérêt pour la musique. »

Danny Clinch, der seit über einer Dekade das Geschehen in der Musikbranche dokumentiert, zeigt in seinem Werk eine grosse Auswahl von fotografischen Themen – von hip-hop-Superstars zu Mönchen bei einem „Free tibet"-Konzert. Clinch hat sich als insider der Musikwelt etabliert, indem er rare Einblicke in die jugendliche Spontanität und Energie, die hinter den Musikern und deren Leben steckt, gibt.

Clinch wurde im Jahr 1964 in New Jersey geboren. Sein Interesse an der Fotografie begann während seines Studiums an der lokalen Uni. Nach dem Abschluss der New England School of Photography in Boston bot ihm Annie Leibovitz, die er bei einem Ansel Adams workshop kennengelernt hatte, eine Praktikumstelle an. Er wurde dann ihr Assistent – und reiste und arbeitete mit anderen Fotografen wie Mary Ellen Mark, Timothy White und Stephen Meisel.

Clinch begann in den 90er Jahren für das Magazin *Spin* zu fotografieren, aber das Fotografieren von Musikern war für ihn nichts Neues. Während seiner Zeit in Boston dokumentierte er die lokale band Rick Berlin in einem Film, Rick Berlin: *The Movie*, womit er seine Liebe für Fotojournalismus und Musik anfeuerte. Das Fotografieren von Musikern war für Clinch eine tolle Möglichkeit spontan zu arbeiten, besonders im Rahmen von Konzerten. Diese spontane Annäherung half Musikern sich mit Clinch komfortabel zu fühlen und hat sich seither zu einem Markenzeichen-Stil in seiner Fotografie entwickelt.

Der Kontaktbogen besteht aus einer Reihe von Fotos, die Clinch für das South by Southwest Conference and Festival in Austin, Texas, im Jahr 1973, gemacht hat. Das Thema ist der verstorbene Musiker Chris Whitley, der damals auf dem Fest spielte.

„Ich war mit Chris befreundet seitdem ich ihn einige Male fotografiert hatte und auf seinen Konzerten gewesen war. Er spielte auf dem Festival und ich traf ihn auf einer Aufführung. Er war damals mit einer kleinen Plattenfirma unter Vertrag, und ich schlug vor, ein wenig Zeit miteinander zu verbringen und Fotos zu machen. Also holte ich ihn mit meinem Mietsauto ab und wir fuhren in Austin herum, um interessante Drehorte zu finden. Wir fanden diese alte Kirche mit einigen rissigen Wänden und das visuelle Element stach mir wirklich ins Auge. So stiegen wir aus und fingen an zu fotografieren. Auch wenn Chris oft bescheiden und scheu schien, hatte er immer Präsenz, wenn ich ihn fotografierte. Ich denke, es machte ihm nichts aus. Manche Musiker geniessen diesen Prozess nicht sehr, aber Chris war ein Naturtalent … sehr ehrlich und einer der intelligentesten und interessantesten Menschen, die ich durch meine Fotografie und Liebe zur Musik kennengelernt habe."

Durante más de una década, el trabajo de Danny Clinch ha documentado la industria de la música desde una amplia variedad de perspectivas fotográficas: desde superestrellas del hip-hop a monjes en conciertos por la liberación del tibet. Clinch se ha afirmado como un gran conocedor del mundo de la música, capturando algunos raros destellos de la espontaneidad juvenil y la energía detrás de los músicos y sus vidas.

Nacido en Nueva Jersey, en 1964, la curiosidad de Clinch por la fotografía nace durante sus estudios en la universidad técnica. Tras graduarse, Annie Leibovitz le ofreció una beca poco después de haberle conocido en el Ansel Adams Workshop. Llegó a convertirse en su ayudante, viajando y trabajando con otros fotógrafos como Mary Ellen Mark, Timothy White y Stephen Meisel.

Clinch empezó a trabajar para *Spin* en los años noventa, aunque fotografiar músicos no era ninguna novedad. Cuando vivía en Boston, ya había plasmado en imágenes el grupo local Rick Berlin: *The Movie*, lo que alimentó su amor por el fotoperiodismo y la música. Retratar músicos suponía para Clinch una forma excelente de trabajar con espontaneidad, especialmente durante actuaciones en conciertos. Este enfoque espontáneo ayudaba a los músicos a sentirse más cómodos con Clinch, y se ha convertido en su sello distintivo en fotografía.

La hoja de contactos está compuesta por una serie de instantáneas tomadas durante la estancia de Clinch en Austin, Texas, durante el festival de música South by Southwest de 2003. El tema es el fallecido músico Chris Whitley, que tocaba en el festival.

"Me hice amigo de Chris después de fotografiarle varias veces y de asistir a muchos de sus conciertos. Tocaba en el festival y me lo encontré en un espectáculo. Estaba con un sello pequeño en aquel momento y le sugerí pasar algo de tiempo juntos y sacar algunas fotos. Así que le recogí en un automóvil de alquiler y deambulamos por Austin buscando algunas localizaciones interesantes. Dimos con esta vieja iglesia con varias paredes agrietadas y el aspecto visual me llamó la atención. Así que salimos del automóvil y empezamos a sacar fotos. Con todo lo modesto y tímido que Chris parece ser, siempre estaba muy presente cuando le fotografiaba. Creo que no le importaba. Algunos músicos no disfrutan con este proceso, pero Chris era muy natural … muy sincero y una de las personas más interesantes e inteligentes que he conocido gracias a la fotografía y mi amor a la música".

Danny Clinch

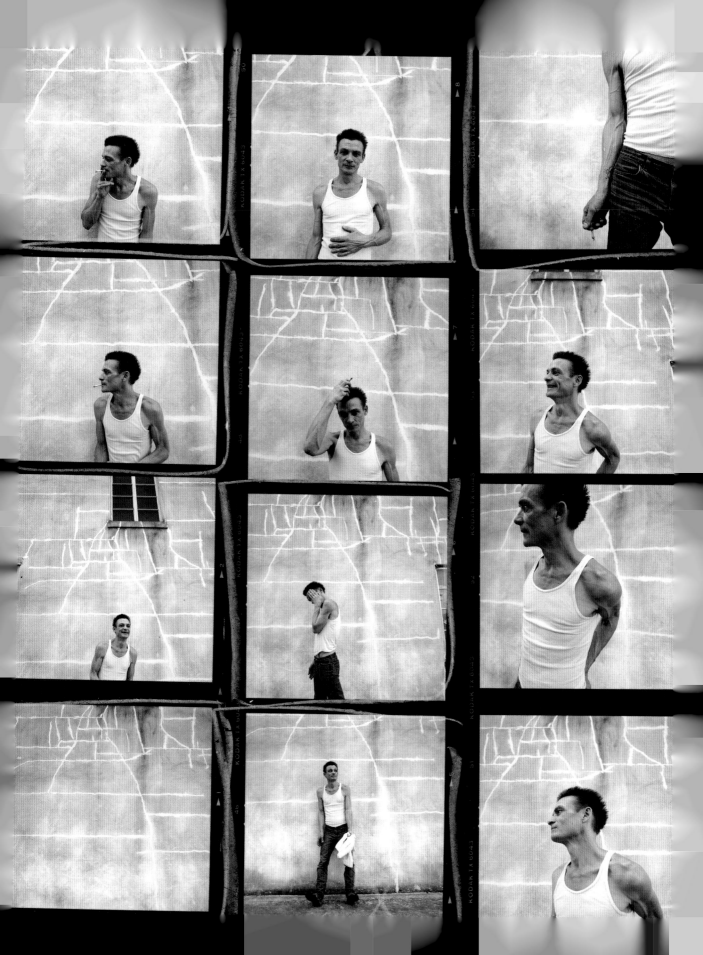

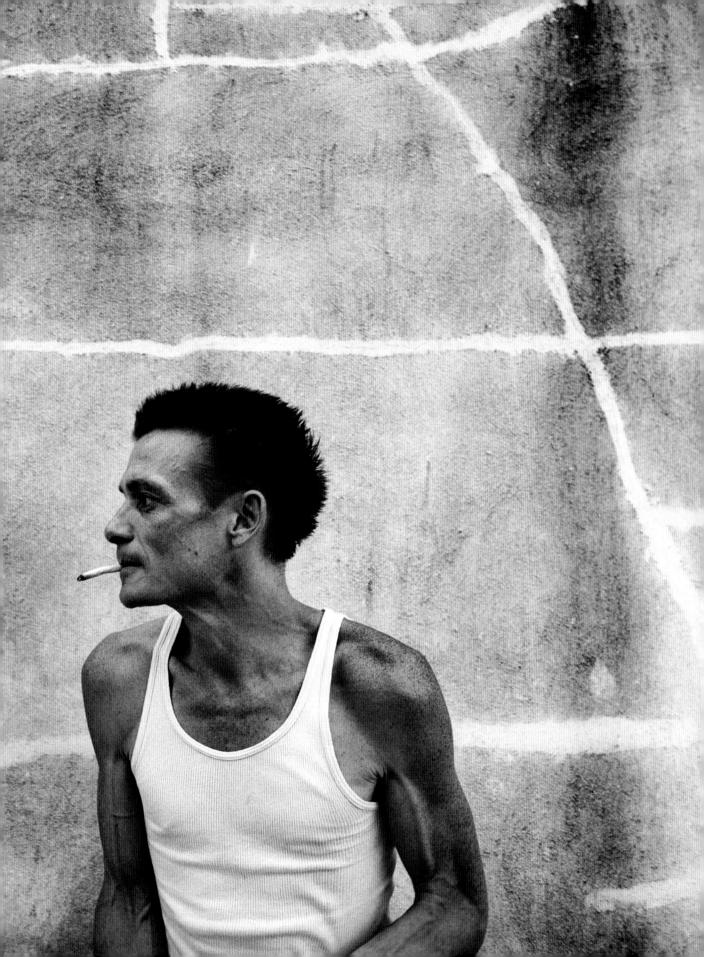

For Chuck Close, portraiture is a constantly evolving art form—from classic black-and-white images to colorful and brightly patterned canvases.

Close began painting from photographs in the late 1960s, using a technique devised by Renaissance masters and adapted by contemporary billboard painters: overlaying a print or photograph with a numbered and lettered grid, and then reproducing the image block by block. Close uses this method to produce works ranging from large-scale paintings to intimate drawings. He also creates portraits using printmaking techniques such as etching, woodcut, linoleum block printing, and screen printing.

Big Self Portrait was a watershed painting for Close, and his first self-portrait. It was the first piece in a series of eight black-and-white "heads," a group of paintings that would propel his rise to fame and set the course for his working method.

"I had just finished working on a twenty-two-foot-long nude and had extra film left, so I turned the camera on me. I decided that even though the nude was twenty-two feet long, the scale still wasn't big enough, and so I decided to focus on just a part of the body, and of course, the head was the most obvious piece. I was the only one in the room, so I photographed myself.

"I wanted to make an image that was so big that it couldn't readily be seen as a whole from a close distance. It would force the viewer to scan the surface and to treat the face almost like a landscape. I shot it from below as if it was a huge head, like the Easter Island heads. I was thinking about *Gulliver's Travels*, about the world of Lilliputians going on the head of the giant, knowing everything they thought there was to know, but still not knowing that they were on the head of a giant—stumbling across an eyebrow or nostril. It would be more like an experience of travel, a journey, rather than just looking at the image as a whole."

Les portraits de Chuck Close sont une forme artistique en évolution constante – parti du noir et blanc classique, il expérimenta ensuite avec la couleur.

A la fin des années 1960, Chuck Close commença à peindre des tableaux sur la base de photographies, imitant une technique des maîtres de la Renaissance adaptée par les créateurs de panneaux publicitaires contemporains: l'application d'un quadrillage sur une épreuve ou une photographie et la reproduction de l'image en grand format, cellule par cellule. Chuck Close reprit cette méthode pour créer des travaux allant de toiles grand format à des dessins intimes. Pour la création de ses portraits, il s'appuya également sur différentes techniques d'impression comme l'eau-forte, la gravure sur bois, le cliché de linoléum ou la sérigraphie.

Big Self Portrait est le premier autoportrait de Chuck Close et marqua un tournant décisif dans sa carrière. Ce fut le tout premier d'une série de huit « têtes » en noir et blanc, un groupe de tableaux qui devaient assurer sa notoriété et qui définit sa méthode de travail.

« Je venais de terminer un grand nu de sept mètres et, comme il me restait un peu de pellicule, j'ai tourné l'objectif sur moi. Je trouvais que même si le nu était long de sept mètres, l'échelle n'était toujours pas assez grande et j'ai donc décidé de zoomer sur une partie de mon corps. La tête était bien sûr le choix le plus évident. J'étais seul dans la pièce, je me suis donc photographié moi-même.

Je voulais faire une image tellement grande qu'on ne pourrait pas la voir en entier de près. L'image devrait forcer le spectateur à scanner sa surface et à regarder le visage presque comme un paysage. J'ai pris la photo en contre-plongée comme si ma tête était aussi imposante que les statues de l'île de Pâques. Je pensais aux *Voyages de Gulliver* et au monde des Lilliputiens qui vivaient sur la tête des géants – croyant avoir la connaissance universelle, mais ignorant qu'ils se trouvaient sur la tête d'un géant et trébuchant sur un sourcil ou une narine. Le tableau invite le regard à une sorte de voyage ou de cheminement à travers l'image, et non simplement à son appréhension en un coup d'œil. »

Unter Chuck Close ist die Porträtfotografie eine sich andauernd entwickelnde Kunstform – von schwarz-weiss Bildern zu bunten und hell gemusterten Leinwänden.

Close begann in den späten 60er Jahren von Fotos zu malen, indem er eine Technik benutzte, die von den Renaissance Meistern erfunden und von kontemporären Werbeschildmalern adaptiert wurde: Ein Druck oder Foto wird mit einem numerierten und mit Buchstaben versehenen Raster überlegt, und dann wird das Bild von Block zu Block reproduziert. Close benutzt diese Methode, um Werke zu erzeugen, die von gross-formatigen Bildern bis zu kleinen Zeichnungen reichen. Er kreiert auch Porträts mit Drucktechniken wie Ätzen, holzschnitt, Linoldruck und Siebdruck.

Big Self Portrait war ein Bild des Wendepunkts für Close, und sein erstes Selbstporträt. Es war das erste Stück in einer Gruppe von acht schwarz-weiss „Köpfen", eine Gruppe von Bildern, die seinen Anstieg zum Ruhm vorwärtstrieben, und den Kurs für seine Arbeitsmethode setzte.

„Ich hatte gerade die Arbeit an einem einen 6.7 Meter langen Akt beendet, und hatte extra Film übrig, so wandte ich die Kamera auf mich selbst. Ich entschied, dass, obwohl der Akt 6.7 Meter lang war, der Massstab immer noch nicht gross genug war, und so entschied ich mich nur auf einen Teil des Körpers zu konzentrieren, und natürlich war der Kopf der am naheliegendste Teil. Ich war die einzige Person im Raum, und so fotografierte ich mich selbst.

Ich wollte ein Bild machen, dass so gross war, dass es nicht leicht von nah betrachtet als Ganzes gesehen werden konnte. Es würde den Betrachter zwingen, die Oberfläche zu scannen und das Gesicht fast als Landschaft zu behandeln. Ich nahm die Aufnahme von unten auf, als ob es ein grosser Kopf wie einer der Steinköpfe der Osterinsel wäre. Ich dachte an *Gullivers Reisen*, an die Welt der Liliputaner auf dem Kopf eines Riesen, mit all dem Wissen, dass sie zu haben glaubten, aber ohne zu wissen, dass sie auf dem Kopf eines Riesen waren – über eine Augenbraue oder ein Nasenloch stolpernd. Es würde mehr wie ein Reiseerlebnis, eine Reise sein, als nur das Bild als Ganzes anzuschauen."

Con Chuck Close, el retrato es un arte en constante evolución: desde imágenes clásicas en blanco y negro a pinturas con brillantes colores y formas.

Close empezó a pintar a partir de fotografías a finales de los años sesenta, usando una técnica desarrollada por los maestros del Renacimiento y adaptada por los pintores contemporáneos de vallas publicitarias: cubriendo una impresión o fotografía con una rejilla con números y letras, y reproduciendo la imagen bloque a bloque. Close utiliza este método para producir trabajos que van desde pinturas a gran escala a dibujos intimistas. También elabora retratos usando técnicas de grabado como aguafuerte, xilografía, clisés de linóleo y serigrafía.

Big Self Portrait era una pintura de Close, y su primer autorretrato. Era la primera pieza de un grupo de ocho "cabezas" en blanco y negro, un grupo de pinturas que impulsarían su ascenso a la fama, y marcarían el rumbo de su método de trabajo.

"había acabado de trabajar en un desnudo de casi 7 metros de largo y me quedaba una película extra, así que dirigí la cámara a mí mismo. Me parecía que aunque el desnudo midiese 7 metros, la escala aún no era lo bastante grande y por eso decidí enfocar sólo una parte del cuerpo, y la cabeza era la elección obvia. Yo era la única persona en la habitación así que me fotografié a mí mismo.

Quería crear una imagen que fuese tan grande que no pudiera verse como un todo desde cerca. Forzaría al espectador a escanear la superficie y tratar la cara casi como un paisaje. La tomé desde abajo como si fuera una enorme cabeza, como las esculturas de la Isla de Pascua. Estaba pensando en *los Viajes de Gulliver*, acerca del mundo de los liliputienses subidos en la cabeza del gigante, creyendo que sabían todo lo habido y por haber, pero desconociendo que estaban en la cabeza de un gigante, tropezando con una ceja o la nariz. Sería como la experiencia de un viaje, una expedición, en lugar de ver sólo la imagen como un todo".

Chuck Close

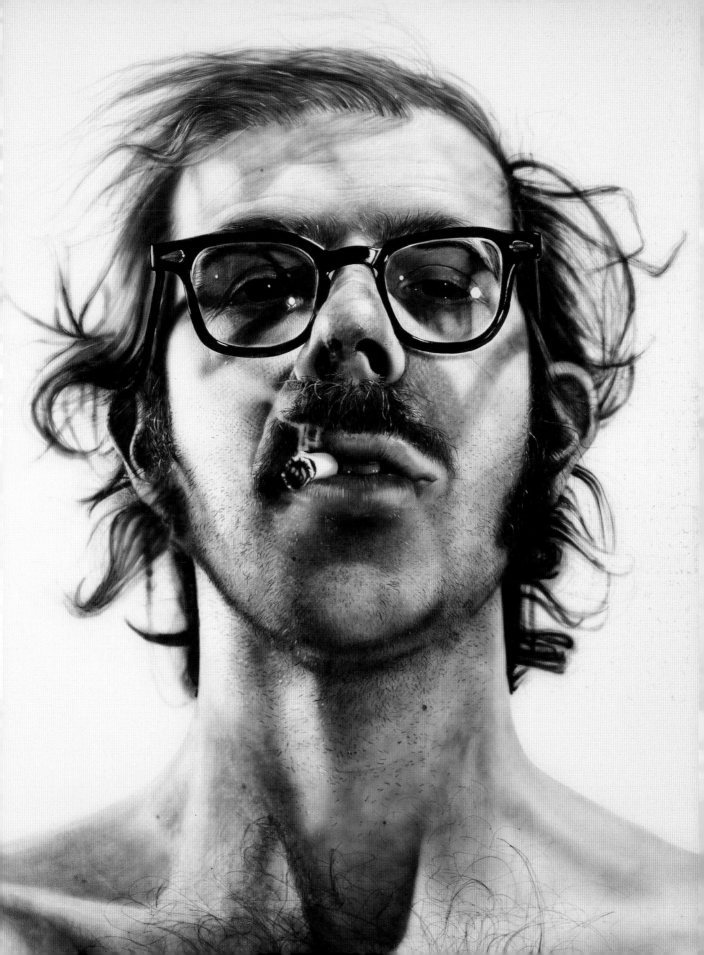

Michel Comte's career took off in the 1970s, when he received his first photography advertising assignment from Karl Lagerfeld for the fashion house Chloé, which also led him to Paris.

A few years later, Comte was offered a position at American *Vogue* and relocated to New York City and later to Los Angeles, reflecting Comte's restlessness: "I have always lived on the edge. … If I no longer have a sense of risk, I immediately move on. I probably inherited that from my grandfather [Swiss aviation pioneer Alfred Comte]."

During the '80s, Comte rose to fame as one of the most sought-after fashion and magazine photographers in the world. Working for *Vanity Fair* and *Vogue*, he has photographed a number of stars from the worlds of art, music, movies, and entertainment.

He is also a respected photojournalist working on assignment for the International Committee of the Red Cross, where he has captured haunting and intimate portraits of people and children in war-torn countries like Iraq, Afghanistan, and Bosnia.

This contact sheet documents an advertising shoot for jeweler Pomellato in 1995. The subject is the now First Lady of France, Carla Bruni-Sarkozy.

"The picture had been taken at the Crillon hotel in Paris. It was part of the Pomellato charity project to raise money for the orthopedic center in Kabur. Many celebrities had participated, and Carla Bruni worked without receiving compensation. It was after a long day of shooting for Italian *Vogue*; therefore, it's a very relaxed picture and as you can see, she feels very comfortable in her role."

Comte and Bruni-Sarkozy had worked together several times before. In fact, one of Comte's photographs of her from 1993—where she is standing nude, pigeon-toed, and covering herself modestly with her hands—was auctioned at Christie's New York in 2008. It was initially expected to fetch around $5,000, but the final bidding price was almost twenty times that amount, at $91,000.

La carrière de Michel Comte fut lancée dans les années 1970 quand Karl Lagerfeld lui confia son premier contrat publicitaire pour la maison de couture Chloé à Paris.

Quelques années plus tard, il partit pour New York et collabora avec l'édition américaine du magazine *Vogue*, puis se rendit à Los Angeles, dévoilant ainsi un besoin constant de mobilité : « j'ai toujours vécu aux limites du possible … si j'ai l'impression de ne plus prendre de risque, je change immédiatement de décor. J'ai dû hériter ça de mon grand-père [le pionnier de l'aviation suisse Alfred Comte].

Michel Comte accéda à la célébrité dans les années 1980 et devint l'un des photographes les plus convoités de la mode et du reportage. Pour les magazines *Vanity Fair* et *Vogue*, il réalisa les portraits des plus grandes personnalités dans les domaines des arts, de la musique, du divertissement et du cinéma.

Sa réputation de photojournaliste n'est plus à faire et il travaille avec le Comité international de la Croix-Rouge pour lequel il créa des portraits poignants et intimes de populations résidant dans les pays déchirés par les guerres comme l'Irak, l'Afghanistan et la Bosnie.

Cette planche contact documente une séance de photos publicitaires réalisée pour le bijoutier Pomellato en 1995. Le modèle est Carla Bruni-Sarkozy, aujourd'hui première dame de France.

« La photographie fut prise à l'hôtel Crillon à Paris dans le cadre d'un projet caritatif au profit d'un centre orthopédique à Kaboul. De nombreuses célébrités y avaient participé et Carla Bruni-Sarkozy avait travaillé sans rémunération. C'était la fin d'une longue journée de séance photos pour l'édition italienne de *Vogue*, nous avons là une photographie à l'atmosphère très décontractée et vous voyez que Carla est tout à fait à l'aise dans son rôle. »

Michel Comte et Carla Bruni-Sarkozy travaillèrent ensemble à de nombreuses reprises. C'est à Michel Comte qu'on doit la photographie prise en 1993 – où Carla Bruni-Sarkozy apparaît nue, le pied tourné vers l'intérieur et les maintes jointes dissimulant son intimité – qui fut mise aux enchères en 2008 par Christie's à New York. Estimée à environ 5 000 dollars, la photo fut adjugée pour presque vingt fois cette somme à 91 000 dollars.

Michel Comtes Karriere hob in den Siebzigern ab, als er seinen ersten fotografischen Werbeauftrag von Karl Lagerfeld für das Modehaus Chloé erhielt, was ihn auch nach Paris führte.

Einige Jahre später wurde Comte eine Stelle bei der amerikanischen *Vogue* angeboten und er übersiedelte nach New York und später nach Los Angeles, was Comtes Rastlosigkeit reflektierte: „Ich hatte immer am Rand gelebt … wenn ich kein Gefühl von Risiko mehr habe, dann ziehe ich sofort weiter. Ich habe dies wahrscheinlich von meinem Grossvater geerbt [Schweizer Flugpionier Alfred Comte]."

Während der achtziger Jahre wurde Comte berühmt als einer der am meist begehrten Mode- und Magazinfotografen der Welt. Für *Vanity Fair* und *Vogue* arbeitend hat er eine Anzahl von Stars der Welt der Kunst, Musik, Film und Unterhaltungsbranche fotografiert.

Er ist auch ein angesehener Fotojournalist der im Auftrag des Internationalen Roten Kreuzes gearbeitet hat, wo er tief bewegende und intime Porträts von Leuten und Kindern in kriegzerissenen Ländern wie Irak, Afghanistan und Bosnien aufgenommen hat.

Dieser Kontaktbogen dokumentiert einen Werbeshoot für den Juwelier Pomellato in 1995. Das Sujet ist die nun die First Lady von Frankreich, Carla-Bruni-Sarkozy.

„Das Bild wurde beim Crillon hotel in Paris aufgenommen. Es war Teil des Pomellato-Wohltätigkeitsprojekts, um Geld für das orthopädische Zentrum in Kabur zu sammeln. Viele Berühmtheiten hatten daran teilgenommen, und Carla Bruni arbeitete umsonst. Es war nach einem langen Tag von Aufnahmen für die italienische *Vogue*, und darum ist es ein sehr entspanntes Bild und wie man sehen kann, fühlt sie sich sehr angenehm in ihrer Rolle."

Comte und Bruni-Sarkozy hatte vorher einige Male zusammen gearbeitet. Tatsächlich wurde eines von Comtes Fotos von ihr von 1993 – wo sie nackt steht, die Zehen nach innen gespreizt, und sich mit ihren Händen bescheiden bedeckt – bei Christies New York in 2008 versteigert. Es wurde ursprünglich erwartet, dass es um die US$5000 erreichen würde, doch der Preis war fast zwanzig Mal so hoch mit US $91000.

La carrera profesional de Michel Comte despegó en la década de los setenta cuando recibió su primer encargo de fotografía publicitaria de Karl Lagerfeld para la casa de moda Chloé, que también le llevaría a París.

Unos años más tarde, a Comte le ofrecieron un puesto en el *Vogue* americano y se trasladó a Nueva York y más tarde a Los Ángeles, reflejo de la inquietud de Comte: "Siempre he vivido en el límite … si dejo de tener una sensación de riesgo cambio de inmediato. Probablemente es algo que heredé de mi abuelo [el aviador suizo pionero Alfred Comte]".

Durante los ochenta, Comte alcanzó la fama como uno de los fotógrafos de moda y de revistas más codiciados del mundo. Mientras trabajó para *Vanity Fair* y *Vogue*, fotografió a numerosas estrellas del mundo del arte, la música, el cine y el entretenimiento.

También es un periodista gráfico respetado que trabaja en encargos para la Cruz Roja Internacional para los que ha captado retratos íntimos y cautivadores de gente y niños en países devastados por la guerra como Iraq, Afganistán y Bosnia.

Esta hoja de contactos documenta una sesión de publicidad para el joyero Pomellato en 1995. La retratada es la actual Primera Dama de Francia, Carla Bruni-Sarkozy.

"La foto se realizó en el hotel Crillon en París. Formaba parte del proyecto benéfico de Pomellato para recaudar dinero para el centro ortopédico de Kabur. Muchos famosos habían participado y Carla Bruni trabajó sin recibir compensación alguna. Fue tras un largo día de trabajo para el *Vogue* italiano, fue por tanto una imagen muy relajada y como puede verse, se siente cómoda en el papel".

Comte y Bruni-Sarkozy habían trabajado juntos con anterioridad en varias ocasiones. De hecho, una de las fotografías de Comte de ella de 1993, en la que aparece de pie, desnuda, de puntillas y cubriéndose modestamente con las manos, fue subastada por Christie's Nueva York en 2008. Inicialmente se esperaba alcanza unos 5.000 dólares, pero el precio de subasta final multiplicó casi por veinte esa cantidad, alcanzando los 91.000 dólares.

Michael Comte

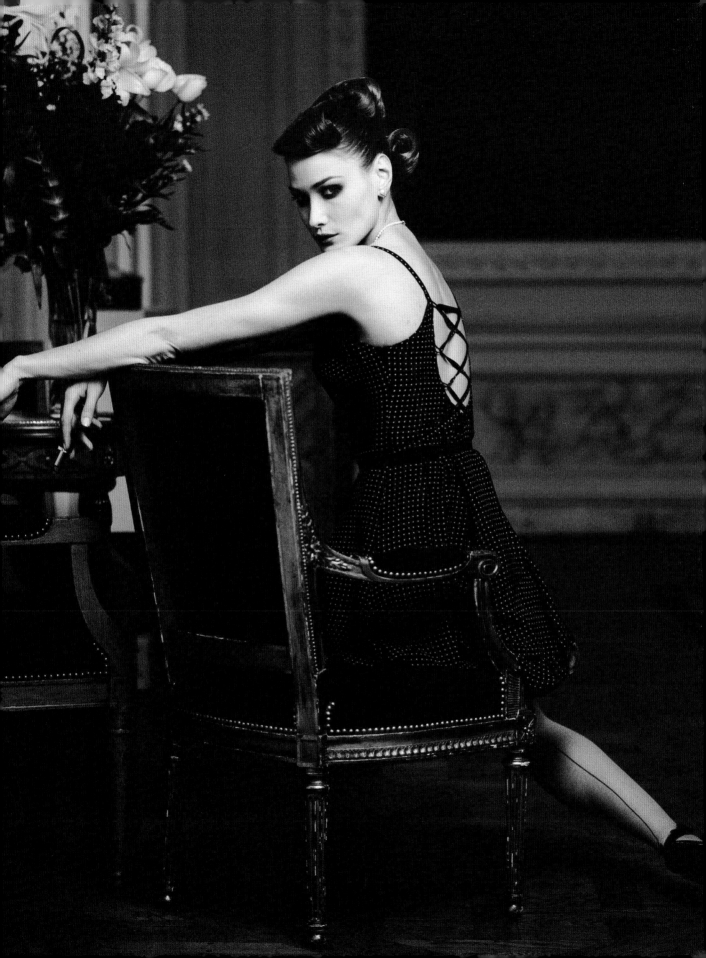

Carla Brun

Roll #12

Roll 14

#4

KODAK TXP 6049 52 53 54 55

KODAK TXP 6049

TXP ▸ 10 TXP ▸ 11 TXP ▸ 12

049 45 46 47 48

KODAK TXP 6049

KODAK TXP 6049

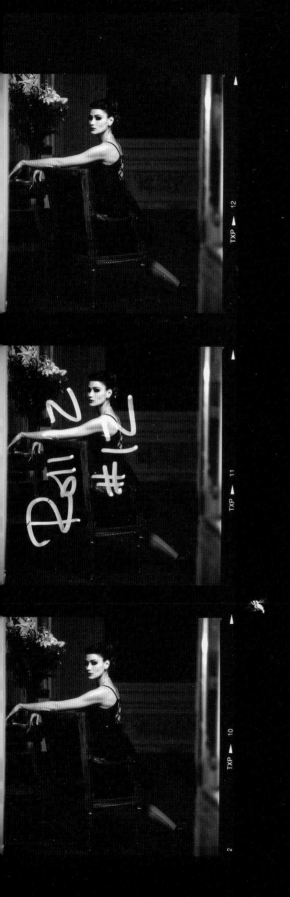

Dutch photographer and director Anton Corbijn has shot portraits of some of the most well-known musicians and artists in the world and has directed roughly eighty music videos for artists as varied as U2, Johnny Cash, and Depeche Mode. His ties to the music industry are deep, with more than one hundred sleeves to his name, including some of the biggest records in the past three decades—among them U2's *The Joshua Tree* and *Achtung Baby* and R.E.M.'s *Automatic for the People* albums.

Corbijn began his photography career in the early 1970s, using his father's camera during an open-air concert of local band Solution. He sent the images to a music magazine that eventually printed three of them. Later, he moved on to portrait photography, with his best-known work being images of artists such as Captain Beefheart, Clint Eastwood, and Miles Davis. Corbijn recently directed the biopic, *Control*, about Joy Division's front man, Ian Curtis. After working in the UK for *New Musical Express* in the early '80s, Corbijn shot for various publications both in Europe and the United States and has had many museum shows in the past fifteen years.

Inspired initially by photographers such as Diane Arbus and Robert Frank, Corbijn's photography was often raw—black-and-white, grainy, and wholly unglamorous. He changed the way he shot several times, as his style has been imitated vastly around the world. His latest books consist of color portraits and self-portraits, and his attention is now focused on film as well as photography and design.

This portrait of Allen Ginsberg was taken one early morning in 1996. "He is sitting in the kitchen of his apartment, looking out his window to the courtyard a few floors down. The significance for me was twofold: One, he is looking out into the world, suggesting he is an open-minded man, that he is interested in the outside world. Two, he himself took a photograph of the view through these windows every single day that he spent in his apartment."

Originaire des Pays-Bas, Anton Corbijn est photographe et réalisateur, il a vu défiler devant son objectif une série impressionnante de musiciens et de personnalités parmi les plus renommés d'aujourd'hui. Il a réalisé environ 80 vidéoclips pour des artistes aussi illustres que U2, Johnny Cash, et Depeche Mode. Ses liens avec le monde de la musique sont solides — il a créé une centaine de pochette d'albums pour certains de musiciens et des plus grands succès des trente dernières années, comme *The Joshua Tree* et *Achtung Baby* de U2, ou *Automatic for the People* de R.E.M.

Anton Corbijn fit ses début en photographie en 1972, utilisant l'appareil de son père lors d'un concert en plein air du groupe de musique Solution. Il envoya les clichés à un magazine qui en retint trois pour publication. Il devint rapidement le photographe vedette des célébrités, avec des portraits de stars aussi connues que Captain Beefheart, Clint Eastwood et Miles Davis. Plus récemment, Anton Corbijn réalisa *Control*, un long métrage sur la vie d'Ian Curtis, chanteur du groupe Joy Division. Après avoir travaillé au Royaume-Uni pour le magazine *New Musical Express* au début des années 1980, Anton Corbijn collabora avec de nombreuses publications en Europe et aux Etats-Unis et exposa dans de nombreux musées dans les quinze dernières années.

Inspirée des œuvres de photographes comme Diane Arbus et Robert Frank, la photographie d'Anton Corbijn est souvent crue — en noir et blanc, avec un grain prononcé et sans aucun glamour. Son style évolua au cours des années et fut amplement imité. Son dernier livre recueille des autoportraits en couleur et son attention est aujourd'hui centrée sur ses activités cinématographiques, sur la photographie et le design.

Ce portrait d'Allen Ginsberg fut tiré un matin de 1996. « J'ai pris cette photo d'Allen Ginsberg chez lui. Il est assis dans la cuisine de son appartement face à la fenêtre et son regard se porte sur la cour à quelques étages en contrebas. A mon sens, la signification de ce cliché est double : d'une part, le regard est tourné vers l'extérieur, ce qui suggère l'ouverture d'esprit et la curiosité pour le monde extérieur. Par ailleurs, Ginsberg prenait lui-même une photo de la vue sur cette cour tous les jours. »

Anton Corbijn, der von den Niederlanden stammt, ist ein Fotograf und Regisseur, der Portraitfotos von einigen der bekanntesten Musikern und Künstlern der Welt gemacht hat. Er hat um die 80 Musikvideos für Künstler so verschieden wie U2, Johnny Cash, und Depeche Mode gedreht. Seine Bindungen zur Musikindustrie sind eng — er hat über 100 hüllen für einige der grössten Plattenalben der letzten drei Dekaden fotografiert, inklusive für U2s Alben *The Joshua Tree* und *Achtung Baby* und für R.E.M.s Plattenalbum *Automatic for the People*.

Corbijn begann seine fotografische Karriere im Jahr 1972, als er die Kamera seines Vaters während eines Freiluftkonzerts der einheimischen Gruppe Solution benutzte. Er sandte die Fotos an ein Musikmagazin, das drei von den Bildern druckte. Dann begann er mit der Portraitfotografie, sein bekanntestes Werk beinhaltet Bilder von Künstlern wie Captain Beefhart, Clint Eastwood und Miles Davis. Corbijn hat vor kurzem die Filmbiographie *Control*, über Ian Curtis, den Sänger von Joy Division, fertig gedreht. Nachdem er in Grossbritannien für den *New Musical Express* in den frühen 80er Jahren gearbeitet hatte, fotografierte er für verschiedene Publikationen in Europa und den Vereinigten Staaten und hatte in den vergangenen fünfzehn Jahren viele Austellungen in Museen.

Anfangs, inspiriert von Fotografen wie Diane Arbus und Robert Frank, war die Fotografie von Corbijn oft roh — schwarz-weiss, körnig, und ganz unglamourös. Er änderte seine Art zu fotografieren einige Male, da sein Stil weltweit gewaltig imitiert wurde. Sein letztes Buch besteht aus Farb-Selbstportraits, und sein Hauptaugenmerk ist nun auf Film als auch Fotografie und Design gerichtet.

Dieses Portrait von Allen Ginsberg stammt von einem frühen Morgen aus dem Jahr 1996. „Ich fotografierte Allen Ginsberg in seinem Zuhause. Er sitzt in seiner Küche und schaut aus dem Fenster in den einige Stockwerke darunterliegenden hof hinaus. Dies hatte für mich zeifache Bedeutung: Erstens, er schaut hinaus in die Welt, was suggeriert, dass er ein aufgeschlossener Mann ist, der an der Aussenwelt interessiert ist. Zweitens, er selbst hat jeden Tag, den er in seiner Wohnungs verbracht hat, ein Foto von dieser Aussicht durch diese Fenster gemacht."

Oriundo de los Países Bajos, Anton Corbijn es fotógrafo y director, y ha retratado a varios de los músicos y artistas más famosos del mundo. Ha dirigido alrededor de 80 vídeos musicales para artistas tan variopintos como U2, Johnny Cash y Depeche Mode. Su relación con la industria de la música viene de lejos; ha fotografiado más de 100 cubiertas entre las que se encuentran algunos de los discos más importantes de las últimas tres décadas, como *The Joshua Tree* y *Achtung Baby* de U2 y *Automatic for the People* de R.E.M.

Corbijn empezó su carrera fotográfica en 1972 utilizando la cámara de su padre durante un concierto al aire libre del grupo local Solution. Envió las imágenes a una revista de música que acabó por publicar tres de ellas. A partir de ahí, comenzó a realizar retratos; entre sus trabajos más conocidos destacan las imágenes de los artistas Captain Beefheart, Clint Eastwood y Miles Davis entre otros. Corbijn también ha dirigido hace poco la película biográfica, *Control*, acerca de Ian Curtis, el cantante de Joy Division. Además de trabajar en el Reino Unido para *New Musical Express* a principios de los 80, ha colaborado con varias publicaciones en Europa y Estados Unidos y ha realizado numerosas exposiciones en los últimos quince años.

Inspirado al principio por fotógrafos como Diane Arbus y Robert Frank, la fotografía de Corbijn era a menudo cruda: en blanco y negro, granulada y carente de glamour. Su modo de trabajar ha cambiado varias veces y su estilo ha sido muy imitado en todo el mundo. Su último libro consiste en una serie de autorretratos en color y, en estos momentos, su atención se centra en el cine además de la fotografía y el diseño.

Este retrato de Allen Ginsberg fue realizado una mañana de 1996. "tomé la foto de Allen Ginsberg en su casa. Estaba sentado en la cocina de su apartamento, mirando por la ventana a un patio unos pisos más abajo. Para mí, el significado es doble: por un lado, está observando el mundo, sugiriendo que es un hombre de mentalidad abierta, que está interesado en el mundo exterior. Por otro, él mismo se dedicó a fotografiar la vista a través de esas ventanas todos los días que pasó en ese apartamento".

Anton Corbijn

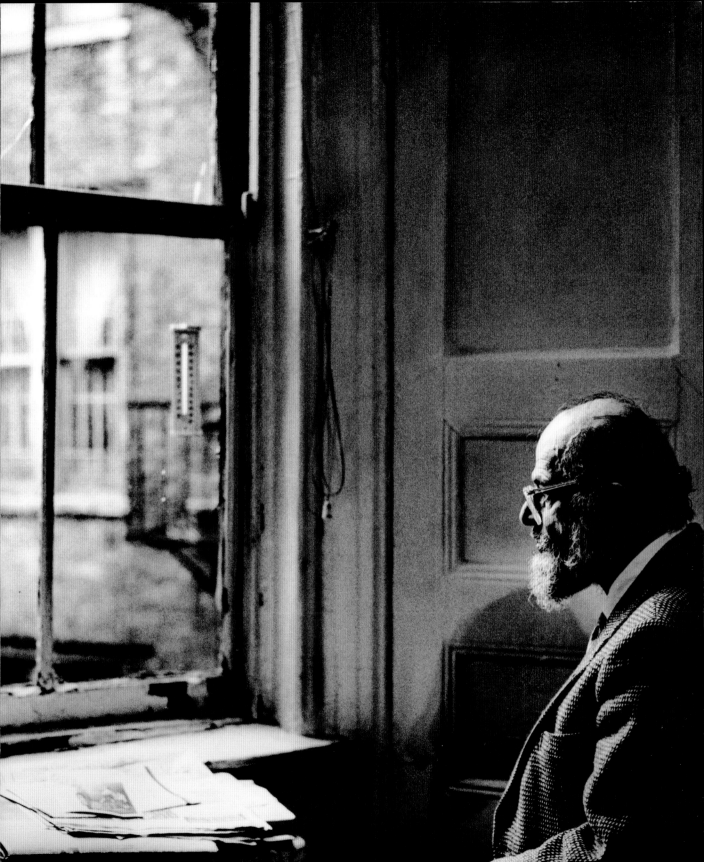

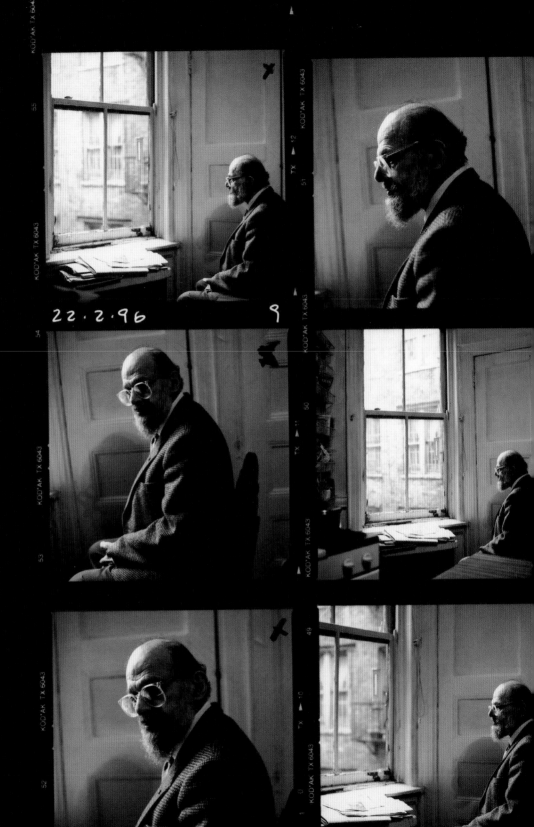

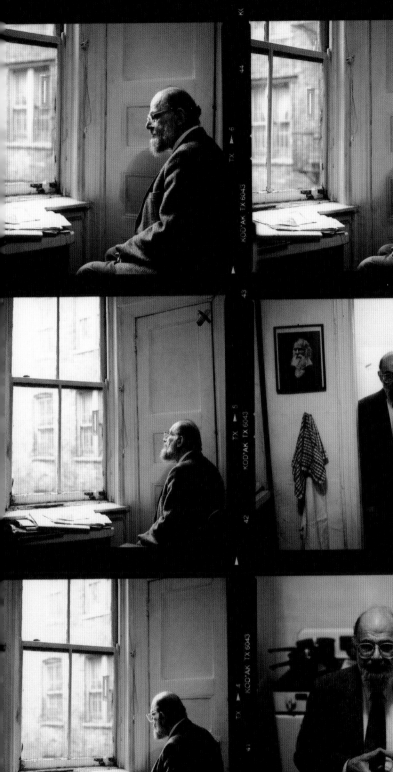

The University of Washington–Seattle did not have a photography program in the early 1900s, so a professor advised Imogen Cunningham to study chemistry. She helped pay for her tuition by creating lantern slides for the botany department, and botany, as a subject of importance, would resurface later in the most prolific years of Cunningham's career.

After graduation, Cunningham found a part-time job with Edward S. Curtis, a photographer then-famous for his documentation of indigenous North Americans. It was in Curtis's studio that she learned to create platinum prints and gained a foundation in the portrait business and other practical aspects of photography.

Cunningham soon obtained a scholarship abroad and left for Germany to study photography. She studied under Robert Luther, an internationally renowned photo scientist. Other inspirations during this time were Alvin Langdon Coburn and Alfred Stieglitz, whom she met in London and reunited with in the United States upon her return.

Cunningham returned to Seattle and opened her own portrait studio. She then moved to San Francisco, where she began photographing plants, taking a special interest in flowers. She also photographed nudes and industry in and around Los Angeles and Oakland. As a photographer for *Vanity Fair* in the 1930s, Cunningham took portraits of film stars as well.

While photographing abroad, Cunningham often took portraits of other photographers, artists, and writers. She had an affinity for creating portraits of those who were in creative fields. She said of her portraits, "I turn people into human beings by not making them into gods." Thus, it seems fitting that she photographed well-known artists, such as August Sander, in their natural habitats. During a trip to Europe in 1960, Cunningham took this photograph of then eighty-four-year-old Sander at his home in Cologne. Europe held a lasting fascination for Cunningham, and she made many lifelong relationships there.

"When you do portraits professionally, it's not a desire; it's for money. But I have done a lot of portraits without money. And whenever I see anything that I want to do, I do it. But I'm not forced to do it. … I'm doing what I want to."

L'université de Washington à Seattle n'offrant pas de cours de photographie, Imogen Cunningham y suivit des études de chimie sur les conseils d'un professeur. Elle participa au paiement de ses frais de scolarité en réalisant des diapositives sur verre pour le département de botanique de l'université, et la botanique devait ressurgir comme le motif privilégié des années les plus prolifiques de sa carrière.

Ayant obtenu son diplôme de chimie en 1907, elle commença une formation dans l'atelier d'Edward Curtis, photographe réputé pour ses travaux sur les Indiens. C'est dans le studio de Curtis qu'elle se familiarisa avec la création d'épreuves aux sels de platine, avec le commerce de la photographie et avec les nombreux aspects techniques du métier.

Elle obtint ensuite une bourse d'étude et partit suivre des cours de photographie en Allemagne où elle étudia sous la tutelle de Robert Luther, scientifique de la photographie de renom international. Elle fut également inspirée par Alvin Langdon Coburn, dont elle fit la connaissance à Londres, et par Alfred Stieglitz qu'elle rencontra aux Etats-Unis à son retour.

De retour à Seattle, Imogen Cunningham ouvrit son propre studio de portraits, puis partit s'installer à San Francisco où elle commença à photographier des plantes, manifestant un intérêt tout particulier pour les fleurs. Elle créa aussi de nombreux nus et prit des clichés d'installations industrielles à Los Angeles, à Oakland et dans les environs. Dans les années 1930, elle réalisa une série de portraits d'artistes d'hollywood pour le magazine *Vanity Fair*.

Ses voyages lui furent souvent l'occasion de prendre le portrait de la fine fleur du monde de la photographie, de l'art et de la littérature, et de consacrer son talent à l'univers artistique. Au sujet de ses portraits, elle déclarait « en n'en faisant pas des dieux, je transforme mes modèles en êtres humains », et il lui était naturel de photographier des célébrités comme August Sander dans leur environnement familier. Lors d'un séjour en Allemagne en 1960, elle réalisa ce portrait du photographe chez lui, Sander avait alors quatre-vingt-huit ans. Imogen Cunningham manifesta toute sa vie une intense fascination pour l'Europe où elle garda de nombreux amis.

« Quand on est portraitiste professionnel, on ne crée pas des portraits pour le plaisir mais pour être rémunéré. Pourtant j'ai réalisé beaucoup de portraits sans rétribution. Et si j'ai envie de me lancer dans une activité, alors je m'y consacre. Rien ni personne ne m'y oblige, je le fais pour le plaisir. »

Da die University of Washington, in Seattle, zu der Zeit kein Fotografieprogramm anbot, studierte Imogen Cunningham auf Anraten eines Professors Chemie. Das Erzeugen von Diapositiva für das Botanikprogramm half ihr, die Studiengebühren zu bezahlen, und die Botanik als Motiv tauchte später wieder in den produktivsten Jahren ihrer Karriere auf.

Nach Studiumabschluss begann Cunningham ihre Karriere mit einem Halbzeitjob bei Edward S. Curtis, ein Fotograf, der damals berühmt für seine Dokumentierung der nordamerikanischen Indianer war. Es war in Curtis' Studio, dass sie Platindrucke anzufertigen lernte und das Gewerbe der Portraits und andere praktische Aspekte der Fotografie kennenlernte.

Cunningham erhielt bald ein Stipendium, und reiste nach Deutschland, um Fotografie im Ausland zu studieren. Sie studierte unter Robert Luther, einem international anerkannten Fotografiewissenschafter. Andere Inspirationen während dieser Zeit waren Alvin Langdon Coburn und Alfred Stieglitz, den sie in London und in den USA nach ihrer Rückkehr kennengelernt hatte.

Cunningham kehrte nach Seattle zurück und eröffnete ihr eigenes Porträtstudio, und dann zog sie nach San Francisco, wo sie anfing, Pflanzen zu fotografieren, und ein spezielles Interesse an Blumen fand. Sie fotografierte auch Akte und die Filmindustrie in, und in der Umgebung von, Los Angeles und Oakland. Als Fotografin für *Vanity Fair* in den dreissiger Jahren nahm Cunningham auch Porträts von Filmstars auf.

Während sie im Ausland fotografierte, machte Cunningham oft Porträts von anderen Fotografen, Künstlern und Schriftstellern. Sie hatte eine Neigung, Porträts von jenen zu machen, die im kreativen Bereich tätig waren. Als sie von ihren Porträts sagte, „Ich verwandle Leute in Menschen indem ich sie nicht in Götter verwandle," dann scheint es passend, dass sie gutbekannte Künstler wie August Sander, in deren natürlichem Habitat fotografierte. Während einer Reise nach Europa in 1960 nahm Cunningham dieses Foto vom damals fünf-und-achtzig-jährigen Sander bei seinem Zuhause in Köln auf. Europa hatte eine dauernde Faszination für Cunningham, da sie dort viele enge Beziehungen hatte.

„Wenn man Porträts professionell macht, dann ist dies nicht ein Wunsch, es ist für Geld. Aber ich habe viele Porträts ohne Geld gemacht. Und wenn immer ich etwas sehe, was ich machen will, dann mache ich es. Aber ich bin nicht gezwungen, es zu machen....Ich mache was ich machen will."

Como la Universidad de Washington, Seattle, no disponía de un programa de fotografía en la época, Imogen Cunningham estudió química después de que un profesor le aconsejase hacerlo. Contribuyó a pagar sus estudios creando diapositivas para el departamento de botánica, y la botánica sería un tema que reaparecería más tarde en los años más prolíficos de la carrera de Cunningham.

Después de graduarse, Cunningham empezó su carrera con un trabajo a tiempo parcial con Edward S. Curtis, un fotógrafo famoso en aquel entonces por su documentación de los indios nativos de Norte América. En el estudio de Curtis aprendió a crear impresiones en platino y el oficio de retratista así como otros asuntos prácticos relacionados con la fotografía.

Al poco tiempo, Cunningham recibió una beca y partió a Alemania a estudiar fotografía. Se formó con Robert Luther, un fotógrafo científico de fama internacional. Otras fuentes de inspiración en esa época fueron Alvin Langdon Coburn y Alfred Stieglitz, a quienes conoció en Londres y en Estados Unidos tras su regreso.

Cunningham regresó a Seattle y abrió su propio estudio de retratos y, más adelante, se trasladó a San Francisco, donde empezó a fotografiar plantas, prestando especial interés a las flores. También realizó fotografías de desnudos e industriales en Los Ángeles y Oakland y sus alrededores. Como fotógrafa de *Vanity Fair* en los años treinta, Cunningham produjo también retratos de estrellas del cine.

Durante su etapa en el extranjero, Cunningham tomó a menudo retratos de otros fotógrafos, artistas y escritores. Le gustaba realizar retratos de personas que participaban en campos creativos. Cuando afirmó: "Convierto a las personas en seres humanos porque no las convierto en dioses" parecía adecuado que fotografiase a famosos artistas, como August Sander, en su entorno natural. Durante un viaje a Europa en 1960, Cunningham tomó esta imagen de August Sander, que ya había cumplido 84 años, en su hogar en Colonia. Europa ejercería una fascinación constante sobre Cunningham, ya que conservaba allí numerosas amistades.

"Si realizas retratos de manera profesional no lo haces por afición, sino por dinero. Pero, yo he hecho numerosos retratos sin motivos económicos. Y siempre que veo algo que quiero hacer, lo hago. Pero no me veo forzada a ello....hago lo que me apetecse hacer".

Imogen Cunningham

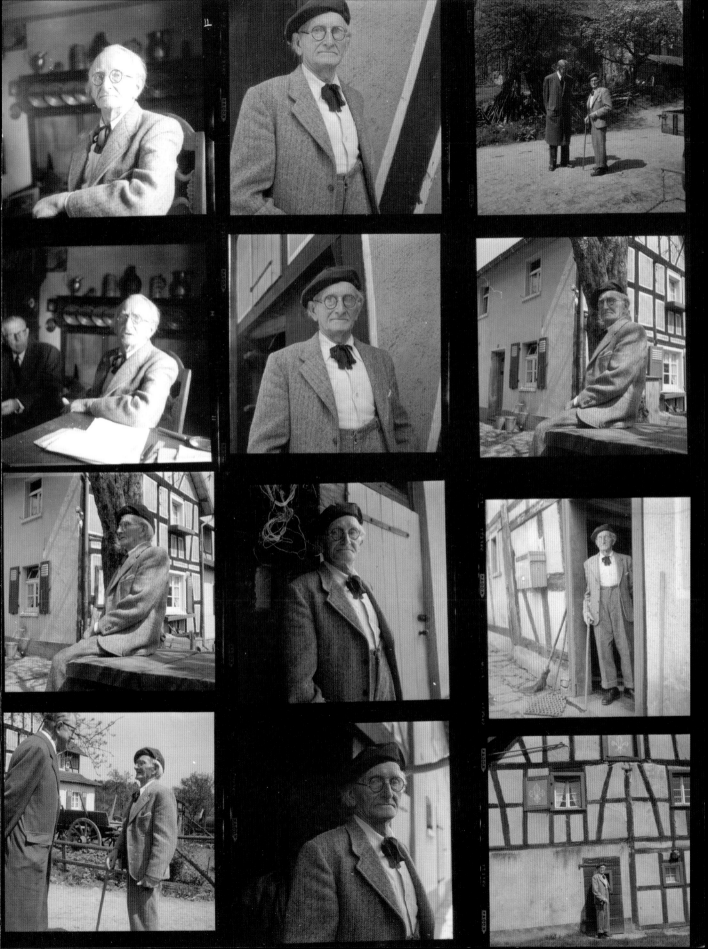

Belgian photographer Carl de Keyzer began his freelance career in the early 1980s while living in Ghent. During that time, he was also teaching at the Royal Academy of Fine Arts, and he eventually co-founded and co-directed the XYZ-Photography Gallery.

A trademark of de Keyzer's work is the scale of his projects—large with expansive themes. His art often focuses on social issues such as overpopulated communities and cities. Often his images accompany text written during his travels—from India to the Soviet Union.

The featured contact sheet is from de Keyzer's Zona: Siberian Prison Camp project. In 2000, Magnum Photos held an exhibition in the Siberian city of Krasnoyarsk—a city that had been "forbidden" since 1994 due to its nuclear sites. While there, a local press photographer offered to take de Keyzer to a prison camp.

"What I saw there was quite surprising. I had a very grim idea of these camps, if they still existed anyway. I had an idea of black-and-white, dark pictures, torture. But the camp itself is sort of a Disneyland. … Everything was in color, all the walls and interiors, mostly light blue, light green. Psychologically chosen colors, I guess, to put prisoners' minds at rest."

There were three kinds of camps de Keyzer visited, and the one featured in this contact sheet is a woodcutters camp—the camp he felt had the most difficult conditions.

"It's a hard regime. Mostly long-term sentences, where prisoners have to cut trees even in wintertime at temperatures of minus-fifty degrees. In this picture, the trees are gathered in an artificial lake inside the camp, a river connects the camp (lake) and the cutting areas. These trees were the remainders of the summer cuttings. They had to be removed by hand by prisoners barely dressed for this kind of work at below-freezing temperatures. My film broke twice during the section, and it was hard to replace with two pairs of gloves and dressed like an astronaut."

Originaire de Belgique, Carl de Keyzer commença une carrière de photographe indépendant à Gand au début des années 1980. Il occupa également un poste d'enseignant à la Royal Academy of Fine Arts de Gand et participa parallèlement à la fondation et à la direction de la XYZ-Photography Gallery.

Les projets de Carl de Keyzer se caractérisent par leur dimension thématique vaste et complexe. Ses photographies interrogent fréquemment les problèmes de société, comme la surpopulation des villes ou des quartiers. Elles viennent souvent illustrer un journal de route écrit au cours de ses voyages en Inde ou en Union Soviétique.

Cette planche contact est extraite du projet Zona: Camps de prisonniers en Sibérie. En 2000, l'agence Magnum présentait une exposition dans la ville de Krasnoïarsk en Sibérie, ville « interdite » depuis 1994 en raison de ses sites nucléaires. Lors de son séjour, Carl de Keyzer fut invité par un photographe de presse local à visiter un camp de prisonniers.

« Ce que j'ai vu en arrivant était très surprenant. Je me faisais une idée très sinistre de ces camps, en admettant qu'ils existent toujours. J'avais une idée de noir et blanc, de photographies obscures, de torture. Mais le camp lui-même ressemble à une sorte de Disneyland. Tout est en couleur, les murs d'enceinte et les intérieurs, dans des tons bleu clair et vert pâle, des couleurs qui ont dû être choisies pour leur effet apaisant sur les prisonniers. »

Carl de Keyzer visita trois types de camps, celui représenté dans cette planche contact est un camp de bûcherons – le camp dans lequel il eut l'impression que les conditions de vie étaient les plus âpres.

« C'est un régime très sévère. Purgeant pour la majorité d'entre eux de lourdes peines, les prisonniers doivent abattre des arbres même l'hiver par des températures de -50 degrés. Sur cette photo, les troncs sont assemblés dans un lac artificiel à l'intérieur du camp, une rivière connectant le camp aux parcelles de coupe. Ces arbres avaient été abattus pendant l'été, ils devaient être déplacés manuellement par des prisonniers dont les vêtements n'étaient pas du tout adaptés à ce type de travail et aux températures glaciales. Ma pellicule s'est cassée à deux reprises pendant le tirage et j'ai eu du mal à la remplacer avec mes deux paires de gants et ma tenue de cosmonaute. »

Der belgische Fotograf Carl de Keyzer begann seine Karriere als freischaffender Fotograf in den frühen achtziger Jahren als er in Ghent lebte. Er unterrichtete auch an der Royal Academy of Fine Arts, und er war einer der Gründer und Leiter der XYZ-Photography-Gallerie.

Ein Kennzeichen von de Keyzers Arbeit ist der Massstab seiner Projekte – gross mit umfassenden Themen. Oft konzentriert sich sein Werk auf soziale Themen wie überbevölkerte Gemeinschaften und Städte. Seine Bilder begleiten auch oft Text, der während seiner Reisen von Indien zur Sowjetunion geschrieben wurde.

Der abgebildete Kontaktbogen stammt von de Keyzers Projekt über das siberische Gefangenenlager. Im Jahr 2000 hielt Magnum eine Ausstellung in der siberischen Stadt Krasnoyarsk – eine Stadt, die seit dem Jahr 1994 „verboten" war wegen der nuklearen Anlagen. Während seines Aufenthalts dort bot ein lokaler Pressefotograf an, De Keyzer zu einem Gefangenenlager mitzunehmen.

„Was ich dort sah, war wirklich überraschend. Ich hatte eine schreckliche Vorstellung von diesen Lagern, falls sie überhaupt existierten. Ich hatte eine Idee von schwarz und weiss, dunkle Bilder, Tortur. Aber das Lager selbst ist eine Art von Disneyland. … Alles war bunt, all die Wände und die Innenräume, vor allem hellblau, hellgrün. Psychologisch ausgesuchte Farben, nehme ich an, um die Gedanken der Gefangenen ruhig zu stellen."

Es gab drei Arten von Lagern, die de Keyzer besuchte, und das Lager von diesem Kontaktbogen ist vom Holzabbau-Lager – das Lager, das seiner Meinung nach die schwierigsten Bedingungen hatte.

„Es ist ein hartes Regime. Vor allem langfristige Strafen, wo die Gefangenen Bäume sogar im Winter abholzen müssen bei Temperaturen von -10 Grad Celsius. In diesem Bild sind die Bäume in einem künstlichen See im Lager gesammelt, ein Fluss verbindet den Lager (See) und die Abholzgebiete. Diese Bäume waren die Reste der Sommerabholzung. Sie mussten von den Arbeitern manuell entfernt werden, und die Arbeiter waren kaum für diese Art von Arbeit bei Temperaturen unter dem Gefrierpunkt bekleidet. Mein Film brach zweimal während dem Abschnitt entzwei, und es war schwierig, den Film, mit zwei Paar Handschuhen und angezogen wie ein Astronaut, auszutauschen."

El fotógrafo belga Carl de Keyzer comenzó su carrera como fotógrafo independiente a principios de los ochenta cuando vivía en Gante. También ha enseñado en la Real Academia de Bellas Artes, y cofundado y codirigido la galería fotográfica XYZ-Photography.

Una señal distintiva del trabajo de de Keyzer es la escala de sus proyectos; grandes, con temas extensos. Es habitual que su obra se centre en temas sociales como las ciudades y comunidades superpobladas. Sus imágenes también suelen estar acompañadas de texto escrito durante sus viajes desde la India a la Unión Soviética.

La presente hoja de contactos procede del proyecto de de Keyzer sobre los campos de prisión siberianos ("Zona"). En el año 2000, Magnum celebró una exposición en la ciudad siberiana de Krasnoyarsk, una ciudad que había estado "prohibida" desde 1994 debido a sus centrales nucleares. Una vez allí, un fotógrafo de la prensa local se ofreció a llevar a de Keyzer a un campo de prisioneros.

"Lo que vi resultó bastante sorprendente. Tenía una idea macabra de esos campos, si es que todavía existían. Me los imaginaba en blanco y negro, con imágenes oscuras, tortura. Pero el campo en sí es una especie de Disneylandia. … Todo era de colores, todas las paredes e interiores, la mayoría azul claro, verde claro. Colores elegidos por su valor psicológico, creo, para que los prisioneros relajaran su mente".

De Keyzer visitó tres tipos de campos, y el que se representa en esta hoja de contactos es un campo de leñadores, el campo que le pareció que tenía las condiciones más difíciles.

"Es un régimen duro. La mayoría de las sentencias son de larga duración, y los prisioneros tienen que cortar árboles incluso en invierno a temperaturas de −50 grados. En esta foto, los árboles están agrupados en un lago artificial en el interior del campo, un río conecta el campo (lago) y las áreas de corte. Estos árboles eran los restos del trabajo del verano. Tenían que ser retirados a mano por los prisioneros que apenas llevaban las ropas necesarias para ese tipo de trabajo a temperaturas bajo cero. La película se rompió dos veces durante la sesión y era difícil sustituirla con dos pares de guantes y vestido como un astronauta".

Carl de Keyzer

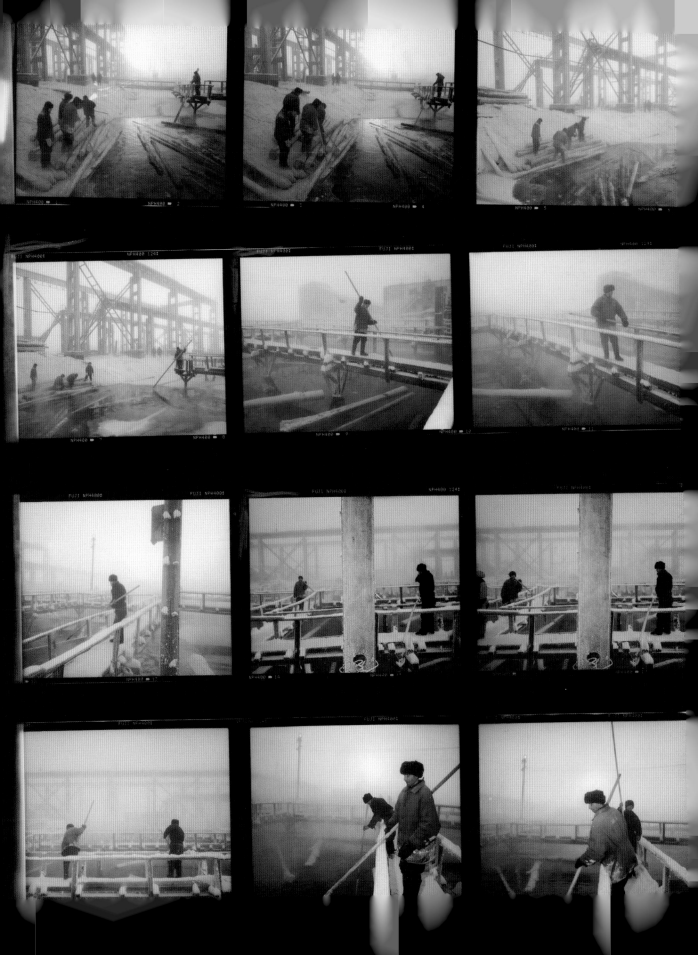

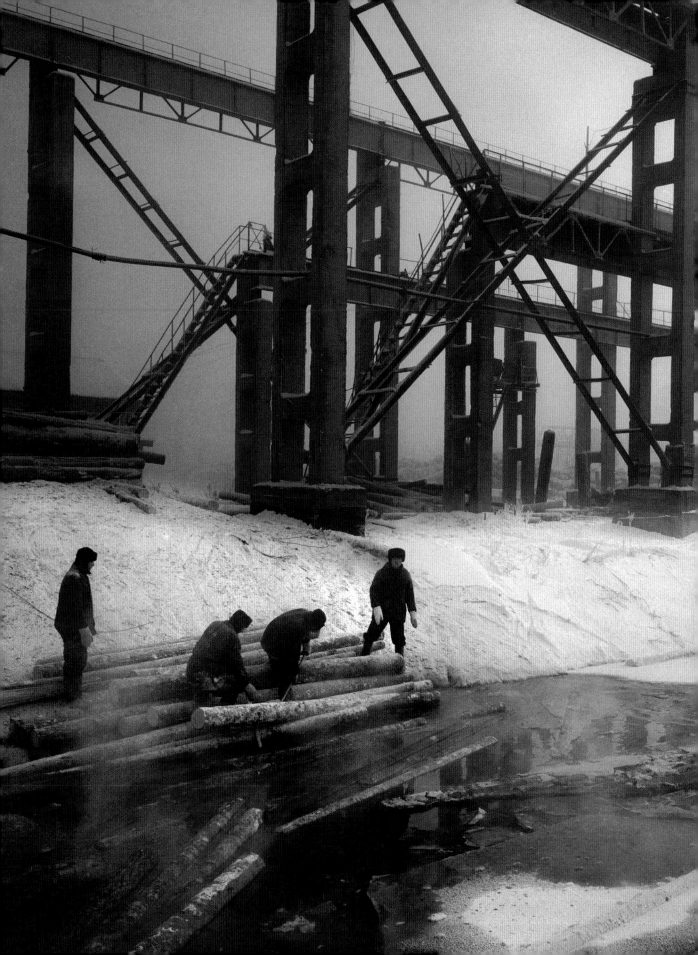

Our impressions of Paris are likely inseparable from the romantic and whimsical work of Robert Doisneau. One of France's most noted photographers, Doisneau created photographs that often chronicled the daily happenings of Parisian street life: images that have since become icons of French culture.

Born in 1912, in Gentilly, France, Doisneau initially studied engraving at the École Estienne in Chantilly. As photography grew popular, engraving became obsolete, and Doisneau began a self-taught education in this new medium. What started as a hobby evolved into a career, as his first photo-story was sold to the *Excelsior* newspaper. Doisneau went on to become a camera assistant to the sculptor Andrei Vigneaux, and then worked as an industrial and advertising photographer for the Renault auto factory until he started freelancing as an advertising and postcard photographer. He was hired by the Rapho photo agency, where he worked until he was drafted into World War II. Doisneau's engraving and photography skills proved to be invaluable for a soldier of the Resistance—useful in forging passport and identification papers, as well as in photographing the Occupation and Liberation of Paris.

After the war, Doisneau began a period of photography that includes some of his best-known work, selling his photographs to *Life* and various other international magazines. After a short-lived stint in fashion photography, he continued to photograph Parisian street life. He lived in the Paris suburb of Montrouge until his death in 1994.

The featured contact sheet is for what is arguably Doisneau's most famous photograph, "Le baiser de l'hôtel de ville." Taken in 1950, the photograph was part of a series Doisneau created for a *Life* magazine photo spread on Paris lovers. Contrary to popular belief, the photo was not spontaneous; Doisneau had posed the couple in several different locations, as is evident on his contact sheet. The two models, real-life couple Françoise Bornet and Jacques Carteaud, were spotted by Doisneau near the school they were attending and were hired for the series. This fact wasn't well known until the 1990s, when several people tried to claim they were the couple in the photo, compelling Bornet to present her payment for the photo shoot—an original print with Doisneau's signature and stamp.

La ville de Paris est indissociablement liée aux clichés romantiques et spontanés de Robert Doisneau. L'un des photographes français les plus célèbres, Doisneau se fit le chroniqueur des évènements de la vie quotidienne des parisiens et ses photographies sont devenues emblématiques de la culture française.

Né en 1912 à Gentilly, Robert Doisneau étudia d'abord la gravure à l'école Estienne de Chantilly. La popularité croissante de la photographie rendant la gravure obsolète, Robert Doisneau se fit autodidacte dans cette nouvelle technique. Ce qui avait commencé comme passe-temps devint bientôt une carrière avec la vente de son premier roman-photo au journal *l'Excelsior*. Robert Doisneau travailla comme assistant caméraman pour le sculpteur Andrei Vigneaux, il fut engagé par les usines Renault en qualité de photographe industriel et publicitaire et il se lança ensuite dans la photographie publicitaire et réalisa des cartes postales en indépendant. Il fut engagé par l'agence de photographie Rapho jusqu'à sa conscription pendant la deuxième guerre mondiale. Les talents de Doisneau lui furent très précieux pendant la guerre où il son activité de faussaire fournit la Résistance en faux papiers ; il prit aussi de nombreuses photographies de la vie quotidienne à Paris sous l'occupation et pendant la libération.

Robert Doisneau connut une période très féconde pendant l'après guerre, il y publia ses photographies les plus connues et collabora avec *Life* et avec de nombreuses magazines internationaux. Après une brève incursion dans la photographie de mode, il continua à brosser le tableau de la vie quotidienne des parisiens. Il vécu dans la ville de Montrouge, en banlieue parisienne, jusqu'à son décès en 1994.

Cette planche contact inclut ce qui est sans doute la photographie la plus célèbre de Robert Doisneau, « Le baiser de l'hôtel de ville ». Pris en 1950, ce cliché s'insère dans une série créée pour une double page dans le magazine *Life* avec pour thème les amants de Paris. Contrairement à la conception populaire, le cliché n'était pas spontané et il est clairement visible sur la planche contact que Doisneau demanda au couple de poser dans des lieux différents. Les deux modèles, le couple Françoise Bornet et Jacques Carteaud, furent repérés par Doisneau à la sortie de leur cours de théâtre et engagés pour le tirage de la série. Ces faits étaient peu connus jusqu'aux années 1990, quand plusieurs personnes se reconnurent dans le couple de la photographie, poussant Françoise Bornet à rendre public sa rémunération pour la séance de photos – une épreuve originale signée de la main de Doisneau et marquée de son cachet.

Moderne Vorstellungen von Paris sind oft synonym mit den romantischen und wunderlichen Bildern von Robert Doisneau. Die Fotografien von Doisneau, einer von Frankreichs bekanntesten Fotografen, zeichnen oft das tägliche Leben der Pariser Strassen auf, und sind zu Ikonen der französischen Kultur geworden.

Doisneau, geboren in 1912 in Gentilly, Frankreich, studierte ursprünglich Gravierkunst an der École Estienne in Gentilly. Durch die wachsende Popularität der Fotografie wurde das Gravieren bald als altmodisch betrachtet, und Doisneau begann seine autodidaktische Ausbildung in diesem neuen Medium. Was als Hobby begann, entwickelte sich zu einer Karriere als er seine erste Foto-Geschichte an die Zeitung *Excelsior* verkaufte. Doisneau wurde Kamera-Assistent für den Bildhauer Andrei Vigneaux, und arbeitete dann als Industrie- und Werbefotograf für die Renault-Autofabrik bis er freiberuflich als Werbe- und Postkartenfotograf zu arbeiten begann. Er wurde von der Rapho Fotoagentur angestellt, für die er, bis er für den Zweiten Weltkrieg einberufen wurde, arbeitete. Doisneaus talent als Gravierer und Fotograf machten ihn unschätzbar als Soldat für die Widerstandsbewegung – er fälschte Pässe und Identifikationspapiere, und fotografierte die Besetzung und Befreiung von Paris.

Nach dem Krieg begann Doisneau eine Reihe von Fotografien, die viele seiner bekanntesten Werke beinhalten, er verkaufte seine Fotos an *Life* und verschiedene andere internationale Magazine. Nach einem Kurzaufenthalt in der Modefotografie, fotografierte er weiterhin das Leben der parisischen Strassen. Er lebte im Pariser Vorort Montrouge bis zu seinem tod in 1994.

Der abgebildete Kontaktbogen zeigt Doisneaus wohl berühmtestes Foto „Le baiser de l'hôtel de ville". Aufgenommen in 1950, dieses Foto war Teil einer Serie, die Doisneau für das *Life* Magazin zu Liebespaaren in Paris gestaltet hatte. Im Gegensatz zur populären Ansicht war dieses Foto nicht spontan, das Paar posierte für Doisneau an einigen verschiedenen Stellen, was auf dem Kontaktbogen deutlich sichtbar ist. Die zwei Modelle, das echte Liebespaar Françoise Bornet und Jacques Carteaud, waren von Doisneau in der Nähe ihre Schule entdeckt und für die Serie angestellt worden. Diese Tatsache war bis in die 1990er Jahre nicht sehr bekannt, wenn einige Leute zu behaupten versuchten, dass sie das Paar im Foto seien. Dies gab Bornet Anlass, als Beweis ihre Bezahlung für die Fotoaufnahme zu zeigen – ein Originalabzug mit Doisneaus Unterschrift und Stempel.

Las percepciones modernas de París son a menudo sinónimo de las románticas y caprichosas imágenes de Robert Doisneau. Uno de los fotógrafos más reconocidos de Francia, las fotografías de Doisneau relatan las ocurrencias diarias de la vida de la calle parisina, y se han convertido en iconos de la cultura francesa.

Nacido en 1912, en Gentilly, Francia, Doisneau empezó a estudiar grabado en la École Estienne de Chantilly. El grabado en seguida quedó obsoleto, la popularidad de la fotografía creció, y Doisneau empezó a aprender por sí mismo este nuevo medio. Lo que empezó como una afición se convertiría en una carrera cuando vendió su primera historia fotográfica al periódico *Excelsior*. Doisneau pasó a ser el asistente de cámara del escultor Andrei Vigneaux, y luego trabajó como fotógrafo industrial y de publicidad para la fábrica de automóviles Renault hasta que empezó a trabajar por su cuenta como fótografo de postales y publicidad. Fue contratado por la agencia de fotografía Rapho, con la que colaboró hasta que se llamaron a filas en la Segunda Guerra Mundial. Las habilidades como grabador y fotógrafo de Doisneau demostraron ser valiosísimas como soldado de la Resistancia, falsificando pasaportes y cédulas de identidad, así como fotografiando la ocupación y la liberación de París.

Después de la guerra, Doisneau empezó un período fotográfico que incluye parte de sus trabajos más conocidos, vendiendo sus fotos a *Life* y otras revistas internacionales. Tras un corto intervalo en el mundo de la moda, pasó a fotografiar la vida de las calles de París. Vivió en el barrio parisino de Montrouge hasta su fallecimiento en 1994.

La presente hoja de contactos pertenece a, probablemente, la fotografía más famosa de Doisneau: "Le baiser de l'hôtel de ville". Tomada en 1950, la imagen forma parte de una serie creada por Doisneau para la revista *Life* acerca de los amantes de París. Al contrario de la creencia popular, la foto no fue espontánea, Doisneau hizo que la pareja posara en varias ubicaciones diferentes, como se ve claramente en esta hoja de contactos. Los dos modelos, una pareja en la vida real, Françoise Bornet y Jacques Carteaud, fueron observados por Doisneau cerca de la escuela a la que acudían, y les contrató para la serie. Este hecho no fue muy conocido hasta los años 90, cuando varias personas intentaron reclamar que ellos eran la pareja de la foto, obligando a Bornet a presentar su pago por la sesión fotográfica: una impresión original con el sello y la firma de Doisneau.

Robert Doisneau

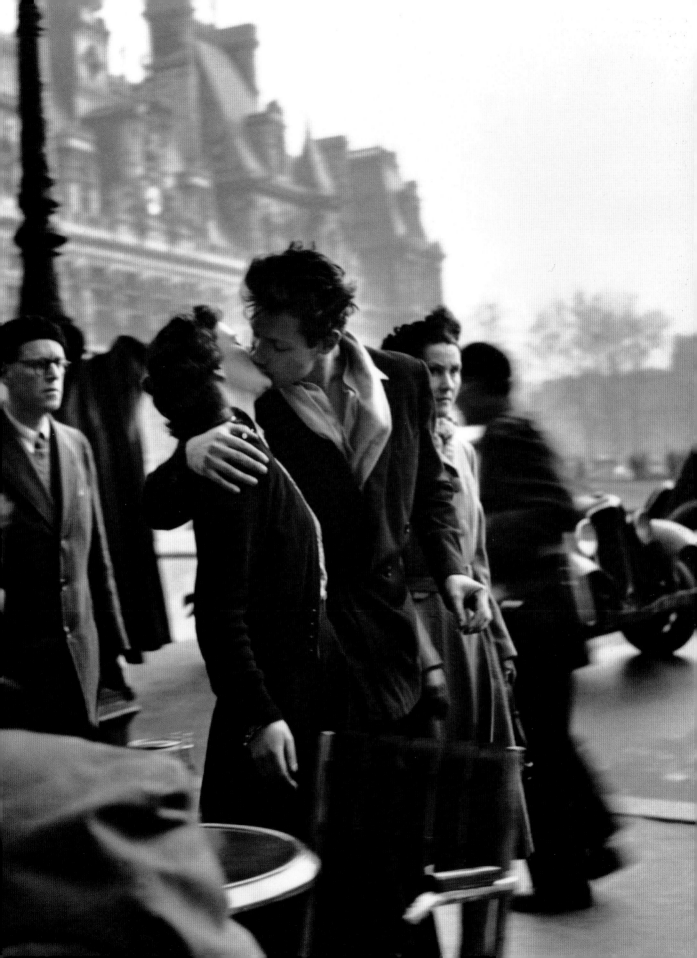

21 200 20 - 3. 19

21 039

21 224

21 201

21 198

21 203

David Doubilet has spent a lifetime photographing the fragile underwater world, since he first put his Brownie Hawkeye camera in a rubber anesthesiologist's bag at the age of twelve. His personal and professional challenge is to capture the essence of our planet's ocean from the smallest plankton to the largest predators.

Doubilet was born in New York City but spent his summers in Elberon, New Jersey, where he was seduced by the sea and knew from an early age that his only goal was to become an underwater photographer. There were just no other options for him. He began shooting in black-and-white and is still fond of the medium for certain subjects.

Doubilet is a contributing author and photographer for *National Geographic* magazine, where he has photographed more than sixty-five stories since his first assignment in 1971. He is a feature columnist, contributing editor, and author of numerous books on the sea.

This contact sheet is a set of images taken by Doubilet while on assignment in New Ireland, Papua New Guinea. The subject is diver Dinah Halstead in a near-perfect circle of Pacific barracuda.

"I was working near a long, finger-like reef with deep water on three sides. As I photographed another subject, an enormous school of Pacific barracuda began to slowly circle me. I was photographing the school from within when I realized that I was in the image that I wanted to make. I swam like hell back to our dive boat and asked Dinah Halstead to come quickly back to the barracuda with me. I dove for the bottom forty-five feet below as the school began to form and move around Dinah. They circled her three times before they broke apart. At one point Dinah put out her hand like a dancer—a single moment that made the image work."

David Doubilet a consacré sa vie à photographier le fragile monde sous-marin depuis le jour où il mit son appareil Brownie hawkeye dans un sac d'anesthésiste à l'âge de 12 ans. Son ambition personnelle et professionnelle est de saisir par la photographie l'essence de la vie dans les océans de notre planète, du minuscule plancton aux plus gros prédateurs.

Né à New York, David Doubilet passait ses étés à Elberon dans le New Jersey où il fut séduit par l'océan. Dès son plus jeune âge, il se fixa pour objectif de travailler dans la photographie sous-marine, et aucune autre option n'aurait su lui convenir. Il commença à travailler avec du noir-et-blanc et aime encore utiliser ce médium pour certains sujets.

David Doubilet collabore avec le magazine *National Geographic* en tant qu'auteur et photographe, et il a réalisé plus de soixante-cinq reportages depuis sa première mission en 1971. Il tient une chronique, est conseiller de rédaction et a écrit de nombreux livres qui prennent la mer pour sujet.

Cette planche contact reprend une série de clichés réalisés par David Doubilet lors d'un reportage sur l'île de la Nouvelle-Irlande en Papouasie-Nouvelle-Guinée. On y voit la plongeuse Dinah Halstead évoluer dans un cercle presque parfait de barracudas du Pacifique.

« Je travaillais en proximité d'un récif de forme allongée avec des grands fonds sur trois côtés. Je photographiais un autre sujet quand un énorme ban de barracudas a commencé à m'encercler lentement. Je me suis rendu compte que je me trouvais à l'intérieur même de l'image que je voulais prendre. Je suis retourné à toute vitesse vers notre bateau et j'ai demandé à Dinah Halstead à revenir avec moi vers les barracudas. J'ai plongé à une profondeur de treize mètres pendant que le ban se reformait autour de Dinah. Ils l'ont encerclée trois fois avant de repartir. A un moment, Dinah a levé la main dans un geste de danseuse – un moment fugitif qui a créé une image parfaite. »

David Doubilet hat sein Leben damit verbracht, die fragile Unterwasserwelt zu fotografieren, seit er zum ersten Mal im Alter von zwölf Jahren seine Brownie hawkeye Kamera in einen anästhesiologischen Gummisack reinsteckte. Seine persönliche und berufliche Herausforderung ist es, die Essenz des Ozeans unseres Planeten vom kleinsten Plankton bis zu den grössten Räubern zu erfassen.

Doubilet wurde in New York City geboren, aber er verbrachte seine Sommer in Elberon, New Jersey, wo er vom Meer verführt wurde und ab frühen jungen Alter an wusste, dass es sein einziges Ziel war, ein Unterwasser-Fotograf zu werden, da gab es für ihn keine andere Optionen. Er begann auf schwarz-weiss zu fotografieren, und ist immer noch ein Fan von diesem Medium für bestimmte Themen.

Doubilet ist ein beitragender Autor und Fotograf für das Magazin *National Geographic*, wo er über fünf-und-sechzig Berichte seit seinem ersten Auftrag in 1971 fotografiert hat. Er ist ein feature Kolumnist, beitragender Editor und Autor von zahlreichen Bücher über das Meer.

Dieser Kontaktbogen ist einer Reihe von Bildern, die Doubilet während eines Auftrags in New Ireland, Papua-Neuguinea aufnahm. Das Thema ist die Taucherin Dinah Halstead in einem fast perfekten Kreis von pazifischen Barracudais.

„Ich arbeitete in der Nähe von einem langen, finger-ähnlichen Riff mit tiefem Wasser an drei Seiten. Als ich ein anderes Thema fotografierte, begann ein riesiger Schwarm von pazifischen Barracudais mich zu umkreisen. Ich fotografierte den Schwarm von innen als ich realisierte, dass ich in dem Bild war, dass ich nehmen wollte. Ich schwam wie der Teufel zurück zu unserem Tauchboot und fragte Dinah Halstead, mit mir schnell zu den Barracudais zurückzukehren. Ich tauchte runter zum Grund auf fünf-und-vierzig Feet runter, als der Schwarm sich zu formen begann und um Dinah kreiste. Sie umkreisten Dinah dreimal bevor sie sich auflösten. Zu einem Zeitpunkt streckte Dinah ihre Hand wie eine Tänzerin aus – ein einzelner Moment, der das Bild funktionieren liess."

David Doubilet se ha pasado la vida fotografiando el frágil mundo submarino desde que puso por primera vez su cámara Brownie hawkeye en una bolsa de plástico de anestesista con doce años de edad. Su desafío personal y profesional consiste en atrapar la esencia del océano de nuestro planeta, desde el plancton más pequeño hasta los grandes predadores.

Doubilet nació de la ciudad de Nueva York pero pasó sus veranos en Elberon, Nueva Jersey, donde resultó seducido por el mar y supo desde muy temprana edad que su única meta era convertirse en fotógrafo submarino, simplemente no consideró ninguna otra opción. Empezó a hacer fotos en blanco-y-negro, y sigue gustándole el medio para determinados temas.

Doubilet es fotógrafo y autor contribuyente de la revista *National Geographic* para la que ha fotografiado más de sesenta y cinco historias desde su primer encargo en 1971. Es cronista, editor colaborador y autor de numerosos libros sobre el mar.

Esta hoja de contactos es un conjunto de imágenes tomadas por Doubilet durante un trabajo en Nueva Irlanda, Papua Nueva Guinea. El objeto de la fotografía es la submarinista Dinah Halstead en un círculo casí perfecto de barracudas del Pacífico.

"Estaba trabajando cerca de un largo arrecife en forma de dedo con agua profunda en tres lados. Mientras fotografiaba otro objeto, un enorme banco de barracudas del Pacífico comenzó a rodearme lentamente. Estaba fotografiando el banco desde dentro cuando me di cuenta de que estaba en la imagen que quería tomar. Regresé nadando a toda velocidad a nuestro barco de submarinismo y le pedí a Dinah Halstead que me acompañara rápidamente hasta las barracudas. Me sumergí hasta alcanzar los algo más de trece metros de profundidad del fondo momento en el que el banco de peces comenzó a formarse y a moverse alrededor de Dinah. La rodearon en tres ocasiones antes de partir. En un momento determinado Dinah extendió su mano como una bailarina, un instante que hizo que la imagen funcionara".

David Doubilet

Diver & Barracuda School 28

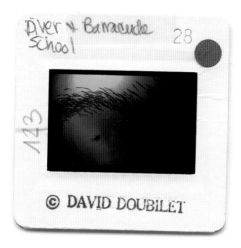

© DAVID DOUBILET

123

Diver & Barracuda School 27

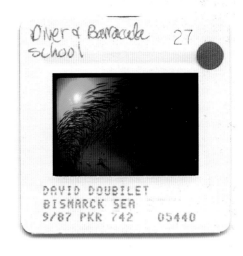

DAVID DOUBILET
BISMARCK SEA
9/87 PKR 742 05440

Diver in Circle Barracuda PNG 28

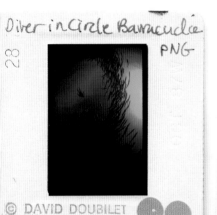

© DAVID DOUBILET

Diver in circle of Barracuda 33

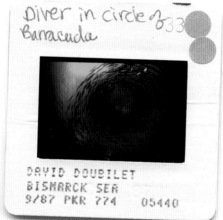

DAVID DOUBILET
BISMARCK SEA
9/87 PKR 774 05440

Diver & Barracuda School 22

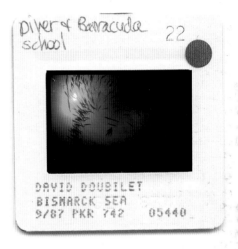

DAVID DOUBILET
BISMARCK SEA
9/87 PKR 742 05440

004
PNG
LECTURE DUPLICATE
BARRACUDA PNG

D. Doubilet ©

24
Diver in circle of Barracuda

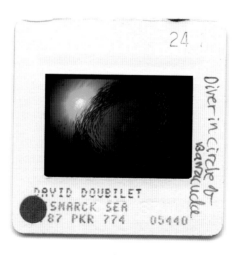

DAVID DOUBILET
BISMARCK SEA
87 PKR 774 05440

Diver & circle of Barracuda PNG

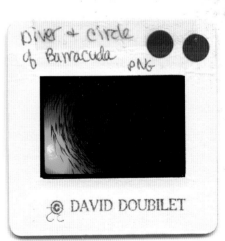

© DAVID DOUBILET

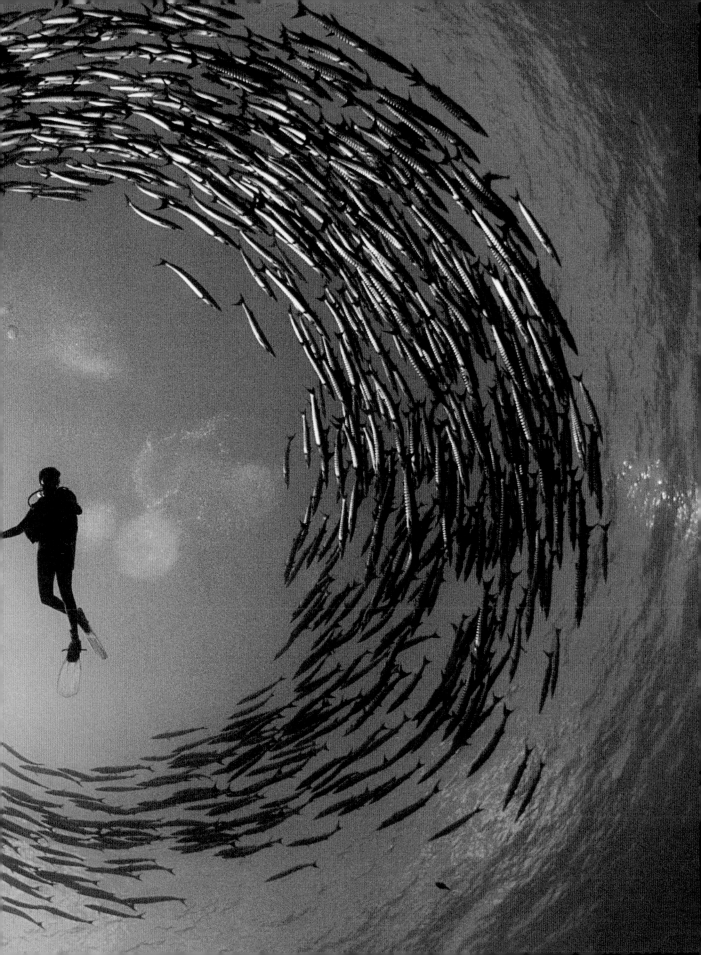

After a childhood spent in Milan, Elliott Erwitt moved to the United States in the late 1930s. His interest in photography grew while spending his adolescence in Hollywood, where he eventually took a job in a commercial darkroom processing prints of movie stars for fans. Erwitt went on to study photography and film in New York, where he befriended Edward Steichen, Robert Capa, and Roy Stryker—mentors who would be instrumental in Erwitt's career.

Erwitt began his turn at professional photography while traveling in France and Italy during the late '40s. He was soon drafted into the army for the Korean War and took on several photographic assignments from various publications while stationed in Europe.

The featured contact sheet is from a session with Marilyn Monroe in 1956 at an apartment in New York City—during the peak of the actress's popularity.

"Marilyn Monroe was an important movie star, and taking pictures of her was a good thing in many ways. She was a nice person and a willing subject. It was also a good career move as good pictures of her were likely to sell. The simple reason behind the shoot was to get it published."

About Monroe, Erwitt says, "She was a very pleasant person; I remember that. She was accessible and easy, and friendly, and she seemed quite intelligent, which was at odds with her reputation of being a ditzy blonde. Very photogenic and pleasantly approachable, considering her star status."

When asked about whether Monroe was staged with the book, he says, "I usually do not stage photographs; I just spent some time there and took pictures. She was working in New York at the time, and consequently we were able to take this picture at the apartment."

Erwitt had photographed Monroe on several occasions before and after this specific session. In fact, in 1960, he photographed her on the set of her last movie before her death, The Misfits.

Après une enfance passée à Milan, Elliott Erwitt émigra aux Etats-Unis à la fin des années 1930. Son intérêt pour la photographie se précisa durant son adolescence, qu'il passa à Hollywood, et il commença à travailler dans un laboratoire commercial où il développait des tirages signés pour les fans de stars de cinéma. Il s'établit ensuite à New York pour y étudier la photographie et le cinéma, et il y fit la connaissance de Edward Steichen, Robert Capa et Roy Stryker qui devaient tous devenir ses mentors et contribuer au développement de sa carrière.

A la fin des années 1940, il effectua des voyages en Europe et ses photographies prises en France et en Italie marquèrent le début de sa carrière professionnelle. Conscrit dans l'armée américaine pendant la guerre de Corée, il continua à photographier pour de nombreuses publications alors qu'il était en poste en Europe.

Cette planche contact fut réalisée en 1956 lors d'une session avec Marilyn Monroe dans l'appartement new yorkais de l'actrice, alors au sommet de sa gloire.

« Marilyn Monroe était une grande star du cinéma et la photographier ne pouvait que m'être bénéfique. C'était une personne adorable et un modèle accommodant. C'était très positif pour ma carrière car les bonnes photos d'elle trouvaient facilement preneur. Nous avions l'intention de publier les photographies prises pendant cette session. »

Evoquant Marilyn Monroe, Erwitt déclara « je me souviens qu'elle était tout à fait charmante. Elle était accessible, simple et conviviale, et contrairement à sa réputation de blonde écervelée, elle paraissait intelligente. Très photogénique et abordable malgré son statut de star. »

A la question de savoir si les photographies étaient mises en scène, Erwitt répondit « je ne donne aucune indication pendant les sessions, je passe seulement du temps avec le modèle et je prends les photos. Marilyn Monroe travaillait à New York à cette époque et nous avons donc pu réaliser ces clichés dans son appartement. »

Elliot Erwitt photographia Marilyn Monroe à de nombreuses reprises avant et après cette session. Il la photographia notamment sur le tournage du dernier film où elle apparut avant son décès, Les Désaxés.

Nach einer Kindheit, die in Milan verbracht wurde, zog Elliott Erwitt in die Vereinigten Staaten in den späten Dreissigern. Sein Interesse an der Fotografie wuchs während er seine Adoleszenz in Hollywood verbrachte, wo er schliesslich eine Stelle in einer kommerziellen Dunkelkammer annahm – wo er Abzüge von Filmstars für Fans ausdruckte. Erwitt studierte dann Fotografie und Film in New York, wo er sich mit Edward Steichen, Robert Capa und Roy Stryker anfreundete – von denen alle dem beginnenden Fotografen Mentoren wurden und seiner Karriere behilflich sein würden.

Erwitt begann seine professionelle fotografische Karriere während der späten vierziger Jahre als er in Frankreich und Italien reiste. Er wurde bald in die Armee für den Krieg in Korea einberufen, und nahm einige fotografische Aufträge von verschiedenen Publikationen an, während er in Europa stationiert war.

Der abgebildete Kontaktbogen ist von einer Sitzung mit Marilyn Monroe in 1956 in einer Wohnung in New York City – während dem Höhepunkt der Popularität der Schauspielerin.

„Marilyn Monroe war ein wichtiger Filmstar und von ihr Fotos zu machen war eine gute Sache auf vielen Ebenen. Sie war eine nette Person und ein bereitwilliges Sujet. Es war auch eine gute Entscheidung für die Karriere, da gute Bilder von ihr sich verkaufen lassen würden. Der einfache Grund hinter dem Shoot war veröffentlicht zu werden."

Über Monroe sagt Erwitt: „Sie war eine sehr angenehme Person, ich erinnere mich daran. Sie war ansprechbar und unkompliziert und freundlich, und sie schien recht intelligent zu sein, was wirklich ihrer Reputation als dummem Blondchen widersprach. Sehr fotogen und angenehm zugänglich, wenn man ihren Status als Star berücksichtigt."

Als er befragt wurde, ob Monroe mit dem Buch inszeniert wurde, sagte er: „Ich inszeniere normalerweise keine Fotos, ich verbrachte etwas Zeit dort und nahm Aufnahmen. Sie war zu der Zeit in New York und folglich war es uns möglich, dieses Bild in der Wohnung zu machen."

Erwitt hatte Monroe zu verschiedenen Anlässen bevor und nach dieser spezifischen Sitzung fotografiert. Tatsächlich fotografierte er sie in 1960 am Drehort ihres letzten Films, The Misfits, vor ihrem Tod.

Tras pasar su infancia en Milán, Elliott Erwitt se trasladó a los Estados Unidos a finales de los años treinta. Su interés por la fotografía creció mientras pasaba su adolescencia en Hollywood, donde acabaría aceptando un trabajo en un cuarto oscuro comercial procesando instantáneas de las estrellas del cine para sus seguidores. Erwitt estudiaría después fotografía y cine en Nueva York, donde entablaría amistad con Edward Steichen, Robert Capa y Roy Stryker, todos ellos se convertirían en maestros del fotógrafo floreciente y serían cruciales en su carrera profesional.

Erwitt inició su carrera como fotógrafo profesional mientras viajaba por Francia e Italia a finales de la década de los años cuarenta. Pronto lo llamaron del ejército para la Guerra de Corea y aceptó varios encargos fotográficos de diferentes publicaciones mientras estuvo estacionado en Europa.

La hoja de contactos incluida procede de una sesión on Marilyn Monroe en 1956 en un apartamento en la ciudad de Nueva York, en un momento de máxima popularidad de la actriz.

"Marilyn Monroe era una estrella importante del cine y hacer fotos de ella era bueno por diferentes razones. Era una persona agradable y estaba dispuesta a posar. También fue una buena decisión profesional pues era probable que sus fotos se vendiesen. La razón simple tras esta instantánea era que se publicase".

Sobre Monroe, Erwitt dice "Era una persona muy agradable, lo recuerdo. Resultó ser cercana y sencilla, y amable, y parecía bastante inteligente, lo que chocaba con su fama de rubia tonta. Muy fotogénica y cercana teniendo en cuenta que estaba ante una estrella".

Cuando se le pregunta por qué Monroe aparece con el libro, contesta "no suelo crear escenas en mis fotografías, simplemente pasé tiempo allí e hice fotos. Estaba trabajando en Nueva York en esos momentos y por tanto pudimos hacer esta foto en el apartamento".

Erwitt fotografió a Monroe en varias ocasiones antes y después de esta sesión específica. De hecho, en 1960 la fotografió en el rodaje de su última película antes de morir, The Misfits.

Elliott Erwitt

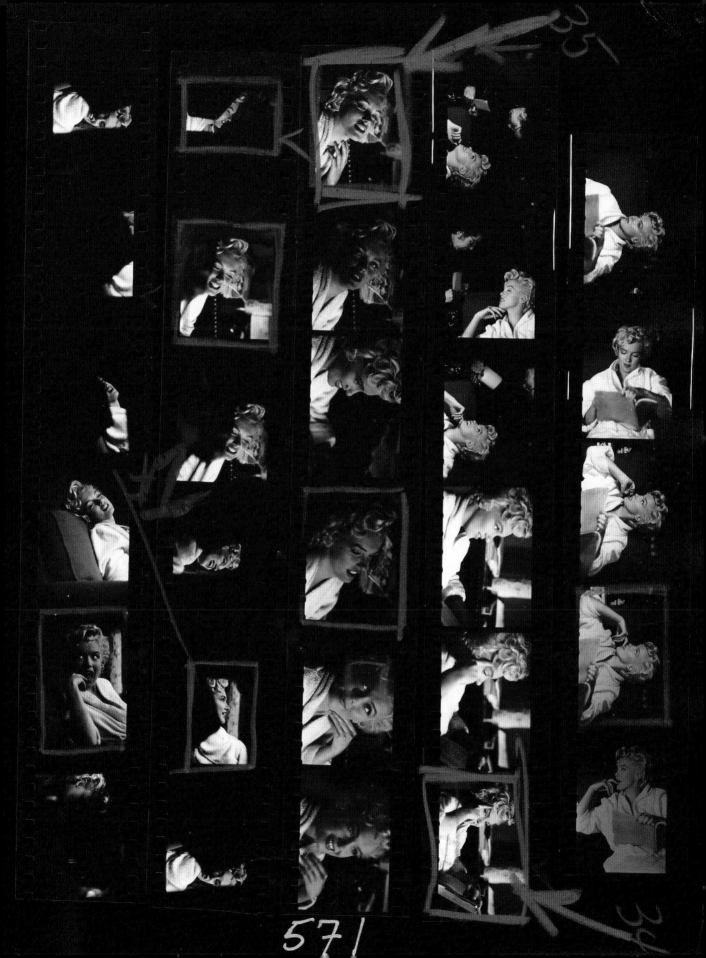

571

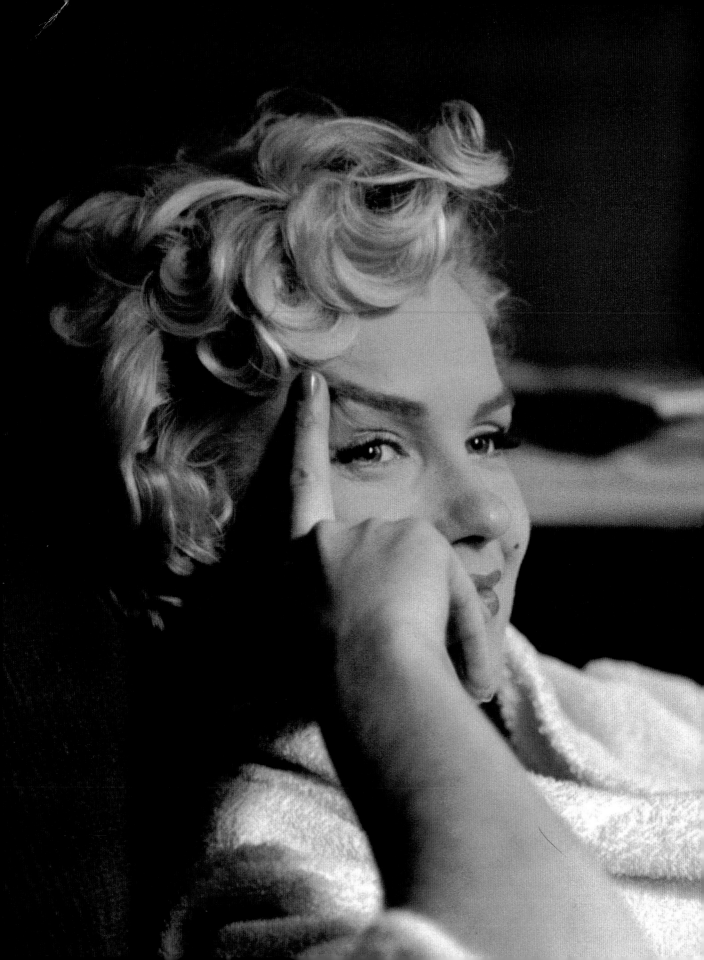

Joakim Eskildsen's first became interested in photography as a fourteen-year-old in Denmark. His brother had learned to print pictures at school, and the two would work together to master this fascinating new hobby. Even though the pictures they developed were less than perfect, Eskildsen knew that this art form was his calling.

After finishing school, Eskildsen became an apprentice for the Royal Court's photographer, Rigmor Mydtskov, in Copenhagen. During his apprenticeship, he created portraits for notable Danish figures and learned the ins and outs of photography. He also continued to photograph on his own, traveling throughout Northern Europe.

A turning point for Eskildsen was when he attended Ritva Kovalainen's exhibition. "Here for the first time, I saw Finnish photography. … In Denmark, I only knew a few photographers that I felt connected to. I was immediately convinced that I had to move to Finland." He did, in fact, move to Finland, and has been living there ever since. It was during the first few years after emigrating that he created his first book of photographs, *Nordic Signs.*

One of his largest projects to date has been *The Roma Journeys,* for which he spent seven years traveling in various countries, documenting his experiences with his wife, writer Cia Rinne.

"To me, it is essential to believe in a better world, in mankind, and in that there is a sense with it all. There are so many problems in the world nowadays—poverty, illness, pollution, environmental disasters, war—that it requires discipline to be an optimist. I try to collect photographs of a world that I can believe in, which gives me hope and moments of magic."

This contact sheet is from Eskildsen's visit to South Africa in 1999. Traveling with Rinne, he stayed in South Africa for three months. "We stayed about a week in this village in the Valley of a Thousand Hills in South Africa together with our guide and friend Moses Khubisa. Together, we would visit the people in the neighborhood, talk to them, and if there was anything of interest, I would take a picture. These boys were standing in the window, watching me curiously while I was taking a picture of a lady dressed in a yellow skirt inside the house. When I noticed this, I kept an eye on them and then simply started to take pictures of them, too."

Originaire du Danemark, Joakim Eskildsen commença à s'intéresser à la photographie vers l'âge de 14 ans. Aux côtés de son frère, qui suivait des cours de photographie au lycée, Joakim s'initia au traitement des négatifs et aux rudiments du métier. Leur photographie n'était alors qu'une passion d'amateur, mais cette activité devait inspirer à Eskildsen une vocation durable.

Après le lycée, Eskildsen suivit une formation aux côtés de Rigmor Mydtskov, photographe à la Cour Royale de Copenhague. Il y réalisa des portraits de célébrités danoises et acquit la maîtrise des nombreux savoir-faire du métier. Il continua aussi à explorer sa propre voie en photographie, effectuant de fréquents voyages dans les pays nordiques.

L'exposition de la photographe finlandaise Ritva Kovalainen marqua un tournant décisif dans la vie de Joakim Eskildsen. « C'était mon premier contact avec la photographie finlandaise. Je ne connaissais au Danemark que quelques photographes avec qui j'avais des affinités et cette exposition m'a tout de suite convaincu que je devais partir en Finlande. » Eskildsen s'est depuis installé en Finlande, son premier livre de photographie Nordic Signs y parut peu après.

The Roma Journeys est l'un des plus projets les plus importants réalisé par Eskildsen. Il représente le fruit de sept années de voyage et de collaboration avec sa femme, l'écrivaine Cia Rinne.

« Pour moi, il est essentiel de croire dans un monde meilleur, dans l'humanité, dans le sens de la vie. Nous faisons face à tant de problèmes aujourd'hui – pauvreté, maladies, pollution, catastrophes écologiques, guerres – qu'il nous faut garder une discipline rigoureuse pour rester optimiste. J'essaie de rassembler des photos d'un monde auquel je puisse croire, un monde qui me donne de l'espoir et des moments de magie. »

Cette planche contact date de la visite d'Eskildsen en Afrique du Sud en 1999. Accompagné de Cia Rinne, il y séjourna pendant trois mois. « Nous sommes restés environ une semaine dans un village de la vallée des Milles Collines avec notre guide et ami Moses Khubisa. Nous allions rendre visite aux gens du village et nous discutions avec eux pour faire naître un contact. Je sortais mon appareil quand je voyais un sujet intéressant. Ces garçons étaient regroupés devant la fenêtre et me regardaient photographier une dame en robe jaune. Quand je les ai remarqués, j'ai gardé l'œil ouvert et je les ai photographiés aussi. »

Joakim Eskildsen, aufgewachsen in Dänemark, fand mit vierzehn Jahren Interesse an der Fotografie. Sein Bruder lernte in der Schule Fotos zu entwickeln, und die beiden arbeiteten gemeinsam an diesem neuen Hobby. Auch wenn die entwickelten Bilder nicht perfekt waren, wusste Eskildsen, dass dies seine Berufung war.

Nach dem Schulabschluss begann Ekildsen eine Lehre bei Rigmor Mydtskov, dem Fotografen des königlichen Hofs, in Kopenhagen. Während der Lehre nahm er Portraitfotos von wichtigen dänischen Persönlichkeiten und lernte alles was es zur Fotografie zu lernen gab. Er fotografierte auch weiterhin für sich selbst auf seinen Reisen durch das nördliche Europa.

Der Besuch einer Ausstellung der finnischen Ritva Kovalainen war der Wendepunkt für Eskildsen. „Hier sah ich zum ersten Mal finnische Fotografie. … In Dänemark kannte ich nur wenige Fotografen, mit denen ich mich verbunden fühlte. Ich war sofort davon überzeugt, dass ich nach Finnland ziehen musste." Er zog in der Tat nach Finnland, wo er seit damals lebt. Er produzierte sein erstes Fotobuch Nordic Signs während seiner ersten Jahre in Finnland.

Eines seiner grössten Projekte bis zum heutigen Tag ist The Roma Journeys, in welchem er die Erlebnisse von Reisen mit seiner Frau Cia Rinne durch verschiedene Länder für sieben Jahre dokumentiert hat.

„Für mich ist es essentiell, in eine bessere Welt zu glauben, in das Menschtum, und dass es alles Sinn macht. Es gibt so viele Probleme in dieser Welt heutzutage – Armut, Krankheiten, Verschmutzung, Umweltkatastrophen, Krieg – dass es Disziplin verlangt, ein Optimist zu sein. Ich versuche Fotos einer Welt zu sammeln, in die ich glauben kann, die mir Hoffnung und Momente von Magie gibt."

Dieser Kontaktbogen stammt von Eskildens Besuch in Südafrika von 1999. Er reiste mit Rinne für mehr als drei Monate durch Südafrika. „Wir blieben für eine Woche in diesem Dorf in Valley of a Thousand Hills in Südafrika zusammen mit unserem Führer und Freund, Moses Khubisa. Zusammen besuchten wir die Menschen in der Nachbarschaft, redeten mit ihnen und, wenn es was Interessantes gab, fotografierte ich es. Diese Jungen standen am Fenster und schauten mir neugierig zu, während ich eine Frau in einem gelben Rock im Haus drinnen fotografierte. Als ich das bemerkte, behielt ich sie im Auge und fing dann einfach an, auch von ihnen Fotos zu machen."

El interés de Joakim Eskildsen por la fotografía se despertó cuando tenía catorce años, durante su infancia en Dinamarca. Su hermano había aprendido a imprimir fotos en la escuela, y los dos trabajaron juntos para dominar esta fascinante nueva afición. Aunque las fotos que revelaban no eran ni mucho menos perfectas, Eskildsen supo que esta era su vocación.

Después de acabar sus estudios, Eskildsen se convirtió en aprendiz del fotógrafo de la Corte Real, Rigmor Mydtskov, en Copenhague. Durante este período de aprendizaje retrató a importantes figuras danesas, y descubrió los entresijos de la fotografía. También se dedicó a realizar fotografías personales del norte de Europa.

Un momento decisivo para Eskildsen surgió tras su visita a la exposición del finlandés Ritva Kovalainene. "Aquí, por vez primera, vi fotografía finlandesa. … En Dinamarca, sólo conocía unos pocos fotógrafos con los sentía cierta afinidad. Me sentí completamente convencido de que tenía que mudarme a Finlandia". Y así lo hizo; y es en Finlandia, donde ha estado viviendo desde entonces. Publicó su primer libro de fotografía Nordic Signs durante sus primeros años en ese país.

Uno de sus principales proyectos hasta la fecha ha sido The Roma Journeys, al que dedicó siete años, durante los que viajó por diversos países documentando sus experiencias junto con su mujer, la escritora Cia Rinne.

"Para mí, es esencial creer en un mundo mejor, en la humanidad, y en que todo tiene sentido. Hay tantos problemas en el mundo hoy día -pobreza, enfermedades, contaminación, desastres medioambientales, guerras- que es necesario tener disciplina para ser optimista. Intento plasmar con la fotografía un mundo en el que puedo creer, que me ofrece esperanza y momentos de magia".

Esta hoja de contactos corresponde a la visita de Eskildsen a Sudáfrica en 1999. En compañía de Rinne, permaneció en Sudáfrica durante 3 meses. "Nos quedamos alrededor de una semana en este pueblo en el Valle de las Mil Colinas de Sudáfrica junto con nuestro guía y amigo Moses Khubisa. Juntos, visitábamos a la gente del barrio, charlábamos con ellos, y si veíamos algo de interés, sacábamos una foto. Estos chicos estaban de pie al lado de la ventana, observándome con curiosidad mientras yo tomaba una foto de una mujer vestida con una falda amarilla dentro de la casa. Cuando me di cuenta, me mantuve atento y simplemente empecé a sacarles fotos a ellos también".

Joakim Eskildsen

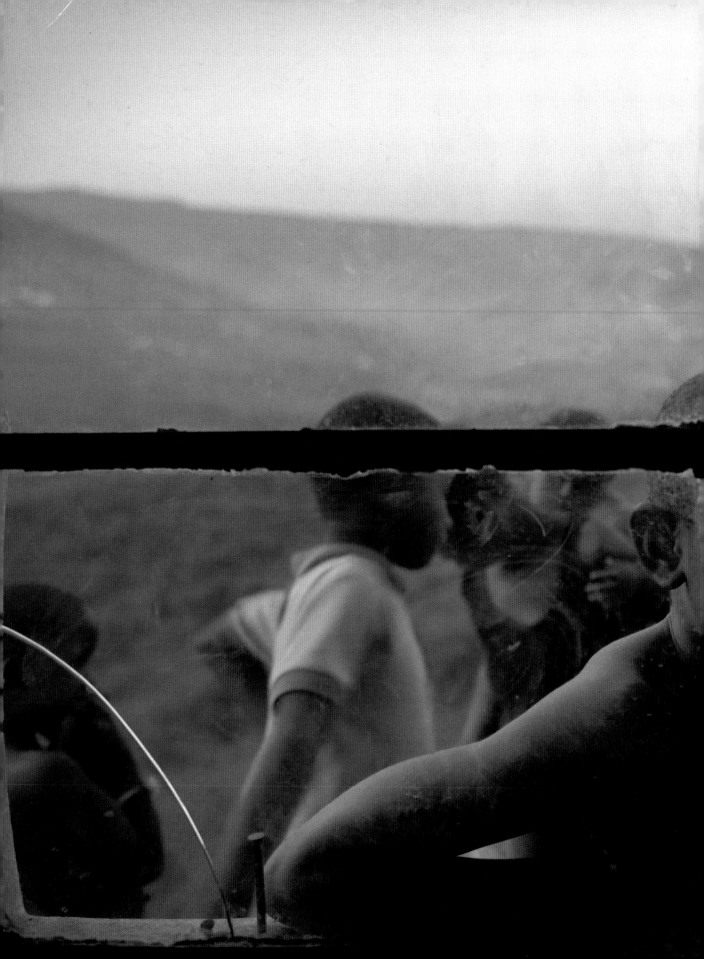

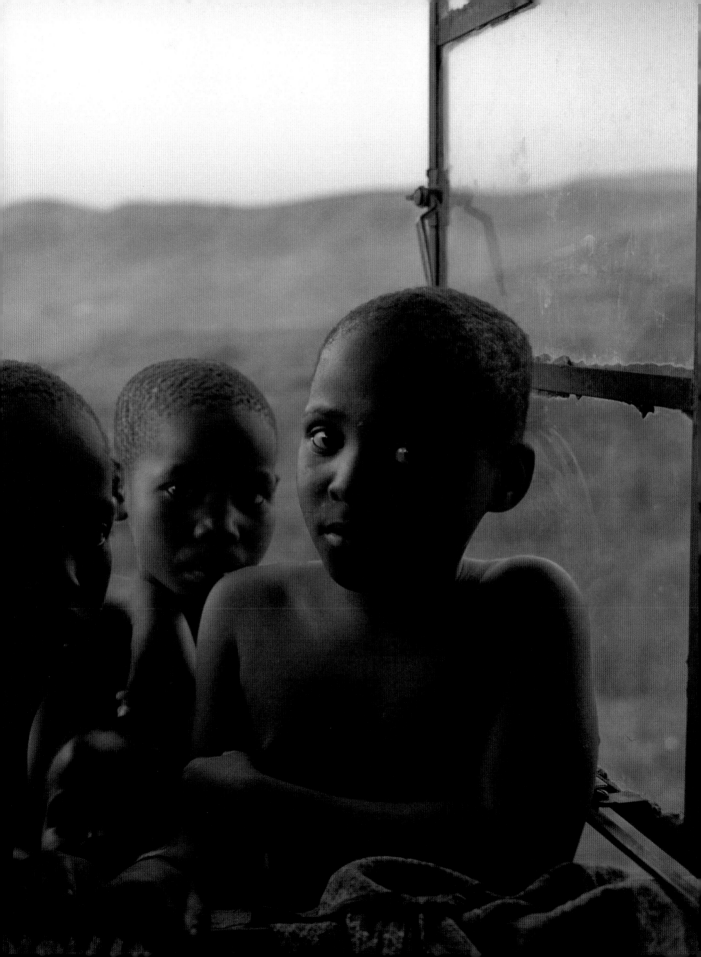

As a teenager in Massachusetts, Paul Fusco grew interested in photography. It became more than a hobby when he joined the United States Army Signal Corps during the Korean War. Fusco photographed for the signal corps for a few years before studying photojournalism at Ohio University.

Fusco moved to New York City in the late 1950s and began a career as a staff photographer for *Look* magazine. While at *Look*, Fusco concentrated on domestic social issues. He produced historically significant works on subjects ranging from the plight of destitute miners in Kentucky and Latino ghetto life in New York City to African-American life in the Deep South and the United Farm Workers and César Chávez in California. Fusco also covered social issues abroad in areas such as Russia, England, Israel, Gaza, and Southeast Asia.

Once *Look* folded in the early '70s, Fusco published his work in various major U.S. and international publications. In the '80s, he moved to California to continue his social documentary—covering AIDS patients, homelessness, the welfare system, and alternative lifestyles.

While a staff photographer at *Look*, Fusco was commissioned to cover all events surrounding the funeral of Robert Kennedy—including capturing images of the thousands of Americans standing by the railroad tracks to pay their final respects to Bobby as his funeral train came through town.

"The RFK photographs were taken from the train that carried the Kennedy family and Bobby's body from NYC to Washington, D.C., for burial at Arlington National Cemetery, June 8, 1968. All of the photographs were taken from the train, of the thousands of mourners who lined the tracks to pay tribute to a beloved leader. It was a tumultuously emotional ride. Tragedy had struck again. The blow was monumental. Hope had been shattered, and those in most need of hope crowded the tracks of Bobby's last train ride, stunned into disbelief, and watched that hope trapped in a coffin pass and disappear from their lives.

"The photographs were never published until the thirtieth anniversary of his death in 1998 in *George* magazine."

Né à Massachusetts, Paul Fusco s'intéressa à la photographie pendant son adolescence et en fit sa vocation après sa conscription dans le United States Army Signal Corps pendant la guerre de Corée. Il travailla plusieurs années comme photographe pour le U. S. Signal Corps avant d'entreprendre des études de photojournalisme à l'université de l'Ohio.

Paul Fusco se rendit à New York à la fin des années 1950 et y commença une carrière de photographe pour le magazine *Look*, une période pendant laquelle son travail fut centré sur les questions sociales aux Etats-Unis. Il produisit un corpus de photographies d'une importance historique significative sur des sujets aussi variés que la misère des mineurs déshérités du Kentucky, la vie dans les ghettos Latinos de New York, la situation des afro-américains dans le Sud profond ou le syndicat des ouvriers agricole United Farm Workers de Cesar Chavez. Paul Fusco couvrit aussi des problèmes sociaux à l'étranger dans des pays comme la Russie, l'Angleterre, Israël, Gaza et l'Asie du Sud-Est.

Après la faillite de *Look* dans les années 1970, Fusco se joignit à l'agence Magnum et son travail est depuis paru dans les plus grandes publications américaines et internationales. Dans les années 1980, il déménagea en Californie et continua à documenter les problèmes sociaux – les patients atteints du sida, les sans-logis, le système de couverture sociale et les styles de vie alternatifs.

En 1968, Paul Fusco fut envoyé par le magazine *Look* pour couvrir les cérémonies liées aux funérailles de Robert Kennedy, et il fixa sur la pellicule les images de milliers d'américains qui se pressaient le long de la voie ferrée pour saluer une dernière fois « Bobby » lors du passage du cortège funéraire.

« Les photographies de RFK ont été prises du train qui emmenait la famille Kennedy et la dépouille mortelle de Bobby de New York City à Washington D.C. pour les obsèques qui devait avoir lieu le 8 juin 1968 au cimetière national d'Arlington. Toutes les photographies sont prises du train, on y découvre les visages des milliers d'anonymes en deuil, massés le long des voies pour rendre hommage à cette figure politique qui avait cristallisé leurs espoirs. Ce fut un voyage très tourmenté et d'une grande intensité émotionnelle. Une tragédie venait encore de s'abattre sur l'Amérique et son impact était immense. Toute une génération venait de voir ses idéaux brisés et se tenait alignée le long des rails que suivait le dernier train de Bobby, frappée de stupeur et d'incompréhension à la vue de ce cercueil enfermant un espoir qui disparaissait de leur vie.

Ces photographies n'ont été publiées par le magazine *George* qu'en 1998, trente ans après le décès de Robert Kennedy. »

Paul Fusco, geboren in Massachusetts, wurde als Teenager an der Fotografie interessiert, und dies entwickelte sich zu mehr als einem Hobby, als er dem United States Army Signal Corps während des Korea-Krieg beitrat. Er fotografierte für das US Signal Corps für einige Jahre, bevor er Fotojournalismus an der Ohio University studierte.

Fusco zog in den späten 1950er Jahren nach New York City, wo er eine Karriere als Stabfotograf für das Magazin *Look* begann. Während er bei *Look* war, konzentrierte Fusco seine Arbeit auf einheimische soziale Themen. Er produzierte historisch bedeutende Werke zu Themen rangierend von der Notlage der mittellosen Minenarbeitern in Kentucky bis zum latino-amerikanischen Ghetto-Leben in New York City, vom afro-amerikanischen Leben im tiefen Süden zu den United Farm Arbeitern und Cesar Chavez in Kalifornien. Fusco behandelte auch soziale Themen in Ländern wie Russland, England, Israel, Gaza, und Südost-Asien.

Als *Look* in den frühen siebziger Jahren einging, tratt Fusco Magnum Photos bei und hat seither sein Werk in bedeutenden US und internationalen Publikationen veröffentlicht. In den 1980ern zog er nach Kalifornien, um seine soziale Dokumentation weiterzuführen – Berichte über AIDS-Patienten, Obdachlosigkeit, das Wohlfahrtsystem und alternative Lebensstile.

Als Stabfotograf für *Look* wurde Fusco beauftragt, über alle Ereignisse rund um das Begräbnis von Rober Kennedy Bericht zu erstatten – was beinhaltete, die Bilder der Tausenden von Amerikanern aufzunehmen, die bei den Zuggleisen standen, um sich von „Bobby" zu verabschieden, als sein Begräbniszug durch die Stadt fuhr.

„Die RFK Fotos wurden von dem Zug aufgenommen, der die Familie Kennedy und Bobbys Leichnam von NYC nach Washington zum Begräbnis beim Arlington National Cemetary am 8. Juni 1968 führte. Alle Fotos wurden vom Zug aus aufgenommen, von den Tausenden von Trauernden, die an den Gleisen standen, um einem geliebten Führer Tribut zu zahlen. Es war eine tumultöse emotionale Fahrt. Die Tragödie hatte wieder zugeschlagen. Der Hieb war monumental. Die Hoffnung war zerschlagen, und die, die die Hoffnung am meisten brauchten, umgaben die Gleise von Bobbys letzter Zugfahrt in Ungläubigkeit und sahen zu, wie diese in einem Sarg gefangene Hoffnung vorbeifuhr und von ihren Leben verschwand."

Die Fotos waren nie veröffentlicht worden bis zum dreissigsten Jahrestag seines Todes in 1998 im Magazin *George*."

Nacido en Massachusetts, Paul Fusco empezó a interesarse por la fotografía cuando era un adolescente, lo que pasó a ser algo más que una afición cuando se incorporó al cuerpo de comunicaciones del ejército de los Estados Unidos durante la Guerra de Corea. Fotografió para el servicio de transmisiones del ejército americano durante unos años antes de decidir estudiar fotoperiodismo en la Universidad de Ohio.

Fusco se mudó a Nueva York a finales de la década de 1950, y comenzó una carrera como fotógrafo de plantilla de la revista *Look*. Durante esa época, Fusco concentró su obra en temas sociales nacionales. Produjo imágenes de relevancia histórica en temas tan variados como la crisis de los desamparados mineros de Kentucky o la vida en los guetos latinos de la ciudad de Nueva York, la vida de los afroamericanos en el Sur o la Unión de Campesinos de César Chávez en California. Fusco también cubrió temas de carácter social en el extranjero en países como Rusia, Reino Unido, Israel, Gaza y el Sudeste asiático.

Cuando *Look* echó el cierre a principios de los años setenta, Fusco se incorporó a Magnum Photos y desde entonces ha publicado su trabajo en importantes publicaciones estadounidenses e internacionales. En los años 80 se trasladó a California para continuar sus documentales sociales: pacientes con SIDA, los sin techo, el sistema de protección social y estilos de vida alternativos.

Como fotógrafo de *Look*, Fusco recibió el encargo de fotografiar todos los eventos que rodearon el funeral de Robert Kennedy, incluyendo las imágenes de miles de norteamericanos apostados a ambos lados del ferrocarril para presentar sus últimos respetos a "Bobby" cuando su tren funerario pasaba por la ciudad.

"Las fotografías de Robert F. Kennedy se tomaron desde el tren que llevaba a la familia Kennedy y el cuerpo de Bobby desde la ciudad de Nueva York a Washington D.C. donde se celebró su entierro en el Cementerio Nacional de Arlington, el 8 de junio de 1968. Todas las fotografías se tomaron desde el tren, miles de personas en duelo que jalonaban el tendido ferroviario para rendir tributo al apreciado líder. El viaje fue un tumulto de emociones. La tragedia había vuelto a golpear. El mazazo fue monumental. La esperanza se había hecho añicos y aquellos con mayor necesidad de esperanza se agolpaban a lo largo del recorrido del último viaje en tren de Bobby aturdidos e incrédulos, y veían sus ilusiones atrapadas en un ataúd y desaparecer de sus vidas.

Las fotografías no se publicaron hasta el trigésimo aniversario de su fallecimiento en 1998 en la revista *George*".

Paul Fusco

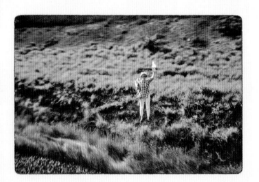

While studying photography in Central London, George Georgiou was heavily influenced by the books he checked out of the college library—selections of works by photographers such as Robert Frank, Bill Owens, and Mary Ellen Mark. After graduation, Georgiou pursued a career in photojournalism.

"Since 1999, I started to work in the Balkans, Eastern Europe, and Turkey, and have lived and worked in the region ever since. During this time, I developed an interest in how people's identities become shaped around ideas of religion, ideology, culture, history, and land. It was also during this period that my work began to change, and it continues to evolve. While working in Kosovo and Serbia, I began to feel that short photo essays were too restrictive and limited for what I considered to be far more complex issues. Since then, I work almost exclusively on long-term projects."

The featured contact sheet is of a wedding in Kosovo, taken by Georgiou in July 1999.

"The photograph was taken very soon after the end of the Kosovo conflict in the summer of 1999. I was driving around Kosovo at the time and came across this small wedding in a village in central Kosovo. The bride was from the village, and she was getting married to a Kosovar Albanian who was living in Belgium, which at the time meant someone who had 'made it.' The wedding ceremony went on all day, and the bride is expected to look solemn the whole time, while all those around her are partying and having a good time.

"There were a lot of weddings taking place at this time—the Serbs had been defeated, and people felt very optimistic and positive about the future."

Étudiant en photographie à la Polytechnic of Central London, George Georgiou fut fortement influencé par les œuvres découvertes dans les livres de la bibliothèque universitaire avec des grands noms de la photographie tels que Robert Frank, Bill Owens et Mary Ellen Mark. Son diplôme en poche, George Georgiou décida de poursuivre une carrière de photojournaliste.

« Je réside depuis 1999 dans les Balkans, en Europe orientale et en Turquie, et tout mon travail est centré sur cette région. C'est depuis que je vis ici que j'ai commencé à m'intéresser à la formation de l'identité des populations, une identité qui se cristallise autour des concepts de religion, d'idéologie, de culture et de nation. C'est ici aussi que la forme de mon travail s'est redéfinie, et elle reste encore un projet en évolution. Je travaillais au Kosovo et en Serbie quand j'ai eu le sentiment que les courts essais photographiques étaient restrictifs et limités pour couvrir ce qui me semblait être des problématiques complexes. Je me consacre depuis exclusivement à des projets à long terme. »

Cette planche contact représente un mariage au Kosovo, elle fut tirée par George Georgiou en juillet 1999.

« Cette photographie a été prise au Kosovo pendant l'été 1999, juste après la fin du conflit. Je parcourais la région en voiture et je me suis trouvé au milieu de ce mariage en petit comité dans un village du centre du pays. La mariée était originaire du village et son mari, un albanais du Kosovo, s'était installé en Belgique, ce qui signifie qu'il avait réussi dans la vie. Pendant toute la cérémonie, qui dure une journée entière, la mariée se doit de garder une attitude solennelle alors que tous les invités font la fête autour d'elle.

On célébrait beaucoup de mariages à cette période, l'ennemi serbe avait connu la défaite et on sentait une vague d'optimisme et d'espoir face à l'avenir. »

Während er am Polytechnischen Institut in London Fotografie studierte, war Georgiou schwer beeinflusst von den Werken, die er in Büchern sah, die er von der College Bibliothek ausgeliehen hatte – Bücher von Werken von Fotografen wie Robert Frank, Bill Owens, und Mary Ellen Mark. Nach dem Studienabschluss ging Georgiou einer Karriere in Fotojournalismus nach.

„Seit 1999 habe ich begonnen im Balkan, Ost-Europa und der Türkei zu arbeiten, und seither lebe und arbeite ich in dieser Region. Während dieser Zeit entwickelte ich ein Interesse daran wie die Identität eines Volkes durch die Ideen von Religion, Ideologie, Kultur, Geschichte und Land geformt wird. Es war auch während dieser Periode, dass sich mein Werk zu ändern begann, und es ist immer noch in diesem Prozess . Während ich in Kosovo und Serbien arbeitete, bekam ich das Gefühl, dass kurze Foto-essays zu restriktiv und beeinschränkend waren für Themen, die ich als weit komplexer betrachtete. Seit damals arbeite ich fast ausschliesslich an langfristigen Projekten."

Der abgebildete Kontaktbogen ist von einer Hochzeit im Kosovo, aufgenommen von Georgiou im Juni 1999.

„Das Foto wurde sehr bald nach dem Ende des Kosovokonflikts im Sommer von 1999 aufgenommen. Ich fuhr im Kosovo herum zu der Zeit und stiess auf diese kleine Hochzeit in einem Dorf im mittleren Kosovo. Die Braut war von diesem Dorf und sie heiratete einen Kosovo-Albanen, der in Belgien lebte, was zur damaligen Zeit bedeutete, dass er erfolgreich war. Die Hochzeitszeremonie dauerte den ganzen Tag an, und es wird von der Braut erwartet, die ganze Zeit ernst auszusehen, während alle um sie herum feiern und eine gute Zeit haben.

Es gab viele Hochzeiten zu dieser Zeit, die Serben waren besiegt worden, und die Leute fühlten sich sehr optimistisch und positiv über die Zukunft.

Durante sus estudios en la Politécnica de Londres, Georgiou se encontró intensamente influido por los trabajos que veía en los libros que tomaba prestados de la biblioteca de la universidad, libros con el trabajo de fotógrafos como Robert Frank, Bill Owens y Mary Ellen Mark. Después de graduarse, Georgiou se lanzó a una carrera en fotoperiodismo.

"En 1999 empecé a trabajar en los Balcanes, el Este de Europa y Turquía, y he vivido y trabajado en la región desde entonces. Durante estos años he desarrollado un interés acerca de cómo se forma la identidad de la gente alrededor de las ideas de religión, ideología, cultura, historia y patria. También en este período mi trabajo comenzó a cambiar, y aún continúa evolucionando. Mientras trabaja en Kosovo y Serbia empecé a sentir que los ensayos fotográficos cortos eran demasiado restrictivos y limitaban lo que yo consideraba problemas mucho más complejos. Desde entonces, trabajo casi exclusivamente en proyectos a largo plazo".

La hoja de contactos es de una boda en Kosovo, fotografiada por Georgiou en julio de 1999.

"La fotografía se tomó muy poco después del final del conflicto de Kosovo en el verano de 1999. Conducía por Kosovo y me encontré con esta pequeña boda en un pueblo en el centro de Kosovo. La novia era del pueblo y se casaba con un albanokosovar que había vivido en Bélgica, lo que en aquel momento representaba alguien que "había triunfado". La ceremonia nupcial se prolonga todo el día y se espera que la novia mantenga un aspecto solemne todo el tiempo, mientras que todos los que están a su alrededor festejan y se divierten.

Se celebraban muchas bodas por esas fechas, los serbios habían sido derrotados y la gente se sentía muy optimista acerca del futuro".

George Georgiou

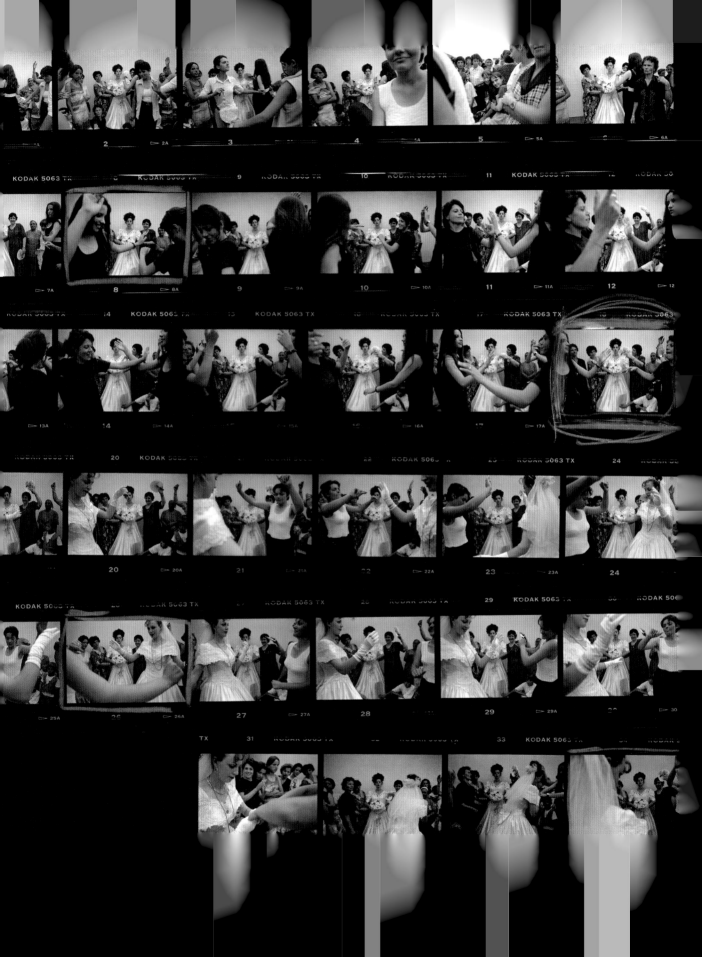

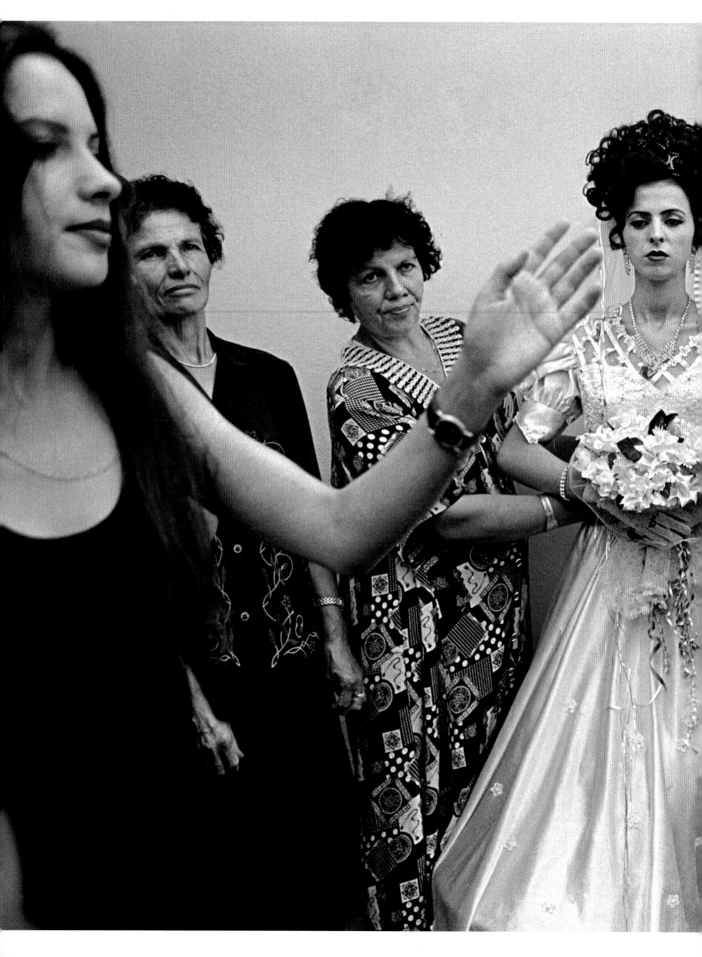

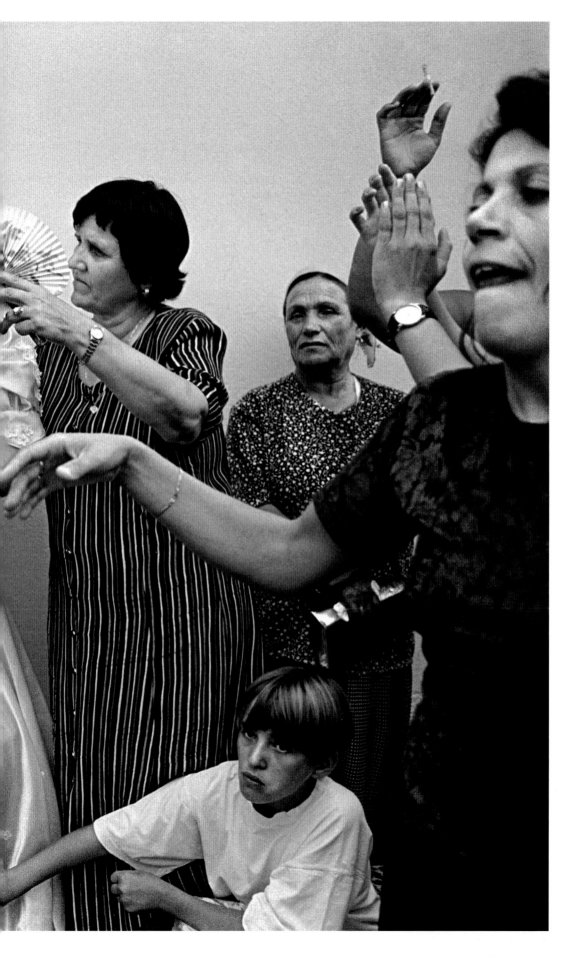

Born in Washington, D.C., in 1953, Nan Goldin grew up in the Boston suburb of Lexington, Massachusetts. In the past decade, Goldin has focused on subjects as varied as New York City, bodies of water, lovers, and children. She currently splits her time between New York and Paris.

When she was fifteen years old, a high school teacher introduced Goldin to the camera, sparking her interest in photography. A few years later, she was living in Boston and became familiar with the city's gay and transsexual communities through a friend. Her first solo show was held in Boston, and its subject was her photographic journey through these communities.

Upon graduation, Goldin moved to New York City where she photographed the city's postpunk and new wave music scenes along with the city's gay subculture. Her influential and well-known work, *The Ballad of Sexual Dependency*, documents the Bowery's drug and gay subculture with images of violence, drug use, and sex. Many of the subjects of these images didn't survive through the 1990s, dying of overdoses or AIDS. The most common themes running through Goldin's early work are love and sexuality. Using minimal natural light, Goldin often captures private, honest, and vulnerable moments between people—whether it's a girl in a bar bathroom or a couple locked in a furtive embrace.

In this contact sheet, Goldin focuses the camera on herself in a similar manner to how she photographs all her subjects, capturing a truly honest moment between her and her lover.

"These pictures were taken in 1983 in my bed on the Bowery in New York City. This is me and my boyfriend after sex. What I found intense in hindsight about this picture is its prescience in the expression of fear—foreshadowing future violence. I realized I needed to put this picture into my slide show and later print it in order to show myself in the same situations I had publicly shown my friends."

Née à Washington D.C. en 1953, Nan Goldin grandit à Lexington, dans la banlieue de Boston. Au cours des dix dernières années, Nan Golding s'est intéressée à des sujets aussi variés que la ville de New York, les masses d'eau, les couples d'amants et les enfants. Elle partage aujourd'hui son temps entre les villes de New York et Paris.

Son intérêt pour la photographie fut révélé par un professeur de collège qui lui en transmit les rudiments quand elle avait quinze ans. Quelques années plus tard, résidant alors à Boston, elle fréquenta bientôt les milieux gays et transsexuels par l'intermédiaire d'un ami et devint intime de ces communautés. Sa première exposition solo eut lieu à Boston avec pour thème son voyage photographique dans les communautés qui forment ces sous cultures.

Nan Goldin déménagea à New York après l'obtention de son diplôme, elle y photographia la scène de la musique post-punk et new-wave ainsi que les sous cultures gays de la ville. L'ouvrage de référence qui fit sa renommée, *The Ballad of Sexual Dependency*, documente la sous culture des gays et de la drogue dans le quartier du Bowery à New York avec des images de violence, de drogue et de sexe. Parmi les modèles photographiés, nombreux sont ceux qui n'ont pas survécu aux années 1990, décédant d'overdose ou du sida. Les thèmes de l'amour et de la sexualité prédominent l'œuvre de jeunesse de Nan Goldin. Utilisant un minimum de lumière naturelle, elle parvient à saisir les moments intimes, naturels et vulnérables de ses modèles – une fille dans les toilettes d'un bar ou l'étreinte furtive d'un couple.

Avec cette planche contact, Nan Goldin tourne l'objectif sur elle-même et sur son amant. Comme avec ses autres modèles, ses images capturent des moments d'authenticité de leur relation.

« Ces photos ont été prises en 1983, dans le lit de mon appartement sur l'avenue Bowery à New York. C'est moi et mon ami après l'amour. En regardant cette photo avec le recul du temps, je trouve que son intensité réside dans un pressentiment de l'expression de la peur, présageant une violence à venir. J'ai compris que je devais l'inclure dans mon diaporama et l'imprimer pour apparaître moi aussi dans le type de situations où j'avais photographié mes amis. »

Nan Goldin, geboren in Washington D.C im Jahr 1953, wuchs in Lexington, Massachusetts, einem Vorort von Boston, auf. In der letzten Dekade hat Goldin sich auf Subjekte so verschieden wie New York City, Körper von Wasser, Liebende, und Kinder konzentriert. Gegenwärtig teilt sie sich ihre Zeit zwischen New York und Paris.

Ihr Interesse an der Fotografie wurde von einem High School Lehrer entfacht, der sie mit der Kamera im Alter von fünfzehn Jahren bekannt machte. Einige Jahre später lebte sie in Boston und lernte die schwulen und transsexuellen Gemeinschaften der Stadt durch einen Freund kennen. Ihre erste Solo-Ausstellung war in Boston und das Thema war ihre fotografische Reise durch diese Gemeinschaften.

Goldin zog nach dem Studiumabschluss nach New York City und fotografierte dort die post-punk und new-wave Musikszenen und die schwule Subkultur der Stadt. Ihr einflussreiches und bekanntes Werk *The Ballad of Sexual Dependency* dokumentiert die Drogen- und Schwulensubkultur der Bowery Stasse mit Bildern von Gewalt, Drogenmissbrauch, und Sex. Viele der Subjekte dieser Bilder überlebten die neunziger Jahre nicht und starben an Überdosen oder an AIDS. Die gemeinsam durchgängigen Themen von Goldins frühem Werk sind Liebe und Sexualität. Durch die Verwendung von minimalen natürlichen Lich erfasste Goldin oft private, ehrliche, verletzliche Momente zwischen Menschen – ob es sich um ein Mädchen in einer Bar-Toilette handelt oder ein Pärchen in einer heimlichen Umarmung.

In diesem Kontaktbogen fokussiert Goldin die Kamera auf sich selbst auf ähnliche Weise wie sie ihre Subjekte fotografiert, und fängt einen wirklich ehrlichen Moment zwischen sich selbst und ihrem Liebhaber.

„Diese Bilder wurden im Jahr 1983 in meinem Bett auf der Bowery in New York City gemacht. Das bin ich und mein Freund, nachdem wir Sex hatten. Was ich im nachhinein so heftig an diesem Bild finde, ist das Vorherwissen im Ausdruck der Angst – was zukünftige Gewalt vorankündigt. Ich sah ein, dass ich dieses Bild in meine Diashow reingeben und es später ausdrucken musste, um mich in denselben Situationen zu zeigen, in denen ich meine Freunde öffentlich gezeigt hatte."

Aunque nació en Washington D.C. en 1953, Nan Goldin creció en Lexington, Massachusetts, una zona residencial de Boston. En la última década, Goldin se ha centrado en temas tan variados como la ciudad de Nueva York, cuerpos de agua, amantes y niños. En la actualidad, divide su tiempo entre Nueva York y París.

Su curiosidad por las imágenes se despertó gracias a un profesor de la escuela secundaria que le ofreció su primer contacto con la fotografía cuando contaba quince años. Algunos años después, viviendo en Boston, se familiarizó con las comunidades homosexuales y transexuales de la ciudad a través de un amigo. Su primera exposición en solitario se celebró en Boston y el tema era un recorrido fotográfico por esas comunidades.

Goldin se mudó a Nueva York al completar sus estudios, y allí plasmó en imágenes los movimientos musicales post-punk y new-wave junto con la contracultura homosexual de la ciudad. Su conocido e influyente trabajo *The Ballad of Sexual Dependency* documenta la subcultura homosexual y de drogadicción del barrio de Bowery con imágenes de violencia, uso de drogas y sexo. Muchos de los personajes de estas imágenes no sobrevivieron a los años noventa: fallecieron de sobredosis o de SIDA. Los temas más comunes en los primeros trabajos de Goldin eran el amor y la sexualidad. Con un mínimo de luz natural, Goldin captura momentos privados, sinceros y vulnerables entre personas: bien sea una chica en el baño de un bar o una pareja unida en una abrazo furtivo.

En esta hoja de contactos, Goldin posa su mirada sobre sí misma de manera similar a como fotografía al resto de las personas, capturando un momento auténtico y sincero entre ella y su amante.

"Estas fotos se tomaron en 1983, en mi cama, en el Bowery de Nueva York. Somos mi novio y yo después de hacer el amor. Lo que encontré intenso a posteriori acerca de esta foto es su presciencia en la expresión del miedo: un presagio de futura violencia. Me di cuenta de que necesitaba incluir esta foto en mi presentación de diapositivas y más tarde imprimirla para mostrarme a mí misma en idéntica situación a la que había mostrado públicamente a mis amigos".

Nan Goldin

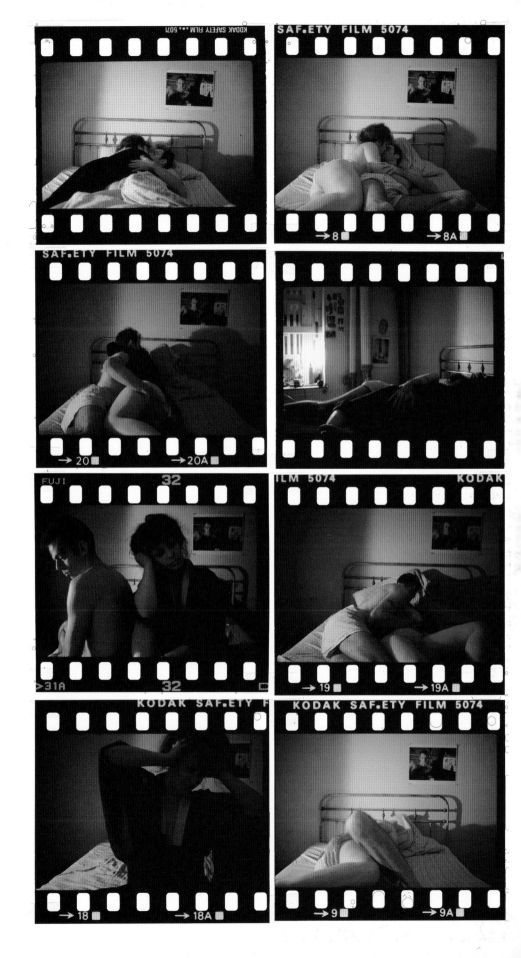

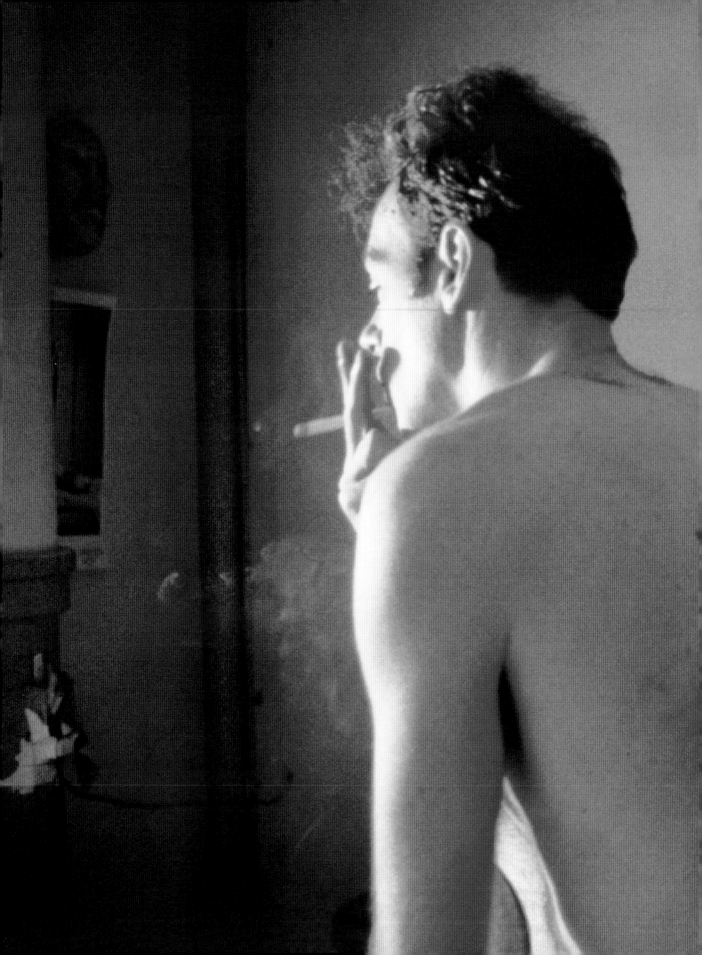

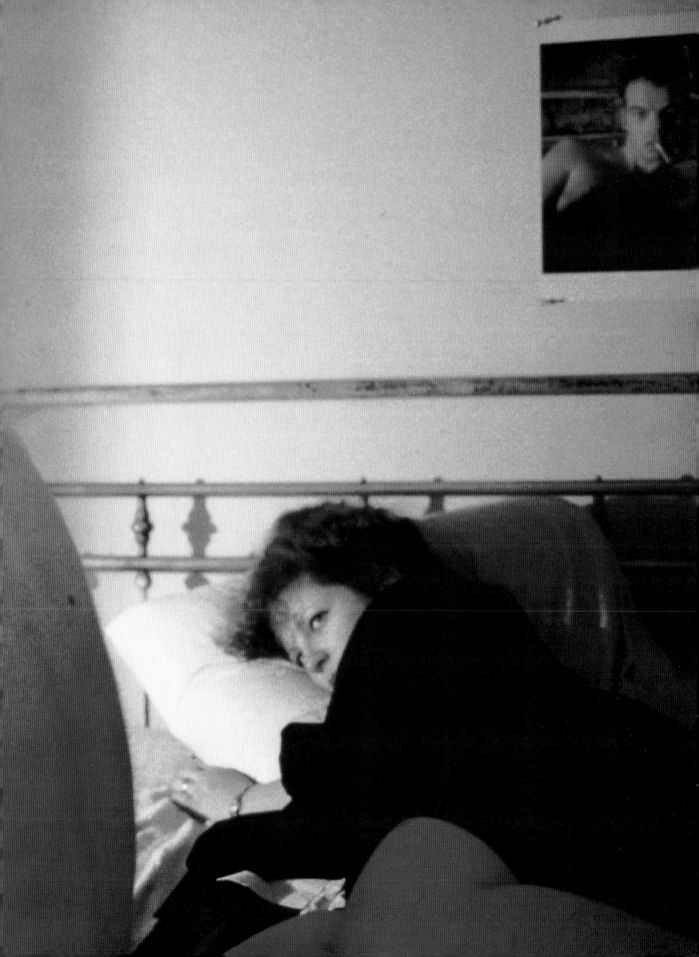

Adam Jeppesen's view of the world opened up when he moved to New York from Denmark at the age of seven. He lived there until he returned to Denmark at the age of fourteen. The experience of growing up in two cultures became a driving force in Jeppesen's later work, which often deals with the similarities of light, mood, and spirituality found in different cultural regions of the world.

Jeppesen attended a small photographic art school in Copenhagen, but quickly found himself working on film projects, mainly documentaries. The majority of this work would include shooting in remote areas or conflict zones, such as Palestine, Liberia, West Africa, and the Amazon. Jeppesen found inspiration in those corners of the globe, and the opportunity to work on his own projects.

While on assignment in Iceland in 2005, Jeppesen decided to take a break from filmmaking and put his own photography at center stage. He isolated himself in a cottage deep in the Finnish woods. The contact sheet series is from that retreat, shot on the lake outside his cottage.

"… [T]he cottage lay on an island on Lake Saimaa. To reach it, I had to cross the frozen waters. There was an hour to the nearest neighbor, and it would often feel like I was left behind on a deserted planet. One night while driving back from the mainland, the car skidded out and into a bank of snow. When stepping out of the car, I noticed how the headlights flickered off this explosion of snow, which the accident had caused—how the lights shone across the frozen landscape of this strange planet, only to dissolve into darkness. It was a spiritual moment standing there under an undisturbed night sky, feeling the warm breath leaving my frozen lips and looking at the tracks and traces of the event that had just taken place. Not a thing moved. It was as if time were standing still—as if the world had become a photograph that I could move within. Fascinated by this, I tried to capture it."

Adam Jeppesen s'ouvrit au monde à l'âge de sept ans à l'occasion d'un déménagement du Danemark à New York, où il vécut jusqu'à l'âge de quatorze ans avant de rentrer au Danemark. L'expérience de grandir au contact de deux environnements culturels distincts eut une influence déterminante sur son œuvre qui repose souvent sur les similarités de lumière, d'atmosphère et de spiritualité entre les différentes régions culturelles du globe.

Adam Jeppesen suivit des cours de photographie d'art dans une petite école de Copenhague et commença rapidement à travailler sur des films, en particulier dans le domaine documentaire. Ces activités l'ont mené sur des tournages dans les lieux les plus reculés ou dans des zones de conflit, comme la Palestine, le Libéria, l'Afrique de l'Ouest ou l'Amazonie. Ses voyages lui fournirent l'inspiration et l'occasion de poursuivre ses propres projets.

Lors d'un tournage en Islande, Adam Jeppesen prit la décision de se consacrer exclusivement à la photographie. Il se retira alors dans un chalet isolé au fond de la forêt finlandaise. La série présentée sur cette planche contact fut prise pendant cette retraite près du lac entourant le chalet.

« … le chalet était situé sur une île du lac Saimaa. Il fallait traverser les eaux gelées pour s'y rendre. Le voisin le plus proche était à une heure de route et j'avais souvent l'impression d'être abandonné sur une planète désertée. Une nuit, alors que je retournais sur l'île, ma voiture a dérapé et s'est enfoncée dans une congère. En sortant sur la route, j'ai remarqué le scintillement des flocons dans la petite explosion de neige provoquée par l'accident – la lumière projetée sur le paysage gelé se dissolvait dans les ténèbres. C'était un moment pénétré de spiritualité ; je me trouvais là, sous un ciel nocturne serein, sentant la chaleur de mon souffle sur mes lèvres gelées, à contempler les traces de l'événement qui venait de se produire. Tout était immobile. C'était comme si le temps s'était arrêté – comme si le monde était une photographie dans laquelle je pouvais m'introduire. Fasciné, j'ai essayé de saisir l'atmosphère du moment. »

Adam Jeppesens Sicht der Welt wurde erschlossen, als er im Alter von sieben Jahren von Dänemark nach New York zog. Er lebte dort, bis er im Alter von vierzehn Jahren sieben Jahre später nach Dänemark zurückkehrte. Das Erlebnis in zwei Kulturen aufzuwachsen, wurde zu einer treibenden Kraft in Jeppesens späterem Werk, das oft mit den Ähnlichkeiten von Licht, Stimmung, und Spiritualität, die in verschiedenen kulturellen Regionen der Welt gefunden werden können, umgeht.

Jeppesen besuchte eine kleine fotografische Kunstschule in Kopenhagen, aber schon bald fand er sich für Filmprojekte arbeiten, vor allem Dokumentationsarbeit. Der Grossteil von dieser Arbeit würde das Filmen in entfernten Regionen oder Konfliktzonen beinhalten, wie Palästina, Liberia, Westafrika, und dem Amazonas. Durch diese Arbeit fand Jeppesen Inspiration und die Gelegenheit, an seinen Projekten zu arbeiten.

Während seiner Versetzung nach Island in 2005 entschied Jeppesen, eine Pause vom Filmemachen einzulegen und seine eigene Arbeit in den Mittelpunkt zu stellen. Als Resultat entschied er, sich in einer Hütte tief im finnischen Wald zu isolieren. Die Kontaktbogenserie ist von diesem Ruhesitz, gefilmt an einem See draussen vor der Hütte.

„… die hütte lag auf einer Insel im See Saimaa. Um sie zu erreichen, musste ich gefrorenes Wasser überqueren. Es war eine Stunde zum nächsten Nachbar und es fühlte sich oft an, als ob ich auf einem verlassenen Planeten zurückgeblieben sei. Eines Nachts, während ich vom Festland zurückfuhr, rutschte das Auto aus und schleuderte in eine Böschung aus Schnee. Als ich aus dem Auto stieg, bemerkte ich, wie die Scheinwerfer die Explosion an Schnee, die der Unfall verursacht hatte, wegflackerten – wie die Lichter über die gefrorene Landschaft dieses seltsamen Planeten schienen, um sich nur in Dunkelheit aufzulösen. Es war ein spiritueller Moment, unter dem ungestörten Nachthimmel zu stehen, den warmen Atem, der meinen gefrorenen Lippen herauskam, zu fühlen, und die Spuren und Zeichen dieses Ereignisses, das soeben stattgefunden hatte, anzuschauen. Nichts bewegte sich. Es war als ob die Zeit stillstand – als ob die Welt ein Foto geworden wäre, in welchem ich mich bewegen konnte. Fasziniert davon versuchte ich, es festzuhalten."

La visión del mundo de Adam Jeppesen se engrandeció cuando se trasladó a Nueva York desde Dinamarca cuando tenía siete años. Vivió allí hasta que regresó a Dinamarca siete años más tarde, cuando tenía catorce años. La experiencia derivada de crecer en dos culturas se convirtió en la fuerza motriz del trabajo posterior de Jeppesen que con frecuencia trata de las similitudes de la luz, estado de ánimo y espiritualidad que se encuentran en diferentes regiones culturales del mundo.

Jeppesen asistió a una pequeña escuela de fotografía en Copenhague, y pronto comenzó a trabajar en proyectos cinematográficos, principalmente trabajos documentales. La mayor parte de este trabajo incluiría la realización de fotografías en áreas remotas o conflictivas, como Palestina, Liberia, África Occidental y el Amazonas. Jeppesen encontró a través de este trabajo inspiración y la posibilidad de trabajar en sus propios proyectos.

Durante un trabajo en Islandia en 2005, Jeppesen decidió descansar del cine y dedicar toda su atención a su propio trabajo. Como consecuencia, decidió aislarse en una casa adentrada en los bosques fineses. La hoja de contactos procede de esta retirada, tomada en el lago fuera de la casa.

"… la casa se encontraba en una isla en el lago Saimaa. Para llegar a ella tenía que atravesar las aguas congeladas. El vecino más cercano se encontraba a una hora de distancia, tenía la sensación de haber sido abandonado en un planeta desierto. Una noche, mientras regresaba de tierra firme, el coche patinó saliéndose de la carretera y chocó contra un banco de nieve. Al salir del coche observé el parpadeo de los faros como consecuencia de esta explosión de nieve que había provocado el accidente, cómo brillaban las luces en el paisaje congelado de este extraño planeta hasta disolverse en la oscuridad. Fue un momento espiritual, ahí de pie bajo el cielo nocturno imperturbable, sintiendo el cálido aliento que salía por mis labios congelados mientras observaba las huellas y el rastro del acontecimiento que acababa de tener lugar. Nada se movió. Era como si el tiempo se hubiera detenido, como si el mundo se hubiera convertido en una fotografía por la que yo podía moverme. Fascinado por la situación, traté de capturarla".

Adam Jeppesen

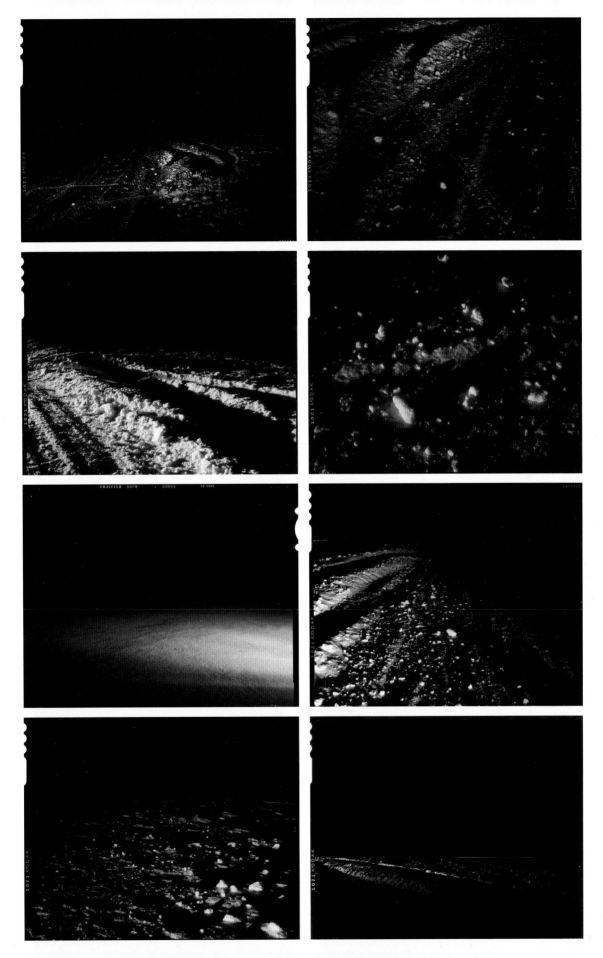

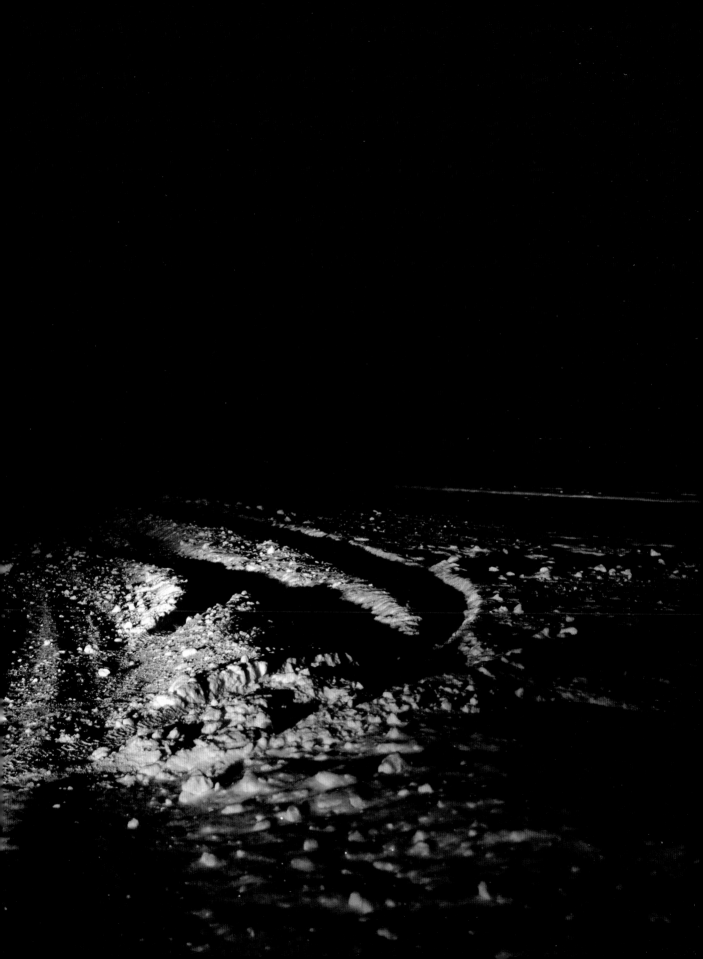

Born in Israel in 1961, Nadav Kander grew up in South Africa, and after completing his required military service there, moved to London in the mid-1980s. As a child, he was always fascinated by the idea of living in anonymity in the middle of a bustling city, and London is where he currently lives and works.

He discovered photography at the age of thirteen and began a self-taught education in the field. "I never went to college. ... I started out by assisting for a while, which is the same thing as being an apprentice, really. I assisted a commercial photographer, which, when I look back on it, I recall with a lot of affection, particularly for the photographer.

"Assisting in the early 1980s was great because commercial photographers of the period were really technically proficient. It was not a time of retouching; people really knew how to photograph. In essence, it was really craft based, which is really out the window now. I found it to be a really good grounding, because later in life you find that those techniques automatically become a part of you."

For the past three decades, Kander has created some of contemporary photography's most memorable landscape and portrait images, depicting Chernobyl, the Yangtze River, and President Obama's inaugural administration.

The featured contact sheet was taken in 1997 at Salt Lake, Utah, and was featured on the cover of his first monograph, *Beauty's Nothing*.

"All of my pictures, the ones that have anything of me in them, tend to be quiet, still. ... I like the edge of oddness in my work: a simple but slightly jarred composition, a delicately surreal detail, a feeling of friction. ...

"Taking pictures and printing have always been interlocked for me. I print everything, including color. If someone else printed my work, it would be like reading three-quarters of a good book then giving it to a friend to finish it off for me. There's so much more you can do in the printing, often more than in the shoot."

Né en Israël en 1961, Nadav Kander a grandi en Afrique du Sud et, après y avoir effectué son service militaire obligatoire, il déménagea à Londres au milieu des années 1980. Enfant, il était toujours fasciné par l'idée de vivre dans l'anonymat au cœur d'une ville trépidante, et c'est à Londres qu'il vit et travaille aujourd'hui.

Il découvrit la photographie à l'âge de 13 ans et débuta dans ce domaine en autodidacte. « Je ne suis jamais allé à l'université. ... j'ai commencé à travailler comme assistant pendant quelques temps, ce qui équivaut à un apprentissage en fait. J'étais l'assistant d'un photographe commercial, une période dont je garde des souvenirs émus, notamment envers le photographe.

Il était très intéressant d'être assistant au début des années 1980 car les photographes commerciaux de l'époque étaient très compétents techniquement. On ne retouchait pas les photos à cette époque, les gens savaient vraiment prendre des photos. C'était par essence un travail artisanal, qui n'existe plus aujourd'hui. J'ai trouvé que c'était un très bon travail fondamental car on se rend compte plus tard que ces techniques sont devenues des réflexes. »

Pendant les trente dernières années, Nadav Kander a créé certaines des photographies les plus mémorables de paysages, notamment de Chernobyl et du fleuve Yangtsé, et il a réalisé des portraits de la cérémonie d'inauguration du président Obama.

Cette planche contact fut réalisée en 1997 à Salt Lake, dans l'Utah, et elle figura sur la couverture de sa première monographie *Beauty's Nothing*.

« Toutes mes photographies, celles qui me ressemblent, évoquent une atmosphère de calme et de repos... j'aime jouer sur la frontière de l'étrange dans mon travail : une composition simple mais légèrement déséquilibré, un détail délicatement surréel, un sentiment de friction. ...

La réalisation des photographies et l'impression m'ont toujours paru liées. J'imprime tout moi-même, même les photos couleur. Si un autre devait imprimer mon travail, ce serait comme lire les trois quarts d'un bon livre et le donner à un ami pour qu'il le finisse. On peut accomplir beaucoup au stade de l'impression, bien plus que pendant la réalisation de la photo. »

Nadav Kander, geboren in Israel in 1961, wuchs in Südafrika auf und nach dem Abschluss seines obligatorischen Militärdienstes dort, zog er nach London in der Mitte der 1980er. Als Kind war er immer fasziniert von der Idee in Anonymität in der Mitte einer belebten Stadt zu leben, und London ist der Ort, wo er gegenwärtig lebt und arbeitet.

Er entdeckte die Fotografie im Alter von dreizehn Jahren, und begann eine autodidaktische Erziehung in diesem Feld. „Ich ging nie aufs College. ... Ich startete als Assistent für eine Weile, was wirklich dasselbe wie ein Lehrling ist. Ich assistierte einem kommerziellen Fotografen, was ich, wenn ich zurückschaue, mit viel Wohlwollen zurückrufe, im besonderen für den Fotografen.

In den frühen 1980ern zu assistieren war grossartig, da die kommerziellen Fotografen jener Zeit wirklich technisch kompetent waren. Es war nicht eine Zeit von Retuschierungen; Leute wussten wirklich wie zu fotografieren. In Essenz war es wirklich basierend im Handwerk, was nun wirklichl zum Fenster hinaus ist. Ich fand es als wirklich als gutes Fundament, da man später im Leben rausfindet, dass jene Techniken automatisch von einem Teil werden."

Für die letzten drei Dekaden hat Kander einige der denkwürdigsten Landschafts- und Porträtbilder der kontemporären Fotografie erzeugt, die Bilder von Tschernobyl, dem Fluss Yangtze, und Porträts von der von Präsident Obama beinhalten.

„Alle meine Bilder, die die etwas von mir drinnen haben, neigen dazu still, leise zu sein. ... Ich mag das Element der Seltsamkeit in meinem Werk: eine einfache, aber ein wenig widerstreitige Komposition, ein delikates surreales Detail, ein Gefühl der Friktion. ...

Bilder zu nehmen und auszudrucken war für mich immer verzahnt. Ich drucke alles, inklusive Farbfotos. Wenn jemand anders meine Arbeit ausdrucken würde, dann wäre das für mich wie Drei-Viertel eines guten Buchs zu lesen und dann einem Freund zu geben, um es für mich fertigzulesen. Da ist soviel mehr was man beim Drucken machen kann, oft mehr als beim Shoot."

Nacido en Israel en 1961, Nadav Kander creció en Sudáfrica y después de cumplir el servicio militar obligatorio allí, se trasladó a Londres a mediados de la década de 1980. Siendo niño siempre le había fascinado la idea de vivir en el anonimato en medio de una ciudad bulliciosa, en la actualidad vive y trabaja en Londres.

Descubrió la fotografía a los trece años e inició un proceso de autoaprendizaje in situ. "Nunca fui a la universidad. ... Empecé como asistente durante un tiempo, en realidad es lo mismo que trabajar como aprendiz. Era el asistente de un fotógrafo comercial, lo cual, cuando echo la vista atrás, recuerdo con mucho afecto, en especial hacia el fotógrafo.

trabajar como asistente a comienzos de la década de 1980 era magnífico porque los fotógrafos comerciales de la época eran realmente buenos desde el punto de vista técnico. En esa época no se hacían retoques; la gente realmente sabía cómo hacer una fotografía. Básicamente era una actividad muy artesana, algo impensable ahora. Resultó ser una base realmente buena porque más adelante en la vida resulta que esas técnicas forman parte de ti automáticamente."

Durante las tres últimas décadas, Kander ha creado algunas de las imágenes de retratos y paisajes más memorables de la fotografía contemporánea entre las que están Chernobil, el río Yangtsé y retratos de la administración inaugural del presidente Obama.

Esta hoja de contactos se tomó en 1997 en Salt Lake, Utah, y apareció en la portada de su primera monografía, *Beauty's Nothing*.

"Todas mis fotografías, aquellas que tienen algo de mí en ellas, suelen ser tranquilas, inmóviles. ... Me gusta el punto de singularidad de mi trabajo: una composición simple y ligeramente chirriante, un detalle delicadamente surrealista, una sensación de fricción. ...

Hacer fotos y revelarlas son dos actividades que para mí siempre han ido de la mano. Revelo todo, incluso color. Si otra persona revelase mi trabajo, sería algo así como leer tres cuartas partes de un buen libro y pasárselo después a un amigo para que lo terminara. Son tantas las cosas que puedes hacer durante el revelado, incluso más que al hacer la fotografía."

Nadav Kander

Final (.
Pourleed

With a career that spanned fifty years, Art Kane created a body of work that crossed several genres—whether it was fashion, portraiture, or editorial work. He has taken photographs of countless celebrities and musicians, ensuring their legacies as well as his own.

Kane began his career in the 1950s, at the age of twenty-five, designing pages for *Esquire*. He was soon hired as the art director of *Seventeen*—the youngest art director in magazines at the time. He earned dozens of awards for his work in art direction but eventually moved on to photography. Kane worked alongside the art director and photographer Alexey Brodovitch—the legendary man who helped shape the careers of photography legends such as Irving Penn and Richard Avedon.

During the 1960s and 1970s, Kane photographed politicians, musicians, actors, and regular Americans on the streets of his native New York City. He was a pioneer in the use of the wide-angle lens in his portraits, and these portraits can be characterized by the use of highly saturated colors along with innovative settings and poses for his subjects. A notable session was one where Kane spent thousands of dollars constructing Plexiglas boxes to contain the members of Jefferson Airplane—or when he posed Frank Zappa and the Mothers of Invention with their infants in their arms.

In this contact sheet of Aretha Franklin from 1967, Kane was shooting for a story on soul music in *Esquire* magazine. The select image was one of several photographs Kane featured in the issue. Kane wanted to specifically reference Franklin's gospel beginning and use the camera to reference her rapid success in the world of pop music. The effect of the halos reflected in her eyes was a result of Kane moving his camera rapidly in a circular motion with long shutter speed.

"There is something about a perfectly lit photograph that I find offensive. If the light happens to drop off, so be it. That might produce a certain mystery. I'm interested in withholding some information—in not spelling things out so clearly that they become dull and cold."

Tout au long d'une carrière qui s'étend sur un demi-siècle, Art Kane créa une œuvre qui se décline sur différents genres – la mode, les portraits et le travail éditorial. Il photographia un nombre impressionnant de célébrités et de musiciens, assurant tout à la fois leur postérité et la sienne.

Art Kane fit ses débuts dans la photographie à l'âge de vingt-cinq ans grâce à une collaboration avec le magazine *Esquire* dans les années 1950. Il fut bientôt engagé au poste de directeur artistique pour le magazine *Seventeen* – devenant alors le plus jeune directeur artistique du milieu de l'édition. Bien qu'ayant recueilli une douzaine de prix récompensant la qualité de son travail éditorial, il décida de se tourner vers la photographie. Il travailla alors aux côtés du photographe et directeur artistique Alexey Brodovitch, personnage légendaire qui contribua à lancer les carrières de photographes aussi illustres qu'Irving Penn ou Richard Avedon.

Pendant les années 1960 et 1970, Art Kane réalisa les portraits de nombreux politiciens, musiciens et acteurs, ainsi que d'anonymes Américains dans les rues de son New York natal. Il fut pionnier dans l'utilisation de l'objectif à grand angle pour ses portraits qui se caractérisent par des couleurs fortement saturées, des poses et des décors novateurs. Lors d'une séance photos devenue célèbre, Art Kane dépensa plusieurs milliers de dollars pour la construction de boîtes en plexiglas destinées à accueillir les membres du groupe Jefferson Airplane ; il fit aussi poser Frank Zappa et the Mothers of Invention avec leurs nouveaux-nés dans les bras.

Cette planche contact d'Aretha Franklin fut créée en 1967 à l'occasion d'un reportage sur la soul music pour le magazine *Esquire*. L'image sélectionnée est l'une des nombreuses photographies publiées dans ce reportage. Art Kane cherchait à obtenir une référence spécifique aux débuts d'Aretha Franklin dans le gospel à et littéralement saisir par la photographie son ascension rapide dans le monde de la pop music. L'effet de halo se reflétant dans les yeux résulte d'un mouvement circulaire imprimé à l'appareil et d'un temps de pose prolongé.

« Toute photographie réalisée avec une lumière parfaite m'est offensante. S'il arrive que la lumière vacille, tant mieux, cela peut créer une atmosphère mystérieuse. Je préfère pour ma part garder le message dissimulé pour éviter qu'une trop grande clarté d'expression ne crée un sujet terne et froid. »

Mit einer fünfzig Jahre umspannenden Karriere hat Art Kane ein Ouevre kreiert, das mehrere Genres überspannt – ob es sich nun um Mode, Portraits, oder editorials Schaffen handelt. Er hat unzählige Berühmtheiten und Musiker fotografiert, und damit deren und sein eigenes Vermächtnis gesichert.

In den 1950er Jahren begann Kane seine Karriere im Alter von fünf-und-zwanzig Jahren als er Seiten für das Magazin *Esquire* entwarf. Er wurde dann schnell als leitender Art Director beim Magazin *Seventeen* angestellt – damals der jüngste Zeitschriften-Art-Director. Er gewann verschiedene Preise für sein Werk in Art Direction, aber schliesslich entschied er sich für die Fotografie. Kane arbeitete mit dem Art Director und Fotografen Alexey Brodovitch – der legendäre Mann, der die Karrieren von fotografischen Legenden wie Irving Penn und Richard Avedon prägte.

Während der 1960er und 1970er Jahre fotografierte Kane Politiker, Musiker, Schauspieler, und normale Amerikaner der Strassen seiner einheimischen Stadt New York. Er bahnte den Weg für die Verwendung von Weitblicklinsen mit seinen Portraits, und diese Portraits sind durch den Gebrauch von hochsaturierten Farben mit innovativen Szenen und Posen der Subjekte gekennzeichnet.

Eine bedeutende Fotositzung war als Kane tausende von Dollar für die herstellung von Plexiglaskisten ausgab, um die Mitglieder von Jefferson Airplane darin einzukapseln – oder als er Frank Zappa und Mothers of Invention mit deren Säuglingen in den Armen posieren liess.

In diesem Kontaktbogen von Aretha Franklin vom Jahr 1967 fotografierte Kane einen Artikel zu Soulmusik für das Magazin *Esquire*. Das ausgewählte Foto war eines von mehreren, die von Kane in der damaligen Ausgabe erschienen. Kane wollte speziell auf Franklins Anfänge in der Gospelmusik Bezug nehmen und nutzte die Kamera, um ihren schnellen Erfolg in der Welt der Popmusik buchstäblich festzuhalten. Der Effekt der in ihren Augen reflektierten Glorienscheine war ein Resultat von Kanes Technik, die Kamera mit langer Belichtungszeit und mit hoher Geschwindigkeit kreisförmig zu bewegen.

„Da ist etwas an einem perfekt belichteten Foto, dass ich widerlich finde. Wenn es geschieht, dass das Licht abschwächt, dann soll es. Das kann ein gewisses Geheimnis erzeugen. Ich bin daran interessiert, etwas Information zurückzuhalten – Dinge nicht so klar zu zeigen, dass sie stumpf und kalt werden."

Con una carrera que abarca cincuenta años, Art Kane ha acumulado un cuerpo de trabajo que cubre diversos géneros: moda, retratos o trabajo editorial. Ha tomado fotografías de innumerables personajes famosos y músicos: asegurando su legado personal y el de los sujetos de su obra.

En los años 50, Kane empezó su carrera a la edad de veinticinco años, diseñando páginas para *Esquire*. En seguida fue nombrado director de arte de *Seventeen*: el director de arte más joven de una revista en aquella época. Ganó docenas de premios por su trabajo en dirección artística, hasta que, finalmente, se pasó a la fotografía. Kane ha trabajado junto con el director de arte y fotógrafo Alexey Brodovitch, el legendario personaje que ayudó a dar forma a las carreras de leyendas de la fotografía como Irving Penn y Richard Avedon.

Durante las décadas de 1960 y 1970, Kane fotografió a políticos, músicos, actores y americanos de a pie en las calles de su nativa Nueva York. Fue un pionero en el uso de las lentes de gran angular en sus retratos, que se caracterizan por el uso de colores muy saturados además de innovadoras poses y puestas en escena. Es famosa la sesión en la que Kane gastó miles de dólares construyendo cajas de plexiglás que dieran cabida a los miembros de Jefferson Airplane, o en la que hizo posar a Frank Zappa y the Mothers of Invention con sus bebés en brazos.

En esta hoja de contactos de Aretha Franklin, que data de 1967, Kane estaba trabajando para una historia acerca de la música soul para la revista *Esquire*. La imagen seleccionada es una de las varias fotografías que Kane publicó en ese número. Kane quería hacer una referencia específica a los inicios en el gospel de Franklin y empleó la cámara para capturar, literalmente, su rápido éxito en el mundo de la música pop. Kane logró el efecto de los halos reflejados en sus ojos moviendo su cámara rápidamente en círculos con velocidad de obturación lenta.

"Hay algo en una imagen con una iluminación perfecta que encuentro ofensivo. Si la luz disminuye, que así sea. Puede producir cierto misterio. Me gusta no revelar cierta información, no explicar las cosas con tanto detalle que acaben por ser aburridas y frías".

Art Kane

David Hume Kennerly's photojournalist career began in Oregon, where he worked for the *Oregon Journal* as a staff photographer. While at the *Journal*, Kennerly photographed well-known figures such as Miles Davis, the Rolling Stones, and notably, Senator Robert F. Kennedy. This meeting with Kennedy would propel his career as a political photographer, and years later, Kennerly would photograph some of the last photos of the senator at the Ambassador Hotel before he was assassinated.

In the 1960s, Kennerly moved to Los Angeles to work as a staff photographer for United Press International (UPI). He eventually left for Saigon during the Vietnam War to be a combat photographer for UPI, and the photographs he took there garnered Kennerly the Pulitzer Prize for Feature Photography.

"This sequence of photos was taken August 9, 1974, on the South Lawn of the White House as President Nixon boarded his helicopter after resigning the presidency. The image just before that little wave—if you were Richard Nixon and looked back at the White House from where I was shooting, you would be looking right at the south portico of the White House. At that moment, he knew he would be seeing that for the last time as the President of the United States. And so it was an incredibly bitter, personal moment for him.

"The crowd there comprised former White House staffers who came out to see him off. They started applauding and cheering, and that's when he started acknowledging them by smiling and waving his arms around with his campaign appearance. But it wasn't a campaign appearance; it was one of the darkest days in presidential history, outside of the assassination, of course.

"I knew we were witnessing history right before our eyes out there. The gravity of it was palpable. So what you see there is almost a mini movie of Nixon leaving the presidency. It's one of the most dramatic series of pictures that I think I have ever taken."

La carrière de photojournaliste de David Hume Kennerly débuta dans l'Oregon où il travailla comme photographe pour le quotidien *The Oregon Journal*. Durant cette période, il eut l'occasion de réaliser les portraits de personnalités telles que Miles Davis, les Rolling Stones et notamment le sénateur Robert F. Kennedy. Cette rencontre avec Kennedy allait lancer sa carrière de photographe politique et, bien des années plus tard, il devait prendre quelques unes des dernières photos du sénateur avant son assassinat à l'Ambassador Hotel de Los Angeles.

Dans les années 1960, David Kennerly déménagea à Los Angeles où il travailla comme photographe pour l'agence United Press International (UPI). Il partit pour Saigon comme photographe de guerre pour UPI et ses clichés du Vietnam furent récompensés par le Prix Pulitzer de la photographie d'information.

« Cette séquence a été prise le 9 août 1974 sur la pelouse sud de la Maison Blanche, alors que le président Nixon montait à bord de l'hélicoptère juste après avoir démissionné de ses fonctions. Pour bien situer la scène, vous devez vous mettre à la place de Nixon et suivre son regard vers la Maison Blanche d'où je le photographiais ; vous voyez alors le portique sud de la Maison Blanche. A cet instant, Nixon voyait ce portique pour la dernière fois en tant que Président des Etats-Unis, et ce devait être un moment très personnel et plein d'amertume pour lui.

A côté de moi se trouvaient d'anciens employés de la Maison Blanche qui étaient venus faire leurs adieux. Ils ont commencé à applaudir et à acclamer Nixon, qui les a alors remarqués. Il leur a souri et les a salués comme s'il était en campagne électorale. Mais ceci n'était pas un meeting de campagne et ce fut une des journées les plus sombres de l'histoire présidentielle, mis à part celle de l'assassinat bien sûr.

Je savais que nous étions les témoins d'un moment historique. La gravité en était tangible. Ce que vous voyez est une sorte de mini film de Nixon quittant la présidence. C'est une des séries de photos les plus dramatiques que je pense avoir jamais prises. »

David Hume Kennerly's fotojournalistische Karriere begann in Oregon, wo er für die Zeitung *The Oregon Journal* als Stabfotograf arbeitete. Während seiner Zeit beim *Journal* fotografierte er gut-bekannte Figuren wie Miles Davis, die Rolling Stones, und bemerkenswerter Weise Senator Robert F. Kennedy. Das Treffen mit Kennedy brachte seine Karriere als Fotograf von Politikern vorwärts, und Jahre später würde Kennerly einige der letzten Fotos des Senator beim Ambassador Hotel aufnehmen, bevor dieser ermordet wurde.

In den sechziger Jahren zog Kennerly nach Los Angeles, um als Stabfotograf für United Press International (UPI) zu arbeiten. Er brach schliesslich während dem Vietnam-Krieg nach Saigon als Kampf-Fotograf für UPI auf, und die Fotos, die er dort aufnahm, gewannen ihm den Pulitzer Prize für Feature Photography.

„Diese Reihe von Fotos ist vom 9. August, 1974, auf dem südlichen Rasen des Weissen Hauses, als Präsident Nixon seinen Helikopter bestieg, nachdem er die Präsidentschaft niedergelegt hatte. Das Bild genau vor dem kleinen Winken – wenn du Richard Nixon wärst, und zurück auf das Weisse Haus schaust, von wo ich fotografierte, dann würdest du direkt auf die südlichen Säuleneingang des Weissen Haus schauen. Zu diesem Moment wusste er, dass er dies für das letzte Mal als Präsident der Vereinigten Staaten sehen würde. Und so war es ein unglaublich bitterer, persönlicher Moment für ihn.

Die Menge bestand aus früheren Angestellten des Weissen Hauses, die rauskamen, um ihn zu verabschieden. Sie begannen zu applaudieren und zu jubeln, und dass war der Moment, als er begann, sie anzuerkennen, mit dem Lächeln und den herumwinkenden Armen seiner Wahlkampferscheinung. Aber es war nicht eine Wahlkampferscheinung, es war einer der dunkelsten Tage in der Geschichte der Präsidentschaften, ausserhalb der Ermordung natürlich.

Ich wusste, dass wir da draussen der Geschichte genau vor unseren Augen beiwohnten. Der Ernst davon war spürbar. So was man hier sehen kann ist fast ein Mini-Film von Nixons Abgang der Präsidentschaft. Es ist eine der dramatischsten Reihe von Bildern, die, ich denke, jemals gemacht habe."

La carrera profesional de David Hume Kennerly como reportero gráfico comenzó en Oregon, donde trabajó para *The Oregon Journal* como fotógrafo de plantilla. Mientras estuvo en el *Journal*, Kennerly fotografió a personajes conocidos como Miles Davis, the Rolling Stones, y como figura destacada al senador Robert F. Kennedy. Este encuentro con Kennedy impulsó su carrera como fotógrafo político y años más tarde Kennerly fotografiaría algunas de las últimas fotos del senador en el Hotel Ambassador antes de su asesinato.

En los años sesenta, Kennerly se trasladó a Los Ángeles para trabajar como fotógrafo de United Press International (UPI). Acabaría marchándose a Saigón durante la Guerra de Vietnam como fotógrafo bélico de UPI y las imágenes que capturó le valieron el Premio Pulitzer a las Mejor Fotografía de Reportaje.

"Esta secuencia de fotos data del 9 de agosto de 1974 en el jardín sur de la Casa Blanca cuando el presidente Nixon abordaba su helicóptero después de dimitir. La imagen que precedió a su saludo, de haber sido Richard Nixon y hubieras mirado hacia la Casa Blanca desde donde me encontraba, habrías estado mirando directamente al pórtico sur de la Casa Blanca. En ese momento sabía que la estaba viendo por última vez como Presidente de los Estados Unidos. Por lo que se trataba de un momento personal extremadamente amargo para él.

El grupo congregado estaba formado por antiguos miembros del personal de la Casa Blanca que había acudido para despedirle. Comenzaron a aplaudir y a gritar, y fue en ese momento en el que reconoció su presencia sonriendo y levantando los brazos como cuando estaba en campaña. Pero no estaba en campaña, se trataba de uno de los días más duros de la historia presidencial, aparte del día del asesinato, por supuesto.

Sabía que estábamos siendo testigos de un momento histórico. La gravedad de lo que estaba sucediendo era palpable. Así que lo que ve es prácticamente un corto de Nixon abandonando la presidencia. Se trata de una de las series de imágenes más dramáticas que creo haber realizado nunca".

David Hume Kennerly

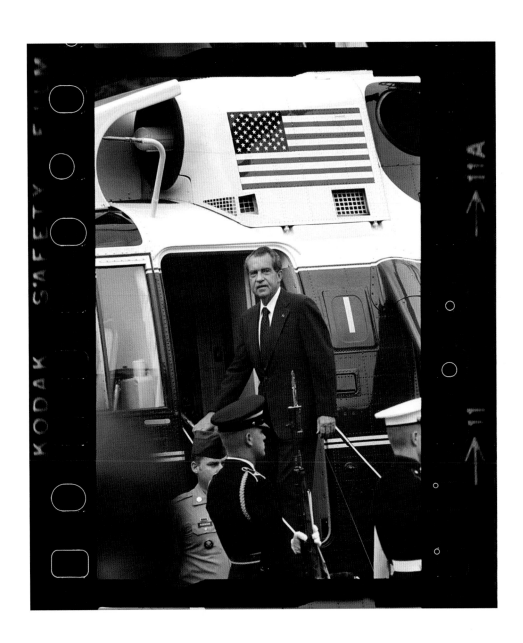

As a young woman living in New York City, Dorothea Lange learned photography in a class taught by Clarence H. White. She also apprenticed at several studios throughout the city, including that of Arnold Genthe. In her twenties, she opened her own successful portrait studio in San Francisco.

The Great Depression soon compelled Lange to focus her lens not on the posed people in her studio but on the unemployed and homeless she saw on the streets. Her journalistic images led to her employment with the federal Resettlement Administration, which later became the Farm Security Administration (FSA). Lange traveled across the country and documented rural poverty and exploited migrant workers. Lange also went on to photograph the Japanese internment camps after the bombing of Pearl Harbor, images that were later impounded by the U.S. Army.

Lange's most famous photograph from her period at the FSA, and perhaps of her career, is "Migrant Mother." It is arguably the most iconic image of the Great Depression. During the peak of the Depression, Lange came across Florence Owens Thompson and her children off the side of the road in Nipomo, California. Thompson had set up camp while a friend went to find help for their car, which had broken down. In an 1960 interview with *Popular Photography*, Lange described the session:

"I saw and approached the hungry and desperate mother, as if drawn by a magnet. I do not remember how I explained my presence or my camera to her, but I do remember she asked me no questions. I made five exposures, working closer and closer from the same direction. I did not ask her name or her history. She told me her age, that she was thirty-two. She said that they had been living on frozen vegetables from the surrounding fields, and birds that the children killed. She had just sold the tires from her car to buy food. There she sat in that lean-to tent with her children huddled around her, and seemed to know that my pictures might help her, and so she helped me. There was a sort of equality about it."

Résidente de New York, Dorothea Lange suivit des cours d'art visuel et fut notamment l'élève du photographe Clarence H. White. Elle poursuivit sa formation de photographe dans de nombreux studios de la ville, dont celui de Arnold Genthe, avant d'ouvrir son propre studio de portraits à San Francisco dans les années 1920.

La Grande Dépression de 1929 détourna Dorothea Lange des clients de son studio et l'amena à pointer son objectif sur la misère des sans-abris et des chômeurs. Ses photographies furent très vite appréciées et elle fut recrutée par la Resettlement Administration, un programme du New Deal de Roosevelt auquel devait succéder la Farm Security Administration (FSA). Elle entreprit alors de voyager dans tout le pays pour documenter la pauvreté rurale et l'exploitation des travailleurs itinérants pendant la dépression qui sévit alors aux Etats-Unis.

La Mère migrante reste la photographie la plus célèbre de sa période à la FSA, et certainement de toute sa carrière. Dans la conscience collective, c'est sans doute l'image la plus emblématique de la Grande Dépression aux Etats-Unis. Au plus noir de la dépression, les chemins de Dorothea Lange et de Florence Owens Thompson se croisèrent au bord de la route de Nipomo, en Californie. Florence Thompson s'était installée avec ses enfants dans un camp de travailleurs migrants pendant qu'un ami était parti chercher de l'aide pour réparer leur voiture. Dans un entretien accordé au magazine *Popular Photography* en 1960, Dorothea Lange décrivit la rencontre en ces termes :

« Quand j'ai vu cette mère affamée et désespérée, je me suis tout de suite approchée. Je ne me rappelle pas comment je lui ai expliqué ma présence ou mon appareil photo, mais je me souviens qu'elle ne me posait aucune question. J'ai pris cinq clichés en me rapprochant peu à peu. Je n'ai pas cherché à connaître son nom ou son passé. Elle m'a dit son âge, elle avait trente-deux ans. Elle m'a expliqué qu'elle vivait de légumes gelés trouvés dans les champs et d'oiseaux que ses enfants tuaient. Elle venait de vendre les pneus de sa voiture afin de se procurer de la nourriture. Elle était assise là, dans cet abri de fortune avec ses enfants blottis contre elle, elle semblait savoir que mes photos pourraient l'aider, et elle m'a donc aidée en retour. Nous nous trouvions sur une sorte de pied d'égalité. »

Dorothea Lange lebte als junge Frau in New York und lernte dort in einer Vorlesung von Clarence H. White die Fotografie. Sie war auch in verschiedenen Foto-Studios der Stadt New York Praktikantin, unter anderem im Studio von Arnold Genthe. In ihren zwanziger Jahren eröffnete sie ihr eigenes erfolgreiches Porträtstudio in San Francisco.

Die Weltwirtschaftskrise brachte Lange bald dazu, ihre Fotolinse nicht auf die posierenden Kunden in ihrem Studio zu richten, sondern auf die arbeits- und obdachlosen Menschen, die sie auf den Strassen sah. Ihre Strassenbilder führten zu einer Anstellung mit der Bundes-Wiederansiedlungsverwaltung, die später die Farm-Sicherheitsverwaltung wurde. Lange reiste durch das Land und dokumentierte die ländliche Armut und die Situation der missbrauchten Migranten-Arbeiter. Danach fotografierte Lange die japanischen Gefangenenlager nach der Bombardierung von Pearl harbor, und diese Bilder wurden später von der U.S. Armee beschlagnahmt.

Lange's berühmtestes Bild von ihrer Zeit mit der Farm-Sicherheitsverwaltung und vielleicht ihrer ganzen Karriere ist *Migrant Mother*. Es ist wahrscheinlich das am ikonischste Bild der Weltwirtschaftskrise. Während dem höhepunkt der Depression traf Lange Florence Owens Thompson und deren Kinder auf der Seite der Strasse in Nipomo, Kalifornien. Thompson campierte dort, während ein Freund hilfe suchen ging für ihr Auto, das zusammengebrochen war. In einem Interview von 1960 mit *Popular Photography*, beschrieb Lange die Session:

„Ich sah die hungrige und verzweifelte Mutter und näherte mich ihr, als ob von einem Magnet angezogen. Ich kann mich nicht erinnern, wie ich ihr meine Präsenz oder meine Kamera erklärte, aber ich erinnere mich daran, dass sie mich keine Fragen fragte. Ich machte fünf Belichtungen, arbeitete näher und näher von der selben Richtung. Ich fragte sie nicht nach ihrem Namen oder nach ihrer Geschichte. Sie sagte mir ihr Alter, dass sie zwei-und-dreissig sei. Sie sagte, dass sie von gefrorenem Gemüse von den umgebenden Feldern gelebt hatten, und den Vögeln, die die Kinder umbrachten. Sie hatte gerade die Reifen von ihrem Auto verkauft, um Essen zu kaufen. Da sass sie in diesem angebautem Zelt mit ihren umsie-herumkauernden Kindern, und schien zu wissen, dass meine Bilder ihr helfen könnten, und so half sie mir. Da war eine Art von Gleichstellung dabei."

Durante sus años de juventud en la ciudad de Nueva York, Dorothea Lange estudió fotografía como alumna de Clarence H. White. También trabajó como aprendiz en varios estudios de la ciudad, incluido el de Arnold Genthe. Con poco más de veinte años, abrió su propio y exitoso estudio de retratos en San Francisco.

La Gran Depresión pronto empujaría a Lange a cambiar el enfoque de sus lentes de los posados de su estudio a las personas desempleadas y sin hogar que veía por la ciudad. Sus imágenes de las calles la llevaron a encontrar un trabajo con la Federal Resettlement Administration, que más tarde se convertiría en la Farm Security Administration (FSA). Lange recorrió el país documentando la pobreza rural y la explotación de los trabajadores inmigrantes. Lange pasó a fotografiar los campos de internamiento para japoneses tras el bombardeo de Pearl harbor, imágenes que más tarde confiscó el ejército de los Estados Unidos.

La fotografía más famosa de Lange de su época en la FSA, y quizá de toda su carrera, es *Migrant Mother*. Es, casi con toda seguridad, la imagen más representativa de la Gran Depresión. Durante el peor momento de la Depresión, Lange se encontró con Florence Owens Thompson y sus hijos a un lado de la carretera en Nipomo, California. Thompson había acampado mientras un amigo iba a buscar ayuda para el automóvil, que se había averiado. En una entrevista concedida a *Popular Photography* en 1960, Lange describió la sesión:

"Vi una madre desesperada y hambrienta y me acerqué a ella, como atraída por un imán. No recuerdo cómo expliqué mi presencia o mi cámara, pero recuerdo que ella no me hizo ninguna pregunta. Hice cinco exposiciones, trabajando más y más cerca desde la misma dirección. No le pregunté su nombre o su historia. Me dijo su edad, tenía treinta y dos años. Me dijo que sobrevivían a base de verduras congeladas de los campos de los alrededores y de pájaros que cazaban los niños. Acababa de vender los neumáticos de su automóvil para comprar comida. Y allí estaba sentada, atendiendo a sus hijos que se amontonaban a su alrededor, y parecía saber que mis fotos podían ayudarla, así que ella me ayudaba a su vez. Había una especie de igualdad en ello".

Dorothea Lange

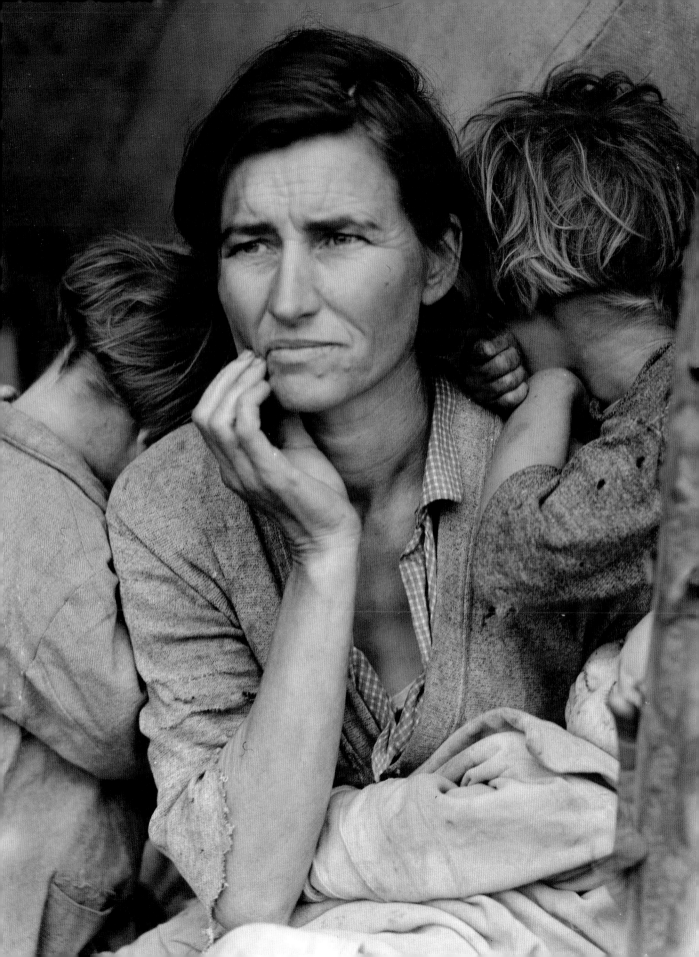

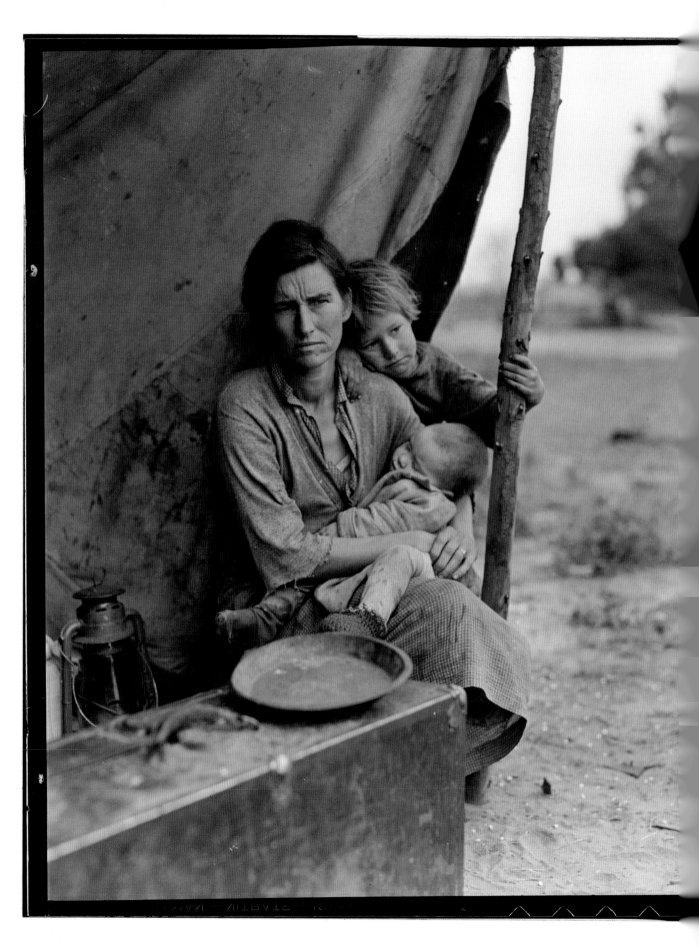

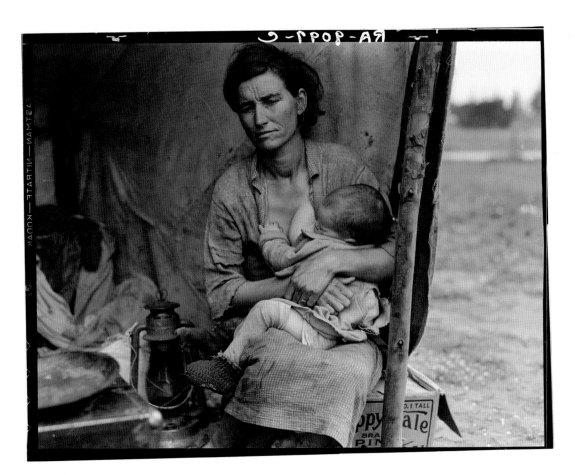

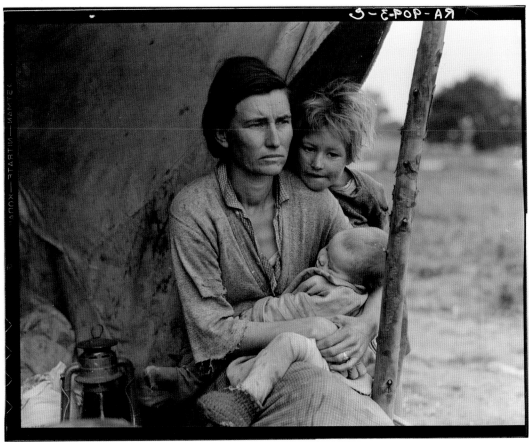

Born in Pittsburgh, the son of a rabbi, Saul Leiter began a self-taught education in both painting and photography during his adolescence—eventually leaving the theological college he was attending to pursue his artistic passions. In the late 1940s, Leiter took to the streets of New York City with his Leica and sparked the beginning of a career in editorial and advertising photography.

Leiter's interest in the medium was greatly influenced by meeting abstract expressionist painter Richard Pousette-Dart, who was experimenting with photography at the time. Other influences, such as the work of Henri Cartier-Bresson, inspired the young Leiter to pursue photography as a career.

In the early 1950s, Leiter showed his portfolio to Edward Steichen, who then included his work in a group show called *Always the Young Strangers*. He was friendly with photojournalist W. Eugene Smith, who introduced him to Alexey Brodovitch, the legendary art director at *Harper's Bazaar*. Leiter would eventually photograph for the publication, along with numerous others, throughout the '50s and '60s.

Leiter's editorial and advertising work was often considered unorthodox, juxtaposing unusual themes in the same work—a model dressed as a homeless lady wrapped in extravagant fur coats, for example. His work in the 1950s was also marked by his use of muted hues and simple forms, especially in his color work. His later work since his advertising and editorial days has focused on personal projects and has been shown in numerous exhibitions and publications.

In this contact sheet, Leiter seated Diane Arbus in front of her collage wall in her East 10th Street apartment on November 2, 1970. Leiter also lived on 10th Street (across the street from Arbus), and often helped her with chores such as carrying her laundry when Arbus was suffering from hepatitis. She once asked him if he knew any "battered people to photograph," and he said that he did not.

When he asked Arbus if he could photograph her, she said, "I would not be afraid to be photographed by you." Arbus later told Leiter she would like to see the world as he did, and Leiter replied that it would not be very good for her work, since she had her own special vision.

Né à Pittsburgh en Pennsylvanie et élevé dans la tradition rabbinique, Saul Leiter étudia la peinture et la photographie en autodidacte durant son adolescence – interrompant des études de théologie pour se consacrer à son penchant artistique. Vers la fin des années 1940, il commença à arpenter les rues de New York avec son Leica en bandoulière et se lança dans une carrière de photographe.

Le travail photographique de Saul Leiter s'inspire fortement de la peinture, et notamment de l'œuvre de l'expressionniste abstrait Richard Pousette-Dart dont il fit la connaissance à Paris et qui expérimentait avec la photographie. Il fut également influencé par l'œuvre d'Henri Cartier-Bresson, œuvre qui l'incita à poursuivre une carrière de photographe.

Au début des années 1950, Saul Leiter présenta son portfolio à Edward Steichen qui l'invita alors à participer à une exposition appelée *Always the Young Strangers*. C'est par son amitié avec le journaliste W. Eugene Smith qu'il fit la connaissance d'Alexey Brodovitch, légendaire directeur artistique du magazine *Harper's Bazaar*. Saul Leiter devait collaborer avec cette publication et avec de nombreux magazines au cours des années 1950 et 1960.

Les reportages réalisés pour les grands magazines et la photographie publicitaire de Saul Leiter furent souvent considérés comme peu orthodoxes, juxtaposant des thèmes incongrus dans un même cliché – on y voit par exemple un mannequin habillée en clocharde et emmitouflée de manteaux de fourrures. Son œuvre des années 1950 est caractérisée par des tonalités nuancées et des lignes épurées, en particulier dans la photographie couleur. Son travail récent se concentre sur des projets plus personnels et fut l'objet de nombreuses expositions et publications.

Cette planche contact fut réalisée le 2 novembre 1970 et présente un portrait de Diane Arbus devant le mur de collages de son appartement de la East 10th rue. Saul Leiter et Diane Arbus étaient voisins et Leiter prêtait fréquemment assistance à Diane dans les tâches quotidiennes ; il l'aidait par exemple à faire sa lessive quand elle souffrait d'hépatite. Elle lui demanda un jour s'il connaissait des « personnes marqués par les épreuves de la vie [qu'elle pourrait] photographier », il lui répondit par la négative.

Diane Arbus accéda à la demande de Leiter de la photographier : « je n'aurais aucune crainte d'être photographiée par toi. » Elle lui fit part de son envie d'appréhender le monde à travers ses yeux à lui, à quoi Leiter rétorqua que ce serait dommage car elle portait déjà un regard très personnalisé sur le monde.

Saul Leiter, geboren in Pittsburgh und aufgewachsen als Sohn eines rabbi, begann eine auto-didaktische Erziehung in Malerei und Fotografie in seiner Jugendzeit – letzten Endes brach er sein Studium an der theologischen Universität ab, um seinen künstlerischen Passionen nachzusetzen. In den späten 1940er Jahren ging Leiter mit seiner Leica-Kamera in die Strassen von New York City raus, und dies markierte den Beginn seiner Karriere in der Redaktions- und Werbefotografie.

Leiters Interesse an dem Medium der Fotografie war sehr beeinflusst von einem Treffen mit dem abstrakten expressionistenmaler Richard Poussette-Dart, der zu diesm Zeitpunkt mit Fotografie experimentierte. Andere Enflüsse, wie das Werk von Henri Cartier-Bresson, inspirierten den jungen Leiter, der Fotografie als Karriere nachzusetzen.

In den frühen 1950er Jahren zeigte Leiter seine Künstlermappe Edward Steichen, der dann sein Werk in einer Ausstellung betitelt *Always the Young Strangers* zeigte. Er war mit dem Fotojournalisten W. Eugene Smith befreundet, der ihn mit Alexey Brodovitch, dem legendären art director bei *Harper's Bazaar*, bekannt machte. Leiter fotografierte letzten Endes für dieses Magazin, und für zahlreiche andere, während der 50er und 60er Jahre.

Leiters Werke von seiner Redaktions- und Werbefotografie wurden oft als unorthodox betrachtet, da er ungewöhnliche Themen im selben Werk nebeneinanderstellte – ein Fotomodell als obdachlose Dame in extravagante Pelzmäntel gewickelt, zum Beispiel. Sein Schaffen in den 1950er Jahren war auch von der Verwendung von gedämpften Farbtönen und einfachen Formen geprägt, vor allem in seinen Farbfotos. Sein späteres Werk seit seinen Tagen in der Redaktions- und Werbefotografie konzentriert sich auf persönliche Projekte und ist in zahlreichen Ausstellungen und Veröffenlichungen gezeigt worden.

In diesem Kontaktbogen setzte Leiter Diane Arbus vor ihre Wand von Collagen in ihrer East10th Street-Wohnung am 2. November 1970. Leiter wohnte auch auf der 10th Street (gegenüber der Strasse von Arbus), und half ihr oft mit Hausarbeiten wie dem Tragen ihrer Wäsche, wenn Arbus an Hepatitis leidete. Sie fragte ihn einmal ob er „zerschlagene Leute zum Fotografieren" kenne, und er sagte dass er keine kannte.

Als er Arbus fragte, ob er sie fotografieren könne, sagte sie „Ich hätte keine Angst, mich von Dir fotografieren zu lassen." Arbus teilte Leiter später mit, dass sie die Welt sehen möchte wie er sie sieht, und er antwortete, dass dies nicht sehr gut für ihre Arbeit wäre, da sie ihre eigene spezielle Vision habe.

Nacido en Pittsburgh e hijo de un rabino, Saul Leiter empezó su educación autodidacta en pintura y fotografía durante su adolescencia, y acabaría por abandonar la escuela de teología a la que asistía para consagrarse a sus pasiones artísticas. A finales de los años 40, Leiter tomó las calles de Nueva York con su Leica, lo que representó el inicio de una carrera en fotografía editorial y publicitaria.

El interés de Leiter en el medio se vio muy influido por el pintor expresionista abstracto Richard Pousette-Dart que estaba experimentando con la fotografía por aquel entonces. Otras influencias, como la obra de Henri Cartier-Bresson, inspiraron al joven Leiter a dedicarse a la fotografía como una carrera.

A principios de los años 50, Leiter mostró su portafolio a Edward Steichen, quien incluyó su trabajo en una exposición colectiva llamada *Always the Young Strangers*. Se hizo amigo del fotoperiodista W. Eugene Smith, quien le presentó a Alexey Brodovitch, el legendario director artístico de *Harper's Bazaar*. Leiter llegaría a trabajar para esta publicación, además de muchas otras, en la década de los cincuenta y los sesenta.

El trabajo editorial y publicitario de Leiter se ha considerado a menudo poco ortodoxo pues combina temas inusuales en un mismo trabajo: una modelo vestida como una mujer sin hogar arropada con extravagantes abrigos de piel, por ejemplo. Su obra en los años 50 también estuvo marcada por el uso de tonos apagados y formas sencillas, especialmente en su trabajo en color. Su trabajo posterior, tras sus días como fotógrafo publicitario y editorial, se ha centrado en proyectos personales, y se ha mostrado en abundantes publicaciones y exposiciones.

En esta hoja de contactos, Leiter ha sentado a Diane Arbus delante del muro de collage de su apartamento en la calle 10th Street el 2 de noviembre de 1970. Leiter también vivía en la calle 10th Street (enfrente de Arbus) y con frecuencia la ayudaba con sus tareas como llevar la ropa a lavar cuando Arbus tenía hepatitis. Ella le preguntó una vez si conocía a alguna "persona maltratada a quien fotografiar" y él contestó que no.

Cuando le preguntó a Arbus si podía fotografiarla, ella le respondió "No me daría miedo que tú me sacaras una foto". Más tarde, Arbus le comentó a Leiter que le gustaría ver el mundo como él y Leiter le replicó que no sería muy bueno para su trabajo ya que ella tenía una visión propia y especial.

Saul Leiter

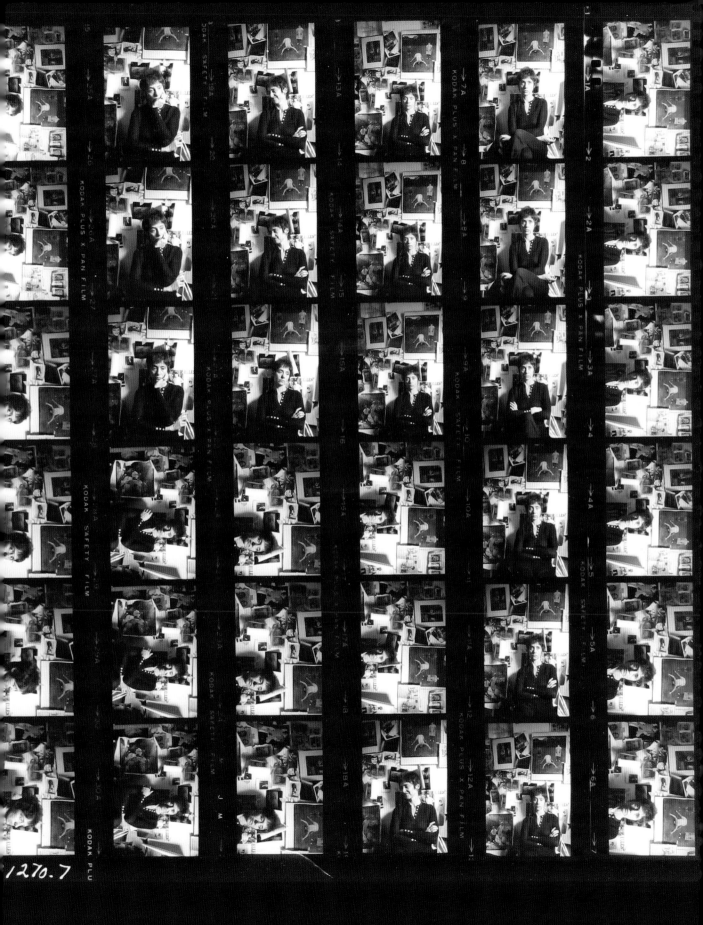

1270.7

Raised in Sunnyvale, California, Mark Leong is a fifth-generation Chinese-American who first visited China in the late 1980s with a traveling fellowship. He returned to China as an artist-in-residence at the Central Academy of Fine Arts in Beijing a few years later and has since been living and photographing in the country of his great-great-great-grandparents.

A few years ago, Leong joined the Redux Pictures photo agency and has garnered several awards and fellowships, including one from the National Endowment for the Arts. His work has been shown in various international publications and exhibitions, and his first book, *China Obscura*, was released in 2004.

This contact sheet is from a session in Shanxi, China, in 2005.

"This came about, as many things do in China, through guanxi—a loose network of friends, acquaintances, and family. My friend Kai, a filmmaker, had a friend Julia, an advertising executive, whose grandmother had just passed away in rural Shanxi. Kai was going to shoot the funeral and asked me if I wanted to come along to take pictures. We drove several hours away from Beijing to her grandmother's old village home for the three-day affair.

"The courtyard was thick with incense and buzzing with neighbors paying their respects at the open coffin. There were firecrackers and food offerings. A live band burst into tunes that clanged and whined in the icy air of early spring. Julia draped the traditional white mourning robes over her clothes and joined her family as they wept at ritual intervals throughout the many hours. They seemed truly sad about her grandmother's death, but after a while, I'm sure cold and exhaustion also factored into their desolate cries.

"As our camera batteries started to fail in the subfreezing temperatures, Kai and I kept ducking into one of the side rooms to thaw out our gear and fingers by a cast-iron stove. One of these times, Julia also joined us to grab a cigarette. Of everything that was going on, that quiet moment ended up being my favorite scene. I chose a frame where you can just see the cigarette sticking out from her hood between her polished nails, the hint of a modern, urban woman emerging, having just lost another connection to a deep and fading ancestral past."

Mark Leong est issu de la cinquième génération d'immigrés asiatiques et a grandi à Sunnyvale en Californie. Après avoir obtenu son diplôme de l'université d'Harvard en 1980, il découvrit la Chine pour la première fois grâce à une bourse d'étude. Il y séjourna quelques années plus tard en qualité d'artiste en résidence à l'Académie Centrale des Beaux-Arts de Beijing et s'est depuis installé dans le pays de ses aïeux où il travaille comme photographe.

Mark Leong collabore avec l'agence de presse Redux Pictures depuis quelques années et recueillit de nombreux prix et bourses, dont une bourse du National Endowment of the Arts aux Etats-Unis. Son œuvre fut l'objet de nombreuses publications et expositions, et son premier livre, *China Obscura*, fut publié en 2004.

Cette planche contact est extraite d'une session tirée dans le Shanxi, Chine, en 2005.

« Comme bien souvent en Chine, tout est arrivé par le biais du guanxi, un réseau d'amis, de connaissances et de membres de la famille. Mon ami Kai, cinéaste, a une amie, Julia, qui travaille dans le marketing et dont la grand-mère venait de décéder dans les campagnes du Shanxi. Kai devait aller filmer les funérailles et m'a demandé si je voulais venir prendre des photos. Nous sommes partis de Beijing et avons roulé plusieurs heures jusqu'au village de la grand-mère pour assister aux cérémonies qui devaient durer trois jours.

Dans la cour de la maison familiale, l'air était saturé d'encens et de nombreux voisins passaient rendre leurs hommages de la défunte. Il y avait des pétards et des offrandes de nourriture, les mélodies d'un groupe de musique claquaient et gémissaient dans l'air glacial du printemps. Julia avait revêtu la robe blanche traditionnelle du deuil et elle avait rejoint sa famille pour participer aux lamentations rituelles qui se produisaient à intervalles réguliers. La douleur que ressentait toute l'assemblée était sans aucun doute très sincère, mais je crois qu'après un certain temps, le froid et la fatigue ont aussi eu leur part dans leurs cris de lamentations.

Quand les batteries de nos appareils faiblissaient à cause de la température glacée, Kai et moi nous réfugiions dans une pièce attenante pour nous réchauffer les doigts et dégivrer notre matériel sur un poêle en fonte. A un moment, Julia nous rejoignit pour fumer une cigarette. Ces instants restent mes préférés. J'ai choisi une photo où on voit seulement la cigarette émerger de la capuche entre les doigts aux ongles vernis de Julia, allusion à une femme urbaine et moderne qui vient de perdre un lien de plus avec un long passé ancestral en train de s'évanouir. »

Mark Leong wuchs in Sunnyvale, Kalifornien, als chinesischer Amerikaner der fünften Generation auf. Nach dem Studiumabschluss von der Universität Harvard besuchte er China zum ersten Mal in den späten 1980er Jahren mit Hilfe eines Reisestipendiums. Er kehrte einige Jahre später als artist-in-residence an der Central Academz of Fine Arts in Beijing nach China zurück und lebt und fotografiert seiher im Land seiner Ur-ur-ur-Grosseltern.

Vor einigen Jahren trat Leong der Redux Pictures Foto-Agentur bei, und er hat einige Auszeichnungen und Stipendien gewonnen, einschlisslich eines vom National Endowment of the Arts. Sein Werk ist in verschiedenen internationalen Publikationen und Ausstellungen gezeigt worden und sein erstes Buch *China Obscura* kam im Jahr 2004 heraus.

Dieser Kontaktbogen ist von einer Fotoserie in Shanxi, China, von 2005:

„Dieses Bild entstand, wie viele Dinge in China, durch guanxi – ein loses Netzwerk von Freunden, Bekannten und Familie. Mein Freund Kai, ein Filmproduzent, hatte eine Freundin Julia, eine Werbemangerin, deren Grossmutter im ländlichen Shanxi gerade gestorben war. Kai plante, das Begräbnis zu filmen und fragte mich, ob ich mitkommen wolle, um Fotos zu machen. Wir fuhren für ein paar Stunden raus von Bejing zum alten Dorfhaus der Grossmutter für die dreitäge Angelegenheit.

Der Hof war mit Weihrauch gefüllt und summte mit Nachbarn, die sich beim offenen Sarg verabschiedeten. Es gab Feuerwerke und Essen wurde angeboten. Eine Kapelle spielte Musik, die in der eisigen Luft des frühen Frühlings schallte und wimperte. Julia drapierte die traditionell weissen Umhänge über ihre Kleidung und gesellte sich zu ihrer Familie, die in rituellen Intervallen durch die viele Stunden weinten. Sie schienen wirklich traurig über den Tod der Grossmutter zu sein, aber nach einer Weile, denke ich, trugen auch die Kälte und die Erschöpfung zu den desolaten Ausrufen bei.

Als unsere Kamerabatterien wegen der Unterfrierungstemperaturen aufhörten zu funktionieren, rannten Kai und ich in einen der Nebenräume, um unsere Finger und Ausrüstung beim Gusseisen-Ofen aufzutauen. Bei einem dieser Male kam Julia mit, um eine Zigarette zu rauchen. Von all den Dingen, die vorgingen, war dieser stille Moment meine Lieblingsszene. Ich wählte das Bild, wo man nur die Zigarette sehen kann, wie sie von der Kapuze zwischen den lackierten Nägeln raussteckt, die Andeutung einer modernen, urbanen Frau, nachdem sie gerade noch eine Verbindung zu einer tiefen und verblühenden Ahnenvergangenheit verloren hat."

El fotógrafo chino-americano Mark Leong se crió en Sunnyvale, California, y visitó China por primera vez con un compañero de viaje a finales de los años 80 tras graduarse en la Universidad de Harvard. Regresó a China unos años después como artista residente de la Academia Central de Bellas Artes de Pekín y, desde entonces, ha vivido y fotografiado el país de sus antepasados.

Hace unos años, Leong se incorporó a la agencia de fotografía Redux Pictures y ha recibido varios premios y becas, incluida una de la fundación National Endowment of the Arts. Su trabajo se ha presentado en diversas publicaciones y exposiciones internacionales, y su primer libro, *China Obscura*, vio la luz en 2004.

Esta hoja de contactos corresponde a una sesión de fotos en Shanxi, China, en 2005.

"Todo esto surgió, como lo hacen muchas cosas en China, a través de guanxi, un especie de red de amigos, conocidos y familiares. Mi amigo Kai, un cineasta, tenía una amiga, Julia, ejecutiva de publicidad, cuya abuela había fallecido en Shanxi. Kai iba a filmar el funeral y me preguntó si querría acompañarle para tomar fotos. Condujimos varias horas desde Pekín a la casa de la aldea de su abuela para observar este acontecimiento de tres días de duración.

El patio estaba enturbiado por el incienso y el cuchicheo de los vecinos que venían a presentar sus respetos frente al ataúd abierto. Habia petardos y ofrendas de alimentos. Una banda de música irrumpió en canciones que resonaban y silbaban en el aire helado de principios de primavera. Julia cubrió su ropa con las tradicionales ropas de luto blanco y se unió a su familia, que estuvo llorando a intervalos rituales durante muchas horas. Parecían sentirse realmente afligidos acerca del fallecimiento de la abuela pero al cabo de un rato estoy seguro de que el frío y el cansancio también contribuyeron a sus desolados gritos.

Como las baterías de la cámara fallaban a temperaturas bajo cero, Kai y yo teníamos que ir constantemente a una de las salas laterales para descongelar el mecanismo y nuestras manos en una estufa de hierro. En una de esas ocasiones, Julia también vino a fumar un cigarrillo. De todo lo que estaba pasando, ese momento de tranquilidad acabó por convertirse en mi escena favorita. Elegi un fotograma donde se puede ver el cigarrillo sobresaliendo de la capucha entre sus uñas pintadas, insinuando la emergencia de una mujer urbana moderna, que acaba de perder una conexión más a un pasado profundo y ancestral desvaneciéndose".

Mark Leong

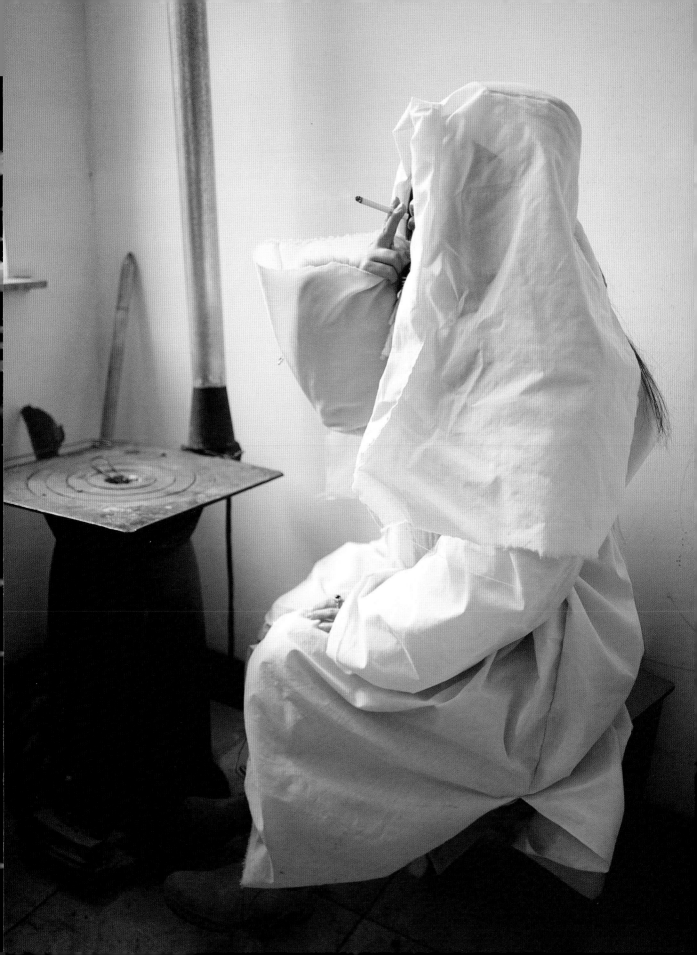

Born in Poland in 1944, Peter Lindbergh initially studied fine art, specifically painting, in Berlin and Krefeld. His interest in photography grew in the late 1970s, and after taking a position assisting a German photographer, he moved to Paris and quickly established himself as one of the most inventive fashion photographers of his generation.

Under contract with *Harper's Bazaar*, Lindbergh has worked with some of the biggest fashion houses and has had several traveling exhibitions of his work, including the retrospective *Images of Women*, which traveled extensively through international museums. His most recent publication is *Untitled 116*, which features 116 portraits of various women.

The models featured in Lindbergh's photography often play a prominent role, but equally important are the narrative and atmospheric quality of his images—through which each series tells a different story, often inspired by the cinema and ranging from the works of Fritz Lang to Jim Jarmusch.

This contact sheet was for a 2006 session for Italian *Vogue*, shot in downtown Los Angeles. The models are Olya Ivanisevic and Romina Lanaro.

"The idea of the story was born out of the fact that the Americans, as one of two countries, have not signed the Kyoto Treaty, which was about reducing industrial emission into the air. To joke about this pretty amazing fact, I was imaging how women would look, once you couldn't breathe the air on this planet anymore:

"'Following the refusal of the Bush Administration to sign the Kyoto Accord, the world will become a different place. It will be impossible, as it has been for hundreds of years, for women to show their beauty openly on the streets of the world's cities. But there will be a little window … which makes the difference!'"

Né en Pologne en 1944, Peter Lindbergh étudia les beaux-arts, et en particulier la peinture, à Berlin et Krefeld. Il développa un intérêt croissant pour la photographie à la fin des années 1970 et, après été l'assistant d'un photographe allemand, il s'installa à Paris où s'imposa très vite comme l'un des photographes de mode les plus créatifs de sa génération.

Sous contrat avec le magazine *Harper's Bazaar*, il travailla avec les plus illustres maisons de couture et son œuvre fit l'objet de nombreuses expositions itinérantes. La rétrospective *Images of Women* voyagea dans les plus grands musées du monde et sa dernière publication, *Untitled 116*, regroupe 116 portraits de femmes.

Le choix des mannequins joue un rôle prépondérant dans sa photographie, mais une place tout aussi déterminante est donnée à la qualité éthérée et le schéma narratif des images, dont chaque série raconte une histoire souvent inspirée des œuvres des maîtres du cinéma de Fritz Lang à Jim Jarmush.

Cette planche contact fut créée à Los Angeles lors d'une session réalisée pour la version italienne de *Vogue* en 2006. Les deux mannequins sont Olya Ivanisevic et Romina Lanaro.

« L'idée nous a été inspirée par le fait que les Américains sont l'uns des deux pays à avoir refusé de signer le protocole de tokyo dont l'objectif est la réduction des émissions de gaz à effet de serre dans l'atmosphère. Pour prendre cette décision ahurissante sur le ton de la plaisanterie, j'ai essayé d'imaginer quel serait le look des femmes quand l'air deviendrait irrespirable sur cette planète :

« Le monde sera différent après le refus de l'administration Bush de signer le protocole de Kyoto. Il deviendra impossible pour les femmes d'afficher leur beauté ouvertement dans la rue, comme elles ont pu le faire pendant des siècles. Mais une petite fenêtre existera toujours, et c'est ce qui fait toute la différence ! »

Peter Lindbergh, geboren in Polen in 1944, studierte zunächst Kunst, speziell Malerei, in Berlin und Krefeld. Sein Interesse an der Fotografie wuchs in den späten 1970er Jahren, und nachdem er eine Stelle als Assistent für einen deutschen Fotografen angenommen hatte, zog er nach Paris und etablierte sich schnell selbst als einer der einfallsreichsten Modefotografen seiner Generation.

Unter Vertrag mit *Harper's Bazaar* arbeitete er mit einigen der grössten Modehäuser, und hat mehrere Wanderausstellungen seines Werks gehabt, inklusive die Retrospektive *Images of Women*, die ausgiebig durch internationale Museen wanderte. Seine neueste Veröffentlichung ist *Untitled 116*, die 116 Porträts von verschiedenen Frauen zeigt.

Die in Lindberghs Fotografie abgebildeten Modelle spielen oft eine prominente Rolle, aber genauso wichtig ist die narrative und stimmungsvolle Qualität seiner Bilder – durch welche jede Serie eine andere Geschichte erzählt, oft inspiriert vom Kino, von den Werken von Fritz Lang zu Jim Jarmusch reichend.

Dieser Kontaktbogen war für eine 2006 Session für die italienische *Vogue*, fotografiert in Downtown Los Angeles. Die Modelle sind Olya Ivanisevic und Romina Lanaro.

„Die Idee der Geschichte entstand aus dem Fakt, dass die Amerikaner, als eines von zwei Ländern, nicht das Kyoto-Abkommen, das von der Reduzierung von industriellen Abgasen in die Luft handelte, unterzeichnet haben. Um über diese ziemlich erstaunliche tatsache einen Scherz zu machen, stellte ich mir vor, wie Frauen aussehen würden, sobald man die Luft auf diesem Planet nicht mehr atmen könnte:

„Nach der Weigerung der Bush-Administration das Kyoto-Abkommen zu unterzeichnen, wird die Welt eine andere werden. Es wird unmöglich sein, was für hunderte von Jahren möglich war, für Frauen ihre Schönheit offen auf den Strassen der Weltstädte zu zeigen. Aber es wird ein kleines Fenster geben … was den Unterschied macht!"

Nacido en Polonia en 1944, Peter Lindbergh estudió inicialmente bellas artes, más concretamente pintura, en Berlin y Krefeld. Su interés por la fotografía creció a finales de la década de 1970, y después de trabajar como asistente de un fotógrafo alemán se trasladó a París donde se estableció rápidamente como una de los fotógrafos de moda más imaginativos de su generación.

Contratado por *Harper's Bazaar*, trabajó con algunas de las casas de moda más importantes, y se han realizado varias exposiciones itinerantes de su trabajo, entre las que se incluye la retrospectiva *Images of Women* que ha viajado ampliamente por museos internacionales. Su publicación más reciente es *Untitled 116*, que incluye 116 retratos de diferentes mujeres.

La modelos que aparecen en la fotografía de Lindbergh suelen tener un papel destacado, pero igual importancia tienen la narrativa y la calidad atmosférica de sus imágenes, a través de las cuales cada serie cuenta una historia diferente inspirada con frecuencia por el cine, desde trabajos de Fritz Lang a Jim Jarmusch.

Esta hoja de contactos fue para una sesión de 2006 para el *Vogue* italiano, realizada en el centro de Los Ángeles. Las modelos son Olya Ivanisevic y Romina Lanaro.

"La idea de la historia surgió del hecho de que Estados Unidos, uno de los dos países que no lo hicieron, no ratificara el protocolo de Kioto que trata sobre la reducción de las emisiones industriales a la atmósfera. Para bromear sobre este hecho increíble imaginé el aspecto que tendrían las mujeres una vez que ya no pudiéramos respirar el aire de este planeta:

'Tras el rechazo de la administración Bush de firmar el protocolo de Kioto, el mundo se convertirá en un lugar diferente. Será imposible, como lo ha sido durante cientos de años, que las mujeres muestren su belleza abiertamente en las calles de las ciudades del mundo. Pero habrá una pequeña ventana … y eso marca la diferencia.'"

Peter Lindbergh

Philadelphia-born Steve McCurry worked as a photojournalist for a newspaper before leaving for India to pursue freelance photography. His time in India proved to be invaluable, as it began a career that would soon take him across the world, photographing some of the biggest international and civil conflicts. McCurry's color photography crosses boundaries and cultures to truly capture a shared human experience.

McCurry spent thirty years covering Afghanistan, where one of his most iconic images was created—the haunting photograph of the Afghan refugee girl that was published on the cover of *National Geographic*. The image is arguably one of the most recognizable photographs in the world. Almost two decades later, McCurry set out to Afghanistan to find the nameless girl and was able to locate the now-grown woman and her family.

This series of images was taken in Jaisalmer, India, in 1983.

"I was in an old taxi going through the desert in Rajasthan headed for Jaisalmer on the India/Pakistan border. I was working on an assignment about the monsoon. It was in June and was one of the hottest days I can remember. There had been a drought in that part of the country for thirteen years, and as we drove along, we noticed a dust storm start to grow.

"The weather instantly changed from being sunny and clear to dark and dusty with a very strong wind. It was hard to breathe and difficult to see through the wall of dust, which was moving like a tidal wave, which sounded like a deafening roar. The light turned a dark orange color and the temperature suddenly dropped.

"My first instinct was to try to protect my camera from the swirling dust. But then I realized that I could always buy a new camera, but the opportunity to shoot this group of women was priceless. I grabbed my camera and ran across the field and squeezed off a few shots. I was there less than ten minutes. They were huddled together for protection and were praying and singing songs."

Né à Philadelphie, Steve McCurry travailla comme photographe pour un journal avant de partir en Inde poursuivre une carrière de photographe indépendant. Ce séjour s'avéra être déterminant pour McCurry et lança une carrière qui devait le mener à sillonner le monde et à couvrir les zones de conflits internationaux ou civils les plus intenses. Sa photographie couleur transcende les frontières et les cultures pour capturer une expérience humaine commune.

Steve McCurry passa trente ans à couvrir l'Afghanistan où il réalisa son portrait le plus emblématique – le portrait poignant de la jeune réfugiée afghane qui illustra la couverture du *National Geographic*. Ce cliché est sans doute le plus connu à travers le monde. Presque deux décennies plus tard, McCurry retourna en Afghanistan pour retrouver la jeune fille anonyme et la rencontra en compagnie de sa famille.

Cette série d'images fut prise en 1983 à Jaisalmer, en Inde.

« Je traversais le désert du Rajasthan dans un vieux taxi en direction de Jaisalmer sur la frontière entre l'Inde et le Pakistan. Je travaillais sur un reportage avec pour sujet la mousson. Nous étions au mois de juin et c'était une des journées les plus chaudes dont je me souviens. La sécheresse avait sévi pendant les treize dernières années dans cette région et on voyait sur l'horizon qu'une tempête de poussière se déclarait.

Le temps a changé en un instant et le ciel clair et ensoleillé a fait place à de gros nuages noirs portés par un vent chargé de poussière. Il était devenu difficile de respirer et de voir à travers le rideau de poussière qui se déplaçait comme un raz de marée dans un vacarme assourdissant. La lumière a pris une teinte orange foncé et la température a baissé soudainement.

Ma première réaction a été de protéger mon appareil de la poussière, mais j'ai pensé que je pourrais toujours en acheter un autre, alors que l'occasion de photographier ce groupe de femmes ne se présenterait plus. J'ai attrapé mon appareil et j'ai traversé le champ en courant pour prendre quelques clichés. Ça m'a prit moins de dix minutes. Les femmes étaient blotties les unes contre les autres pour se protéger, elles chantaient et psalmodiaient des prières. »

Steve McCurry, geboren in Philadelphia, arbeitete als Fotojournalist für eine Zeitung, bevor er nach Indien ging, um freischaffende Fotografie zu betreiben. Seine Zeit in Indien bewies sich als unschätzbar für McCurry, da sie eine Karriere begann, die ihn bald über die ganze Welt führen würde, wo er einige der grössten internationalen und zivilen Konflikte fotografieren würde. McCurrys Farbfotografie überschreitet Grenzen und Kulturen, um ein geteiltes menschliche Erlebnis wahrhaftig festzuhalten.

McCurry verbrachte dreissig Jahre damit, über Afghanistan zu berichten, wo eines von McCurrys ikonischsten Bilder erzeugt wurde – das tief bewegende Foto eines afghanischen Flüchtlingsmädchen, das auf der Titelseite von *National Geographic* veröffentlicht wurde. Das Bild ist wohl eines der am meist erkennbaren Fotos der Welt. Fast zwei Dekaden später machte McCurry sich auf den Weg, um das namenlose Mädchen zu finden, und es war ihm möglich, die nun erwachsene Frau und ihre Familie zu lokalisieren.

Diese Reihe von Bildern wurde in Jaisalmer, Indien, in 1983, aufgenommen:

„Ich fuhr in einem alten Taxi durch die Wüste in Rhajastan in Richtung nach Jaisalmer and der Grenze von Indien-Pakistan. Ich arbeitete an einem Auftrag über den Monsun. Es war im Juni und einer der heissesten Tage, an die ich mich erinnern kann. Es hatte in diesem Teil des Landes für dreizehn Jahre eine Dürre gegeben, und als wir durchfuhren, bemerkten wir eine Staubwolke, die zu wachsen begann.

Das Wetter änderte sich sofort von sonnig und klar zu dunkel und staubig mit einem sehr starken Wind. Es war schwierig zu atmen und schwierig, durch die Wand von Staub, die sich wie eine Flutwelle bewegte, was wie ein ohrbetäubender Lärm lautete, zu sehen. Das Licht wurde dunkelorangefarbig, und die Temperatur fiel plötzlich nach unten.

Mein erster Instinkt war zu versuchen, meine Kamera vor dem herumwirbelnden Staub zu beschützen, aber dann sah ich ein, dass ich immer eine neue Kamera kaufen könnte, aber die Möglichkeit diese Gruppe von Frauen zu fotografieren, war unbezahlbar. Ich schnappte meine Kamera und rannte über das Feld und drückte ein paar Fotos ab. Ich war in weniger als zehn Minuten dort. Sie waren zum Schutz zusammengedrängt, und sie beteten und sangen Lieder."

Nacido en Filadelfia, Steve McCurry trabajó como periodista gráfico en un periódico antes de partir hacia la India para dedicarse a la fotografía freelance. El tiempo pasado en la India demostró ser de un valor incalculable para McCurry, ya que iniciaría una carrera que pronto le llevaría a fotografiar algunos de los mayores conflictos civiles e internacionales. La fotografía en color de McCurry cruza fronteras y culturas para capturar de verdad una experiencia humana compartida.

McCurry pasó treinta años cubriendo Afganistán, lugar donde se creó una de las imágenes más representativas icónicas de McCurry, la cautivadora fotografía de la niña refugiada afgana publicada en la portada del *National Geographic*. La imagen es indiscutiblemente una de las fotografías más reconocibles del mundo. Prácticamente dos décadas más tarde, McCurry partió hacia Afganistán para buscar a la chica sin nombre, y pudo localizar a una mujer adulta y a su familia.

Esta serie de imágenes se tomó en Jaisalmer, la India en 1983.

"Iba en un taxi viejo atravesando el desierto de Rajastán en dirección a Jaisalmer en la frontera de la India/Pakistán. Estaba trabajando en un encargo sobre el monzón. Era el mes de junio y uno de los días más calurosos que recuerdo. Había habido sequía en esa parte del país durante trece años y mientras avanzábamos en el coche observamos cómo comenzaba a formarse una tormenta de arena.

El tiempo cambió al instante y pasó de soleado a oscuro y polvoriento con un viento muy intenso. Resultaba difícil respirar y complicado ver a través de la pared de polvo que se movía como si de una ola se tratase y que sonaba con un rugido ensordecedor. La luz se volvió de un color naranja oscuro y la temperatura descendió repentinamente.

Mi primer instinto fue tratar de proteger la cámara del remolino de polvo, pero después me di cuenta de que siempre tendría la posibilidad de comprar una cámara nueva, pero la oportunidad de captar a este grupo de mujeres no tenía precio, Agarré la cámara y atravesé el campo y pude sacar unas cuantas fotos. Estuve allí menos de diez minutos. Se habían agrupado para protegerse y estaban rezando y cantando".

Steve McCurry

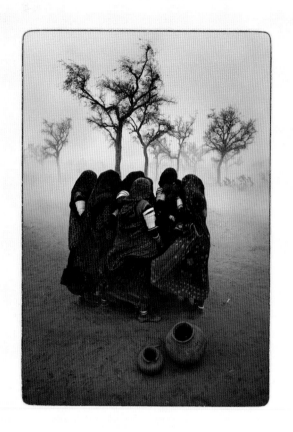

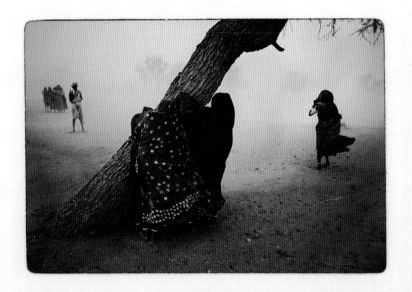

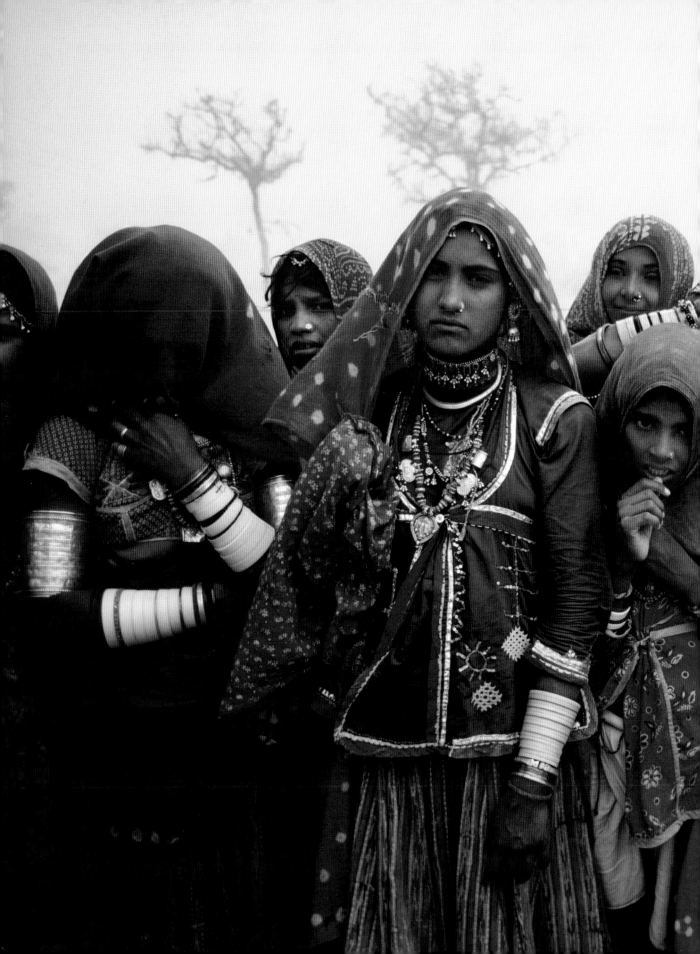

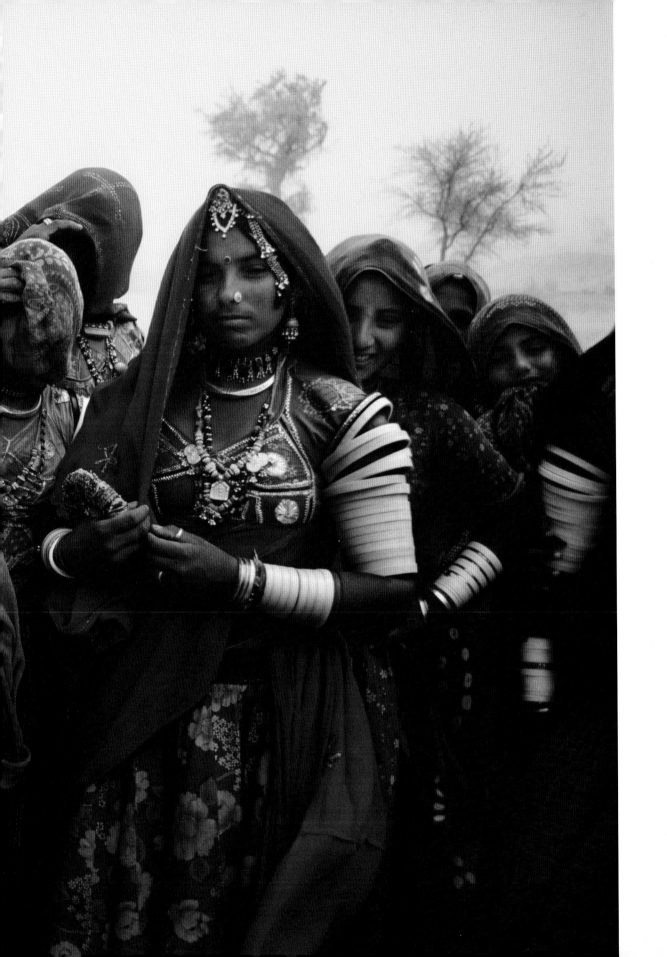

Jerry McMillan left his native Oklahoma to trek off to California with Ed Ruscha in the late 1950s. Ruscha had been attending the Chouinard Art Institute in Los Angeles for a year, and McMillan decided to enroll there as well. While at Chouinard, McMillan studied fine art and learned the basic fundamentals of photography from one of his roommates, Patrick Blackwell (another fellow Chouinard student and Oklahoma transplant).

"We had a dark room, and [Blackwell] was a very good photographer, and so I just kind of learned it from him and by trial and error. The wonderful thing about it was that I could go out and shoot, walk into the house, develop film, and make a print in hours. It was really easy."

Throughout the '60s and '70s, McMillan worked as a commercial photographer and designer in advertising, before leaving that world behind to focus on his own work and to teach.

The featured contact sheet is of McMillan's childhood friend Ruscha, posing with two models. Ruscha asked McMillan to make this image for a full-page ad in *Artforum* magazine in 1967. Titled "Ed Ruscha Says Goodbye to College Joys," it ran as a wedding announcement of sorts.

"We started out with three girls, and it just looked too awkward. It wouldn't really work out well as a photograph. So we eliminated one model and then went on with two girls, and just started shooting and tried different ideas.

"We shot this at Nancy Ames's house. She was the girlfriend of Mason Williams and was an actress, singer, and songwriter on a television program called *The Week That Was*. Mason was one of the writers, and they wrote the theme song for the show together. I'm going to assume that Ed had visited their home, as Mason was one of Ed's oldest friends from Oklahoma, and had seen the bed and selected the location.

"It became a very well-known photograph and really got a lot of attention because I believe that it probably was the first time an artist had actually advertised himself in an art magazine. I believe that Ed had traded a drawing for the [ad] space."

Jerry McMillan quitta son Oklahoma natal à la fin des années 1950 pour rejoindre Ed Ruscha en Californie. Ruscha suivait des cours au Chouinard Art Institute de Los Angeles depuis un an quand McMillan décida de s'inscrire aussi dans cette école. Il y étudia les beaux arts et acquit les techniques fondamentales de la photographie grâce à son ami Patrick Blackwell – également étudiant à Chouinard et originaire de l'Oklahoma.

« Nous avions une chambre noire et [Blackwell] était très bon photographe, j'ai donc simplement appris à son contact par une méthode d'essais et erreurs. C'était fabuleux de pouvoir sortir prendre des photos, rentrer à la maison, développer le négatif et créer les épreuves en l'espace de quelques heures. C'était vraiment facile. »

Dans les années 1960 et 1970, Jerry McMillan exerça des activités de photographe commercial et de dessinateur publicitaire avant de s'en détourner définitivement pour enseigner et se consacrer à ses propres projets.

Sur cette planche contact, Jerry McMillan fit poser son ami d'enfance Ed Ruscha en compagnie de deux modèles. Ed Ruscha lui avait demandé de réaliser cette photographie pour une annonce pleine page à paraître dans le magazine *Artforum* en 1967. Intitulée « Ed Ruscha Says Goodbye to College Joys », c'était une sorte de faire-part de mariage.

« On a commencé avec trois filles et on a obtenu un résultat un peu étrange qui ne donnait pas une bonne photo. On a supprimé un des modèles et on a continué la séance avec deux filles en essayant différentes idées.

La séance se passait chez Nancy Ames. C'était la petite amie de Mason Williams et elle travaillait comme actrice, compositeur et interprète pour un programme de télévision appelé *The Week That Was*. Mason était l'un des auteurs et ils composèrent ensemble la chanson thème de l'émission. Comme Mason venait aussi de l'Oklahoma et était l'un des plus vieux amis d'Ed, je pense qu'Ed connaissait déjà la maison, qu'il avait vu le lit et sélectionné le lieu.

Ce cliché attira énormément d'attention et devint très célèbre car je pense que c'était la première fois qu'un artiste assurait sa propre publicité dans un magazine d'art. Je crois qu'Ed avait obtenu l'espace publicitaire en échange d'un dessin. »

Jerry McMillan verliess sein einheimisches Oklahoma, um mit Ed Ruscha in den späten 1959ern nach Kalifornien zu trekken. Ruscha hatte das Chouinard Art Institute in Los Angeles für ein Jahr besucht, und McMillan beschloss, sich auch einzuschreiben. Während der Zeit bei Chouinard studierte McMillan Fine Art und die Grundfundamente der Fotografie durch einen seiner Zimmerkollegen, Patrick Blackwell (noch ein Chouinard Student und Oklahoma-Verpflanzter).

„Wir hatten eine Dunkelkammer und [Blackwell] war ein sehr guter Fotograf und so lernte ich irgendwie von ihm und durchs Ausprobieren. Die wundervolle Sache daran war, dass ich rausgehen und Fotos machen konnte, ins Haus zurück gehen konnte, den Film entwickeln und Ausdrücke in ein paar Stunden machen konnte. Es war wirklich einfach."

Während der sechziger und siebziger Jahre arbeitete McMillan als kommerzieller Fotograf und Designer in der Werbung, bevor er diese Welt permanent hinter sich liess, um sich auf sein eigenes Werk zu konzentrieren, und zu unterrichten.

Der abgebildetete Kontaktbogen ist von McMillans Kindheitsfreund Ruscha, der mit zwei Modellen posierte. Ruscha fragte McMillan in 1967, dieses Bild für eine ganzseitige Anzeige in der Zeitschrift *Artforum* zu machen. Betitelt „Ed Ruscha Says Goodbye to College Joys", lief die Anzeige als eine Art Heiratsannonce.

„Wir begannen mit drei Mädchen und es sah zu peinlich aus. Es würde nicht wirklich zu gut als Foto funktionieren. So eliminierten wir ein Modell, und dann machten wir mit zwei Mädchen weiter, und filmten und versuchten verschiedene Ideen.

Wir schossen das in Nancy Ames' house. Sie war die Freundin von Mason Williams und war eine Schauspielerin, Sängerin, und Liedermacherin für eine Fernsehserie, betitelt *The Week That Was*. Mason war einer der Schreiber, und sie schrieben gemeinsam das Titellied für die Show. Ich nehme an, dass Ed ihr Zuhause besucht hatte, da Mason einer von Eds ältesten Freunde von Oklahoma war, und das Bett gesehen und die Lokalität ausgesucht hatte.

Es wurde zu einem sehr gutbekannten Foto und es bekam wirklich viel Aufmerksamkeit, da ich glaube, dass dies wahrscheinlich das erste Mal war, dass ein Künstler sich selbst in einem Kunstmagazin inseriert hatte. Ich glaube, dass Ed eine Zeichnung für die Anzeigeseite gehandelt hatte."

Jerry McMillan abandonó su Oklahoma natal para viajar por carretera hasta California con Ed Ruscha a finales de la década de 1950. Ruscha había asistido al Chouinard Art Institute en Los Ángeles durante un año, así que McMillan decidió que también se matricularía. Mientras estuvo en Chouinard, McMillan estudió bellas ares y aprendió los aspectos básicos de la fotografía a través de uno de sus compañeros de habitación, Patrick Blackwell (otro estudiante de Chouinard procedente de Oklahoma).

"Teníamos una cámara oscura y [Blackwell] era un fotógrafo muy bueno así que en cierto modo aprendí gracias a él y por ensayo y error. Lo maravilloso era que podía salir y hacer fotos, volver a la casa, revelar la película y tener una impresión en unas horas. Era realmente fácil."

Durante los sesenta y los setenta, McMillan trabajó como diseñador y fotógrafo comercial en publicidad antes de abandonar ese mundo permanentemente para centrarse en su propio trabajo y en la enseñanza.

La hoja de contactos incluida es de Ruscha, amigo de la infancia de McMillan, posando con dos modelos. Ruscha pidió a McMillan que tomara esta imagen para un anuncio a toda página en la revista *Artforum* en 1967. Titulada "Ed Ruscha Says Goodbye to College Joys", era una especie de anuncio de boda.

"Empezamos con tres chicas y era una situación muy extraña. En realidad no funcionaría bien como fotografía. Así que eliminamos una modelo y continué con dos chicas, y comencé a disparar y a probar nuevas ideas.

hicimos las fotografías en casa de Nancy Ames. Era la novia de Mason Williams y era la actriz, cantante y compositora en un programa de televisión llamado *The Week That Was*. Mason era uno de los guionistas y escribieron juntos la sintonía del programa. Voy a asumir que Ed había visitado su casa, ya que Mason era uno de los amigos más antiguos de Ed de Oklahoma, y había visto la cama y había seleccionado el sitio.

Se convirtió en una fotografía muy conocida y recibió mucha atención pero creo que quizás se trataba de la primera vez que un artista se había anunciado a sí mismo en una revista de arte. Creo que Ed había entregado un dibujo a cambio del espacio [del anuncio]".

Jerry McMillan

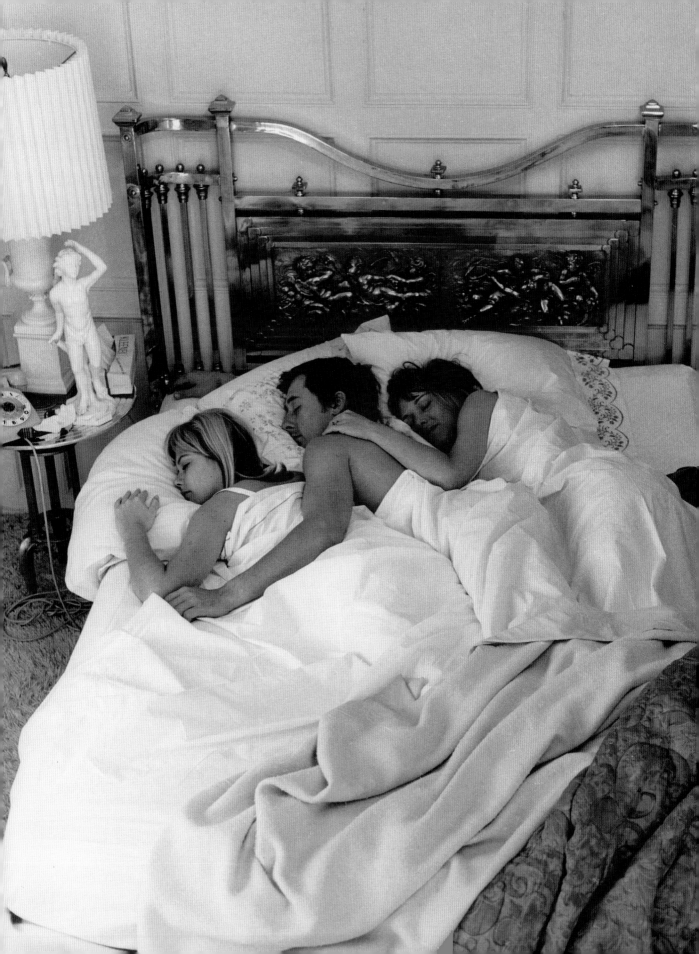

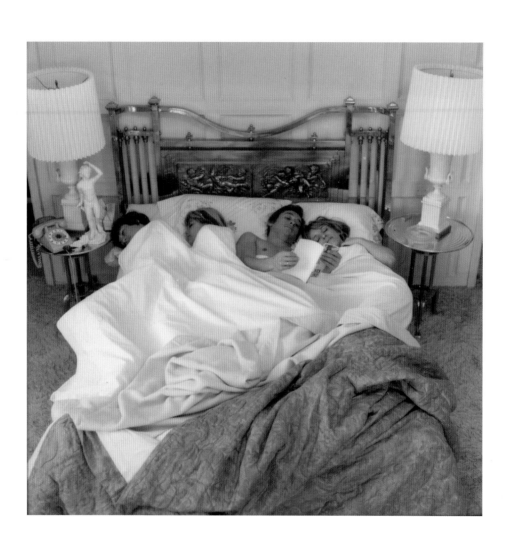

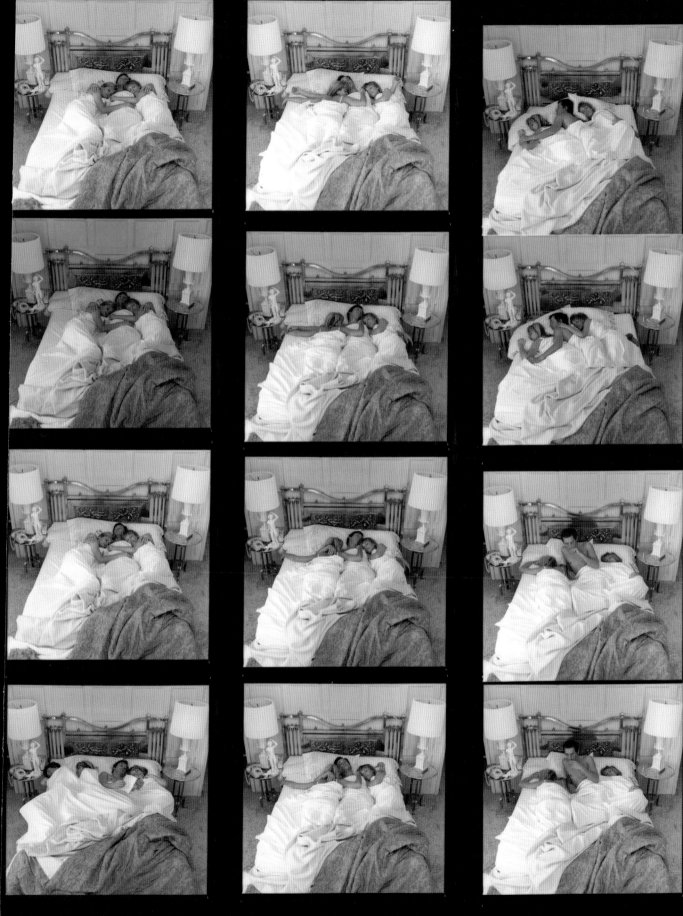

Born in New York in 1938, Joel Meyerowitz began photographing in the early 1960s and is a street photographer in the tradition of Henri Cartier-Bresson and Robert Frank. As an early advocate of color photography in the mid-'60s, Meyerowitz was instrumental in changing the attitude toward the use of color photography from one of resistance to nearly universal acceptance.

Within a few days of the September 11, 2001, attacks on the World Trade Center in New York, Meyerowitz began to create an archive of the destruction and recovery at Ground Zero and in the immediate neighborhood. The World Trade Center Archive consists of more than eight thousand images and was created with the sponsorship of the Museum of the City of New York, to which a set of digital files was donated for its archives and for exhibition. The Archive is a historic photographic record of the immediate and evolving aftermath of the tragedy and a documentation of the neighborhood's devastation.

Meyerowitz has recently completed the ambitious project of documenting and creating an archive of New York City's twenty-nine thousand acres of parkland. It is the first long-term visual documentation of NYC parks since the 1930s, when they were photographed as part of Franklin Roosevelt's WPA program. The comprehensive database will be available for future use by the Department of Parks & Recreation and communities from all five New York City boroughs.

"The roll of film was shot in 1968 in New York City, a few blocks from Chinatown. At that time, I had a show of work on view at MoMA in which all pictures were made from a moving car. It happens that on the day I made this photograph, I was driving my VW bus downtown, when alongside me this motorcyclist pulled up. I saw the crazy life-size doll she had made, and started shooting out the window. We traveled along together for a few blocks, and finally, at a stoplight, I made the picture you see here."

Né à New York City en 1938, Joel Meyerowitz se lança dans la photographie au début des années 1960 et se présente comme un photographe de scènes de rue inscrit dans la tradition d'Henri Cartier-Bresson et de Robert Frank. Précurseur de l'utilisation de la couleur au milieu des années 1960, Meyerowitz créa une rupture qui transforma l'attitude réticente des photographes à l'usage de la couleur en une acceptation devenue quasi universelle.

Dans les jours qui ont suivi les attentats du 11 septembre au World Trade Center de New York, Meyerowitz commença la création d'une archive documentant la destruction et la reconstruction de Ground Zero et des quartiers limitrophes. La World Trade Center Archive rassemble aujourd'hui plus de 8 000 images et fut créée avec le parrainage du Museum of the City of New York qui reçut en donation une copie des fichiers numériques pour ses archives et collections. The Archive est un compte-rendu photographique de l'impact de la tragédie immédiatement après les attentats et de l'évolution du quartier.

Meyerowitz compléta récemment le projet ambitieux de documenter les 117 kilomètres carré de parcs de la ville de New York et d'en créer une archive. C'est la première documentation visuelle de grande ampleur réalisée sur les parcs de New York depuis les années 1930 quand ces parcs ont été photographiés dans le cadre du programme WPA (Work Projects Administration) initié par Franklin Roosevelt. Cette base de données exhaustive sera disponible pour le département des parcs et sera accessible aux communautés des cinq boroughs de la ville.

« Cette pellicule a été tirée en 1968 à New York, à quelques rue de Chinatown. Je venais juste de sortir d'une exposition au Musée d'Art Moderne dans laquelle toutes les photos avaient été prises à partir d'une voiture en mouvement. Le jour où j'ai fait cette photo, j'étais au volant de ma camionnette dans le sud de la ville quand une moto s'est rangée à côté de moi. J'ai vu cette poupée à taille humaine derrière la conductrice et j'ai commencé à prendre des photos à travers le pare-brise. On a roulé sur la distance de quelques rues l'un à côté de l'autre et finalement, à un feu rouge, j'ai pris le cliché que vous voyez là. »

Geboren in New York im Jahr 1938, Joel Meyerowitz begann in den frühen sechziger Jahren zu fotografieren, und ist ein Strassenfotograf in der Tradition von Henri Cartier-Bresson und Robert Frank. Als ein früher Advokat der Farbfotografie in der Mitte der sechziger Jahre Meyerowitz trug wesentlich dazu bei, die Haltung gegenüber dem Gebrauch von Farbfotografie von einer des Widerstands zu fast universeller Akzeptanz zu ändern.

Innerhalb weniger Tage nach den 9/11-Angriffen auf das World Trade Center in New York, begann Meyerowitz, ein Archiv der Zerstörung und des Wiederaufbaus vom Ground Zero und der nahen Umgebung aufzubauen. Das World Trade Center Archiv besteht aus über 8.000 Bildern und wurde mit einem Stipendium des Museums of the City of New York gestartet, welchem ein Set der digitalen Akten für deren Archive und Ausstellungen gespendet wurde. Das Archiv ist eine historische, fotografische Aufzeichnung der direkten Nachwirkungen der Tragödie und der Nachbarschaft und deren Enwicklung.

Meyerowitz hat vor kurzem das ambitiöse Projekt der Dokumentation und Archivierung von 29.000 Acker an Parkland von New York City abgeschlossen. Es ist die erste langfristige visuelle Dokumentation der Stadtpärke von New York seit den 1930er Jahren, als sie als Teil von Franklin Roosevelts WPA Programm fotografiert wurden. Die umfangreiche Dateibank wird den Parkabteilungen für den zukünftigen Gebrauch zugänglich sein, und um diese Bilder der Pärke mit Gemeinden aller fünf Boroughs zu teilen.

„Die Filmrolle wurde im Jahr 1969 in New York City ein paar Blocks von Chinatown geschossen. Zu dieser Zeit hatte ich eine Ausstellung im MoMA, in der alle Bilder von einem sich in Bewegung befindlichen Auto gemacht wurden. An dem Tag, an dem ich dieses Foto machte, war es so, dass ich mit meinem VW-Bus nach Richtung Downtown fuhr, als neben mir ein Motorradfahrerin heranfuhr. Ich sah diese verrückte lebensgrosse Puppe, die sie gemacht hatte, und fing an, sie aus dem Fenster aus zu fotografieren. Wir fuhren zusammen nebeneinander her für ein paar Blocks, und schliesslich nahm ich dieses Bild, dass man hier sehen kann, bei einem roten Licht, auf."

Nacido en Nueva York en 1938, Joel Meyerowitz empezó a fotografiar a principios de los años sesenta y es un fotógrafo de la calle en la tradición de Henri Cartier-Bresson y Robert Frank. Uno de los primeros partidarios de la fotografía en color a mediados de los sesenta, Meyerowitz contribuyó sobremanera al cambio de actitud hacia el uso de la fotografía en color desde la resistencia inicial hasta una aceptación prácticamente universal.

A los pocos días del atentado del 11 de septiembre contra el World Trade Center de Nueva York, Meyerowitz empezó a crear un archivo de la destrucción y recuperación de la "zona cero" y el barrio circundante. El archivo del World Trade Center comprende más de 8.000 imágenes, y se creó con el patrocinio del Museo de la Ciudad de Nueva York, a quien donó un juego de archivos digitales para sus registros y exposiciones. El archivo es una recopilación histórica en imágenes de las secuelas inmediatas de la tragedia y las consecuencias en el barrio según ocurrían.

Meyerowitz ha completado hace poco un ambicioso proyecto de documentación y creación de un archivo de las casi 12.000 hectáreas de jardines de la ciudad de Nueva York. Es la primera documentación visual a largo plazo de los parques de Nueva York desde la década de 1930 cuando se fotografiaron como parte del programa de obras públicas WPA de Franklin Roosevelt. Esta completa base de datos estará a disposición del servicio de parques, y las imágenes se compartirán con las comunidades de los cinco barrios.

"La película se disparó en 1968, en Nueva York, a unos pocos bloques del barrio chino (Chinatown). En esa época tenía una exposición en el MoMA en la que las fotos se habían realizado desde un automóvil en marcha. Un día tomé esta fotografía cuando iba conduciendo mi VW Bus hacia el centro; en un momento dado, una motociclista se detuvo a mi altura. Vi la extraña muñeca de tamaño natural que había hecho y empecé a tomar fotos desde la ventanilla. Avanzamos juntos varios bloques hasta que finalmente, en un semáforo, capturé esta imagen".

Joel Meyerowitz

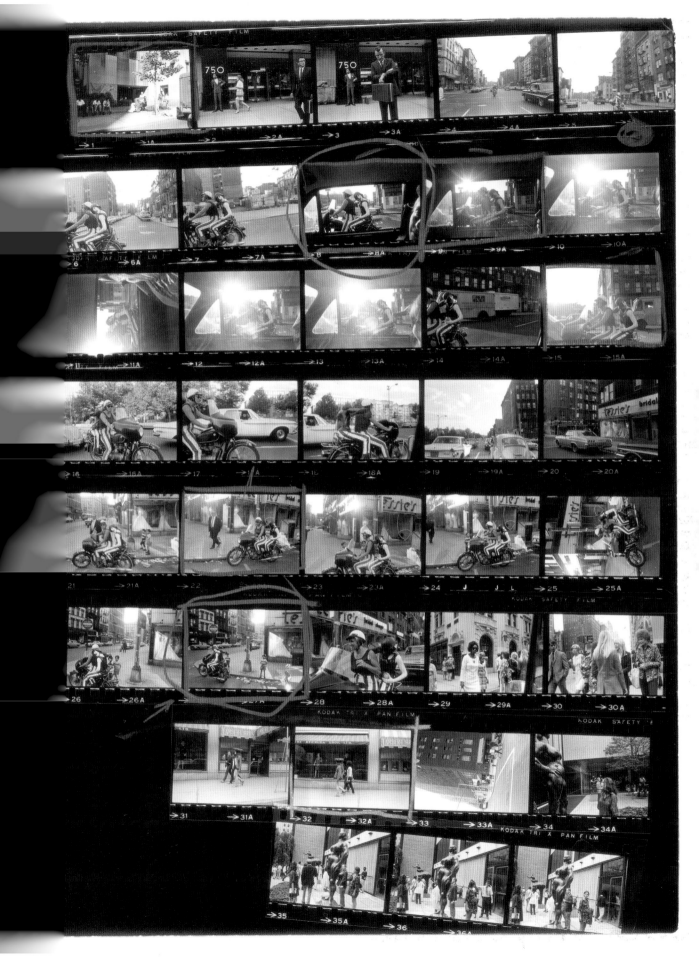

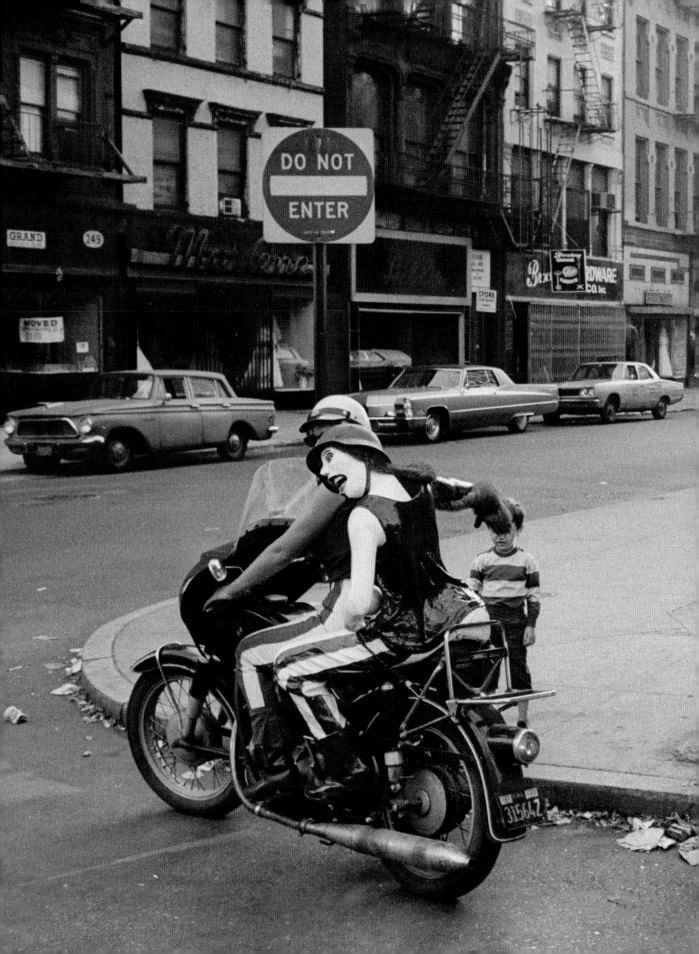

Richard Misrach has been a pioneer in contemporary photography since the 1970s, exploring the use of large-scale color prints and photography as a means of social criticism. Best known for his ongoing epic series, *Desert Cantos*, a multifaceted approach to the study of place and man's complex relationship to it, he has worked in the landscape for nearly forty years. Other series include his documentation of the industrial corridor along the Mississippi River known as *Cancer Alley*, the rigorous study of weather and time in his serial photographs of the Golden Gate, and an aerial examination of human interaction and isolation, *On the Beach*.

The contact sheet for "Desert Fire #153 (Man with Rifle)" was created in 1984.

"Working with an 8-by-10-inch camera presents infinite problems, not least of which is the expense of the film and its processing, and the cumbersome nature of handling a heavy view camera. Both of these elements inhibit the kind of spontaneous, rapid exposures of a small camera. Nonetheless, while working on my fire series (*Desert Canto III: The Fires, 1983–1985*), I found it necessary to move and shoot quickly. Because the smoke and fire were constantly shifting, I had to work the scene rapidly, much like a 35-millimeter photographer would do. One day on a burning field, I ran into two men who were targeting rabbits fleeing the fire. I knew that there was a picture to be made—two guys hanging out in this post-apocalyptic landscape—but it didn't come together until one lifted his rifle to point into the smoke. It appears that he is aiming at his buddy, but in fact, the two men are on different planes. (The one on the right is much closer to me.) But the photographic illusion is convincing enough. One guy is smiling at me while the other seems to be aiming at him with a deadly weapon. I took this shot at the peak of the Reagan cold war years, and I remember thinking: *Russia and the U.S. fooling around with nuclear weapons while Rome burns.* Not sure why that popped into my head—I know it doesn't make any sense—but it stuck. I was about to make a follow-up exposure, but as I was refocusing under the hood, the two men sprinted past me. I looked up to discover that the wind had changed direction and a wall of flames was coming at me. I clicked the shutter, picked up my camera, and started running after the two men."

Né à Los Angeles en 1949, Richard Misrach est un pionnier de la photographie contemporaine depuis les années 1970, explorant l'usage d'épreuves de grand format en couleur et utilisant la photographie pour aborder la critique sociale. Connu principalement pour son imposante série évolutive, *Desert Cantos*, Richard Misrach se consacre à la photographie de paysages depuis une quarantaine d'années. Il réalisa une série documentaire sur le corridor industriel de la vallée du Mississipi, connu sous le nom de *Cancer Alley* (l'Allée du Cancer), il créa une étude rigoureuse sur les effets des intempéries et du passage du temps dans sa série photographique sur le pont Golden Gate de San Francisco, et la série *On the Beach* rassemble des photographies aérienne dépeignant l'isolement et l'interaction entre les hommes.

La planche contact de « Desert Fire # 153 (Man with Rifle) » fut créée en 1984.

« Photographier avec un appareil 8 inches x 10 inches présente certaines contraintes, notamment le coût de la pellicule et du développement, et la manipulation d'un appareil assez lourd. Ces éléments ont tendance à inhiber le type de clichés rapides et spontanés qu'on peut prendre avec un petit appareil. Je travaillais sur la série d'incendies (*Desert Canto III : The Fires, 1983-1985*) quand j'ai pris conscience qu'il m'était nécessaire de me déplacer et de photographier rapidement. La fumée et le feu étaient en mouvement constant et je devais saisir la scène rapidement, un peu comme un photographe ferait avec un 35 mm. Un jour, dans un champ en flammes, je suis tombé sur deux hommes qui tiraient sur des lièvres en fuite. J'ai tout de suite vu qu'il y avait un cliché à prendre – deux types au milieu de ce paysage post-apocalyptique – mais la scène est devenue vraiment intéressante quand l'un des deux a levé son fusil pour le pointer vers la fumée. On a l'impression qu'il vise son ami, mais les deux hommes sont en fait sur des plans différents (celui placé sur la droite est bien plus proche de moi), l'illusion photographique est cependant assez convaincante. L'un des deux hommes me sourit pendant que l'autre semble le viser avec une arme mortelle. J'ai pris cette photo pendant les années Reagan au plus fort de la guerre froide et je me souviens avoir pensé : « *la Russie et les Etats-Unis s'amusent avec l'arme nucléaire pendant que Rome est en flamme.* » Je ne sais pas pourquoi cette pensée m'est venue – je sais que ça n'a pas de sens – mais ça m'est resté. J'allais faire une deuxième photo et j'étais en train d'ajuster le viseur quand les deux hommes sont passés en courant à côté de moi. J'ai levé les yeux et je me suis rendu compte que la direction du vent avait changé et qu'un mur de flammes avançait vers moi. J'ai refermé l'obturateur, j'ai remballé mon appareil et j'ai pris mes jambes à mon cou. »

Richard Misrach, geboren in Los Angeles in 1949, ist ein Pionier der gegenwärtigen Fotografie seit den 1970er Jahren. Er nutzt umfangreiche Farbdrucke und Fotografie als Mittel zur Sozialkritik. Misrach, am bekanntesten für seine laufende epische Serie, *Desert Cantos*, eine viel-seitige Annäherung zur Studie von Ort und der komplexen Beziehung von Mensch und Ort, hat für die letzten vierzig Jahre im Bereich Landschaft gearbeitet. Andere Serien beinhalten seine Dokumentierung des industriellen Korridors entlang des Mississippi Rivers bekannt als *Cancer Alley*, die rigoröse Studie von Wetter und Zeit in seinen seriellen Fotos von der Golden Gate Brücke, und eine Luftstudie von menschlichen Interaktionen und Isolation, *On the Beach*.

Der Kontaktbogen für „Desert Fire #153 (Mann mit Gewehr)" wurde 1984 erzeugt.

„Wenn man mit einer 8 x 10 Kamera arbeitet, präsentiert dies einen mit unzähligen Problemen, nicht das geringste davon sind die Filmkosten und die Filmentwicklung, und die lästige Art, mit einer schweren Grossbildkamera zu arbeiten. Beide diese Elemente verhindern die spontanen, schnellen Belichtungen einer kleinen Kamera. Dennoch, während ich an meiner Feuerserie (*Desert Canto III: The Fires, 1983-1985*) arbeitete, fand ich es notwendig, mich schnell zu bewegen und schnell zu fotografieren. Weil der Rauch und das Feuer sich konstant änderten, musste ich schnell arbeiten, so ähnlich wie ein 35mm Fotograf. Eines Tages auf einem brennenden Feld, rannte ich in zwei Männer, die die Hasen jagten, die vor dem Feuer flüchteten. Ich wusste, dass es da ein Foto zu machen gab – zwei Männer, die in dieser post-apokalyptischen Landschaft rumhängen – aber es passte nicht, bis einer der beiden sein Gewehr in die Höhe hob und in den Rauch richtete. Es scheint, als ob er auf seinen Kollegen zielt, aber in Wirklichkeit sind beide Männer auf verschiedenen Ebenen (der eine rechts ist viel näher zu mir). Aber die fotografische Illusion ist überzeugend genug. Einer lächelt mich an während der andere seine tödliche Waffe auf ihn gerichtet zu haben scheint. Ich machte diese Aufnahme zum Höhepunkt der Reagan/Cold War-Jahre und dachte: „*Russland und die Vereinigten Staaten spielen mit nuklearen Waffen herum, während Rom brennt.*" Ich bin mir nicht sicher, warum mir das einfiel – ich weiss, es macht keinen Sinn – aber es blieb hängen. Ich wollte noch eine Aufnahme machen, aber als ich unter der Haube am Wiedereinstellen war, rannten die beiden Männer an mir vorbei. Ich schaute hoch und entdeckte, dass der Wind sich gedreht hatte und eine Feuerwand auf mich zukam. Ich knipste die die Linse, nahm die Kamera auf, und begann, hinter den zwei Männern herzurennen."

Nacido en Los Ángeles en 1949, Richard Misrach ha sido un pionero en fotografía contemporánea desde los años 70, explorando el uso de impresiones en color a gran escala y de la fotografía como un medio de crítica social. Famoso por sus series épicas, *Desert Cantos*, un enfoque multidimensional al estudio de un lugar y la compleja relación del hombre con el mismo, ha trabajado con el paisaje durante casi cuarenta años. Otras series incluyen su documentación del corredor industrial a lo largo del río Mississippi conocido como *Cancer Alley*, el riguroso estudio del tiempo y el clima en su serie de fotografías del Golden Gate, y el examen aéreo de la interacción y el aislamiento humano en *On the Beach*.

La hoja de contactos de "Desert Fire #153 (Man with Rifle) se creó en 1984.

"Trabajar con una cámara de 8 x 10 pulgadas presenta problemas infinitos, uno de ellos, y nada desdeñable, es el gasto en películas y su procesamiento, y la naturaleza aparatosa de manipular una cámara muy pesada. Ambos elementos inhiben la clase de exposición rápida y espontánea de una cámara pequeña. No obstante, durante mi trabajo en la serie de incendios (*Desert Canto III: The Fires, 1983-1985*), me resultaba necesario moverme y disparar a toda velocidad. Como el humo y el fuego cambiaban de rumbo sin cesar, tenía que trabajar la escena con presteza, como lo haría un fotógrafo con una 35 mm. Un día en un campo quemado, me topé con dos hombres dando caza a los conejos que se escapaban del fuego. Supe que tenía que hacer una foto: dos tipos pasando el rato en este paisaje apocalíptico, pero la idea no cuajó hasta que uno de ellos levantó su rifle y apuntó hacia el humo. Parecía que estaba apuntando a su amigo, aunque, en realidad, los dos hombres están en planos diferentes (el de la derecha está mucho más cerca de mí). Pero la ilusión fotográfica es lo bastante convincente. Un tipo me sonríe mientras que el otro parece apuntarle con un arma letal. Tomé esta foto en el punto álgido de los años de la Guerra Fría de Reagan y recuerdo que pensé: *"Rusia y los Estados Unidos haciendo el tonto con armas nucleares mientras arde Roma"*. No estoy seguro de que porqué se me ocurrió esa idea – ya sé que no tiene sentido – pero ahí se quedó. Estaba a punto de hacer una exposición de seguimiento, pero, cuando estaba volviendo a enfocar debajo de la capucha, los dos hombres echaron a correr. Miré y vi que el viento había cambiado de dirección y que un muro de llamas venía hacia mí. Disparé el obturador, recogí la cámara y eché a correr detrás de ellos".

Richard Misrach

Joseph Mougel examines his own identity as a first-generation American, a former marine, and an artist, creating works that focus on his relationship to the military and the futility and repetition of one's existence within an apathetic institution. These ideas prompted an installation at Elsewhere Artist Collaborative in Greensboro, North Carolina, and videos shot while traveling with Land Arts of the American West. Mougel currently works with ideas of storytelling and political constructs of identity, utilizing media ranging from photography and video to interactive installation.

"I had never played Cowboys and Indians as a child, nor any games that supported the illusion of an absolute and just society. The contact sheet operates as a documentation of my attempt to play the game. My role as soldier quickly resulted in a lack of active participation, leaving the story to be told by the children. I was neither victim nor active player but rather a viewer forced to observe a scenario beyond my control.

"The location depicts an open field, reminiscent of the great prairies of the nineteenth-century Midwest. In fact, this is rural Georgia in the fall of 2004, behind the house of my sister, whose children play the roles of Cowboy and Indian. I was released from my bonds from time to time, and an assistant showed me Polaroid after Polaroid image. Given only a window of twenty minutes prior to sunset, I had to act fast and maintain the focus of my crew. To further complicate the production, I was utilizing the swings and tilts of the view camera to distort the scale of the scene, making it difficult to focus on two fidgety children. The happy accident came in the form of an ant on the foot of the little girl, resulting in an expression of futility and sorrow. The last reflection of the sun's rays on low-lying clouds to the west gave an extra five minutes of light, and the final images were taken with a self-timer and depict the end of the day and the shoot."

Joseph Mougel se penche sur sa propre identité d'Américain de la première génération, d'ancien membre des Marines et d'artiste ; il crée une œuvre qui met l'accent sur sa relation avec l'armée, sur la futilité et la répétition inhérentes à une vie passée dans le cadre d'une institution apathique. Ces concepts ont inspiré la création de l'installation du Elsewhere Artist Collaborative à Greensboro, en Caroline du Nord, ainsi que les vidéos réalisées lors d'un voyage avec Land Arts of the American West. Le travail de Joseph Mougel est aujourd'hui centré sur la narration et le développement politique de l'identité au moyen de médias aussi divers que la vidéo, la photographie ou les installations interactives.

« Je n'ai jamais joué aux cow-boys et aux indiens quand j'étais enfant, ni à aucun jeu qui reprend l'illusion d'une société absolue et juste. Cette planche contact constitue un moyen de documenter ma tentative de jouer le jeu. Mon rôle de soldat évolue vers une absence de participation active, l'histoire étant ensuite appropriée et racontée par les enfants. Je ne suis ni victime ni acteur, mais plutôt spectateur forcé d'un scénario hors de mon contrôle.

Le décor est un champ ouvert semblable aux grandes prairies du 19ième siècle dans le Midwest. Nous sommes en fait dans la Géorgie rurale de l'automne 2004, derrière la maison de ma sœur dont les enfants jouaient aux cow-boys et aux indiens. J'étais lié à un poteau et on me libérait de mes liens de temps en temps pour qu'un assistant puisse me montrer Polaroïd sur Polaroïd. Comme nous n'avions qu'un lapse de temps d'environ vingt minutes avant le coucher de soleil, je devais agir vite et garder mon équipe concentrée. Pour compliquer encore plus la production, j'utilisais les mouvements de l'appareil pour modifier l'échelle de grandeur de la scène et il était encore plus difficile de prendre les deux enfants en mouvement constant. Le déclic est venu quand une fourmi est montée sur le pied de la fillette qui prit alors une expression puérile et chagrinée. Les derniers reflets du couchant sur les nuages nous ont donné cinq minutes de lumière supplémentaires et les dernières images ont été prises avec un déclencheur à retardement, elles marquent la fin de la journée et de la séance photos. »

Mougel erforscht seine eigene Identität als erstgeborener Amerikaner, als ehemaliger Marineinfanterist, und als Künstler, in dem er Werke erschafft, die sich auf seine Beziehung zum Militär und die Wertlosigkeit und Wiederholung der eigenen Existenz in einer apathischen Institution konzentrieren. Diese Ideen führten zu einer Installation am Elsewhere Artist Collaborative in Greensboro, North Carolina, und zum Drehen von Videos, während er mit Land Arts of the American West reiste. Mougel arbeitet derzeit mit Ideen vom Geschichtenerzählen und politischen Konstruktionen von Identität, wobei er sich an Medien von Fotografie und Video bis zu interaktiven Installationen bedient.

„Ich habe als Kind nie Cowboys und Indianer gespielt, oder andere Spiele, die die Illusion einer absoluten und gerechten Gesellschaft unterstützen. Der Kontaktbogen funktioniert als Dokumentation meines Versuchs, das Spiel zu spielen. Meine Rolle als Soldat resultierte schnell in einem Fehlen von aktiver Teilnahme, was dazu führte, dass die Geschichte von den Kindern erzählt wird. Ich war weder Opfer noch aktiver Spielteilnehmer, aber eher ein Zuschauer, der gezwungen ist, ein Szenario ausserhalb seiner Kontrolle zu observieren.

Der Standort stellt ein offenes Feld dar, das an die grossen Prärien des neunzehnten Jahrhunderts im mittleren Westen erinnert. Tatsächlich handelt es sich um das ländliche Georgia im Herbst des Jahres 2004, hinter dem Haus meiner Schwester, deren Kinder das Rollenspiel Cowboy und Indianer spielen. Ich wurde von Zeit zu Zeit von meinen Fesseln befreit, und ein Assistent zeigte mir ein Polaroidbild nach dem anderen. Da ich nur einen Zeitrahmen von zwanzig Minuten bevor Sonnenuntergang hatte, musste ich schnell handeln, und den Fokus meiner Crew beibehalten. Was die Produktion noch mehr komplizierte, war die Tatsache, dass ich die Schaukeln und Kippen der Grossbildkamera benutzte, um den Maßstab der Szene zu verzerren, was es schwierig machte, auf zwei kleine zappelige Kinder zu fokussieren. Der glückliche Unfall passierte in Form einer Ameise auf dem Fuss des kleinen Mädchens, was einen Ausdruck von Wertlosigkeit und Trauer hervorbrachte. Die letzte Reflektion der Sonnenstrahlen auf den niedrig-liegenden Wolken im Westen gaben fünf Minuten extra Licht, und die endgültigen Bilder wurden mit einem Selbstauslöser genommen und beschreiben das Ende des Tages und des Filmshoot."

Mougel examina su propia identidad como estadounidense de primera generación, ex infante de Marina y artista, creando trabajos que se centran en su relación con lo militar y en la futilidad y repetición de la propia existencia dentro de una institución apática. Estas ideas impulsaron una instalación en el Elsewhere Artist Collaborative de Greensboro, Carolina del Norte, así como una serie de vídeos grabados durante sus viajes con el programa Land Arts of the American West. En la actualidad, Mougel trabaja con ideas para contar historias e interpretaciones políticas de la identidad, utilizando medios que abarcan desde la fotografía y el vídeo hasta instalaciones interactivas.

"Nunca jugué a indios y vaqueros de niño, ni a ningún juego que promoviese la ilusión de una sociedad justa y absoluta. La hoja de contactos sirve como documentación de mi intento de participar en ese juego. Mi papel como soldado se tradujo rápidamente en una falta de participación activa, dejando que la historia la contaran los niños. No era ni una víctima ni un jugador, más bien un observador forzado a examinar un escenario fuera de mi control.

La ubicación muestra un campo al aire libre que evoca las grandes praderas del siglo XIX en el medio oeste. De hecho, se trata de una zona rural de Georgia, en otoño de 2004, detrás de la casa de mi hermana, con sus hijos interpretando los papeles de india y vaquero. Me liberaban de mis ataduras de vez en cuando, y un ayudante me mostraba las imágenes Polaroid. Como sólo faltaban veinte minutos antes de la puesta del sol, tenía que actuar rápido y mantener a mi equipo concentrado. Para complicar aún más la producción, estaba utilizando los mecanismos de rotación y oscilación de la cámara para distorsionar la escala de la escena, lo que hacía difícil enfocar a dos niños inquietos. El feliz accidente se presentó en forma de una hormiga en el pie de la niña, resultando en una expresión de futilidad y tristeza. Los últimos reflejos de los rayos del sol en las nubes bajas hacia el oeste nos ofrecieron unos cinco minutos extra de luz, y las imágenes finales se tomaron con un temporizador automático y representan el final del día y la sesión de fotos".

Joseph Mougel

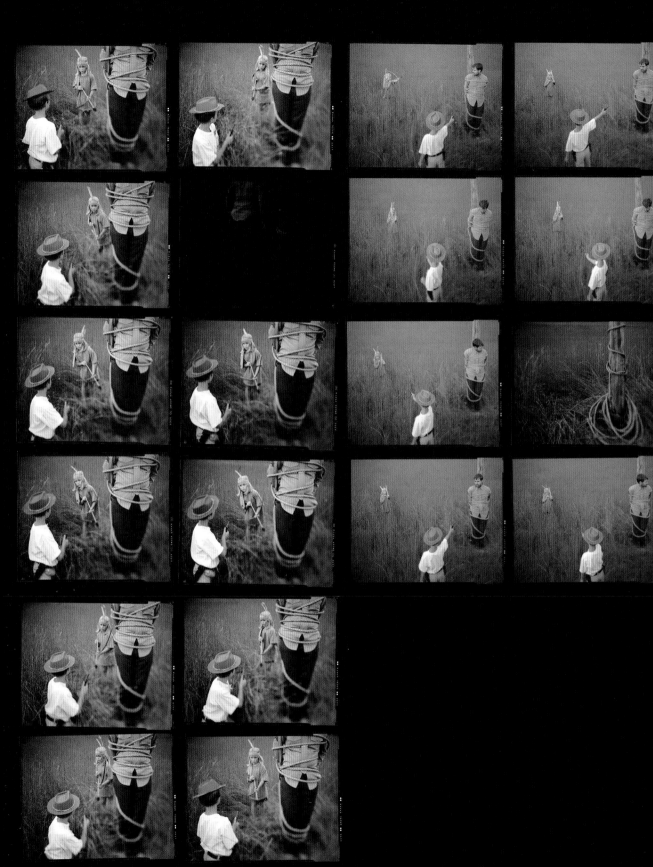

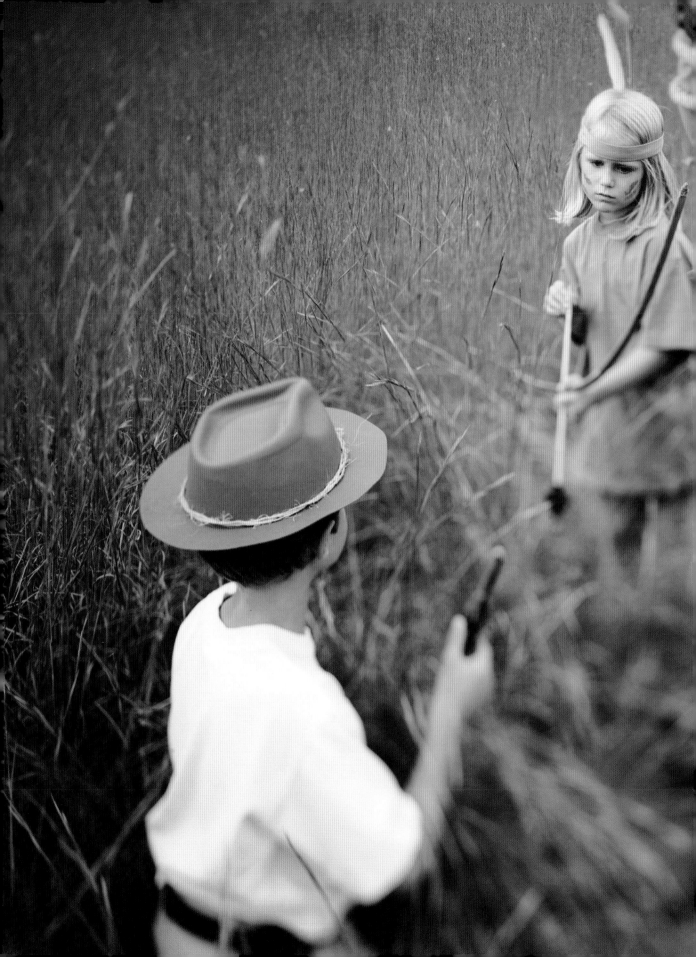

At a young age, Arnold Newman was encouraged by his family to pursue his artistic interests in drawing and painting. When his studies in college were cut short because of financial hardship, Newman moved to Philadelphia, where friends introduced him to photography. Working at a portrait studio, he learned photographic techniques by creating hundreds of forty-nine-cent portraits.

While in Philadelphia, Newman began creating his own work—drawn to other artists, abstracts, and street scenes as subject matter. Supported and encouraged by such photographers as Alfred Stieglitz and Beaumont Newhall, Newman eventually moved to New York City and began a career as a freelance magazine photographer. He also maintained his own studio and took private commissions.

In a career that spanned six decades, Newman created portraits of some of the world's most well known personalities—from movie stars and athletes to international political figures.

The featured contact sheet uses a style that many have credited to Arnold Newman: "environmental portraiture." Newman would place his subject in a carefully staged and controlled setting to represent the artist's professions and personalities. He would use various visual elements to capture the essence of both the person and their work. In this contact sheet created in 1974, the two subjects are Charles and Ray Eames. The Eameses were American designers famous for their iconic contributions to the fields of furniture design, architecture, industrial design, photography, and film. In true environmental portraiture fashion, Newman had posed them with one of their famous chairs in their office in Venice, California. In fact, Newman had an Eames chair at his very own studio, which many dubbed the "Eames Interview Chair."

"I began to take photographs of all these artists who were so important to me, and that was why I did that, besides doing other portraits. And I began to experiment, and to this day I remain involved in environmental portraiture, which to me, that was a natural step, it was an obvious step. … But it could be abstract; it could be surrealistic; it could be symbolic."

Dès son plus jeune âge, Arnold Newman fut encouragé par sa famille à poursuivre ses intérêts artistiques en dessin et en peinture.

A Philadelphie, il se lança dans ses premières expérimentations personnelles en photographie – prenant pour sujets des artistes, des abstractions et des scènes de rue. S'appuyant sur le soutien et les encouragements de photographes comme Alfred Stieglitz et Beaumont Newhall, Arnold Newman s'installa à New York et commença à collaborer avec des magazines en tant que photographe indépendant.

Au long d'une longue carrière qui s'étend sur plus de six décennies, il fut le photographe vedette des personnalités les plus renommées – des stars de cinéma aux athlètes en passant par les ténors de la politique internationale.

Cette planche contact est représentative du style de portraits dont Arnold Newman se fit pionnier, le « portrait environnemental ». Caractérisé par un espace parfaitement organisé et contrôlé, chaque portrait dépeint le domaine de prédilection et la personnalité du modèle. Divers éléments visuels sont présents pour capturer l'essence du rapport entre le modèle et son univers personnel. Charles et Ray Eames sont représentés sur cette planche contact créée en 1974. Ce couple de designers nous est célèbre pour sa contribution mythique aux domaines du design de mobilier, de l'architecture, du design industriel, de la photographie et du film. Dans la veine du portrait environnemental, les Eames posèrent ici aux côtés d'une de leurs célèbres chaises dans leur cabinet de Venice, en Californie. Arnold Newman possédait une chaise Eames dans son bureau, que beaucoup surnommait la Chaise d'Entrevue Eames. »

« J'ai commencé à réaliser les portraits des artistes qui m'étaient importants et je me suis lancé dans cette activité en parallèle à mon travail de portraitiste. J'ai commencé à expérimenter et je suis à ce jour encore impliqué dans la réalisation de portraits environnementaux, ce qui me semble être une étape naturelle et évidente. Les portraits pouvaient être abstraits, ils pouvaient être surréalistes, ils pouvaient être symboliques. »

Arnold Newman wurde von seiner Familie ermutigt, seinen künstlerischen Interessen am Zeichnen in der Malerei nachzugehen.

Während seiner Zeit in Philadelphia begann Newman sein eigenes Werk zu produzieren – er war zu anderen Künstlern, Abstrakten, und Strassenszenen als Sujets hingezogen. Unterstützt und ermutigt von anderen Fotografen wie Alfred Stieglitz und Beaumont Newhall, zog Newman nach New York City und begann eine Karriere als freischaffender Zeitschriftenfotograf.

In einer Karriere, die sechs Dekaden umspannte, kreierte Newman Porträts für einige der meistbekannten Persönlichkeiten der Welt – angefangen von Filmstars zu Athleten zu internationalen politischen Figuren.

Der abgebildete Kontaktbogen zeigt den Stil, den viele Arnold Newman zuschreiben: „environmental portraiture" – „umweltbezogene Porträtkunst". Newman plazierte sein Sujet in eine vorsichtig gestellte und kontrollierte Szene, um die Berufe und die Persönlichkeiten der Künstler zu repräsentieren. Er benutzte verschiedene visuelle Elemente um die Essenz sowohl der Person als auch von dessen Werk zu erfassen. In diesem Kontaktbogen vom Jahr 1974 sind die beiden Sujets Charles und Ray Eames. Die Eames waren amerikanische Designer, berühmt für ihre ikonischen Beiträge zu den Bereichen des Möbeldesigns, der Architektur, des industriellem Design, der Fotografie, und des Film. Im echten Stil der umweltbezogenen Porträtkunst posierte Newman sie mit einem ihrer berühmten Stühle in ihrem Büro in Venice, Kalifornien. Tatsächlich hatte Newman einen Eames Stuhl in seinem eigenen Studio, den viele den „Eames Interview Stuhl" tauften.

„Ich begann Fotos von all diesen Künstlern aufzunehmen, die für mich so wichtig waren, und das war, warum ich das tat, neben anderen Porträts. Und ich begann zu experimentieren, und bis zu diesem Tag bin ich mit umweltbezogener Porträtkunst involviert, was für mich ein natürlicher Schritt war, es war ein selbstverständlicher Schritt. … Aber es könnte abstrakt sein; es könnte surrealistisch sein; es könnte symbolisch sein."

Desde muy temprana edad, la familia de Arnold Newman le animó a perseguir sus ambiciones artísticas en dibujo y pintura.

Durante sus años en Filadelfia, Newman comenzó a crear su propia obra, atraído por otros artistas, escenas de la calle y abstractos como temática. Animado y alentado por fotógrafos de la talla de Alfred Stieglitz y Beaumont Newhall, Newman decidió mudarse a Nueva York y empezar una carrera como fotógrafo independiente para revistas.

En una trayectoria que abarca seis décadas, Newman ha elaborado retratos de abundantes personalidades de fama mundial, desde estrellas del cine a atletas o figuras políticas internacionales.

Esta hoja de contactos utiliza un estilo que muchos acreditan a Arnold Newman: el "retrato medioambiental". Newman colocaba a sus personajes en un entorno controlado y muy bien organizado que representase la profesión y la personalidad del artista. Usaba diversos elementos visuales para capturar la esencia de la persona y su trabajo. En esta hoja de contactos creada en 1974, las dos personas son Charles y Ray Eames. Los Eames eran diseñadores norteamericanos famosos por sus contribuciones icónicas a los campos del diseño de muebles, arquitectura, diseño industrial, fotografía y cine. Siguiendo el más puro dictado del retrato medioambiental, Newman los hace posar con una de sus famosas sillas en su oficina de Venice, California. De hecho, Newman tenía una silla de Eames en su propio estudio, que podría llamarse la "Silla Eames para Entrevistas".

"Empecé a tomar fotografías de todos los artistas que eran importantes para mí, por eso lo hacía, además de realizar otros retratos. Comencé a experimentar, y hasta el día de hoy me he mantenido involucrado en el mundo del retrato, lo que resulta un paso natural en mi caso, un paso obvio. … Pero podría ser el arte abstracto; podría ser el surrealismo; podría ser el arte simbólico".

Arnold Newman

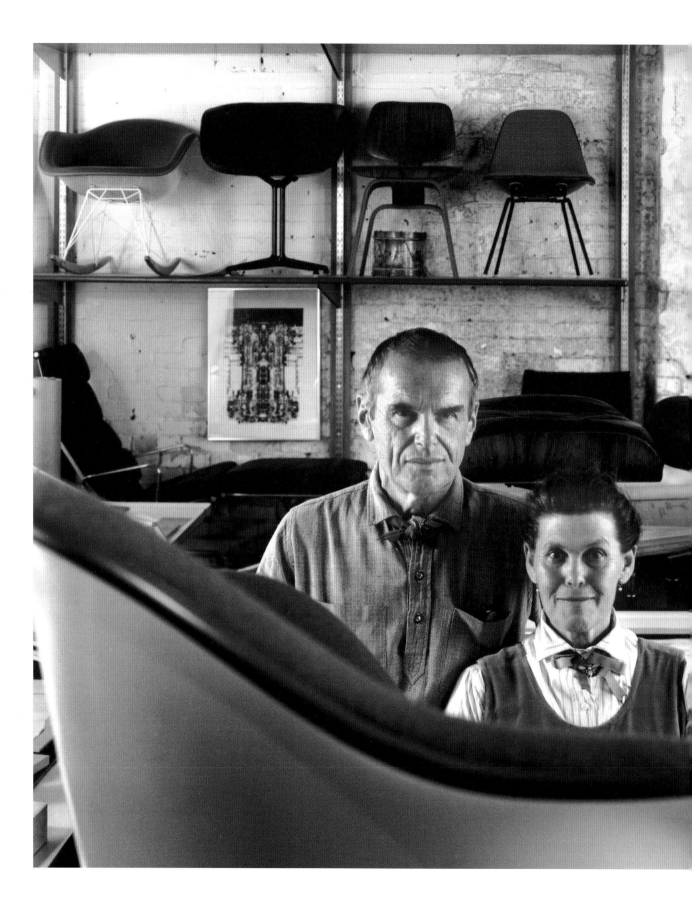

Paul Outerbridge Jr. was an early American modernist photographer who began a successful career as an artist and advertising photographer in New York in the early 1920s. During this time, Outerbridge moved to Paris and worked for Condé Nast, among other clients. He fell into an elite circle that included many of the most important artists of the time, including Duchamp, Picasso, Picabia, Braque, Man Ray, and his darkroom assistant, Berenice Abbott. Later in the decade, he moved to Berlin to work on motion pictures with German film director Georg Wilhelm Pabst and later to London, where he was a set advisor to film director E. A. Dupont.

Returning to New York at the beginning of the Great Depression, Outerbridge was unable to find commercial work, so he spent the next few years perfecting the tri-carbro-color print process. By the '30s, Outerbridge had reinvented himself as a leading color photographer in art and advertising, going on to make some of the most well-known commercial and art color photographs of the time. His commercial clients included many of the new color magazines, such as *House Beautiful*, and Outerbridge's art photographs, particularly his female nudes, caused a sensation when exhibited.

Outerbridge moved to California in the '40s, eventually taking up residence in Laguna Beach. Until his death in 1958, Outerbridge made his last important body of work throughout California and Mexico.

While in Laguna Beach, Outerbridge became friends with a talented young photographer, William Current, whom he mentored for several years. Here, in this 1950 photo session in Current's apartment, Outerbridge is photographing a stripped-to-the-waist Bill Current, who is horsing around with his wife, Ruth. In only a few frames, Outerbridge shows that he can still make a powerful and compelling nude that is very much characteristic of his most famous work from the 1920s and '30s.

Photographe moderniste américain, Paul Outerbridge Jr. commença une brillante carrière d'artiste et de photographe de publicité à New York dans les années 1920. Ces mêmes années, il déménagea à Paris où il travailla entre autres pour l'agence Condé Nast et fut introduit dans les cercles fréquentés par les artistes les plus influents de l'époque, tels que Duchamp, Picasso, Picabia, Braque, Man Ray et son assistante de laboratoire, Berenice Abbott. Vers la fin des années 1920, il se rendit à Berlin pour collaborer avec le réalisateur allemand Georg Wilhelm Pabst, puis déménagea à Londres où il travailla comme conseiller artistique aux côtés du réalisateur E. A. Dupont.

De retour à New York au début de la grande dépression, Paul Outerbridge se trouva sans emploi et profita de l'occasion pour perfectionner le processus d'impression couleur au charbon. A partir des années 1930, il s'était imposé comme l'un des plus grands noms de la photographie couleur dans l'art et la publicité, et il devait réaliser les plus remarquables clichés couleur commerciaux et artistiques de son époque. Parmi ses clients commerciaux se trouvent nombre de magazines nouvellement imprimés en couleur, tel que *House Beautiful*, et ses photographies artistiques, notamment les nus féminins, firent sensation dans les expositions.

Paul Outerbridge déménagea en Californie dans les années 1940, prenant résidence à Laguna Beach. Son œuvre tardive fut consacrée à la Californie et au Mexique jusqu'à son décès en 1958.

A Laguna Beach, Paul Outerbridge se lia d'amitié avec William Current, jeune photographe talentueux dont il se fit le mentor pendant de nombreuses années. Lors cette session prise en 1950 chez William Current, Paul Outerbridge photographia William, torse-nu, et sa femme Ruth en train de batifoler dans leur appartement. En quelques clichés, Outerbridge créa un nu photographique intense et raffiné qui s'inscrit dans la droite ligne de ses photographies les plus illustres des années 1920 et 1930.

Paul Outerbridge Jr. war ein früher amerikanischer modernistischer Fotograf, der in den frühen 1920er Jahren eine erfolgreiche Karriere als Künstler und Werbefotograf in New York begann. Während dieser Zeit zog Outerbridge nach Paris und arbeitete unter anderem für Condé Nast, und war Teil eines Elitekreises und lernte viele der wichtigsten Künstler seiner Zeit inklusive Duchamp, Picasso, Picabia, Braque, Man Ray und dessen Dunkelkammer-assistentin Berenice Abbott kennen. Später in dieser Dekade zog er nach Berlin, um mit dem Deutschen Regisseur Georg Wilhelm Pabst Filme zu drehen und dann nach London, wo er als Set-Berater für den Regisseur E.A. Dupont arbeitete.

Als er nach dem Beginn der Weltwirtschaftskrise nach New York zurückkahm, konnte Outerbridge keine kommerzielle Arbeit finden, und so verbrachte er die nächsten Jahre damit, die Tri-Carbro-Color-Technik zu perfektionieren. Bei Beginn der 1930er Jahre hatte Outerbridge sich als der führende Farbfotograf im Bereich Kunst und Werbung etabliert und nahm einige der wichtigsten Gewerbe- und Kunstfarbfotografien der Zeit auf. Zu seinen kommerziellen Kunden zählten viele der neuen Farbmagazine wie zum Beispiel *House Beautiful*, und Outerbridges Kunstfotos, vor allem seine weiblichen Akte, verursachten eine Sensation, wenn ausgestellt.

Outerbridge zog in den vierziger Jahren nach Kalifornien, und wohnte schliesslich in Laguna Beach. Bis zu seinem Tod im Jahr 1958 nahm Outerbridge den wichtigsten Teil seines Werkes in Kalifornien und Mexiko auf.

Während seiner Zeit in Laguna Beach befreundete Outerbridge sich mit einem talentierten jungen Fotografen, William Current, für den er für einige Jahre Mentor war. Hier in dieser Fotositzung von 1950 in Currents Wohnung, fotografiert Outerbridge einen hemdlosen Bill Current, der mit seiner Frau Ruth herumblödelte. Für nur ein paar Einstellungen zeigt Outerbridge, dass er immer noch ein kraftvolles und überzeugendes Aktfoto, was sehr charakteristisch für sein berühmtes Werk der 1920er und 1930er Jahre war, aufnehmen kann.

Paul Outerbridge, Jr., fue uno de los primeros fotógrafos modernistas de América y empezó una exitosa carrera como fotógrafo artístico y publicitario en Nueva York a principios de la década de los años 20. En esa época, Outerbridge se trasladó a París donde trabajó para Condé Nast, entre otros clientes, y donde conoció a un grupo de élite del que formaban parte muchos de los artistas más importantes de la fecha como Duchamp, Picasso, Picabia, Braque, Man Ray y su asistente en el cuarto oscuro, Berenice Abbott. Unos años más tarde, se trasladó a Berlín donde trabajó en el cine con el director alemán Georg Wilhelm Pabst y más tarde a Londres donde ejerció de consejero del director de cine E. A. Dupont.

De regreso a Nueva York, en los inicios de la Gran Depresión, Outerbridge era incapaz de encontrar trabajo comercial, por lo que pasó los siguientes años perfeccionando el proceso de la impresión tricolor. En la década de 1930 Outerbridge se había reinventado a sí mismo como el fotógrafo líder en color en arte y publicidad y llegaría a realizar algunas de las fotografías en color artísticas y comerciales más importantes de su tiempo. Entre sus clientes comerciales se encontraban muchas de las nuevas revistas en color como *House Beautiful*, y las fotografías artísticas de Outerbridge, en especial sus desnudos femeninos, causaban sensación cuando se exponían.

Outerbridge se mudó a California en los años cuarenta y, por último, se convertiría en residente de Laguna Beach. Hasta su fallecimiento en 1958, Outerbridge siguió trabajando en su última obra importante a través de California y México.

Durante su estancia en Laguna Beach, Outerbridge se hizo amigo del joven y prometedor fotógrafo, William Current, a quien asesoró durante varios años. Aquí, en esta sesión de fotos de 1950 en el apartamento de Current, Outerbridge está fotografiando a un Bill Current desnudo hasta la cintura que juguetea con su mujer Ruth. En unos pocos fotogramas Outerbridge demuestra que todavía puede crear un desnudo atractivo y poderoso, la característica de sus obras más famosas de los años de 20 y 30.

Paul Outerbridge

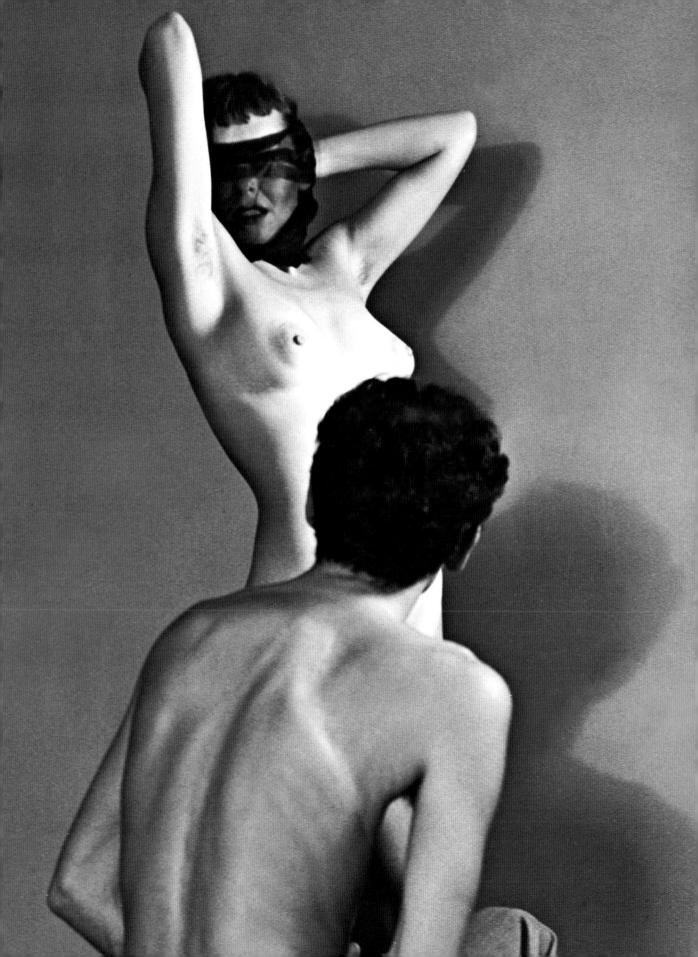

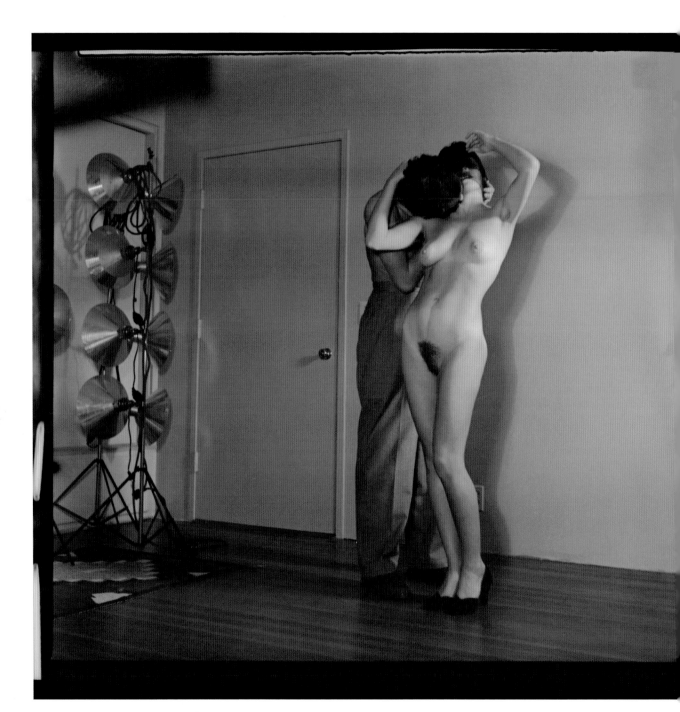

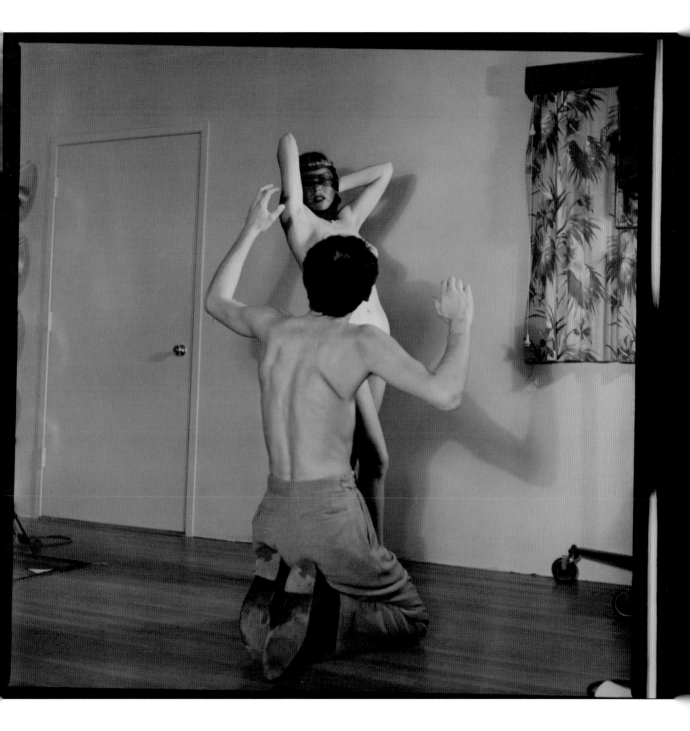

Known for his provocative and often controversial photographs, Martin Parr uses his camera to document and critique lifestyles around the world. Parr understands the power behind his published images, and his work aims to balance out the visual onslaught of mainstream media with a healthy dose of criticism and humor.

As a teenager growing up in England, Parr was introduced to photography by his grandfather, an amateur photographer, who would lend him a camera, take him out on shooting expeditions, and process film with him. These intimate moments left a permanent mark on Parr, and he later went on to study photography. He soon tired of learning basic studio techniques and began working on his own projects.

In his early days, Parr was attracted to the work of photographers like Henri Cartier-Bresson and Garry Winogrand, but his biggest influence came after college, when he saw the work of Tony Ray-Jones. Parr eventually began shooting predominately in color in the early 1980s after seeing emerging American color photographers such as Joel Meyerowitz and Stephen Shore. His work often focused on the "ordinary British people" and were social critiques of classism in UK society.

The featured contact sheet was taken in Benidorm, Spain, in 1997, while shooting for a project on European clichés. It is reflective of much of Parr's travel work—examining national characteristics and international phenomena to help understand cultural peculiarities. Images such as this luxuriant sunbather help us understand society as seen through Parr's eyes, and in turn, it speaks volumes on what we value and how we choose to live.

"I don't regard myself particularly as a photojournalist. I'm a documentary photographer. The idea of my work is to try to put my finger on the zeitgeist of what's happening. That's constantly changing and shifting. I'm not interested in photographing things that are disappearing, although I've engaged in a slight bit of nostalgia. I'm interested in things as they are now."

Réputé pour son style provocateur souvent controversé, Martin Parr met son appareil au service du documentaire et de la critique sociale à travers le monde. Conscient de l'impact de sa photographie, il est en quête d'un équilibre entre le déferlement visuel continu des médias et un œil critique allié à une bonne dose d'humour.

Martin Parr grandit en Angleterre et fut initié à la photographie par son grand-père, un photographe amateur qui lui prêtait son appareil, l'emmenait en excursion prendre des photos et traitait ensuite les négatifs avec lui. Ces moments d'intimité furent déterminants pour Martin Parr qui décida de suivre des études de photographie. Lassé des cours de techniques fondamentales du travail en studio, il se consacra rapidement à ses propres projets.

Si Martin Parr fut initialement attiré par l'œuvre de photographes comme Henri Cartier-Bresson et Garry Winogrand, il reçut une influence plus significative en découvrant le travail de Tony Ray-Jones après l'université. S'inscrivant dans le sillage de photographes américains tels que Meyerowitz ou Stephen Shore, sa photographie commence à être dominée par la couleur au début des années 1980. Son œuvre se concentre souvent sur le « citoyen britannique ordinaire » et se présente comme une critique sociale de la société de classe britannique.

Cette planche contact a été tirée en 1997à Benidorm, en Espagne, dans le cadre d'un projet sur les stéréotypes européens. Elle est caractéristique du travail de Martin Parr qui porte son regard sur les caractéristiques nationales et sur le phénomène international pour tenter de déchiffrer les particularités culturelles de chacun. Les images luxuriantes de ce bain de soleil nous dévoilent la société vue à travers l'objectif de Martin Parr et forment un commentaire incisif de nos valeurs et de notre style de vie.

« Je ne me considère pas vraiment comme un photojournaliste, mais plutôt comme un photographe documentaire. Je cherche à mettre le doigt sur le zeitgeist de l'événement présent. Sur ce qui est constamment en évolution et en mouvement. Je n'ai pas envie de photographier ce qui est en train de disparaître, bien qu'il me soit arrivé d'être un brin nostalgique. Ce qui m'intéresse, c'est le monde contemporain. »

Bekannt für seine provokativen und oft umstrittenen Fotos, Martin Parr verwendet seine Kamera, um Lebensstile rund um die Welt zu dokumentieren und zu kritisieren. Parr versteht die Macht seiner veröffentlichten Bilder, und mit seinem Werk versucht er, den visuellen Ansturm der Mainstream Medien mit einer gesunden Dosis von Kritik und Humor zu balancieren.

Als ein in England aufwachsender Teenager wurde Parr von seinen Grossvater in die Fotografie eingeführt, ein Amateurfotograf, der ihm seine Kamera auslieh, mit ihm auf Filmexpeditionen ging und gemeinsam mit ihm Film entwickelte. Diese intimen Momente hinterliessen einen permanenten Eindruck auf Parr, und später studierte er Fotografie. Er war es bald leid, die Grundstudiotechniken zu lernen und begann an seinen eigenen Projekten zu arbeiten.

In seinen frühen Tagen wurde Parr sehr vom Werk von Fotografen wie Henri Cartier-Bresson und Garry Winogrand beeinflusst, aber sein grösster Einfluss kam nach dem College, als er das Werk von Tony Ray-Jones sah. Parr begann schlussendlich in den frühen 1980ern vor allem in Farbe zu fotografieren, nachdem er aufkommende amerikanische Farbfotografen wie Joel Meyerowitz und Stephen Shore gesehen hatte. Seine Werke konzentrierten sich oft auf die „ordinären britischen Leute" und waren oft Sozial-Kritiken am Klassismus der britischen Gesellschaft.

Der abgebildete Kontaktbogen wurde in Benidorm, Spanien, in 1997 aufgenommen, während er an einem Projekt an europäischen Klischees arbeitete. Es reflektiert viel von Parrs Reisework – nationale Charakteristika und internationale Phänomene werden untersucht, um zu helfen, kulturelle Besonderheiten zu verstehen. Bilder wie dieses einer üppigen Sonnenbadenden helfen uns die Gesellschaft, durch Parrs Augen betrachtet, zu verstehen, und sprechen Bände davon, wie wir zu leben wählen und was wir für wichtig halten.

„Ich halte mich speziell nicht für einen Fotojournalisten. Ich bin ein Dokumentarfotograf. Die Idee meiner Arbeit ist es zu versuchen, meinen Finger auf den Zeitgeist des Geschehens zu legen. Das ändert und verschiebt sich konstant. Ich bin nicht daran interessiert, Dinge zu fotografieren, die am Verschwinden sind, obwohl ich mich ein klein bisschen Nostalgie beschäftigt habe. Ich bin an Dingen interessiert wie sie jetzt sind."

Famoso por sus provocadoras y a menudo controvertidas fotografías, Martin Parr utiliza la cámara para documentar y criticar los diferentes estilos de vida humanos en todo el planeta. Parr entiende el poder detrás de las imágenes publicadas, y su trabajo aspira a equilibrar el ataque visual de los grandes medios de comunicación con una saludable dosis de crítica y humor.

Durante su adolescencia en Inglaterra, Parr solía visitar a su abuelo que fue quien le introdujo en la fotografía. Su abuelo, un fotógrafo aficionado, le prestaba su cámara cuando iban a sacar fotos y luego procesaban juntos la película. Estos momentos íntimos dejaron una huella permanente en Parr, que más adelante decidió cursar fotografía. Pronto se cansó de estudiar técnicas básicas de estudio y empezó a trabajar en sus propios proyectos.

En sus primeros días, Parr estuvo influido por la obra de fotógrafos como Henri Cartier-Bresson y Garry Winogrand, pero su mayor influjo procede de sus años universitarios cuando vio la obra de Tony Ray-Jones. Parr acabó por trabajar sobre todo en color a principios de la década de 1980 tras descubrir a los nuevos fotógrafos en color de América como Joel Meyerowitz y Stephen Shore. Su trabajo se centraba con frecuencia en la gente normal y corriente de Gran Bretaña y constituía una crítica social de la clasista sociedad británica.

Esta hoja de contactos se tomó en Benidorm, España, en 1997, durante un proyecto realizado en ese país acerca de los clichés europeos. Revela mucho acerca del trabajo documental de Parr: el examen de características nacionales y fenómenos internacionales para ayudar a entender las peculiaridades culturales. Imágenes como este exuberante bañista nos ayudan a comprender la sociedad vista a través de los ojos de Parr y además nos dice mucho acerca de cómo elegimos vivir y qué valoramos.

"Particularmente, yo no me considero periodista gráfico. Soy un fotógrafo documental. La idea tras mi trabajo es tratar de poner el dedo en la llaga y mostrar lo que está ocurriendo. Esto es algo que cambia y se desplaza constantemente. No me interesa fotografiar cosas que están desapareciendo, si bien en estos momentos siento una ligera nostalgia. Me interesan las cosas tal y como están ahora".

Martin Parr

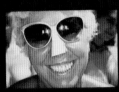

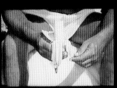

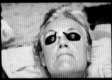
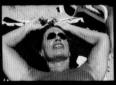
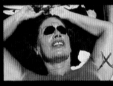
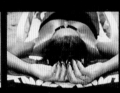
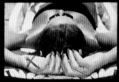

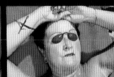

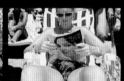

Based in Evanston, Illinois, Melissa Ann Pinney has spent the past dozen years creating works around the theme of female identity—whether it's childhood, adolescence, adulthood, motherhood, or old age.

Raised as a Catholic with five brothers and two sisters, Pinney observed the contrasts between the experiences of her male and female siblings and learned to articulate the female experience through her images.

"When I found the courage to articulate my views, it was by way of wordless photographs that depict precisely what has often been considered insignificant in the domestic, social, or cultural sphere. I'm interested in the ways in which feminine identity is constructed, taught, and communicated between mothers and daughters."

Regarding the contact sheet for the image "Emma & Doll, Ritz Pool," Pinney says, "Some of my best photographs have resulted from my love of water—on the beaches of Florida and Maui and the shores of Lake Michigan. This picture was made in Los Angeles in 2001. My husband was working in L.A. at the time. My daughter, Emma, and I would fly out for long weekends. We were staying at a nearby hotel, but the pool was much nicer at the Ritz, across the street. It became our pool when we were in L.A. This is one of the very few photographs where I've included myself.

"I'm intrigued to see the part that the mechanics of each particular camera play in determining composition and meaning. In 1999 I started working with a medium-format camera after many years of shooting with only a Leica and a 35-millimeter lens. This camera was a range finder, too, but heavier, with a difficult focusing mechanism and a slower lens. Frustrated at first, I saw many of the pictures I wanted go right by while I fumbled with the camera. At the pool, I remember trying to focus, not only on a fast-moving child, but one who was also partially underwater. Looking at the contact sheet now, I'm pleased to see the variety—and not surprised that the most successful image was the result of Emma's brief rest by the side of the pool."

Résidante d'Evanston dans l'Illinois, Melissa Ann Pinney a passé ces douze dernières années à explorer la thématique de l'identité féminine – que ce soit pendant l'enfance, l'adolescence, l'âge adulte, la maternité ou la vieillesse.

Elevée dans une famille catholique aux côtés de cinq frères et deux sœurs, elle put observer le contraste entre les expériences de ses frères et sœurs et apprit à articuler l'expérience féminine à travers ces images.

« Quand j'ai trouvé le courage de donner forme à mes opinions, je l'ai fait par le biais d'une photographie silencieuse qui met en lumière précisément ce qui est souvent considéré comme insignifiant dans la sphère domestique, sociale ou culturelle. Je m'intéresse à la manière dont l'identité féminine est construite, enseignée et transmise de mère en fille. »

Décrivant la planche contact de la photographie « Emma & Doll, Ritz Pool », Melissa Ann Pinney déclare : « certaines de mes photos les plus connues sont le résultat de mon amour pour l'eau – elles furent prises sur les plages de Floride et de Maui et sur les rives du lac Michigan. Cette photo a été prise à Los Angeles en 2001, quand mon mari y travaillait. Avec ma fille Emma, nous lui rendions visite pour de longs week-ends. Nous étions descendues dans un hôtel des environs, mais la piscine du Ritz était bien plus agréable et c'était devenu notre piscine quand nous étions à Los Angeles. C'est une des rares photos où j'apparais en personne.

Je suis intriguée de voir l'importance que prend le mécanisme de chaque appareil quand il s'agit de déterminer la composition et la signification des images. En 1999, j'ai commencé à travailler avec un appareil de moyen format après des années passées à utiliser seulement un Leica avec son objectif de 35 mm. Cet appareil est aussi un télémètre, mais plus lourd et avec un mécanisme de mise au point compliqué et des lentilles moins rapides. J'étais d'abord un peu frustrée en l'utilisant et j'ai vu de nombreuses prises de vue potentielles disparaître sous mes yeux alors que j'hésitais avec l'appareil. Au bord de la piscine, je me souviens avoir essayé de régler l'objectif non seulement sur un enfant en mouvement, mais de plus un enfant à demi immergé dans l'eau. En regardant la planche contact, je suis satisfaite de la variété des clichés et je ne suis pas surprise de voir que la meilleure prise de vue est celle où Emma est en arrêt au bord de la piscine. »

Melissa Ann Pinney, basierend in Evanston, Illinois, hat die vergangenen zwölf Jahren damit verbracht, Werke um das Thema der weiblichen Identiät zu schaffen – ob es sich um Kindheit, Adoleszenz, Erwachsenenalter, Mutterschaft, oder spätes Alter handelt.

Aufgewachsen als Katholikin, mit fünf Brüdern und zwei Schwestern, Pinney beobachtete die Unterschiede zwischen den Erlebnissen ihrer männlichen und weiblichen Geschwister und lernte das weibliche Erlebnis durch ihre Bilder auszudrücken.

„Als ich den Mut fand, meine Ansichten zu artikulieren, fand dies in der Form von wortlosen Fotos statt, die genau darstellen, was oft als unwichtig in der häuslichen, sozialen oder kulturellen Sphäre bedacht wird. Ich bin daran interessiert, wie weibliche Identität zwischen Müttern und Töchtern konstruiert, gelehrt und kommuniziert wird."

Zum Kontaktbogen für das Bild „Emma & Doll, Ritz Pool" betreffend, meint Pinney: „Manche meiner besten Fotos resultieren von meiner Liebe zum Wasser – an den Stränden von Florida und Maui und den Ufern von Lake Michigan. Dieses Bild wurde in Los Angeles im 2001 aufgenommen. Mein Mann arbeitete zu der Zeit in L.A. Meine Tochter und ich flogen dahin für lange Wochenenden. Wir wohnten in einem hotel in der Nähe, aber der Pool war viel netter beim Ritz, auf der gegenüberliegenden Strasse. Es wurde unser Pool, wenn wir in L.A. waren. Das ist eines der sehr wenigen Fotos, wo ich mich inkludiert habe.

Ich bin fasziniert den Teil zu sehen, den die Mechanik jeder einzelner Kamera in der Bestimmung der Komposition und der Bedeutung spielt. In 1999 begann ich mit einer mittelformatigen Kamera zu arbeiten, nachdem ich für viele Jahre mit nur einer Leica und einer 35mm Linse fotografiert hatte. Diese Kamera war auch eine Sucherkamera, aber schwerer, mit einem schwierigen Fokussierungsmechanismus und einer langsameren Linse. Zunächst frustriert, sah ich viele der Bilder, die ich wollte, einfach vorbeigehen, während ich mit der Kamera herumfummelte. Beim Pool erinnere ich mich daran, versucht zu haben, nicht nur auf ein sich schnell bewegendes Kind zu fokussieren, sondern auf eines, das auch teilweise unter Wasser war. Wenn ich nun den Kontaktbogen anschaue, dann bin ich erfreut, die Vielfältigkeit zu sehen, und nicht überrascht, dass das am erfolgreichste Bild das Resultat von Emmas kurzer „Pause bei der Seite des Pools war."

Desde su base en Evanston, Illinois, Melissa Ann Pinney ha dedicado la última docena de años a crear trabajos acerca del tema de la identidad femenina, tanto la infancia como la adolescencia, la edad adulta, la maternidad o la vejez.

Procedente de una familia católica con cinco hermanos y dos hermanas, Pinney observaba los contrastes entre las experiencias de sus hermanos varones y hembras, y aprendió a articular la experiencia femenina mediante imágenes.

"Cuando encontré el valor necesario para articular mis puntos de vista, fue a través de silenciosas instantáneas que representan justo lo que se suele considerar insignificante en la esfera doméstica, social o cultural. Estoy interesada en las formas en las que se construye, enseña y comunica la identidad femenina entre madres e hijas".

En cuanto a la hoja de contactos de la imagen "Emma & Doll, Ritz Pool", Pinney comenta: "Algunas de mis mejores fotos son el resultado de mi amor por el agua, en las playas de Florida y Maui y en las costas del Lago Míchigan. Esta foto se realizó en Los Ángeles en 2001. Por ese entonces, mi marido trabajaba en L.A. y mi hija Emma, y yo le visitábamos algunos fines de semana. Nos alojábamos en un hotel cercano, pero la piscina del Ritz era mucho mejor y estaba cruzando la calle. Se convirtió en nuestra piscina cuando íbamos a L.A. Esta es una de las poquísima fotos donde me incluyo a mí misma.

Me resulta intrigante la parte que juega la mecánica de cada cámara a la hora de determinar la composición y el significado. En 1999, empecé a trabajar con una cámara de formato medio después de utilizar, durante muchos años, sólo una Leica y una lente de 35 mm. La cámara también era una cámara telemétrica, pero más pesada, con un complicado mecanismo de enfoque y lentes más lentas. Al principio, frustrada, veía pasar de largo muchas instantáneas que me hubiese gustado capturar mientras jugueteaba con la cámara. En la piscina recuerdo que estaba intentando enfocar a una niña moviéndose a toda velocidad que además estaba parcialmente bajo el agua. Mirando ahora la hoja de contactos, me satisface ver la variedad y no me sorprende que la imagen más exitosa fuera el resultado de un pequeño descanso de Emma al lado de la piscina".

Melissa Ann Pinney

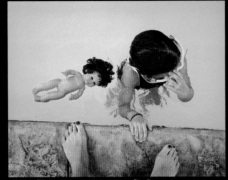
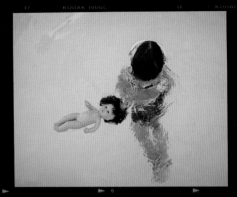

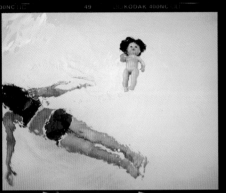
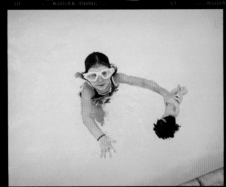
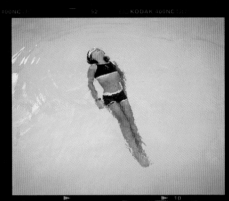

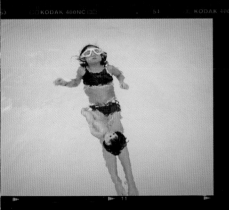
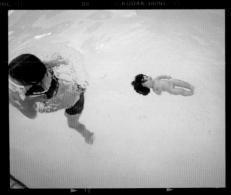
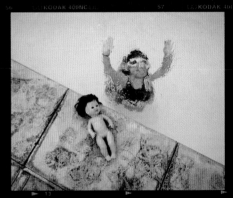

Mark Power traces his interest in photography back to the day he discovered his father's homemade enlarger in the family attic—a machine cobbled together with a lightbulb, a camera lens, and a flower pot. His official photography career began in the early 1980s; he worked on various editorial and charity projects and then turned to teaching in the '90s. Today his projects are often long-term and large-scale commissions in the industrial sector. His work has been seen in exhibitions across the world and in various published books, and he is currently a Professor of Photography at the University of Brighton.

"The picture was made in Warsaw on April 8, 2005. It shows a live broadcast from the Vatican of the funeral of the Polish pope, John Paul II. The death of John Paul had a profound effect on the mood of the entire country; the outpouring of grief was extraordinary. I had witnessed the effect of Princess Diana's death on the population of Britain eight years before, but that couldn't hold a candle to this.

Advances in telecommunications meant that John Paul was the most recognizable pope in history. It therefore seemed appropriate to photograph this momentous event as it was—a television broadcast—and I approached the day intending to do exactly that.

"I rarely make more than one picture of anything, because of the sheer cost of working large format. But in this case, I realized that I had to get it right—this was a piece of history which was never to be repeated—so I worked the situation until I felt I had the picture. It was only when I saw the contact sheet that I realized how strange the picture looks, and, indeed, when others see an enlargement, they often struggle to understand just what they are looking at, since the crowd appears to be closer to the camera than the screens. It's an illusion—something photography is very good at. Seen within the context of the contact sheet, it might be difficult to ever see the picture in the same way again."

Mark Powers s'intéressa à la photographie le jour où il découvrit un agrandisseur fabriqué par son père dans le grenier de la maison – assemblage d'une ampoule électrique, d'une lentille d'appareil photo et d'un pot de fleurs. Sa carrière officielle débuta au début des années 1980, période pendant laquelle il travailla sur plusieurs projets d'édition et de bénévolat avant de se tourner vers l'enseignement dans les années 1990. Il travaille aujourd'hui sur des projets de grande envergure et à long terme commissionnés par le secteur industriel. Ses travaux ont été exposés internationalement et ont fait l'objet de nombreuses publications, il occupe aujourd'hui le poste de professeur de photographie à l'Université de Brighton.

« Cette photo été prise à Varsovie le 8 avril 2005. Elle montre la retransmission en direct du Vatican des funérailles du pape polonais Jean-Paul II. Le décès du pape eut un impact très profond sur tout le pays et la population polonaise manifesta une douleur extrême. J'avais pu voir le choc provoqué par le décès de la Princesse Diana sur les Britanniques huit ans plus tôt, mais leur réaction était faible comparée à l'émotion éprouvée en Pologne.

Les progrès dans le domaine des télécommunications ont fait de Jean-Paul II le pape le plus reconnaissable de l'histoire. Il me semblait donc approprié de photographier cet événement tel qu'il se présentait – comme une retransmission télévisé – et c'est l'approche que j'ai adoptée.

Je fais rarement plus d'un cliché de chaque événement, tout simplement en raison du coût des grands formats. Dans ce cas, je me suis dit que la photo devait être parfaite – c'était un moment historique unique – et j'ai travaillé jusqu'au moment où j'ai pensé avoir le cliché parfait. C'est seulement en voyant la planche contact que je me suis rendu compte à quel point cette photo est étrange, et en effet, on est souvent dérouté en voyant l'agrandissement car la foule paraît être plus proche de l'appareil que les écrans. C'est une illusion d'optique, comme la photographie en produit souvent. Vu dans le contexte de la planche contact, il me sera difficile d'appréhender cette photo de la même manière qu'avant. »

Mark Powers Interesse an der Fotografie kann dem Tag zugeschrieben werden, an dem er die selbstgemachte Lupe auf dem Familiendachboden entdeckte – eine Maschine, die aus einer Glühbirne, einer Kameralinse und einem Blumentopf zusammengeflickt war. Seine offizielle fotografische Karriere begann in den frühen achtziger Jahren, als er an verschiedenen Editorial- und Wohltätigkeitsprojekten arbeitete, bevor er sich in den neunziger Jahren dem Unterrichten zuwandte. Seine heutigen Projekte sind oft langzeitige und weiträumige Aufträge im industriellen Sektor. Sein Werk ist in Ausstellungen der ganzen Welt und in verschiedenen veröffentlichten Büchern zu sehen, und er ist gegenwärtig Professor of Photography an der University of Brighton.

„Das Bild wurde in Warschau, am 8. April 2005 aufgenommen. Es zeigt die Live-Fernsehsendung vom Vatikan des Begräbnis vom polnischen Papst, Johannes Paul II. Der Tod von Johannes Paul hatte einen grossen Effekt auf die Stimmung des ganzen Landes; das Ausströmen der Trauer war aussergewöhnlich. Ich hatte den Effekt von Prinzessin Dianas Tod auf die britische Bevölkerung acht Jahre zuvor miterlebt, doch das konnte damit nicht mithalten.

Die Fortschritte im Bereich der Telekommunikation bedeuteten, dass Johannes Paul der am meist bekannte Papst der Geschichte war. Es schien daher angemessen, dieses bedeutsame Ereignis so zu fotografieren wie es war – eine live Fernsehübertragung – und ich ging den Tag mit diesem Vorsatz an.

Ich mache selten mehr als ein Foto von irgendwas, wegen der reinen Kosten mit Grossformat zu arbeiten. Aber in diesem Fall sah ich ein, dass ich es richtig erwischen musste – dies war ein Teil von Geschichte, der sich nie wiederholen würde – und so blieb ich an der Lage dran, bis ich das Gefühl hatte, ich hatte das Bild erwischt. Erst als ich den Kontaktbogen sah, realisierte ich, wie seltsam das Bild aussieht, und, wirklich, wenn andere eine Vergrösserung sehen, kämpfen sie oft damit zu verstehen, was genau sie sehen, da die Menschenmenge der Kamera näher scheint als den Fernseherbildschirmen. Es ist eine Illusion – etwas wobei Fotografie sehr gut ist. Im Kontext des Kontaktbogens betrachtet, könnte es schwierig sein, das Bild jemals wieder auf dieselbe Weise zu sehen."

El interés de Mark Power en la fotografía se remonta al día en el que descubrió la ampliadora casera de su padre en el ático: una máquina ensamblada con una bombilla, una lente fotográfica y una maceta. Su carrera oficial como fotógrafo se inició a principios de los años ochenta en los que trabajó en varios proyectos editoriales y benéficos antes de empezar a enseñar en los noventa. Sus proyectos, hoy día, son a menudo encargos a largo plazo y a gran escala del sector industrial. Su trabajo se ha expuesto en diversos puntos en todo el planeta y ha aparecido en varios libros. En estos momentos, es Profesor de Fotografía en la Universidad de Brighton.

"La foto fue tomada en Varsovia, el 8 de abril de 2005. Muestra una transmisión en directo desde el Vaticano del funeral del Papa polaco, Juan Pablo II. La muerte de Juan Pablo tuvo un profundo efecto en el estado de ánimo de todo el país; la efusión de dolor era extraordinaria. Yo había sido testigo del efecto del fallecimiento de la Princesa Diana en la población británica hacia ocho años, pero no tenía ni punto de comparación con esto.

El desarrollo de las telecomunicaciones significó que Juan Pablo fuera el Papa más identificable de la historia. Por lo tanto, parecía apropiado fotografiar este evento trascendental tal y como era – una retransmisión televisiva – así que me planteé el día desde ese punto de vista.

Casi nunca hago más de una foto de cualquier tema, debido sobre todo al coste de trabajar con un formato grande. Pero en este caso, me di cuenta de que tenía que tomar la foto precisa, era un momento histórico irrepetible, así que trabajé hasta que creí tener la imagen que buscaba. No me di cuenta del extraño aspecto de las imágenes hasta que vi la hoja de contactos y, de hecho, cuando otras personas ven una ampliación a menudo tienen que esforzarse en entender que es lo que están viendo, ya que la multitud parece estar más cerca de la cámara que las pantallas. Es una ilusión, algo muy propio de la fotografía. Vista en el contexto de la hoja de contactos incluso podría ser difícil volver a apreciar la foto de la misma forma".

Mark Power

Born in Los Angeles in 1979, Alex Prager had a nomadic childhood, growing up in Florida, California, and Switzerland. She is a self-taught scholar and photographer.

Prager's interest in photography was sparked by her discovery of William Eggleston's work, and she later taught herself the nuts and bolts of the craft—whether it was familiarizing herself with the equipment or perfecting lighting. Her images have been shown in various exhibitions in the United States and Europe, and published in both national and international publications. Her first book, *The Book of Disquiet*, came out in 2005.

"I think this picture was taken in the beginning of March 2008. We shot it on the asphalt outside my apartment building during midafternoon with a smoke machine and Arri lights. I literally just laid the sheet out on the asphalt. I probably should have put some cushions underneath it so she would be more comfortable, but we were in the moment, and I kind of liked the way her body had kind of stiffened up because of the hard ground.

"The original idea behind this shoot was that there was going to be tons of smoke from her cigarette wafting up towards my camera, almost so much smoke that it would cover her face to the point that we would only see her red lips. (I was going to be shooting from above her.) As you can see, that's not the shot I ended up using. This happens a lot. I'll start out with an idea, but I'm always open to what's happening as the shoot is taking place. It's not really in my control at the point. The shoot kind of takes on its own personality. With this particular shoot, it ended up being more about the colors and the position of her body with my camera, rather than the concept boldly spelled out in the shot. It's subtle, so it leaves more room for interpretation."

Née à Los Angeles en 1979, Alex Prager connut une enfance nomade passée entre la Floride, la Californie et la Suisse, une enfance qui marquera de façon déterminante sa formation d'autodidacte au plan académique aussi bien que photographique.

La découverte de l'œuvre de William Eggleston éveilla son intérêt pour la photographie et elle apprit par elle-même les rudiments du métier, développant ses connaissances de la technique de l'équipement ou de l'utilisation de la lumière. Son œuvre fut exposée aux Etats-Unis et en Europe, et parut également dans de nombreuses publications nationales et internationales. Son premier livre, *The Book of Disquiet*, fut publié en 2005.

« Je crois que cette photo a été prise au début de mars 2008. Nous l'avons prise dans la rue juste en dehors de mon appartement, avec une machine à fumée et des projecteurs Arri. J'ai littéralement jeté la couverture sur le goudron. J'aurais pu mettre quelques coussins en dessous pour que ce soit plus confortable pour le modèle, mais on travaillait dans l'instant et j'aimais bien le raidissement du corps au contact de la dureté du sol.

A l'origine, l'idée était qu'il y aurait de grosses volutes de fumée de cigarette en direction de l'appareil, à tel point que le visage du modèle serait dissimulé et qu'on ne distinguerait que le rouge de ses lèvres (je devais me placer au dessus d'elle). Comme vous voyez, ce n'est pas le cliché que j'ai fini par choisir. Ça m'arrive souvent. Je pars d'une idée mais je reste ouverte au déroulement spontané de la séance. Je ne suis pas vraiment en contrôle de la situation et je laisse la séance développer sa propre personnalité. Avec cette photographie, l'accent est placé spécifiquement sur le jeu des couleurs et sur la position du corps plutôt que sur le concept d'origine. Cette subtilité laisse le champ plus libre à l'interprétation. »

Die nomadische Kindheit von Alex Prager, (geboren in Los Angeles im Jahr 1979), die sie in Florida, Kalifornien und der Schweiz verbrachte, spielte eine grosse Rolle in ihrer auto-didaktischen Erziehung – in der akademischen sowie in der fotografischen.

Ihr Interesse an der Fotografie wurde entfacht nachdem sie das Werk von William Egglestan entdeckt hatte, und sie brachte sich selbst das A und O des Handwerks bei – ob es sich um die Eingewöhnung an die Ausrüstung oder die perfekte Belichtung handelte. Ihr Werk wurde in verschiedenen Ausstellungen in den USA und in Europa gezeigt, und ist in nationalen sowie internationalen Veröffentlichungen publiziert worden. Ihr erstes Buch, *The Book of Disquiet* kam im Jahr 2005 heraus.

„Ich denke dieses Bild entstand Anfang März, 2008. Wir fotografierten auf dem Asphalt draussen vor meinem Wohngebäude in der Nachmittagsmitte mit einer Rauchmaschine und Arri-Lichtern. Ich legte das Leintuch buchstäblich einfach auf den Asphalt. Ich hätte wahrscheinlich ein paar Kissen darunter legen sollen, damit sie komfortabler wäre, aber wir waren im Moment gefangen und mir gefiel, wie ihr Körper sich wegen dem harten Untergrund versteift hatte.

Die ursprüngliche Idee für diesen Fotoshoot war, dass ganz viel Rauch von ihrer Zigarette zu meiner Kamera wehen würde, fast soviel Rauch, dass er ihr Gesicht soweit bedecken würde, so dass wir nur ihre roten Lippen sehen würden (Ich plante, sie von oben zu fotografieren). Wie ersichtlich ist, ist das nicht das Foto, dass ich zum Schluss ausgesucht habe. Das passiert oft. Ich beginne mit einer Idee, aber ich bin immer dazu aufgeschlossen, was während des shoot passiert. Es ist zu diesem Punkt nicht wirklich in meiner Kontrolle. Der Fotoshoot nimmt eine eigene Persönlichkeit an. Bei diesem Fotoshoot ging es schlussendlich mehr um die Farben und die Position ihres Körpers mit meiner Kamera und weniger um das Konzept, das so mutig im Foto vorbuchstabiert ist. Es ist subtil, so dass es mehr Raum für Interpretation lässt."

Nacida en Los Ángeles en 1979, la infancia nómada de Alex Prager transcurrida entre Florida, California y Suiza jugó una parte importante en su educación autodidacta, tanto en el ámbito académico como en el fotográfico.

Su interés en la fotografía se despertó tras descubrir la obra de William Eggleston, y con el tiempo aprendió por sí misma los secretos del oficio, desde familiarizarse con el equipo hasta perfeccionar la iluminación. Su trabajo se ha expuesto en diversas galerías en Estados Unidos y Europa y ha aparecido en publicaciones nacionales e internacionales. Su primer libro, *The Book of Disquiet* se publicó en 2005.

"Creo que saqué esta foto a principios de marzo de 2008. Fue una tarde, en la calle, al lado de mi apartamento, con una máquina de humo y luces Arri. Me limité a extender la sábana sobre el asfalto. Debería haber puesto algunos cojines debajo para que la modelo estuviese más cómoda, pero estábamos entusiasmados, y en cierto modo me gustaba como el cuerpo de la modelo se había tensado debido a la dureza del suelo.

La idea original de la foto era que iba a haber un montón de humo ascendiendo desde su cigarrillo hacia mi cámara, casi tanto que le cubriría la cara hasta el punto de que sólo serían visibles sus labios rojos (iba a tomar la foto desde arriba). Como puedes ver, esa no fue la foto que acabé usando. Pasa con frecuencia. Empiezo con una idea, pero siempre estoy atenta a lo que ocurre durante la sesión de fotos. Es algo ajeno a mi control en ese momento. La foto desarrolla su propia personalidad. Esta imagen, en concreto, acabó por tratar más los colores y la posición de su cuerpo, en lugar de representar un concepto demasiado explícito. Es sutil, por lo que hay más espacio para la interpretación".

Alex Prager

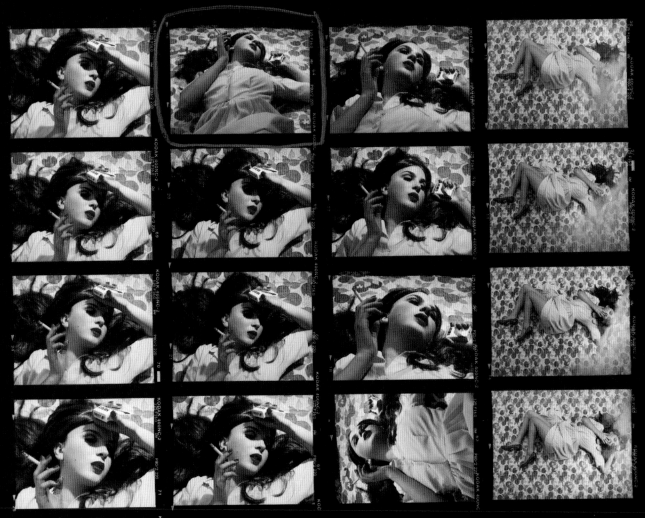

03307

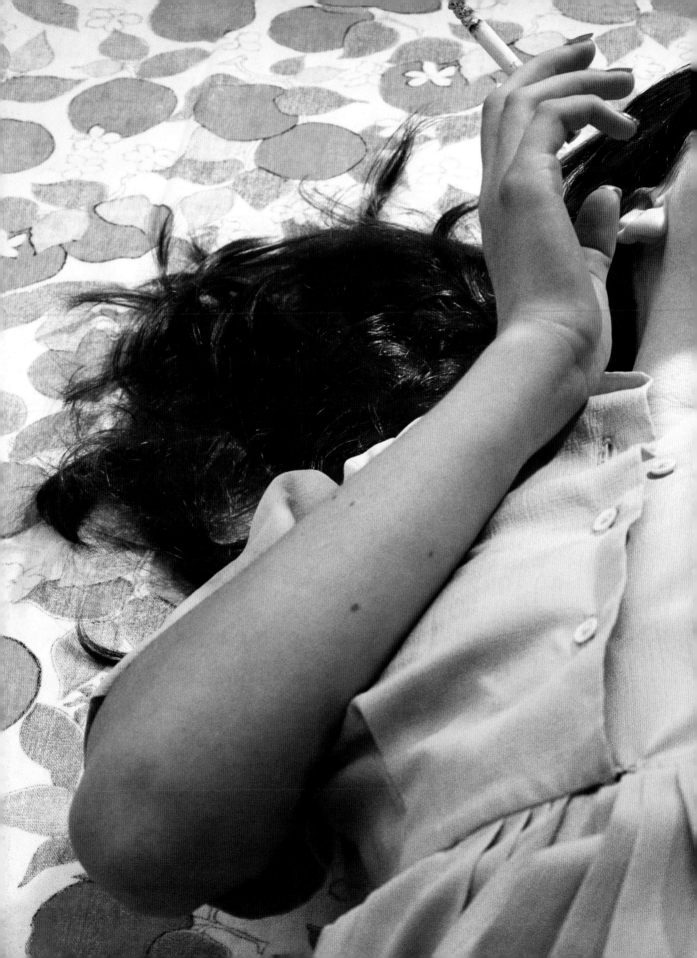

A photographer, painter, and filmmaker, Ed Ruscha has become synonymous with the California pop art movement. Born in Omaha, Nebraska, Ruscha was inspired by cartoons in his youth, a passion that went well into his adolescence. He eventually trekked out to Los Angeles in the mid-1950s to attend the Chouinard Art Institute (now the California Institute of the Arts).

Ruscha was part of an exciting young art movement in 1960s Los Angeles, and his work was included in a groundbreaking exhibition at the Pasadena Art Museum, curated by Walter Hopps, called *New Painting of Common Objects*. It included work by Roy Lichtenstein, Andy Warhol, and Wayne Thiebaud, and it is considered one of the first pop art exhibitions in America.

The featured contact sheet was created in 1971 and includes images from various locations in Hollywood:

"For 'A Few Palm Trees,' I shot around two dozen images of the title trees on the streets and nearby neighborhoods of Hollywood with my Yashica, using 120 (2 ¼ x 2 ¼ inches) black-and-white film. Then I made proof sheets so I could edit, print, then alter the photographs I had chosen for the book. Fourteen were selected from the proofs for the final images of the palm trees. These were then printed and later painted out in white to eliminate the houses, cars, streets, et cetera showing in the background. Although the address of each palm tree was identified, I was not interested in the ambience of the palm tree's surroundings; I only wanted to isolate the trees themselves and just have them 'floating' on each empty white page. I liked giving the address of each tree, even though that meant nothing without showing any identifiable surroundings of the street where it was shot. I did, however, give the direction of the tree from where I shot it. Lastly, I put down my layout of images for the printer, who dropped out the background around the trees; then he printed the book from my paste-up boards. I used a black wraparound cover for the book without any title printing on it."

Photographe, peintre et réalisateur, Ed Ruscha est étroitement lié au mouvement du pop Art de Californie. Né à Omaha dans le Nébraska, il s'intéressa très tôt à la bande dessinée et poursuivit cette passion jusqu'à l'adolescence. Il se rendit à Los Angeles vers le milieu des années 1950 et y suivit des cours au Chouinard Art Institute (devenu le California Institute of the Arts).

A Los Angeles, Ed Ruscha fut partie prenante du jeune mouvement artistique des années 1960. Son œuvre fut exposée lors de l'exposition *New Painting of Common Objects*, réalisée sous la curatelle de Walter Hopps au Pasadena Art Museum et qui marqua l'essor du pop art. Des œuvres de Roy Lichtenstein, Andy Warhol et Wayne Thiebaud y furent exposées et elle est considérée comme la première exposition du pop art aux Etats-Unis.

Cette planche contact fut créée en 1971 et présente des photographies prises dans divers quartiers d'Hollywood.

« Pour la série 'A Few Palm Trees', j'ai pris environ deux douzaines de photos d'arbres dans les rues et les quartiers d'Hollywood avec mon appareil Yashica en utilisant une pellicule noir et blanc de 120 (2-¼ x 2-¼ pouces). J'ai ensuite tiré des épreuves de manière à pouvoir éditer, imprimer et modifier les clichés choisis pour le livre. Quatorze photographies ont été sélectionnées parmi ces épreuves. Elles furent imprimées et peintes en blanc pour éliminer les maisons, les voitures et les rues qui apparaissaient dans l'arrière-plan. Bien que l'adresse de chaque palmier soit identifiée, l'ambiance créée par l'environnement du palmier ne m'intéressait pas. Mon intention était seulement d'isoler chaque arbre et de le voir 'flotter' au milieu d'une page blanche. J'aime aussi donner l'adresse de chaque arbre même si elle ne signifie rien sans éléments propres à identifier la rue. En revanche, j'indique l'angle de prise de vue de la photographie. J'ai remis mes images à l'imprimeur qui fit d'abord disparaître l'arrière-plan autour des arbres, et qui imprima ensuite le livre à partir de mes collages. Pour ce livre, j'ai choisi une couverture brochée noire sans titre. »

Als Fotograf, Maler und Filmemacher ist Ed Ruschas Name synonym mit der kalifornischen pop Art-Bewegung. Geboren in Omaha, Nebraska, war Ruscha in seiner Jugend zu Cartoons hingezogen, eine Leidenschaft, die sich bis spät in die Adoleszenz hinzog. Er trekkte schlussendlich nach Los Angeles in der Mitte der 1950er, um das Chouinard Art Institute zu besuchen (nun das California Institute of the Arts).

Ruscha war Teil einer spannenden, jungen Kunstbewegung im Los Angeles der sechziger Jahre, und sein Werk war Teil einer bahnbrechenden Ausstellung im Kunstmuseum von Pasadena, unter dem Kurator Walter Hopps, betitelt *New Painting of Common Objects*. Sie beinhaltete Werke von Roy Lichtenstein, Andy Warhol, und Wayne Thiebaud, und wird als eine der ersten "pop art" Austellungen in Amerika betrachtet.

Der abgebildete Kontaktbogen wurde in 1971 kreiert, und beinhaltet Bilder von verschiedenen Orten in Hollywood:

„Für ‚A Few Palm Trees' schoss ich um die zwei Dutzend Bilder von den Titelbäumen der Strassen und nahe gelegenen Nachbarschaften von Hollywood mit meiner Yashica und verwendete 120er (2-¼ x 2-¼ inches) schwarz-weissen Film. Dann machte ich Korrekturabzüge, damit ich editieren, ausdrucken und dann die Fotos, die ich für das Buch ausgesucht hatte, ändern konnte. Vierzehn waren von den Korrekturabzügen als endgültige Bilder der Palmen ausgewählt worden. Diese wurden dann ausgedruckt und später in weiss ausgemalt, um die Häuser, Autos, Strassen, etc. im Hintergrund zu eliminieren. Auch wenn die Adresse jeder Palme identifiziert wurde, so war ich nicht am Milieu der Umgebungen der Palme interessiert; ich wollte nur die Palmen selbst isolieren und sie auf jeder weissen Seite ‚schweben' lassen. Es gefiel mir, die Adressen von jeder Palme anzugeben, obwohl das nichts bedeutete, ohne irgendwelche identifizierbaren Umgebungen der Strasse, wo sie gefilmt wurde, zu zeigen. Ich gab aber wie auch immer die Adresse des Baum an, von wo aus ich fotografierte. Zum Schluss gab ich mein Lay-out der Bilder dem Drucker, der die Hintergründe um die Bäume rausstrich, dann druckte er das Buch von meinen Paste-Ups. Ich benutzte einen schwarzen Wickeleinband für das Buch, ohne einen Titel darauf zu drucken."

Fotógrafo, pintor y cineasta, el nombre de Ed Ruscha es sinónimo del movimiento del arte pop de California. Nacido en Omaha, Nebraska, Ruscha se sentía atraído por los dibujos animados en su juventud, una pasión que perduró hasta bien entrada la adolescencia. Acabaría viajando hasta Los Ángeles a mediados de la década de 1950 para asistir al Chouinard Art Institute (conocido ahora como el California Institute of the Arts).

Ruscha formó parte de un movimiento de arte joven y fascinante en el Los Ángeles de la década de los sesenta, y su trabajo se incluyó en una exposición rompedora en el Museo de Arte de Pasadena, comisariada por Walter Hopps, denominada *New Painting of Common Objects*. Se incluyeron trabajos realizados por Roy Lichtenstein, Andy Warhol y Wayne Thiebaud, y es considerada una de las primeras exposiciones de "arte pop" de América.

La hoja de contactos incluida se creó en 1971 e incluye imágenes desde diferentes puntos de Hollywood:

"Para 'A Few Palm Trees', tome unas veintitantas imágenes de los árboles objeto del título en las calles y barrios cercanos de Hollywood con mi Yashica con una película en blanco y negro de 120 (2-¼ x 2-¼ pulg.). A continuación hice unas hojas de prueba para poder modificar, imprimir y luego alterar las fotografías que había escogido para el libro. Se seleccionaron catorce de estas pruebas para las imágenes definitivas de las palmeras. A continuación se revelaron y se pintaron en blanco para eliminar las casas, vehículos, calles, etc. que aparecían de fondo. Si bien se identificó la ubicación de cada palmera, no estaba interesado en el ambiente que rodeaba a la palmera; sólo deseaba aislar los árboles y que simplemente 'flotaran' en cada página blanca vacía. Me gustó la idea de proporcionar la dirección de cada árbol si bien eso no tenía significado alguno si no mostraba nada identificable de lo que rodeaba a la calle donde se tomó. No obstante, proporcioné la dirección del árbol desde donde la tomé. Finalmente, entregué la distribución de las imágenes a la imprenta que eliminó el fondo alrededor de los árboles y luego imprimió el libro a partir de mis tableros de composición. Utilicé una portada negra doble para el libro sin ningún título impreso en ella".

Ed Ruscha

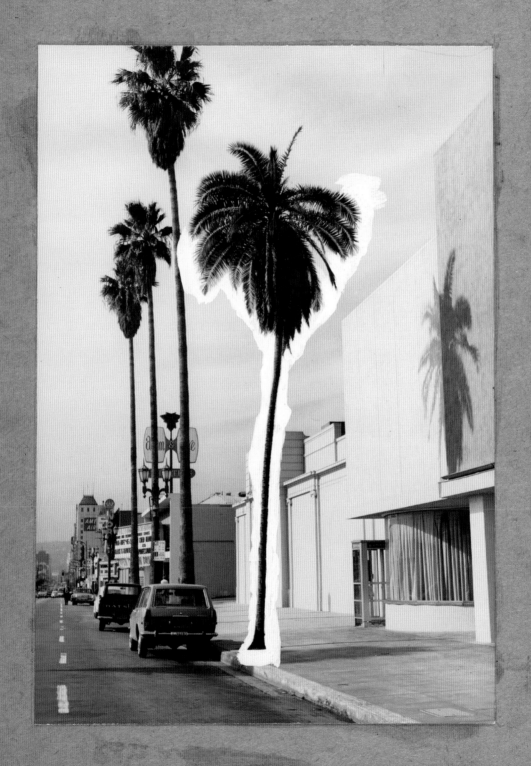

4 NORTH SIDE OF HOLLYWOOD BLVD

(5941). 5"

(25)

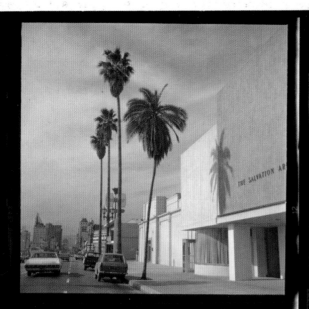

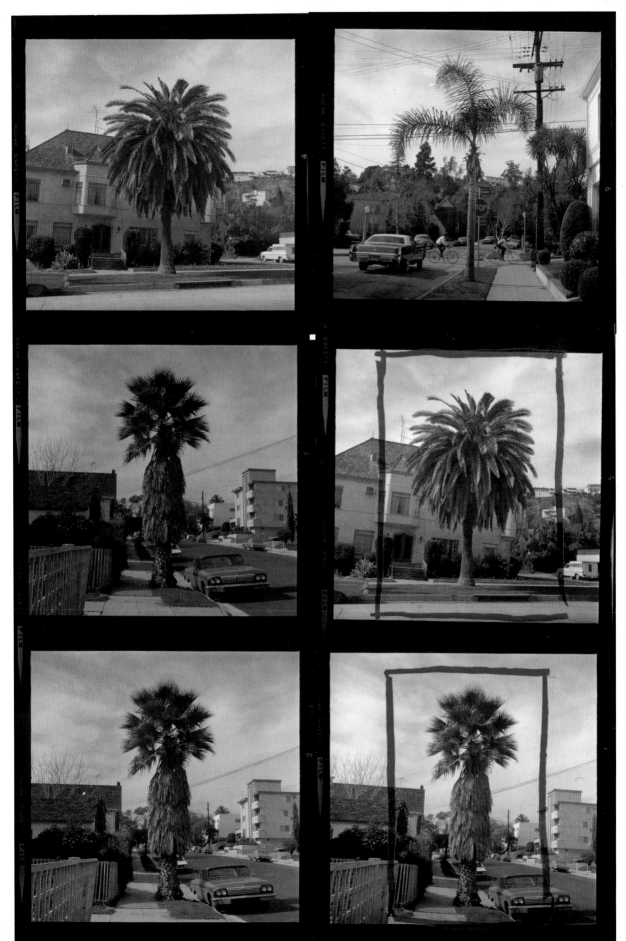

California mid-century modern architecture has been immortalized by the photographs of Julius Shulman. Although he was born in Brooklyn in 1910 and grew up on a farm in Connecticut, Shulman and his work will forever be tied to the sun-drenched homes of Southern California. His seventy-year career as an architectural photographer has created an amazingly comprehensive visual documentation of modern architecture.

Shulman's most well-known image, and one of the most iconic photographs of Los Angeles, is "Case Study House 22." The Case Study Program was sponsored by *Arts & Architecture* magazine and commissioned major architects at the time to design and build inexpensive and efficient model homes. "Case Study House 22," otherwise known as the Stahl House, was designed by Pierre Koenig and photographed by Shulman in 1960.

"The elements are there. The two girls in the picture were the girlfriends of two of the young architectural associates of Pierre Koenig, students. And a very nice warm summer evening.

"… My assistant and I were setting up lights and taking pictures all along. I was outside looking at the view. And suddenly I perceived a composition. Here are the elements. I set up the furniture, and I called the girls. I said, 'Girls. Come over sit down on those chairs, the sofa in the background there.' And I planted them there, and I said, 'You sit down and talk. I'm going outside and look at the view.' And I called my assistant and I said, 'Hey, let's set some lights.' Because we used flash in those days. … We set up lights, and I set up my camera and created this composition in which I assembled a statement. It was not an architectural quote-unquote 'photograph.' It was a picture of a mood, and it's what comes out forty years later—and more—in the statement by Paul Goldberger of the *New York Times*, in which he recognized that this picture is the embodiment of the spirit which we had hoped—*Arts & Architecture*, John Entenza—we had dreamed that this would be the essence of the ensuing decades, generations, of architecture in the Hollywood Hills."

L'architecture californienne moderne du milieu du siècle est immortalisée par les photographies de Julius Shulman. Bien que né à Brooklyn en 1910 et élevé dans une ferme du Connecticut, l'œuvre de Shulman restera toujours associée aux maisons gorgées de soleil du Sud de la Californie. Avec une carrière de photographe architectural qui s'étend sur soixante-dix ans, Shulman a créé un impressionnant corpus de documentation visuelle exhaustif des œuvres du modernisme en architecture.

Le cliché le plus célèbre de Julius Shulman, et la photographie la plus emblématique de Los Angeles, est la « Case Study House 22. » Le programme des Case Study houses était parrainé par le magazine *Arts & Architecture* et commissionnait les architectes les plus illustres de l'époque pour concevoir et construire des modèles de maisons individuelles économiques et fonctionnelles. « Case Study House 22, » également appelée la Maison Stahl, fut conçue par Pierre Koenig et fut photographiée par Julius Shulman en 1960.

« Les éléments y sont présents. Les deux femmes sur la photo étaient les amies des deux jeunes associés de Pierre Koenig, des étudiantes. Nous avions une belle soirée d'été.

… Avec l'aide de mon assistant, je réglais l'éclairage et prenais des photos. Je suis sorti pour regarder la vue et j'ai soudain aperçu une composition. Tous les éléments y étaient présents. J'ai arrangé le mobilier et j'ai appelé les filles. Je leur ai demandé de venir s'asseoir sur les chaises, sur le sofa dans l'arrière-plan. Je les ai plantées là en leur disant « vous vous asseyez et vous discutez, je sors pour la prise de vue. » J'ai appelé mon assistant je lui ai dit « on va travailler sur l'éclairage ». On utilisait des flashes à cette époque. On a mis en place l'éclairage en place, j'ai installé mon appareil et j'ai réalisé cette composition dont j'ai fait un symbole. Ce n'était pas une « photographie » architecturale. C'était une image d'ambiance, et c'est ce qui ressort quarante ans plus tard — et même plus — dans la déclaration de Paul Goldberger du *New York Times*, dans lequel il reconnaît que cette photo cristallise l'esprit que nous avions pressenti avec John Entenza de *Arts & Architecture*. Nous avions rêvé qu'il serait l'essence de décennies, de générations à venir de style architectural des Hollywood Hills. »

Kalifornien's moderne Architektur der Mitte des Jahrhunderts ist auf immer durch die Fotografien von Julius Shulman verewigt worden. Obwohl er in Brooklyn in 1910 geboren wurde und auf einer Farm in Connecticut aufwuchs, wird sein Werk für immer mit den sonnengetränkten Häusern des Südlichen Kalifornien verbunden sein. Seine siebzig-jahre-lange Karriere als ein Architektur-Fotograf hat eine hervorragend ausführliche visuelle Dokumentation von moderner Architektur hervorgebracht.

Shulmans bekanntestes Bild, und eines der ikonischsten Fotografien von Los Angeles, ist „Case Study House 22." Das Case Study house Programm war von der Zeitschrift *Arts & Architecture* gesponsort und beauftragte wichtige Architekten der damaligen Zeit, billige und effizient Modellhäuser zu entwerfen und zu bauen. „Case Study House 22," auch bekannt als das Stahl-haus, wurde von Pierre Koenig entworfen, und von Shulman in 1960 fotografiert.

„Die Elemente sind da. Die zwei Mädchen im Bild waren die Freundinnen von zwei der jungen Architektur von Pierre Koenig, Studenten. Und ein sehr schöner warmer Sommerabend.

… Mein Assistent und ich stellten die Lichter auf und nahmen die ganze Zeit Bilder auf. Ich war draussen und schaute die Aussicht an. Und plötzlich erhielt ich eine Komposition. Hier sind die Elemente. Ich arrangierte die Möbel und rief die Mädchen. Ich sagte, ‚Mädchen, kommt rüber und setzt euch auf diese Stühle, das Sofa da im hintergrund.' Und ich plazierte sie dort, und ich sagte, ‚Ihr setzt euch hier her und redet. Ich gehe raus und schaue die Aussicht an.' Und ich rief meinen Assistenten und ich sagte, „hey, lass`uns ein paar Lichter einstellen.' Weil wir benutzten Blitzlicht zu jenen Tagen. … Wir stellten die Lichter ein, und ich stellte meine Kamera ein und kreierte diese Komposition, wodurch ich eine Stellungnahme anfertigte. Es war nicht ein architekturelles, unter Anführungszeichen ‚Foto'. Es war ein Bild der Stimmung, und das ist es, was vierzig Jahre später rüberkommt — und mehr — in der Aussage von Paul Goldberger der *New York Times*, in der er erkannte, dass dieses Bild der Inbegriff des Geistes ist, den wir erhofft hatten — *Arts & Architecture*, John Entenza — wir hatten geträumt, dass dies die Essenz von kommenden Dekaden, Generationen, von der Architektur in den Hollywood Hills sein würde."

La arquitectura moderna de mediados de siglo de California ha sido inmortalizada para siempre con las fotografías de Julius Shulman. Si bien nació en Brooklyn en 1910 y creció en una granja en Connecticut, el trabajo de Shulman estará siempre vinculado a las casas bañadas por el sol del Sur de California. Su carrera profesional durante 70 años como fotógrafo de arquitectura ha creado una documentación visual increíblemente exhaustiva de la arquitectura moderna.

La imagen conocidísima de Shulman y una de las fotografías más icónicas de Los Ángeles, es la "Case Study House 22". El Case Study house Program fue patrocinado por la revista *Arts & Architecture* y encargó a grandes arquitectos del momento que diseñaran y construyeran casas modelo económicas y eficientes. La "Case Study House 22", conocida también como la Casa Stahl, fue diseñada por Pierre Koenig y fotografiada por Shulman en 1960.

"Estos son los elementos. Las dos chicas de la imagen eran las novias de dos de los colegas del estudio de arquitectura de Pierre Koenig, estudiantes. Y una cálida noche de verano muy agradable.

… Mi asistente y yo montábamos las luces y hacíamos las fotos. Yo estaba fuera contemplando la vista. De repente percibí una composición. Estos son los elementos. Coloqué los muebles y llamé a las chicas. Dije, 'Chicas. Venid a sentaos en esas sillas, con el sofá de fondo'. Y las coloqué allí, y dije, 'Os sentáis y habláis. Voy a salir a contemplar la vista'. Y llamé a mi asistente y le dije, 'Mira, vamos a montar unas luces'. Porque por aquel entonces utilizábamos flash. … Colocamos las luces y la cámara y creé esta composición con la que monté una declaración. No era una fotografía de arquitectura propiamente dicha. Era una imagen de un estado de ánimo y transmite exactamente eso cuarenta años más tarde, o más, en la declaración realizada por Paul Goldberger del *New York Times*, en la que reconoció que esta imagen engloba el espíritu que esperábamos, *Arts & Architecture*, John Entenza, que habíamos soñado que sería la esencia de décadas, generaciones, de arquitectura futuras en Hollywood Hills".

Julius Shulman

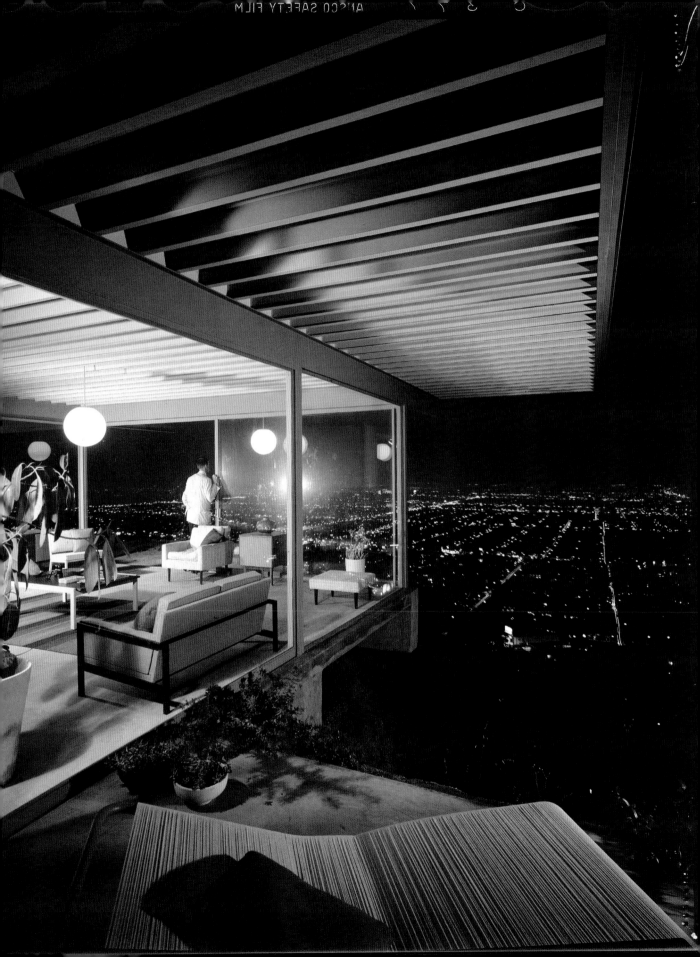

Jeanloup Sieff was born in Paris and introduced to photography at the age of fourteen, when he received a Photax Bakelite camera as a birthday gift. In the 1950s, Sieff attended the Vaugirard School of Photography in Paris, later moving to the Vevey School in Switzerland, and shortly thereafter, he started working as a freelance reporter.

He began his career in fashion photography in the mid-1950s and built a solid reputation in the United States, working with various magazines. His work for Magnum Photos took him on various travels throughout Italy, Greece, Poland, and Turkey. In the '60s he settled in New York, where he continued his fashion photography.

Sieff's work is recognizable by his trademark clean, modern elegance. Influenced by the new-wave filmmakers of the 1950s, his work often hints at melancholy—focusing on nudes and landscapes with delicate lines and strong shapes.

The featured contact sheet was made on assignment for the May issue of *Harper's Bazaar* magazine and was shot in Palm Beach in 1964 for a fashion story titled "Chic Is."

"When I look at my '60s fashion shots, in particular those I did for *Harper's Bazaar*, I am full of admiration not for their quality but for the energy I then possessed. Was it the euphoric energy of youth that made me want to invest so much of myself, or was it the particularly stimulating atmosphere at *Harper's*? It was probably both, but I fear the first reason was the essential one. ... Those were the halcyon days when one could still have fun doing fashion photographs that showed things other than boring garments."

Showcasing summer fashions of beach and evening wear, the "Chic Is" story featured a model named Astrid. Sieff had photographed Astrid on several occasions, and he felt "she had an aristocratic profile and a very inspiring back."

"The editor [of *Harper's Bazaar*] thought that this picture was not at all 'chic,' and it took Richard Avedon's friendly insistence to mellow her reticence. Thanks be to him!"

Jeanloup Sieff compte parmi les photographes de mode les plus estimé et révéré de notre époque. Né à Paris, il fut initié à la photographie à l'âge de quatorze ans après avoir reçu un appareil Photax Bakelite pour son anniversaire. Il réalisa des clichés de jeunes filles lors de vacances en Pologne et se prit de passion pour la photographie. Dans les années 1950, il suivit des cours de photographie à l'Ecole Vaugirard à Paris, puis à l'Ecole Vevey en Suisse, et travailla très vite comme reporter indépendant.

Il se lança dans la photographie de mode au milieu des années 1950 et se bâtit une solide réputation aux Etats-Unis grâce à son travail publié dans de nombreux magazines. Sous contrat avec l'agence Magnum, il se rendit en reportage en Italie, en Grèce, en Pologne et en Turquie. Il s'installa à New York dans les années 1960 et y poursuivit sa carrière dans la photographie de mode.

L'œuvre de Sieff se distingue par son élégance sobre, moderne et raffinée. Influencé par les metteurs en scène de la Nouvelle Vague dans les années 1950, son travail est centré sur des nus ou des paysages aux formes énergiques soulignées de lignes délicates et il se teinte souvent de touches mélancoliques.

Cette planche contact fut réalisée à Palm Beach dans le cadre d'un reportage intitulé « Chic Is » paru dans l'édition de mai 1964 du magazine *Harper's Bazaar*.

« Quand je revois les photographies de mode que j'ai réalisées dans les années 1960, notamment celles publiées dans *Harper's Bazaar*, je suis rempli d'admiration non pour leur qualité mais pour l'énergie qui m'habitait alors. Est-ce que c'était l'énergie euphorique de la jeunesse qui me portait à m'investir autant, ou alors l'atmosphère particulièrement stimulante du magazine ? Probablement une combinaison de ces deux raisons, avec, j'en ai peur, une part prépondérante pour la première. ... C'était une période généreuse où on pouvait encore prendre plaisir à faire de la photographie de mode en y montrant autre chose que des vêtements ennuyeux.

C'est un modèle nommée Astrid qui présentait les collections d'été dans le cadre du reportage « Chic Is ». Jeanloup Sieff travaillait souvent avec Astrid à qui il trouvait un profil aristocratique et un dos séduisant.

« L'éditeur du magazine pensait que cette photo n'était pas du tout « chic », et c'est seulement sur l'insistance amicale de Richard Avedon qu'il finit par céder. Un grand merci à Richard ! »

Jeanloup Sieff, der als einer der hochrangigsten und meist verehrten Mode- und Kunstfotografen angesehen ist, wurde in Paris geboren und in die Fotografie mit vierzehn Jahren eingeführt, als er eine Photax Bakelite Plastikkamera als ein Geburtstagsgeschenk erhielt. Während eines Ferienaufenthalts in Polen fotografierte Sieff verschiedene einheimische Mädchen und wurde schnell vom Handwerk beansprucht. In den 1950ern besuchte Sieff die Vaugirard School of Photography in Paris, später siedelter er zur Vevey Schule in der Schweiz, und kurz danach arbeitete er schon als freischaffender Reporter.

Er begann seine Karriere in Modefotografie in der Mitte der 1950er und baute sich eine solide Reputation in den US durch seine Arbeit für verschiedene Zeitschriften auf. Seine Aufträge für die Magnumagentur brachten ihn auf verschiedenen Reisen durch Italien, Griechenland, Polen und die Türkei. Er siedelte sich schlussendlich in New York in den sechziger Jahren an, wo er weiterhin seine Modefotografie fortführte.

Sieffs Werk ist erkennbar durch sein Markenzeichen der klaren, modernen Eleganz. Beeinflusst von den new wave filmemachern der 1950er, macht sein Werk oft Andeutungen an die Melancholie – sich konzentrierend auf Akte und Landschaften mit delikaten Linien und starken Formen.

Der abgebildete Kontaktbogen wurde für einen Auftrag für die Mai-Ausgabe der Zeitschrift *Harper's Bazaar* gemacht und wurde in Palm Beach in 1964 für eine Modegeschichte, betitelt „Chic Is," aufgenommen.

„Wenn ich meine 60er Modefotos ansehe, vor allem die, die ich für *Harper's Bazaar* aufgenommen habe, dann bin ich voller Bewunderung, nicht für die Qualität, aber für die Energie, die ich besass. War es die euphorische Energie der Jugend, die mich soviel von mir selbst investieren lassen wollte, oder war es die besonders stimulierende Atmosphäre bei *Harper's*? Es war wahrscheinlich beides, aber ich befürchte der erste Grund war der essentielle. ... Das waren die glücklichen Tage, wenn man immer noch Spass haben konnte beim Machen von Modefotos, die Dinge zeigten und nicht nur langweilige Kleidung."

Eine Vorführung von Sommermode für Strand und Abendmode, die „Chic Is" story zeigte ein Modell namens Astrid. Sieff hatte Astrid bei einigen Gelegenheiten fotografiert und fühlte, dass „sie ein aristokratisches Profil und einen sehr inspirierenden Rücken hatte."

„Die herausgeberin [von *Harper's Bazaar*] meinte, dass dieses Bild überhaupt nicht ‚chic' wäre und es bedurfte Richard Avedons freundlicher Insistenz, um ihre Zurückhaltung zu mildern. Dank gehört ihm!"

Jealoup Sieff, considerado uno de los mejores y más venerados fotógrafos de arte y moda, nació en París y entró en el mundo de la fotografía a los catorce años, cuando recibió una cámara de plástico Photax Bakelite como regalo de cumpleaños. Durante unas vacaciones en Polonia, Sieff fotografió a diferentes chicas de la zona y pronto quedó cautivado por este arte. En la década de 1950, Sieff asistió a la Vaugirard School of Photography en París, más adelante acudió a la Vevey School en Suiza, y poco después comenzó a trabajar como periodista gráfico freelance.

Inició su carrera profesional en la fotografía de moda a mediados de la década de 1950 y desarrolló una sólida reputación en los Estados Unidos gracias a su trabajo en diferentes revistas. Su trabajo para la agencia Magnum le llevó a realizar diferentes viajes por Italia, Grecia, Polonia y Turquía. Acabó estableciéndose en Nueva York en los años sesenta, donde continuó con la fotografía de moda.

El trabajo de Sieff es reconocible por su característica elegancia moderna y limpia. Influenciado por los cineastas de la nueva ola de la década de 1950, su trabajo apela con frecuencia a la melancolía, centrándose en desnudos y paisajes con líneas delicadas y formas robustas.

La hoja de contactos incluida fue un encargo para el número de mayo de la revista *Harper's Bazaar* y se tomó en Palm Beach en 1964 para una historia de moda titulada "Chic Is" (Chic es).

"Cuando veo mis fotos de los años 60, en particular las que hice para *Harper's Bazaar* lo que más admiro no es su calidad sino la energía que tenía entonces. ¿Se trataba de la energía eufórica de la juventud que me hacía invertir tanto en mí mismo o se trataba de la atmósfera especialmente estimulante de *Harper's*? Quizás se trataba de ambas cosas, pero me temo que la primera razón era la esencial. ... Eran los días dorados en los que uno podía seguir divirtiéndose haciendo fotografías de moda que mostraban otras cosas aparte de ropa aburrida."

Un escaparate de moda de verano de ropa para la playa y de noche, la historia "Chic Is" contó con una modelo llamada Astrid. Sieff había fotografiado a Astrid en diferentes ocasiones y creía que "tenía un perfil aristocrático y una espalda muy inspiradora".

"La editora [de *Harper's Bazaar*] pensó que esta fotografía no era nada 'chic' y fue la amable insistencia de Richard Avedon la que suavizó su reticencia. Es a él a quien tenemos que darle las gracias".

Jeanloup Sieff

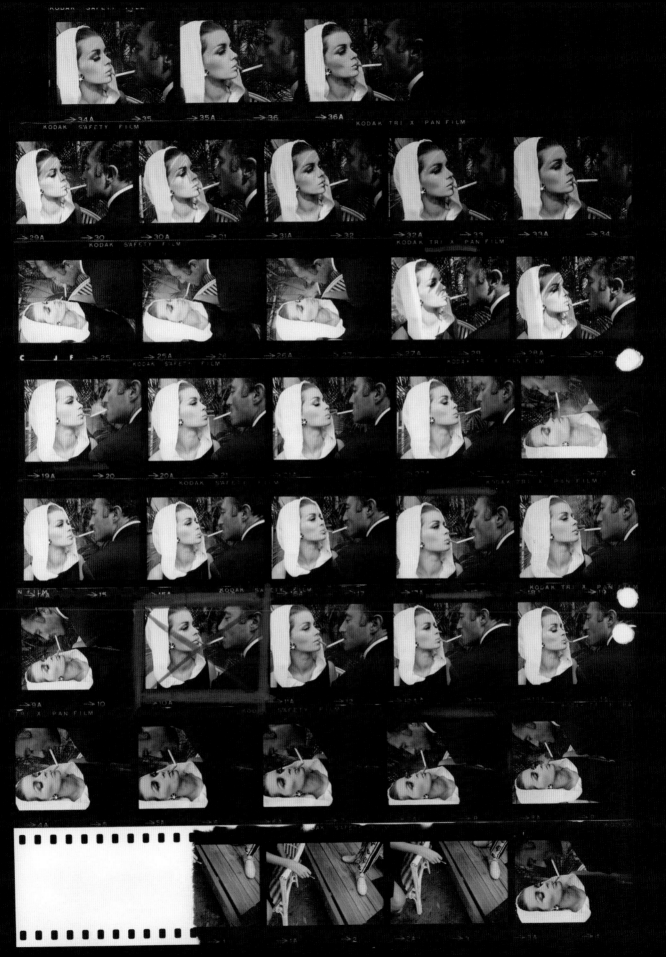

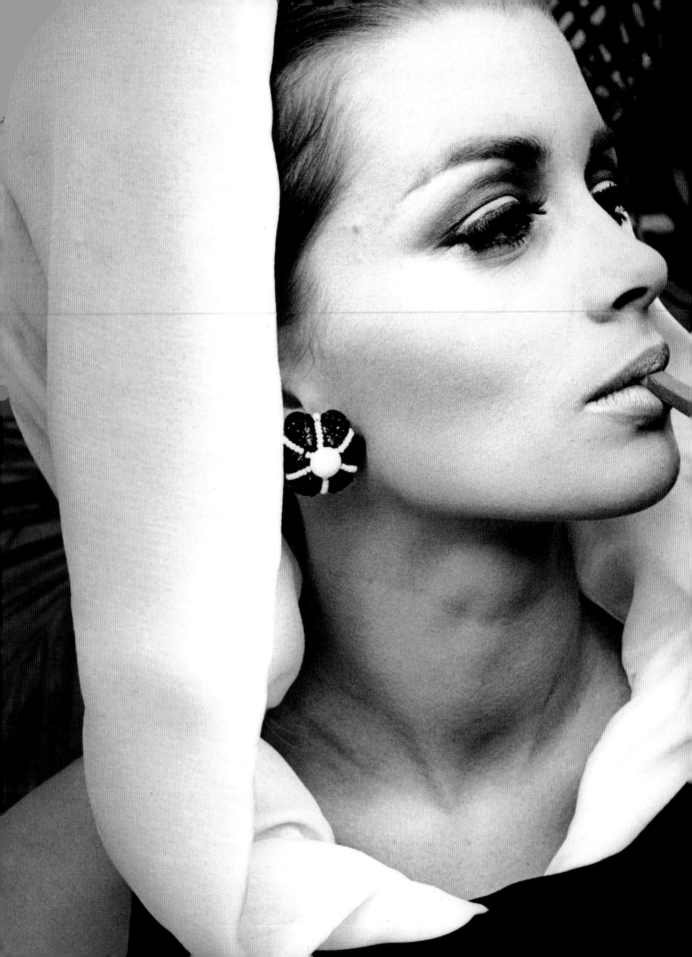

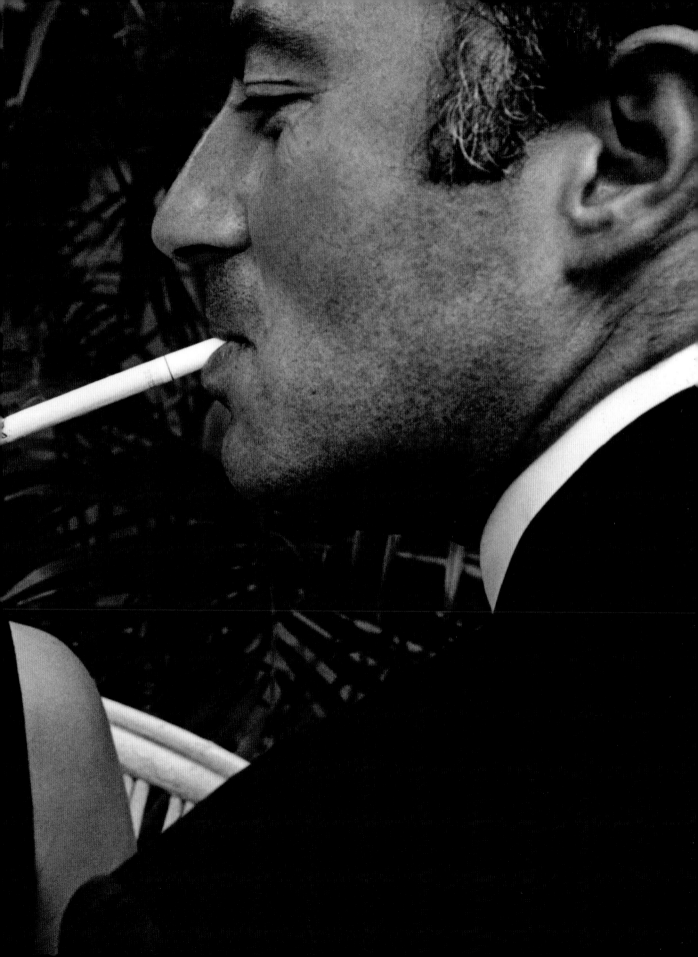

Born in Chicago in 1911, Edmund Teske was introduced to photography at a young age. His photography career began in the early '30s, when he took an assistant position at a commercial photography studio in Chicago. It was also during this time that he was a resident at the Jane Addams Hull House, where he met photographers Max Thorek, Edwin Boland, and A. George Miller. Following his apprenticeship, Teske took up the first fellowship in photography under architect Frank Lloyd Wright. After Wright reviewed Teske's portfolio, he invited him to become an honorary member of the fellowship.

Later in that decade, Teske taught alongside László Moholy-Nagy at the New Bauhaus/Institute of Design in Chicago. He eventually moved to New York City, where he worked as an assistant to Berenice Abbott.

Teske became known for duotone solarization, a printing process he accidentally discovered, and which was later coined by Edward Steichen. This process produced a range of colors from unusual blue grays and umbers to burnt sienna because of changes in the concentration of chemicals and reexposure to bursts of light.

The images on this contact sheet were photographed at the Bronson Caves in the Hollywood Hills in 1969. At first Teske was photographing Jim Morrison and his girlfriend at the time, Pamela Courson, at the singer's apartment nearby. They eventually moved to the caves for a more natural setting. Being a fan of the rough-hewn stones, Teske would often take his students there. For this particular session, Teske liked the idea of having Morrison coming out of the dark caves and into the light. He viewed Morrison more as a poet than as a rock star, and this poetic quality was the inspiration behind the session. Teske achieved the look of the select image by combining two different negatives and printing them as one image.

Morrison and the Doors were often photographed by Teske. His photographs appeared on the cover of *An American Prayer* and on the back cover and insert sleeve for the album *13*.

Né à Chicago en 1911, Edmund Teske fut initié à la photographie dès son plus jeune âge. Sa carrière photographique débuta au début des années 1930 quand il obtint un poste d'assistant dans un studio de photographie commerciale de Chicago. Il était également artiste en résidence à la Jane Addams Hull House où il fit la connaissance des photographes Max Thorek, Edwin Boland et A. George Miller. Suite à cette formation, il obtint la première bourse d'étude attribuée en photographie et travailla sous la direction de l'architecte Frank Lloyd Wright. Après avoir consulté son portfolio, Wright invita Teske à devenir membre honoraire de la taliesin fellowship.

Au New Bauhaus Institute of Design de Chicago, Teske enseigna aux côtés de László Moholy-Nagy et il se fixa par la suite à New York où il fut l'assistant de Berenice Abbott.

Edmund Teske fut célèbre pour le processus appelé la solarisation double-ton qu'il avait découvert par hasard lors d'expérimentations et qui fut baptisé ainsi par Edward Steichen. Grâce à des modifications dans la concentration du révélateur et une exposition du négatif à la lumière, ce procédé créé une palette de tons allant d'insolites bleu gris et ombre aux nuances terre de Sienne.

Les clichés de cette planche contact furent réalisés en 1969 dans les grottes de Bronson situées dans les collines d'Hollywood. Jim Morrison possédait un appartement situé aux alentours de ces grottes et il y fut photographié par Edmund Teske en compagnie de sa petite amie de l'époque, Pamela Courson. Fan de gros blocs de pierres sommairement équarris, Teske emmenait souvent ses étudiants dans ce lieu. Pour cette session, il aimait l'idée de voir Jim Morrison émerger de l'obscurité vers la lumière. Il considérait Morrison comme un poète plutôt qu'une star du rock et cette qualité poétique devait déterminer l'atmosphère de la session. Teske finalisa les images sélectionnées en combinant deux négatifs et en les imprimant sur une seule épreuve.

Jim Morrison et the Doors furent souvent photographiés par Edmund Teske et ses clichés furent repris pour les albums *An American Prayer* et *13*.

Edmund Teske wurde in Chicago in 1911 geboren und in die Fotografie in einem jungen Alter eingeführt. Seine fotografische Karriere begann in den frühen dreissiger Jahren als er eine Assistentenstelle bei einem kommerziellen Fotografiestudio in Chicago annahm. Es war während dieser Periode, dass er wohnhaft im Jane Addams Hull House war, wo er die Fotografen Max Thorek, Edwin Boland, und A. George Miller kennenlernte. Nach seiner Lehre begann Teske seine erste Fellowship in Fotografie unter dem Architekten Frank Lloyd Wright. Nachdem Wright das Portfolio von Teske begutachtet hatte, lud er ihn ein, ein Ehrenmitglied der fellowship zu werden.

Später in dieser Dekade unterrichtete Teske neben László Moholy-Nagy am New Bauhaus Institute of Design in Chicago. Er zog schliesslich nach New York, wo er als Assistent für Berenice Abbott arbeitete.

Teske wurde bekannt für seine duotone solarization, ein Druckprozess, den er zufällig entdeckte, und dessen Namen später von Edward Steichen stammt. Dieser Prozess erzeugt eine Reihe von Farben von ungewöhnlichen blau-grau Tönen zu bernsteinfarbigen zu voll Sienna wegen der Veränderungen in der Konzentration von Chemikalien und Neubelichtung von Licht.

Die Bilder dieses Kontaktbogens wurde bei den Bronson Caves in den Hollywood Hills in 1969 aufgenommen. Jim Morrison hatte eine Wohnung die Strasse runter von den höhlen, wo Teske Morrison und seine damalige Freundin, Pamela Courson, fotografierte. Sie zogen schliesslich zu den höhle für ein natürlicheres Setting. Da er ein Fan von „rohen, unbearbeiteten Steinen" war, nahm Teske oft seine Studenten dorthin mit. Für diese Session gefiel Teske die Idee, Morrison aus den dunklen Höhlen herauskommen und ins Licht hinein treten zu lassen. Er betrachtete Morrison mehr als einen Dichter denn als einen Rockstar und diese poetische Qualität war die Inspiration hinter der Session. Teske erreichte den Look des ausgewählten Bildes indem er zwei verschiedene Negative kombinierte und als ein Bild ausdruckte.

Morrison und die Doors wurden oft von Teske fotografiert. Seine Fotos erschienen auf der Albumhülle von *An American Prayer* und auf der Rückseite und der inneren Hülle für das Album *13*.

Edmund Teske nació en Chicago en 1911 y se introdujo en la fotografía a muy temprana edad. Su carrera fotográfica comenzó a principios de los años treinta cuando aceptó un puesto como ayudante en un estudio de fotografía comercial en Chicago. Durante ese tiempo también colaboró con el departamento teatral de la Jane Addams Hull House, donde conoció a los fotógrafos Max Thorek, Edwin Boland y A. George Miller. Tras este periodo como aprendiz, Teske logró la primera beca en fotografía con el arquitecto Frank Lloyd Wright. Wright invitó a Teske a convertirse en miembro honorífico de las beca tras de repasar su portfolio.

Más adelante, en esa misma década, Teske impartió clases junto con László Moholy-Nagy en el Instituto de Diseño New Bauhaus de Chicago. Acabaría trasladándose a la ciudad de Nueva York, donde trabajó como ayudante de Berenice Abbott.

Teske se dio a conocer por la solarización duotono, un proceso de revelado que descubrió accidentalmente, y que posteriormente sería acuñado por Edward Steichen. Este proceso producía una gama de colores que iba desde inusuales grises azulados y ocres oscuro a sienas tostados debido a los cambios en la concentración de químicos y a la reexposición a explosiones de luz.

Las imágenes de esta hoja de contactos se fotografiaron en Hollywood Hills en 1969. Jim Morrison tenía un apartamento en una calle cercana a las cuevas, Teske fotografió allí a Morrison y a su novia en aquel momento, Pamela Courson. Acabaron trasladándose a las cuevas para obtener un entorno más natural. Un enamorado de las piedras rústicas, Teske llevaba allí con frecuencia a sus estudiantes. Para esta sesión en particular, a Teske le gustó la idea de que Morrison saliera de las cuevas oscuras en dirección a la luz. Veía a Morrison más como un poeta que como estrella de rock y esta cualidad poética sirvió de inspiración para esta sesión. Teske logró el aspecto de la imagen seleccionada combinando dos negativos diferentes y revelándolos como una sola imagen.

Morrison y the Doors eran fotografiados con frecuencia por Teske. Sus fotografías aparecieron en la portada de *An American Prayer* y en la contraportada y en la funda interior del álbum *13*.

Edmund Teske

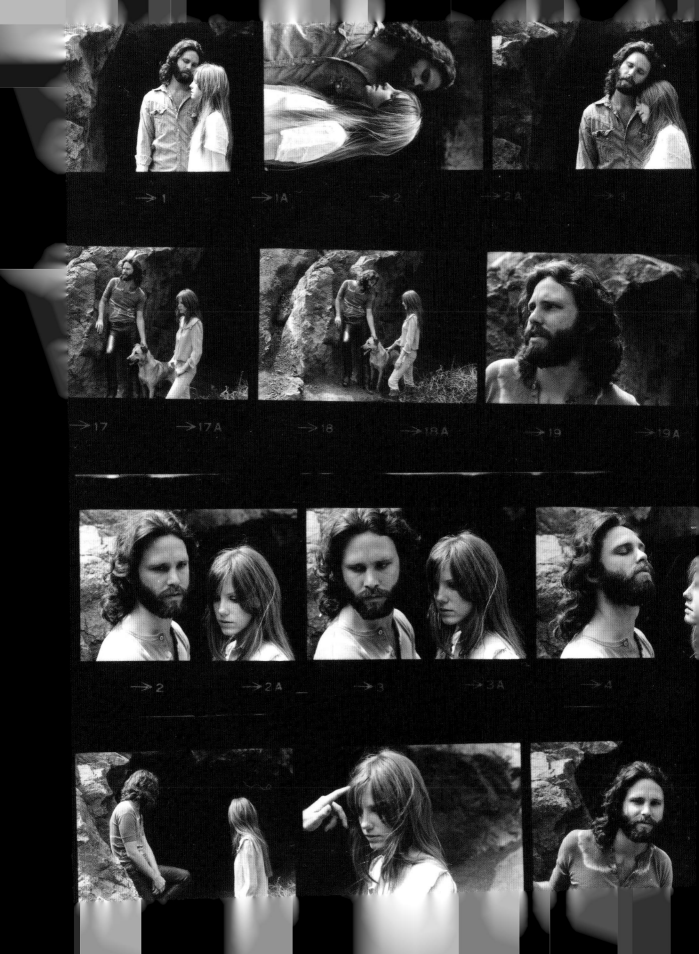

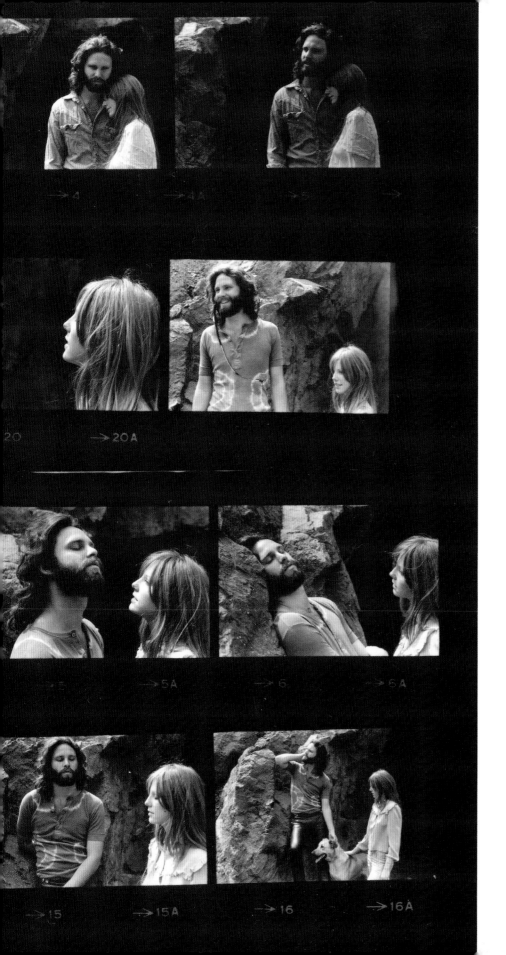

As a boy, Pete Turner converted his bedroom closet into a darkroom, intrigued by the chemical reactions and processes with which he had begun to experiment.

Years later, his first assignment as a professional photographer was for Airstream Trailer—a seven-month trek through Africa, from Capetown to Cairo. He has since worked as a commercial photographer while showing his images in museums and galleries across the world.

The following contact sheet was created in 1958 and includes three images: "Times Square," "The Quiet American," and "Madison Avenue."

"All was quiet, it was dawn, and snow was falling. I was staying at my aunt's, who lived on Madison Avenue. I quickly dressed, grabbed my camera, and went up Madison Avenue. The avenue was just plowed, the red traffic lights the only color in the blue dawn of the snowstorm. I crossed over to Times Square and again traffic lights caught my eye. Right across the square was a movie theater marquee playing the newly released film by Mankiewicz, *The Quiet American*. The natural daylight coming on mixed with artificial lights gave me all the mood I wanted.

"My select became 'Times Square' and I eventually gave the other two to a stock agency and forgot about them. We were dealing with originals back then, no duplicates, and we didn't shoot hundreds of rolls, it was costly and besides there is a very short window with light at dawn. Years later, I kept wondering about those two pictures. I was no longer with the original agency, and there was no record of them.

"Fifty years after, I received a brown banker's box from Texas, full of 2 ¼-inch negatives I had given to the agency that was eventually acquired by another company. Actually *The Quiet American* movie release date, February 6, 1958, gave me a time frame for that snowstorm, February 1958.

"My select is still 'Times Square' with the traffic lights perspective and reflection in the manhole cover. But I have a new appreciation of the other two images; they fill in a gap. Discoveries never cease."

Pete turner fit ses premiers pas en photographie à l'âge de sept ans quand son père lui offrit un appareil. Il transforma le placard de sa chambre en chambre noire et développa une certaine fascination pour les résultats de ses expérimentations avec les réactions chimiques.

Il reçut son premier contrat de photographe par la compagnie Airstream trailer et effectua dans ce cadre un périple de sept mois en Afrique entre Capetown le Caire. Il travaille depuis comme photographe commercial, son œuvre fait partie des collections des plus grands musées et est exposée dans les galeries à travers le monde.

Cette planche-contact fut créée en 1958 et comprend trois photos : « Times Square », « Madison Avenue », et « The Quiet American ».

« Tout était calme, l'aube se levait et il neigeait. J'habitais dans l'appartement de ma tante sur Madison Avenue. Je me suis habillé rapidement, j'ai pris mon appareil et j'ai remonté Madison Avenue. Les chasses-neiges venaient de passer et on ne voyait que la lueur rouge des feux de circulation dans la lumière bleutée de la tempête de neige. J'ai traversé la ville jusqu'à Times Square et j'ai à nouveau remarqué les feux de circulation. De l'autre côté de la rue, on distinguait la marquise d'un cinéma qui affichait *The Quiet American*, le film de Mankiewicz qui venait de sortir. Le mélange de la lumière du jour naissant et des lumières artificielles ont créé l'atmosphère que je recherchais pour ces images.

J'ai choisi « Times Square » pour publication et j'ai fini par donner les deux autres photographies à une banque d'images où je les ai oubliées. On traitait uniquement avec les originaux à l'époque, pas avec des copies, et on ne photographiait pas des centaines de pellicules, c'était cher et dans ce cas je devais tirer parti de la lumière à l'aube pendant un lapse de temps très cours. Pendant des années, je me suis demandé ce qu'étaient devenues ces deux photographies, je ne travaillais plus avec cette agence et il n'y avait plus trace des négatifs.

Cinquante ans plus tard, j'ai reçu du texas un coffre de banque marron, rempli de négatifs de 2-¼ que j'avais envoyés à cette agence, qui avait par la suite été rachetée par une autre compagnie. La sortie du film *The Quiet American*, le 6 février 1958, m'a aidé à identifier la date de cette tempête de neige, le mois de février 1958.

Ma photo préférée reste « Times Square », avec la perspective des feux de circulation et leur reflet sur la bouche d'égout, mais j'ai une appréciation nouvelle pour les deux autres images qui semblent combler une lacune. On n'en finit jamais de faire des découvertes. »

Pete turner wurde von seinem Vater im Alter von sieben Jahren mit der Fotografie bekannt gemacht, als ihm dieser eine Kamera kaufte. Er verwandelte seinen Schlafzimmerschrank in eine Dunkelkammer und begeisterte sich an den Ergebnissen der faszinierenden chemischen Reaktionen.

Sein erster Auftrag war für Airstream trailer – ein sieben-monate-langer treck durch Afrika, von Capetown nach Kairo. Er hat seitdem als kommerzieller Fotograf gearbeitet und hat gleichzeitig sein Werk in Museen und Gallerien der ganzen Welt ausgestellt.

Der folgende Kontaktbogen entstand im Jahr 1958 und beinhaltet drei Bilder: „Times Square", „Madison Avenue", und „The Quiet American".

„Es war alles ruhig, es war Morgendämmerung, und der Schnee fiel. Ich wohnte bei meiner tante, die auf der Madison Avenue wohnte. Ich zog mich schnell an, schnappte meine Kamera, und ging die Madison Avenue hoch. Die Avenue war frisch gepflugt und die roten Ampellichter waren die einzige Farbe in der blauen Dämmerung des Schneesturms. Ich überquerte die Strasse zu Times Square und wieder fielen mir die Ampeln auf. Genau gegenüber vom Platz spielte ein Kinomarkise den neu veröffentlichten Film von Mankiewicz, *The Quiet American*, spielte. Das aufkommende natürliche Tageslicht vermischt mit dem künstlichen Lichtern gab mir die all die Stimmung, die ich wollte.

Meine Auswahl war ‚Times Square' und schliesslich gab ich die anderen zwei Bilder einer Bildagentur und vergass sie. Wir arbeiteten damals nur mit Originalen, keine Duplikate, und wir schossen nicht hunderte von Rollen von Film, es war teuer und ausserdem hat man mit Dämmerungslicht einen sehr kurzen Zeitrahmen. Jahre später wunderte ich mich über diese zwei Bilder, ich war nicht mehr bei dieser Agentur und es gab keine Daten dazu.

Fünfzig Jahre später erhielt ich ein braunes Schliessfach von texas, voll mit 2-¼ Negativen, die ich der Agentur, die dann von einer anderen Firma gekauft wurde, gegeben hatte. Tatsächlich gibt mir das Erscheinungsdatum des Films *The Quiet American*, vom 6. Februar 1958, den Zeitrahmen für den Schneesturm vom Februar 1958.

Meine Auswahl ist immer noch ‚Times Square' mit der Perspektive der Ampeln und der Reflektion im Strassenschachtdeckel. Aber ich habe eine neue Schätzung für die beiden Bilder, sie füllen ein Loch. Entdeckungen enden nie."

Pete turner descubrió la fotografía cuando tenía siete años y su padre le regaló una cámara. Convirtió el armario de su dormitorio en un cuarto oscuro y su fascinación se multiplicó al ver los resultados de las curiosas reacciones químicas.

Su primer encargo fue para Airstream trailer, y consistió en un viaje de siete meses por África, desde Ciudad del Cabo a El Cairo. Desde entonces, ha trabajado como fotógrafo comercial, además de exponer en museos y galerias de todo el mundo.

La presente hoja de contactos se creó en 1958 e incluye tres imágenes: "Times Square", "Madison Avenue", y "The Quiet American".

"Todo estaba tranquilo, estaba amaneciendo y nevaba. Estaba alojado en casa de mi tía que vivía en Madison Avenue. Me vestí a toda prisa, agarré la cámara y empecé a andar por Madison Avenue. La máquina quitanieves acababa de pasar por la avenida y el rojo de los semáforos era el único color en el azul amanecer de la nevada. Cruce a Times Square y de nuevo me llamaron la atención los semáforos. Justo enfrente de la plaza reparé en la marquesina de un cine que proyectaba la última película de Mankiewicz, *The Quiet American*. La luz natural del día mezclada con las luces artificiales me dieron el ambiente que buscaba.

Mi selección fue 'Times Square' y, finalmente, di las otras dos fotos a un banco de imágenes y me olvidé de ellas. En aquellos años, tratábamos con originales, no duplicados, y no disparábamos cientos de películas, era muy caro y además hay una intervalo muy corto de luz en el amanecer. Años más tarde me pregunté que habría ocurrido con esas dos fotos. Ya no estaba con la agencia original, y no había ningún registro de ellas.

Cincuenta años después, recibí una caja bancaria marrón procedente de texas, llena de negativos 2-¼ que yo había dado a la agencia, que más tarde había sido adquirida por otra empresa. De hecho, la fecha de estreno de *The Quiet American*, el 6 de febrero de 1958, me ofreció un marco temporal de esa tormenta: febrero de 1958.

Mi selección sigue siendo 'Times Square' con la perspectiva de los semáforos y el reflejo en la tapa del alcantarillado. Pero tengo una nueva apreciación por las otras dos fotos, llenan un vacío. Los descubrimientos nunca cesan".

Pete Turner

As a child, Jerry Uelsmann found photography to be "magical," and after high school, he decided to pursue it seriously. In the 1950s, he attended the Rochester Institute of Technology, one of the few American schools at the time that offered a photography major. He later attended graduate school and became increasingly immersed in the art world.

Uelsmann's earliest influences were mainly artists working in other media—such as Max Ernst and Joseph Cornell. Uelsmann's own works are more artistic pieces than traditional photographs. His printing methods are multilayered and complex. The Uelsmann technique involves producing composite photographs with multiple negatives and uses up to seven enlargers at a time to produce a single final image.

"My images aren't completed at the camera. They're like any artist going to the studio with a blank piece of paper, using various elements. There are elements that I respond to with my camera. It's not like when I'm photographing I think I have to complete the image at that time.

"I wrote a paper many years ago called 'Post-Visualization,' and it's simply an appeal for photographers to allow for an in-process discovery. Because every other medium in art allows for that—there's a dialogue that goes on in the process that's creating the work, and that's the way in which I work."

The featured contact sheets and final image were created using three different locations at three different times.

"The hands are my wife's [Maggie Taylor's] hands. They were shot in our studio approximately fifteen years ago—the background with the little building in the water and the mountains was taken somewhere in Austria probably about ten years ago. I usually throw a rock in any still body of water I see to photograph the ripples…. I have been doing this for many many years.

"My hope is that individuals will find personal ways of relating to the image. I personally feel the image has a poetic and spiritual quality that alludes to the fragility of life."

La photographie fut une découverte magique pour Jerry Uelsmann qui décida d'y consacrer ses études après le lycée. Il s'inscrivit au Rochester Institute of Technology dans les années 1950, une des rares écoles américaines qui offrait un cursus de photographie, et y suivit ses études universitaires tout en s'immergeant dans le monde de l'art.

L'inspiration de Jerry Uelsmann trouve racine dans des domaines artistiques autres que la photographie, comme chez Max Ernst ou Joseph Cornell. Ses propres réalisations s'apparentent à des œuvres d'art plutôt qu'à des photographies. Il utilise un processus d'impression complexe basé sur l'usage de couches juxtaposées : il crée des photographies composites à l'aide de négatifs multiples et utilise jusqu'à sept agrandisseurs pour produire une image finale unique.

« Mes images ne sont pas créées par l'appareil au moment où je prends une photo. Elles sont comme n'importe quel artiste qui arrive au studio avec un matériel vierge, ce sont des éléments auxquels je vais m'adresser avec l'appareil photo. Je n'aborde pas une séance photo avec en tête l'idée que l'image doit être finalisée à ce stade initial du processus.

J'ai écrit il y a longtemps un essai qui s'intitulait « Post-Visualization » et qui décrit simplement la possibilité pour un photographe d'ouvrir un champ d'exploration au cours du processus. Parce que tous les autres médias en art le permettent – c'est l'ouverture d'un dialogue qui va prendre place au cours du processus créatif de l'œuvre, et c'est cette méthode de travail que j'ai adoptée. »

Ces planches contact et l'image finale proviennent de trois séances différentes dans trois lieux différents.

« Les mains sont celles de ma femme (Maggie Taylor), elles ont été prises dans notre studio il y a une quinzaine d'années. Le petit bâtiment qui émerge au ras de l'eau et les montagnes de l'arrière-plan ont été prises en Australie il y a environ dix ans. Je jette en général une pierre dans les plans d'eau pour photographier les ridules de l'eau sur la surface…. C'est une vieille habitude.

J'ai l'espoir qu'un public va se découvrir des affinités avec cette image. Personnellement, je trouve que l'image possède une qualité poétique et spirituelle qui évoque la fragilité de l'existence. »

Als Kind empfand Jerry Uelsmann die Fotografie als „magisch", und nach der High-School entschied er sich, sie ernsthaft zu studieren. In den 1950er Jahren besuchte er das Rochester Institute of Technology, eine der wenigen amerikanischen Schulen zur damaligen Zeit, die Fotografie als Hauptfach anboten. Später besuchte er die Graduate School und vertiefte sich zunehmend in der Welt der Kunst.

Uelsmanns frühesten Einflüsse waren hauptsächlich Künstler, die in anderen Medien arbeiteten – so wie Max Ernst und Joseph Cornell. Uelsmanns eigenes Werk besteht aus mehr künstlerischen Werken als traditionellen Fotografien. Seine Druckmethoden sind vielschichtig und komplex: Sie erzeugen gemischte Fotos mit multiplen Negativen, und er benutzt jeweils bis zu sieben Vergrösserungsgeräte, um ein einzelnes endgültiges Bild zu produzieren.

„Meine Fotos werden nicht mit der Kamera fertig. Sie sind wie Werke eines Künstlers, der mit einem leeren Blatt Papier zum Studio geht und verschiedene Elemente verwendet. Es gibt Elemente, auf die ich mit meiner Kamera anworte. Es ist nicht so, dass ich, wenn ich fotografiere, denke, dass ich das Bild zu diesem Zeitpunkt fertig machen muss.

Ich schrieb vor vielen Jahren eine Abhandlung betitelt ‚Post-Visualisation', und es ist einfach ein Appell an Fotografen, eine sich im Gange befindliche Entdeckung zuzulassen. Weil jedes andere Medium in der Kunst lässt dies zu – es gibt einen Dialog, der im Prozess der Herstellung des Werkes vorgeht, und das ist die Weise, in der ich arbeite.

Der abgebildete Kontaktbogen und die endgültigen Bilder wurden an drei verschiedenen Stellen zu drei verschiedenen Zeiten hergestellt:

„Die Hände sind die von meiner Frau Maggie Taylor. Sie wurden in unserem Studio vor ungefähr fünfzehn Jahren aufgenommen – der Hintergrund mit dem kleinen Gebäude im Wasser und den Bergen wurde irgendwo in Österreich wahrscheinlich vor zehn Jahren aufgenommen. Ich werfe meistens einen Stein in jedes stehende Gewässer dass ich sehe, um die kleinen Wellen zu fotografieren…. Ich mache dies schon seit vielen, vielen Jahren.

Meine Hoffnung ist, dass Individuen auf persönliche Weise zu diesem Bild eine Beziehung finden. Ich persönlich finde, dass Bild hat eine poetische und spirituelle Qualität, die auf die Zerbrechlichkeit des Lebens anspielt."

Durante su infancia Jerry Uelsmann descubrió la "magia" de la fotografía y después de acabar la escuela secundaria, decidió tomársela en serio. En los años cincuenta, asistió al Rochester Institute of Technology, una de las pocas universidades de América que ofrecía en esas fechas una licenciatura en fotografía. Más adelante, realizó estudios de posgrado y se introdujo cada vez más en el mundo del arte.

Las primeras influencias de Uelsmann proceden sobre todo de artistas que trabajaban en otros medios como Max Ernst y Joseph Cornell. El propio trabajo de Uelsmann está compuesto más por obras de arte que por fotografías tradicionales. Sus métodos de impresión comprenden varias etapas y son complejos: produce fotografías compuestas con múltiples negativos y utiliza hasta siete ampliadoras a la vez para producir una única imagen final.

"Mis imágenes no se completan en la cámara. Soy como cualquier artista que va al estudio con una pieza de papel en blanco y varios elementos. Son esos elementos a los que respondo con mi cámara. Cuando estoy tomando una foto no pienso que tengo que completar la imagen en ese momento.

Escribí una obra hace muchos años llamada 'Post-Visualization' y se trata de un llamamiento a los fotógrafos para que dejen espacio para el descubrimiento durante el proceso. Cualquier otro medio artístico lo hace, hay un diálogo en el proceso que es el que crea la obra y esa es la forma en que trabajo".

Esta hoja de contactos y la imagen final se crearon usando tres ubicaciones diferentes en tres momentos distintos.

"Las manos son de mi mujer (Maggie Taylor). Se fotografiaron en nuestro estudio hace unos quince años; el fondo con el pequeño edificio en el agua y las montañas proviene de algún lugar en Austria, probablemente es de hace diez años. Suelo lanzar una piedra si veo un cuerpo de agua inmóvil para fotografiar las ondas…. Lo he estado haciendo durante muchos años.

Espero que los individuos encuentren formas personales de establecer una relación con la imagen. Por mi parte, siento que la imagen tiene una calidad poética y espiritual que alude a la fragilidad de la vida".

Jerry Uelsmann

Born in Washington, D.C., Peter van Agtmael is a documentary photographer known for his images of America's wars abroad. After graduating from Yale with a history degree, van Agtmael received a photography fellowship in China to document the effects of the Three Gorges Dam—arguably China's largest construction project since the Great Wall, and also the most controversial. After the fellowship, van Agtmael began a freelance career that covered the Asian Tsunami, and the AIDS epidemic in South Africa, eventually throughout Africa. A large portion of his AIDS story followed an HIV-positive Zimbabwean refugee named Holly Moyo.

During the past several years, van Agtmael has documented the wars abroad as an embedded photographer, which he feels gives him access to images from the point of view of the military, which is often off-limits for other photojournalists. He has traveled with both the United States and British military in places like Afghanistan and Iraq, but has also photographed the war when it is brought home—following wounded soldiers and the families of those who have died in the wars.

The featured contact sheet is from March 2006 in Rawah, Iraq, a town in the Al Anbar province of western Iraq.

"I was photographing day-to-day life for American soldiers in Iraq as the insurgency increased and had been struck by the familiar and domestic surroundings of the homes we were raiding. I think I was subconsciously trying to make a photo that would help people at home relate to the nature of the war as I was seeing it.

"Things were a lot more complicated than good and evil, and over time it became very important to me to try to crystallize the contradictions I was seeing into effective photographs. War is an abstraction for those that don't experience it, but we can all relate to the familiar."

Né à Washington D.C., Peter van Agtmael est un photographe documentaire connu pour ses images des forces armées américaines en opération dans les zones de combat. Après avoir obtenu un diplôme d'histoire de l'université de Yale, Peter van Agtmael bénéficia d'une bourse du gouvernement chinois pour documenter les effets de la construction du Barrage des Trois Gorges, sans doute le projet de construction le plus ambitieux depuis la Grande Muraille – et le plus controversé. Peter van Agtmael commença une carrière de photographe indépendant et couvrit le tsunami en Asie, l'épidémie de sida d'abord en Afrique du Sud puis sur tout le continent africain. Une large partie de ce documentaire retrace la vie de Holly Moyo, réfugié séropositif originaire du Zimbabwe.

Au cours de ces dernières années, Peter van Agtmael se consacra au documentaire en tant que journaliste embarqué dans les zones de guerre, ce qui lui donna accès à des images prises du point de vue des forces armées souvent hors limite pour les autres journalistes. Il voyagea avec les forces américaines et britanniques en Irak et en Afghanistan, mais il photographia aussi la guerre avec le retour des soldats au pays et en suivant les soldats blessés et les famille de ceux qui perdirent la vie.

Cette planche contact fut réalisée en mars 2006 à Rawah, une ville située dans la province irakienne d'Al Anbar.

« Je photographiai la vie quotidienne des soldats américains en Irak quand le conflit s'est intensifié et j'ai été frappé par l'environnement familier et domestique des habitations touchées par les raids de l'armée. Je pense que, inconsciemment, j'essayais de prendre des clichés révélant une facette de la guerre à laquelle les américains pourraient s'identifier.

La situation est devenue complexe et a dépassé la simple opposition entre le bien et le mal, et j'ai trouvé important de cristalliser ces contradictions par la photographie. La guerre est une abstraction pour tous ceux qui n'en font pas l'expérience directe, mais on peut tous s'identifier à ce que l'on reconnaît. »

Geboren in Washington, D.C., Peter van Agtmael ist ein Dokumentarfotograf, der für seine Bilder von Amerikas Kriegen im Ausland bekannt ist. Nach dem Abschluss von Yale mit einem Diplom der Geschichte, erhielt Agtmael ein Fotografiestipendium in China, um die die Auswirkungen des Drei-Schluchten-Damms zu dokumentieren – wohl das grösste Bauprojekt für China seit dem Bau der Grossen Mauer, und auch das umstrittenste. Nach der Fellowship begann van Agtmael eine freischaffende Karriere, die den asiatischen Tsunami und die AIDS-Epidemie in Südafrika, und schliesslich durch ganz Afrika, behandelte. Ein grosser Teil seiner AIDS-Reportage folgte einer HIV-positiven, simbabwenesischen Flüchtling namens Holly Moyo.

Für die letzten Jahre hat van Agtmael die Kriege im Ausland als eingelagerter Fotograf dokumentiert, was ihm seiner Meinung nach Zugang zu Bildern vom Blickwinkel des Militär gibt, was für andere Fotojournalisten oft nicht zugänglich ist. Er ist mit jeweils dem US und dem britischen Militär gereist, an Orten wie Afghanistan und Irak, aber er hat auch den Krieg fotografiert, wenn er nach Hause gebracht wird – indem er den verwundeten Soldaten und den Familien von denen, die gestorben sind, folgte.

Der abgebildete Kontaktbogen ist vom März 2006 in Rawah, Irak, eine Stadt in der Al Anbar Provinz im westlichen Irak.

„Ich fotografierte das tägliche Leben von amerikanischen Soldaten in Irak als der Aufstand am zunehmen war, und war betroffen von den vertrauten und heimischen Umgebungen der Häuser, die wir durchsuchten. Ich denke, dass ich unterbewusst versuchte, ein Foto zu machen, dass den Menschen zu Hause helfen würde, sich mit dem Wesen des Krieges, so wie ich es sah, in Verbindung zu bringen.

Die Dinge waren viel komplizierter wie gut und böse, und mit der Zeit wurde es für mich sehr wichtig, die Widersätze, die ich sah, in wirksame Fotos zu kristallisieren. Krieg ist eine Abstraktion für die, die ihn nicht erleben, aber wir alle können uns mit Vertrautem in Verbindung setzen."

Nacido en Washington, D.C., Peter van Agtmael es un fotógrafo de documentales, conocido por sus imágenes de las guerras de Estados Unidos en el extranjero. Tras licenciarse en historia por la Universidad de Yale, van Agtmael consiguió una beca de fotografía en China para documentar los efectos de la Presa de las Tres Gargantas, indiscutiblemente el mayor proyecto de construcción de China desde la Gran Muralla y también el más controvertido. Tras su estancia, van Agtmael inició una carrera profesional como freelance cubriendo el tsunami de Asia y la epidemia del SIDA en Sudáfrica y finalmente en Arica. Una gran parte de su historia sobre el SIDA gira en torno al seguimiento de un refugiado de Zimbabue VIh positivo llamado Holly Moyo.

Durante los últimos años, van Agtmael ha estado documentando las guerras en el extranjero como reportero de guerra, lo cual cree que le da acceso a imágenes desde el punto de vista del militar que con frecuencia está fuera del alcance de otros periodistas gráficos. Viajó con soldados estadounidenses y británicos a lugares como Afganistán e Iraq, pero también ha fotografiado la guerra cuando vuelve a casa, siguiendo a soldados heridos y a las familias de aquellos que murieron en las guerras.

Esta hoja de contactos es de marzo de 2006 en Rawah, Iraq, una ciudad en la provincia de Al Anbar al oeste de Iraq.

"Estaba fotografiando el día a día de los soldados americanos en Iraq y la insurgencia iba en aumento, me había llamado la atención el entorno familiar y doméstico de los hogares que estábamos atacando. Creo que, subconscientemente, estaba tratando de hacer una foto que ayudara a la gente en casa a ponerse en la situación de la naturaleza de la guerra tal y como yo la estaba viendo.

No era tan fácil como hablar de buenos y malos, y con el tiempo empezó a ser muy importante para mí tratar de cristalizar las contradicciones que estaba viendo en fotografías eficaces. La guerra es una abstracción para aquellos que no la experimentan, pero todos podemos ponernos en la piel de aquello con lo que estamos familiarizados".

Peter Van Agtmael

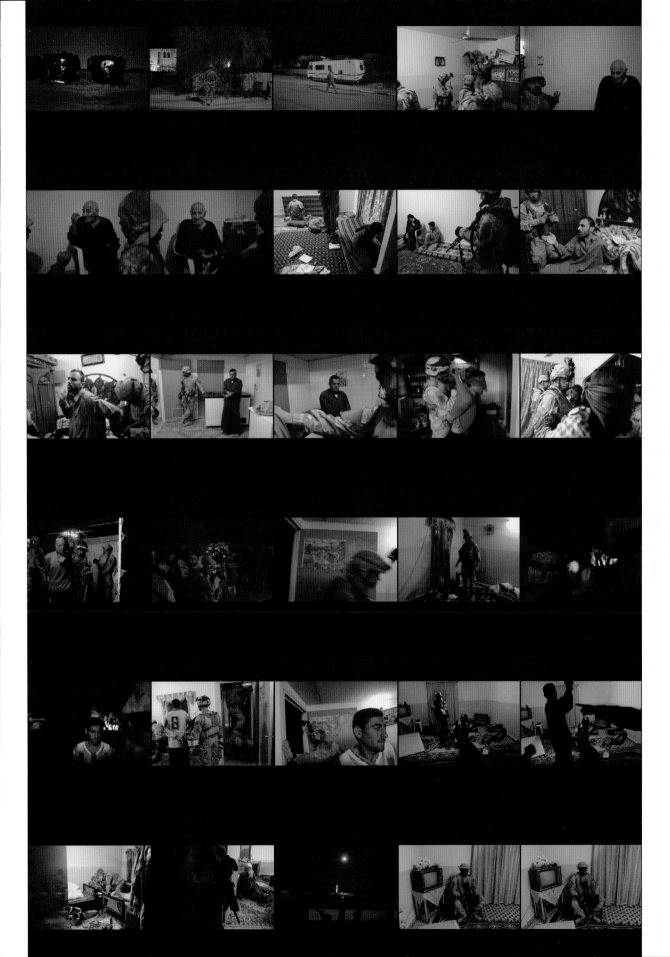

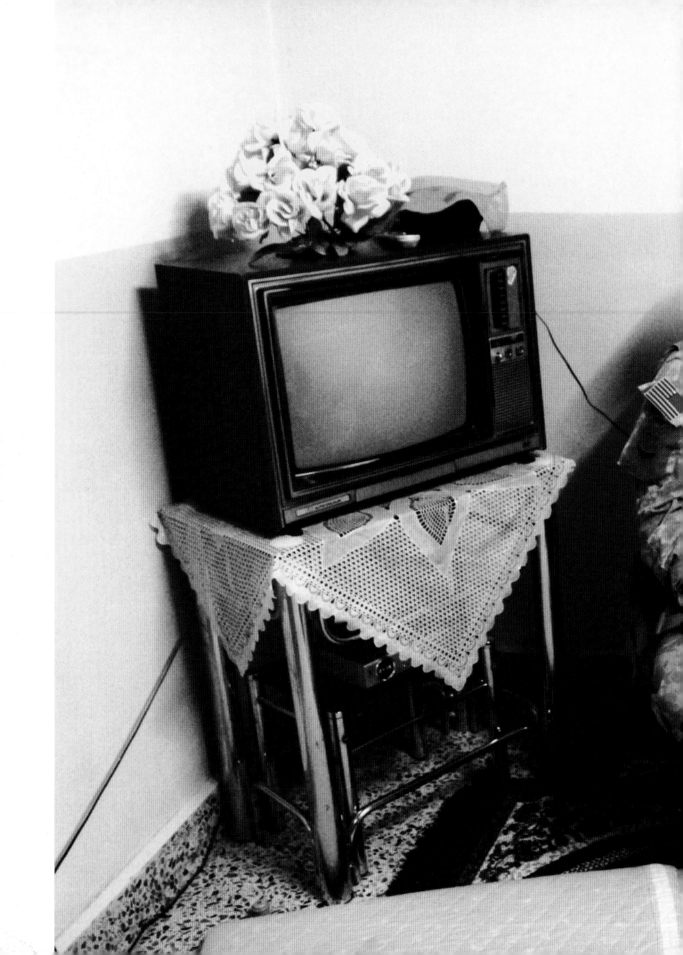

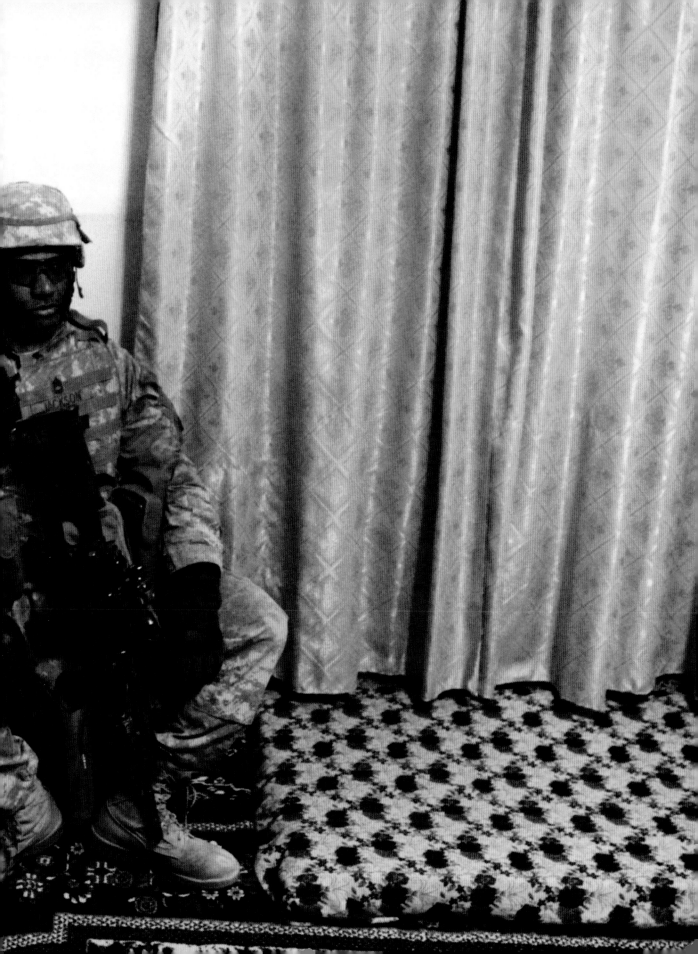

Dutch photographer Hellen van Meene is known for her haunting photographs of women—of all ages, nationalities, and places in life. Born in 1972, van Meene had her first brush with photography one Christmas when she received a plastic camera as a gift.

Van Meene studied photography in Amsterdam and Edinburgh and has shown her work in galleries and museums around the word. She currently resides in Heiloo, The Netherlands.

The featured contact sheet was taken in Louisiana in 2007.

"We did not know the children. We were staying in another camp with our camper (me, my husband, and our two children). I spoke with someone that night that I had met on the campsite (she lived there in a camper with her three children) and made an appointment for the next day to take photos.

"The next morning she was not there, and her neighbor told me that she might be at her mother's. I remembered from our conversation that her mother lived close to the McDonald's around there, so we drove the camper to a place close to it.

"I got out of the car and walked to the door. And although I was a bit scared and did not know what to expect, my longing for making photos was stronger than my sense of mind. A young man opened the door, and before I knew it, I asked him to pose. And at that moment, two beautiful teenagers looked across his shoulder.

"Then there were other teenagers, and they were happy to be in my photos. It was a great time. I felt so happy with them. Afterwards, I wanted to show my appreciation to them, and by looking inside their camper's kitchen, I realized that cooking was not a daily habit. Buying them groceries would have been better for them, but maybe less festive. Although my children and I never had set a foot in a McDonald's before, I realized that I was not there to lecture. Therefore, I let them order what they liked from there to finish a great time with them."

La photographe néerlandaise Hellen van Meene est connue pour ses photographies à l'atmosphère inquiétante montrant des femmes de tous âges, de toutes nationalités et de tous horizons. Née en 1972, Hellen van Meene fit ses débuts en photographie après avoir reçu un appareil comme cadeau de Noël.

Elle étudia la photographie à Amsterdam et à Edimbourg, et son œuvre est aujourd'hui exposée dans les galeries et les musées du monde entier. Elle s'est établi à Heiloo aux Pays-Bas.

Cette planche contact fut réalisée en Louisiane en 2007.

« Nous ne connaissions pas ces enfants. Nous logions dans les environs avec notre camping-car, mon mari, nos deux enfants et moi. Un soir, j'ai discuté avec une personne que j'avais rencontrée au camping (elle y vivait dans un camping-car avec ses trois enfants). Nous avons convenu d'un rendez-vous pour prendre des photos le lendemain.

Le lendemain matin, elle n'était pas là et ses voisins m'ont indiqué qu'elle avait dû se rendre chez sa mère. Je me souvenais que sa mère vivait à côté du McDonald's et nous y sommes donc allés.

Je suis sortie de la voiture et je suis allée frapper à la porte. J'étais un peu tendue car je ne savais pas trop à quoi m'attendre, mais mon envie de photographier était la plus forte. Un jeune homme m'a ouvert la porte et, un instant plus tard, je lui ai demandé de poser. C'est à ce moment que deux magnifiques adolescents ont regardé par dessus son épaule.

D'autres jeunes gens sont arrivés et se sont joints au groupe pour être photographiés. Nous avons passé un bon moment ensemble et je me sentais à l'aise avec eux. J'ai voulu les remercier et, après avoir vu la cuisine de leur camping-car, je me suis dit qu'ils ne devaient pas cuisiner tous les jours. Il aurait été préférable de faire des courses, mais sûrement moins plaisant. Mes enfants et moi n'avions jamais mis les pieds dans un McDonald's, mais nous n'étions pas là pour leur faire la leçon. Nous y sommes tous allés, nous les avons laissé commander ce dont ils avaient envie et nous avons tous passé un moment agréable ensemble. »

Die holländische Fotografin Hellen Van Meene ist bekannt für ihre eindrucksvollen Fotografien von Frauen – aller Alter, Nationalitäten und Plätzen des Lebens. Geboren in 1972, van Meenes erster Kontakt mit Fotografie war an Weihnachten als sie eine Plastikkamera als ein Geschenk erhielt.

Van Meene studierte Fotografie in Amsterdam und Edinburgh und hat ihr Werk in Gallerien und Museen der Welt gezeigt. Sie lebt derzeit in Heiloo, den Niederlanden.

Der abgebildete Kontaktbogen wurde in Louisiana in 2007 aufgenommen.

„Wir kannten die Kinder nicht. Wir blieben auf einem anderen Zeltplatz mit unserem Wohnmobil (ich, mein Mann und unsere zwei Kinder). Ich sprach mit jemandem jene Nacht, die ich auf dem Zeltplatz kennengelernt hatte (sie wohnte dort in einem Wohnmobil mit ihren drei Kindern) und verabredete mich mit ihr für den nächsten Tag, um Fotos zu machen.

Am nächsten Morgen war sie nicht dort, und ihr Nachbar erzählte mir, dass sie vielleicht bei ihrer Mutter sei. Ich erinnerte mich von der Unterhaltung, dass ihre Mutter in der Nähe des umgebenden McDonald's wohnte, und so fuhren wir das Wohnmobil zu einem Platz in der Nähe.

Ich stieg aus dem Auto und gind zur Tür. Und auch wenn ich ein wenig Angst hatte und nicht wusste, was ich erwarten sollte, mein Verlangen, Fotos zu machen stärker als mein Verstand. Ein junger Mann machte die Tür auf, und bevor ich es realisierte, fragte ich ihn, für mich zu posieren. Und zu diesem Moment schauten zwei schöne teenager über seine Schulter.

Dann waren andere Teenager dort und sie waren froh, in meinem Fotos zu sein. Es war eine tolle Zeit. Ich fühlte mich so glücklich mit ihnen. Nachher wollte ich mich erkenntlich zeigen, und als ich in die Küche des Wohnmobils sah, realisierte ich, dass das Kochen nicht eine tägliche Gewohnheit war. Ihnen Lebensmittel zu kaufen wäre für sie besser gewesen, aber vielleicht weniger festlich. Obwohl meine Kinder und ich noch nie zuvor einen McDonald's betreten hatten, sah ich ein, dass ich nicht zum Vortraghalten da war. Darum liess ich sie bestellen, was sie von dort wollten, um eine tolle Zeit mit ihnen abzuschliessen."

La fotógrafa holandesa Hellen van Meene es conocida por sus fotografías cautivadoras de mujeres, de todas las edades, nacionalidades y procedencias. Nacida en 1972, el primer contacto de van Meene con la fotografía se produjo una Navidad cuando le regalaron una cámara de plástico.

Van Meene estudió fotografía en Amsterdam y en Edimburgo, y ha expuesto su trabajo en galerías y museos de todo el mundo. En la actualidad reside en Heiloo, Países Bajos.

Esta hoja de contactos se tomó en Louisiana en 2007.

"No conocíamos a los niños. Nosotros nos estábamos quedando en otro camping con nuestra caravana (yo, mi marido y nuestros dos hijos). Esa noche hablé con alguien que había conocido en el camping (ella vivía allí en una caravana con sus tres hijos) y concerté una cita con ella para hacer fotos al día siguiente.

A la mañana siguiente no se encontraba allí y su vecina me dijo que podría estar en casa de su madre. Recordaba que me había dicho durante nuestra conversación que su madre vivía cerca del McDonald's cerca de allí, así que fuimos con la caravana hasta un sitio cercano.

Salí del coche y me dirigí hasta la puerta de entrada. Y si bien estaba un poco asustada y no sabía qué esperar, mi deseo de hacer fotos era más intenso que mi sentido común. Un joven abrió la puerta y antes de que pudiera darme cuenta le pedí que posara. Y en ese momento dos bellas adolescentes miraron por encima de su hombro.

Luego aparecieron otros adolescentes y estaban muy contentos de salir en mis fotos. Me lo pasé bien. Me sentí muy feliz con ellos. Después, quise mostrarles mi agradecimiento y al mirar en el interior de la cocina de su caravana me di cuenta de que cocinar no se encontraba entre sus tareas diarias. Comprar comida habría sido mejor para ellos, pero quizás menos lúdico. Si bien mis hijos y yo nunca habíamos entrado con anterioridad a un McDonald's, me di cuenta de que no estaba allí para darles una lección. Así que les dejé pedir lo que quisieron para concluir un magnífico momento con ellos".

Helen Van Meene

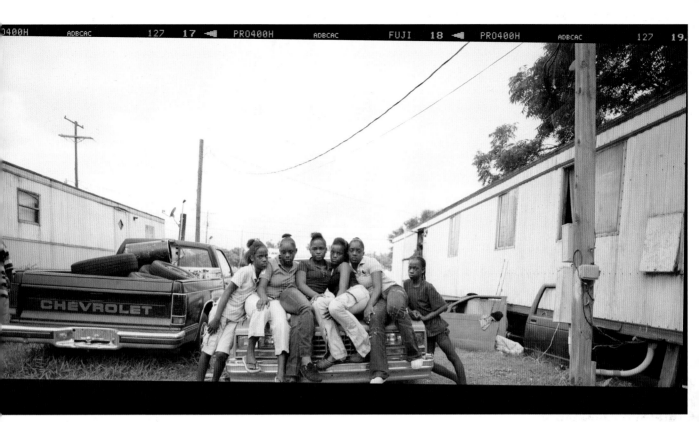

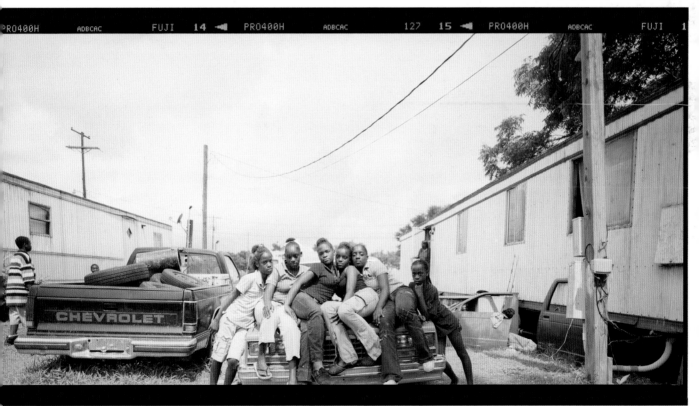

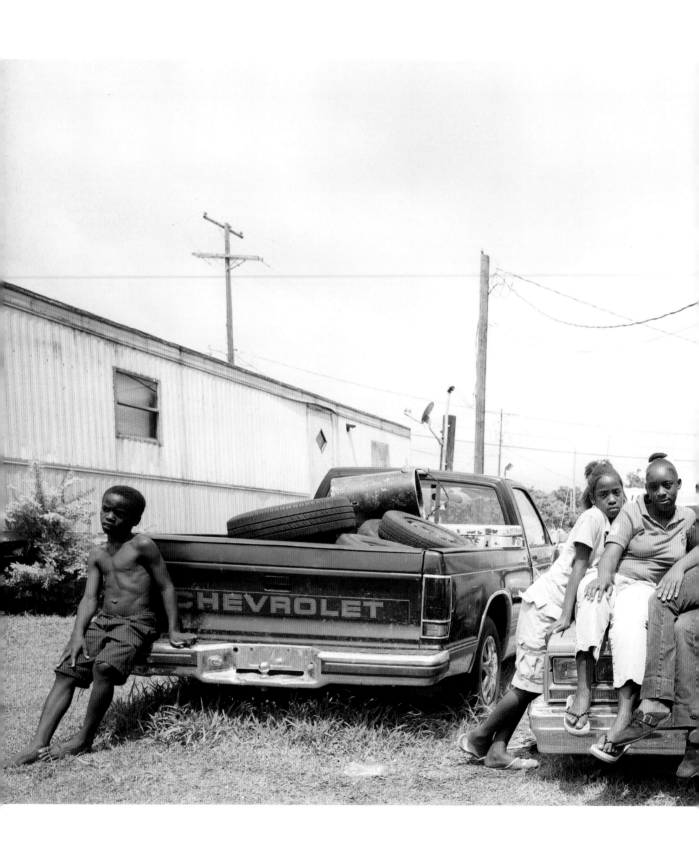

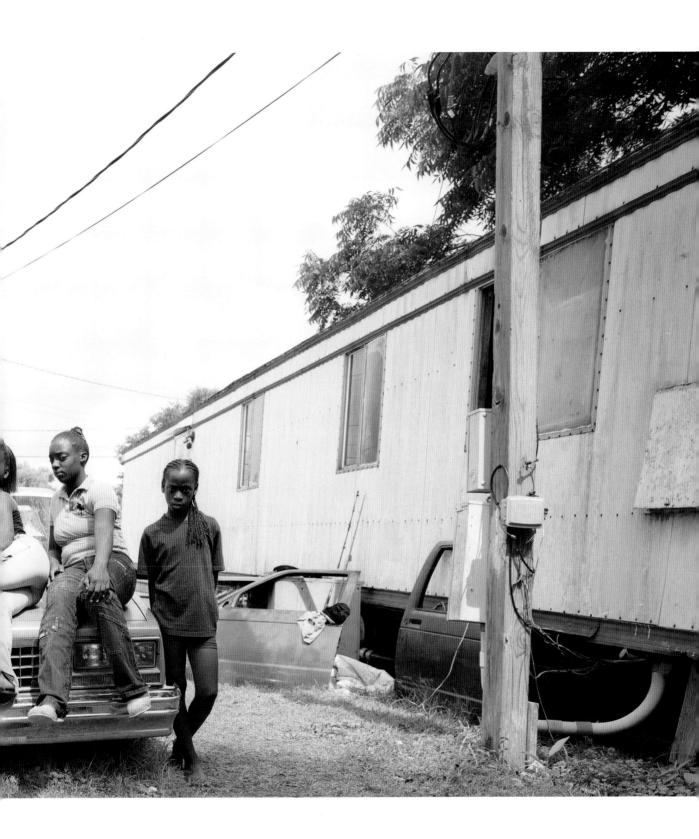

With his Speed Graphic at the age of thirteen, Julian Wasser photographed news events in Washington, D.C., inspired by the "street photography" of Weegee and Henri Cartier-Bresson. Later, while at the Sidwell Friends School, Wasser worked as a copy boy in the Washington bureaus of the Associated Press and United Press and photographed D.C. crime scenes, images that he would sell to the *Washington Post* and *New York Daily News*.

After attending the University of Pennsylvania and serving in the U.S. Navy, Wasser eventually moved to Hollywood and worked as a contract photographer for *Time* and freelanced for *Life* and *People* magazines.

In 1963, the Pasadena Art Museum held a retrospective for artist Marcel Duchamp. It was in the museum's galleries that Wasser photographed Duchamp playing chess with a nude Eve Babitz. Duchamp was a celebrated artist at the time, but also an accomplished chess competitor.

In an interview with the Smithsonian in 2000, Babitz revealed that Wasser had approached her during the opening for Duchamp's retrospective and asked her to play chess in the nude with Duchamp, whom she had never met before. She agreed to it for two reasons: for the sake of creating art, and as a bit of revenge against her lover at the time, Pasadena Art Museum curator Walter Hopps. According to Babitz, Hopps had not allowed her into a party because his wife was in town. So Babitz, Wasser, and Duchamp met at the museum in the early hours of the morning and began the photo session. The gallery in which they were shooting had to be closed off, as the museum was actually open for the day. Babitz exacted her revenge when Hopps walked in on the shoot, completely unaware that it was taking place. Recalls Babitz, "I said 'Hello, Walter,' and he dropped his gum."

Duchamp chose this final image of his chess games with Babitz. He told Italian photographer Ugo Mulas that it was his favorite photo of himself and is shown looking at the image in Mulas's 1967 book *New York: The New Art Scene*.

Résidant de Washington D.C., Julian Wasser se rendait fréquemment à des manifestations muni de son appareil Speed Graphic, et il en rapportait des clichés inspirés de la photographie de rue de Weegee ou Henri Cartier-Bresson. Alors étudiant à la Sidwell Friends School, il travailla comme garçon de bureau pour Associated Press à Washington et photographia les scènes de crime de la ville, des images qu'il ensuite vendait aux journaux le *Washington Post* et le *New York Daily News*.

Après des études à l'université de Pennsylvanie et un passage dans l'US Navy, Julian Wasser s'installa à Hollywood où il travailla sous contrat pour le magazine *Time* et collabora avec les magazines *Life* et *People*.

Le Musée d'Art de Pasadena présenta en 1963 une rétrospective de l'artiste Marcel Duchamp, et c'est dans les galeries de ce musée que Wasser photographia Duchamp jouant aux échecs avec une Eve Babitz nue. Duchamp était un artiste célébré, mais il était aussi un redoutable joueur d'échecs.

Lors d'un entretien avec le Smithsonian en 2000, Eve Babitz révéla que Wasser l'avait approchée pendant le vernissage de la rétrospective pour lui demander de jouer aux échecs nue avec Duchamp, qu'elle n'avait jamais rencontrée auparavant. Elle décida d'accepter pour deux raisons. D'une part pour s'inscrire dans une démarche artistique, et d'autre part pour prendre une sorte de revanche envers son amant, le curateur du Pasadena Art Museum Walter Hopps. En effet, d'après Eve Babitz, Hopps lui avait interdit de se rendre à une soirée par égard envers sa femme qui se trouvait alors à Pasadena. Babitz, Wasser et Duchamp se retrouvèrent au musée un matin et commencèrent la séance photos dans une galerie qui avait dû être fermée au public pour l'occasion. Babitz était en train de prendre sa revanche quand Hopps est entré dans la galerie, sans avoir été informé de la tenue de la séance. Selon les dires de Babitz, son chewing-gum lui tomba de lèvres quand elle lui lança « Hello Walter ».

Duchamp choisit cette image de sa partie d'échec avec Eve Babitz. Il révéla à Ugo Mulas, un photographe italien, que c'était son portrait préféré et il apparaît en train de regarder cette photographie dans le 1967 livre de Mulas, *New York : The New Art Scene*, paru dans les années 1970.

Mit seiner Speed Graphic fotografierte Julian Wasser im Alter von dreizehn Jahren Nachrichtenereignisse in Washington, D.C., inspiriert von der „Strassenfotografie" von Weege und Henri Cartier-Bresson. Später, während er an der Sidwell Friends School war, arbeitete Wasser als Copy Boy in den Washington Büros der Associated Press und United Press und fotografierte Tatorte, Bilder, die er an die *Washington Post* und an die *New York Daily News* verkaufen würde.

Nachdem er die University of Pennsylvania besucht und in der U.S. Navy Dienst geleistet hatte, zog Wasser schliesslich nach Hollywood und arbeitete als Stabfotograf für das Magazin *Time*, und als freischaffender Fotograf für das Magazin *Life*, und *People*.

In 1963 hielt das Pasadena Art Museum eine Retrospektive für den Künstler Marcel Duchamp. Es war in den Gallerien des Museums, wo Wasser Duchamp fotografierte, der mit einer nackten Eve Babitz Schach spielte. Duchamp war ein gefeierter Künstler zu der Zeit, aber er war auch zugleich ein vollendeter Schachwettbewerber.

In einem Interview mit dem Smithsonian in 2000 verriet Babitz, dass Wasser sich ihr während der Eröffnung der Retrospektive von Duchamp genähert hatte und gefragt hatte, ob sie nackt mit Duchamp, den sie nie zuvor kennegelernt hatte, Schach spielen würde. Sie entschied es aus zwei Gründen zu machen: Um der Erschaffung von Kunst wegen, und ein wenig aus Rache gegenüber ihrem Liebhaber zu der Zeit, dem Kurator des Pasadena Art Museum, Walter Hopps. Nach Babitz hatte Hopps sie zur Party nicht zugelassen, da seine Frau auf Besuch war. So trafen sich Babitz, Wasser und Duchamp beim Museum in den frühen Stunden des Morgens und begannen die Fotosession. Die Gallery, in der sie Fotos schossen, musste abgeschlossen werden, da das Museum wirklich für den Tag offen war. Babitz bekam ihre Rache als Hopps in den Shoot reinlief, total nicht bewusst, dass dieser ablief. Sagt Babitz, „Ich sagte ‚Hallo Walter' und sein Kaugummi fiel ihm aus dem Mund."

Duchamp wählte das endgültige Bild von seinem Schachspiel mit Babitz aus. Er sagte zum italienischen Fotografen Ugo Mulas, dass dies sein Lieblingsbild von ihm selbst sei, und er wird in Mulas' 1967 Buch *New York: The New Art Scene*, das in den siebziger Jahren veröffentlicht wurde, gezeigt, wie er das Bild ansieht.

A los trece años y con su Speed Graphic, Julian Wasser fotografió acontecimientos noticiables en Washington, D.C., inspirado por la "fotografía de la calle" de Weegee y Henri Cartier-Bresson. Más adelante, mientras estaba en la Sidwell Friends School, Wasser trabajó como recadero llevando noticias de la mesa del redactor a la mesa de copias en las sedes de Washington de Associated Press y United Press y fotografió escenas de crímenes de D.C., imágenes que después vendería a los periódicos el *Washington Post* y el *New York Daily News*.

Después de asistir a la Universidad de Pensilvania y de servir en la Marina estadounidense, Wasser acabaría trasladándose a Hollywood donde trabajaría como fotógrafo de plantilla para la revista *Time*, y trabajó como freelance para las revistas *Life* y *People*.

En 1963, el Museo de Arte de Pasadena celebró una retrospectiva del artista Marcel Duchamp. Fue en las galerías del museo donde Wasser fotografió a Duchamp jugando al ajedrez contra una Eve Babitz desnuda. Duchamp era un artista reconocido en aquel momento, pero también era un consumado competidor de ajedrez.

En una entrevista con el Smithsonian en 2000, Babitz reveló que Wasser se había acercado a ella durante la inauguración de la retrospectiva de Duchamp y le había pedido que jugara desnuda al ajedrez con Duchamp, a quien no conocía. Decidió hacerlo por dos razones: por el simple hecho de crear arte y por vengarse de su amante por aquel entonces, el comisario del Museo de Arte de Pasadena, Walter Hopps. Según Babitz, Hopps no le había permitido acudir a una fiesta porque su esposa estaba en la ciudad. Así que Babitz, Wasser y Duchamp se reunieron en el museo a primera hora de la mañana y comenzaron la sesión fotográfica. La sala en la que estaban haciendo las fotografías tuvo que ser cerrada pues el museo estaba abierto ese día. Babitz ejecutó su venganza cuando Hopps entró en la sesión, ajeno por completo a lo que allí estaba sucediendo. Babitz recuerda, "Yo dije 'Hola Walter' y él se quedó boquiabierto".

Duchamp eligió esta imagen final de sus partidas de ajedrez con Babitz. Le contó al fotógrafo italiano Ugo Mulas que esta era su foto personal preferida y aparece mirando a la imagen en el 1967 libro de Mulas *New York: The New Art Scene* publicado en los setenta.

Julian Wassar

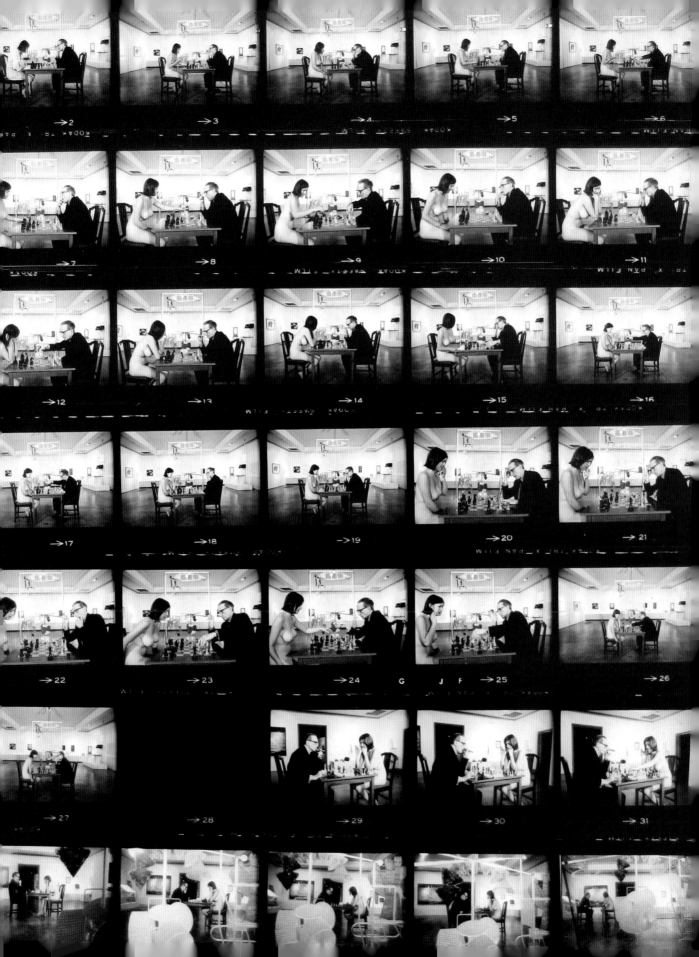

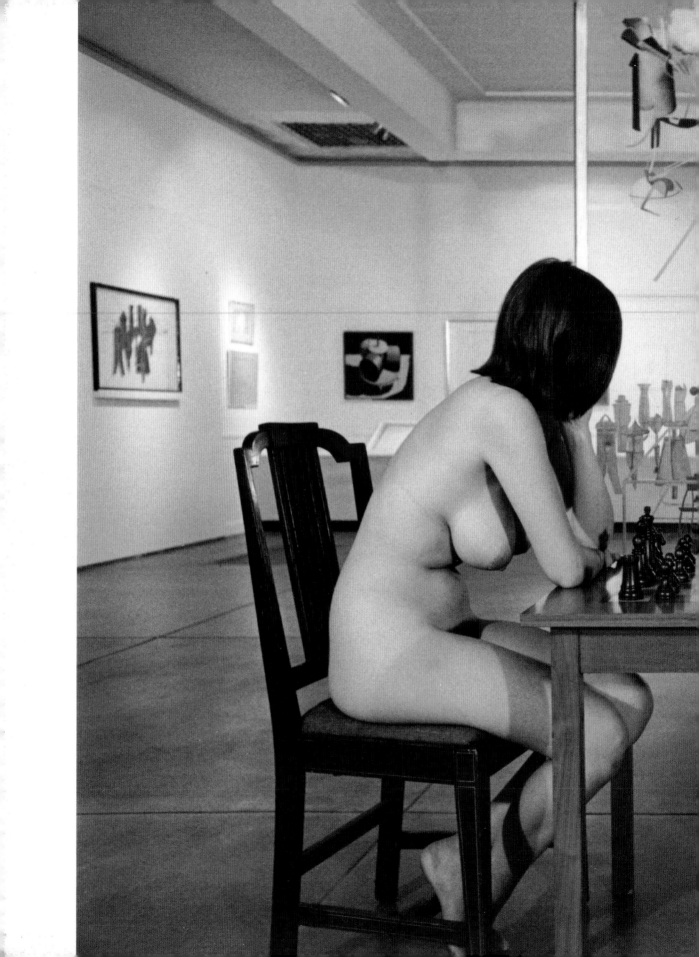

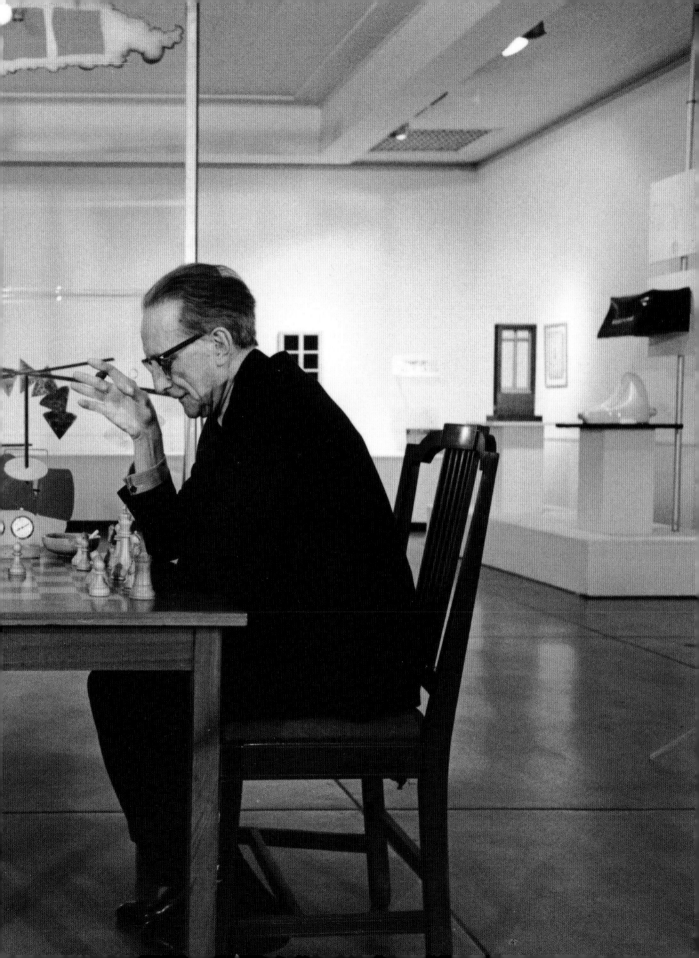

The image of the graceful gray Weimaraner is irrevocably linked with William Wegman. He has spent the last two decades creating some of the most stunning images of these canines in various poses, costumes, and settings—ensuring the breed's place in American iconography.

Born in Massachusetts in 1943, Wegman originally pursued painting—and studied it for several years as an undergrad and later graduate student. While taking various teaching positions, Wegman was exposed to different artistic mediums and grew interested in photography.

While teaching in Long Beach, California, Wegman adopted his first Weimaraner. Named Man Ray after the artist and photographer, he was a central figure in Wegman's work for the next twelve years. Man Ray shot to popularity through Wegman's photographs and videos and was even named the *Village Voice*'s "Man of the Year" in 1982.

This contact sheet features Fay Ray, Man Ray's female successor (her name being a play on the silent screen star Faye Wray). He acquired Fay Ray in the late '80s while living in New York City and found her to be quite different from Man Ray—she was continually skittish and terrified by the noises of the city. After witnessing months of this behavior, Wegman worried that he would have to send her back to her native Tennessee. It was only when Wegman pulled out his camera and started photographing her that Fay grew confident and comfortable in her environment.

For the next decade, Fay Ray grew to be as famous as Man Ray—her images appearing in exhibitions across the world and gracing the covers of national magazines. She's made television appearances and was a guest with Wegman on *Sesame Street* and *David Letterman*. When she eventually had puppies, three of them also became subjects in Wegman's work.

In this contact sheet, she is standing on a dock at Loon Lake in Rangeley, Maine, in 1987, ears flapping in a strong wind.

Les courbes élégantes du braque de Weimar sont indissociablement liées au nom de William Wegman, qui passa les deux dernières décennies à réaliser certaines des images les plus stupéfiantes de ces canins dans des poses, des costumes et des décors variés, assurant la renommée de cette race dans l'iconographie américaine.

Né dans le Massachusetts en 1943, William Wegman se consacra d'abord à des études de peinture. Il occupa plusieurs postes d'enseignant grâce auxquels il fut exposé à différents médiums d'expression artistiques et développa un intérêt pour la photographie.

William Wegman adopta son premier braque alors qu'il était enseignant à Long Beach en Californie. Appelé Man Ray comme l'artiste et photographe, il fut le motif central du travail de Wegman pendant les douze années qui suivirent. La popularité de Man Ray fut portée à son comble par les photographies et les vidéos de William Wegman, et il fut même consacré « l'Homme de l'année » par l'hebdomadaire *Village Voice* en 1982.

Cette planche contact présente Fay Ray, qui succéda à Man Ray (son nom est un jeu de mot sur l'actrice de film muet Faye Wray). William Wegman fit l'acquisition de Fay Ray à la fin des années 1980 à New York et remarqua qu'elle avait une personnalité très différente de celle de Man Ray – elle était tendue et continuellement terrifiée par bruits de la ville. Au bout de quelques mois, Wegman, inquiet, se demanda si elle devrait retourner dans son Tennessee natal. C'est seulement quand Wegman commença à la photographier qu'elle prit confiance en elle et se sentit à l'aise dans son environnement.

Pendant les dix années suivantes, Fay Ray devait devenir aussi célèbre que Man Ray – son image apparaissant dans des expositions à travers le monde et ornant les couvertures des magazines américains. Elle fut l'invité des plateaux de télévision et participa aux émissions *Sesame Street* et *David Letterman* aux côtés de William Wegman. Elle eut des chiots dont trois devinrent aussi modèles du photographe.

Sur cette planche contact prise en 1987 à Rangeley dans le Maine, elle est assise sur un ponton du lac Loon, les oreilles soulevées par des bourrasques de vent.

Das Bild des würdevollen grauen Weimaraner ist unwiderruflich mit William Wegman verbunden. Er hat die vergangenen zwei Dekaden damit verbracht, einge der tollsten Bilder dieser Hunde in verschiedenen Posen, Kostümen, und Szenen zu kreieren – und hat damit dieser Züchtung einen Platz in der amerikanischen Ikonografie gesichert.

Wegman, geboren in Massachusett in 1943, ging ursprünglich der Malerei nach – und studierte es für einig Art Jahre als ein Student und dann als Akademiker. Während er verschiedenen Lehrpositionen annahm, wurde Wegman anderen künstlerischen Medien ausgesetzt, und er wurde an der Fotografie interessiert.

Während er in Long Beach, Kalifornien, unterrichtete, adoptierte er seinen ersten Weimaraner. Benannt Man Ray nach dem Künstler und Fotografen, war er eine zentrale Figur in Wegmans Werk für die nächsten zwölf Jahre. Man Ray wurde durch Wegmans Fotos und Videos über Nach berühmt, und wurde von der *Village Voice* zum „Man of the Year" in 1982 gewählt.

Dieser Kontaktbogen zeigt Fay Ray, die Nachfolgerin von Man Ray (ihr Name ist ein Wortspiel des Namens der Stummfilmschauspielerin Faye Wray). Er legte sich Fay Ray in den späten achtziger Jahren zu, als er in New York City lebte, und fand, dass sie sehr anders wie Man Ray war – sie war immer scheu und verängstigt von dem Lärm der Stadt. Nachdem er für einige Monate dieses Verhalten beobachtet hatte, befürchtete Wegman, dass er sie in ihr einheimisches Tennessee zurückschicken müsse. Erst als er seine Kamera herauszog und sie zu fotografieren begann, wurde Fay Ray sebstsicherer und komfortabler in ihrer Umgebung.

Für die nächste Dekade wurde Fay Ray so berühmt wie Man Ray – ihre Bilder erschienen in Ausstellungen der ganzen Welt und schmückten die Titelseiten von nationalen Zeitschriften. Sie ist im Fernsehen erschienen und war mit Wegman Gast bei der *Sesamstrasse* und *David Letterman*. Als sie schliesslich Welpen hatte, wurden drei von denen auch Sujets in Wegmans Werk.

In diesem Kontaktbogen steht sie auf einem Dock bei Loon Lake in Rangeley, Maine, in 1987, die Ohren flatternd im starken Wind.

La imagen del grácil Braco de Weimar se encuentra irrevocablemente ligada a William Wegman. Este fotógrafo ha pasado las últimas dos décadas creando algunas de las imágenes más espectaculares de estos canes en diversas poses, disfraces y entorno; otorgando a esta raza un lugar en la iconografía americana.

Nacido en Massachusetts, en 1943, Wegman se dedicó primero a la pintura y obtuvo primero una licenciatura y más adelante un máster. Mientras ejercía la docencia, Wegman se vio expuesto a diferentes medios artísticos y empezó a interesarse por la fotografía.

Cuando estaba dando clases en Long Beach, California, Wegman adoptó su primer Braco de Weimar. Lo llamó Man Ray en honor al artista y fotógrafo, y se convirtió en una figura central en el trabajo de Wegman durante los siguientes doce años. Man Ray se hizo popular gracias a las instantáneas y vídeos de Wegman, e incluso fue nombrado "Hombre del año" en 1982 por la publicación *Village Voice*.

Esta hoja de contactos presenta a Fay Ray, la hembra sucesora de Man Ray (su nombre es un juego de palabras con la estrella del cine mudo Faye Wray). Adquirió Fay Ray a finales de los ochenta viviendo en la ciudad de Nueva York, y descubrió que era bastante diferente a Man Ray, era muy asustadiza y le aterrorizaban los ruidos de la ciudad. Tras ser testigo durante meses de este comportamiento, a Wegman le preocupaba la posibilidad de tener que devolverla a su Tennessee natal. Fue necesario que Wegman desenfundara su cámara y empezara a fotografiarla para que Fay Wray desarrollara su autoconfianza y se sintiera cómoda en su entorno.

Durante la siguiente década, Fay Ray llegó a ser tan famosa como Man Ray, sus imágenes han aparecido en exposiciones en todo el mundo y adornan las portadas de revistas nacionales. Ha aparecido en televisión y junto con Wegman acudió a *Barrio Sésamo* y al programa de *David Letterman*. Cuando tuvo cachorros, tres de ellos también se convirtieron en objeto del trabajo de Wegman.

En esta hoja de contactos, está en un muelle de Loon Lake en Rangeley, Maine, en 1987, con las orejas batiéndose al viento.

William Wegman

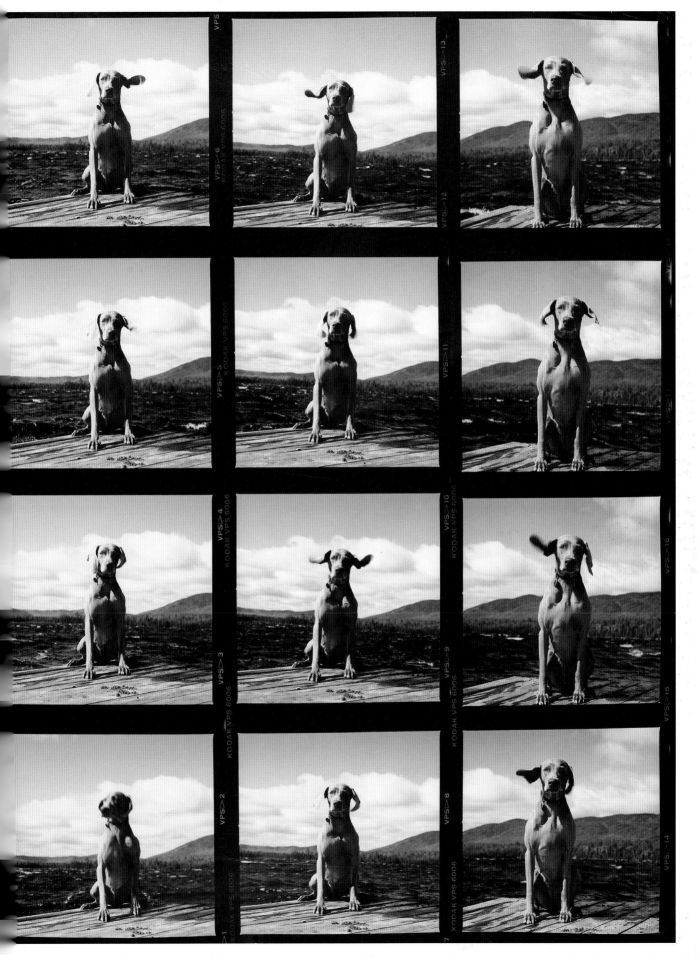

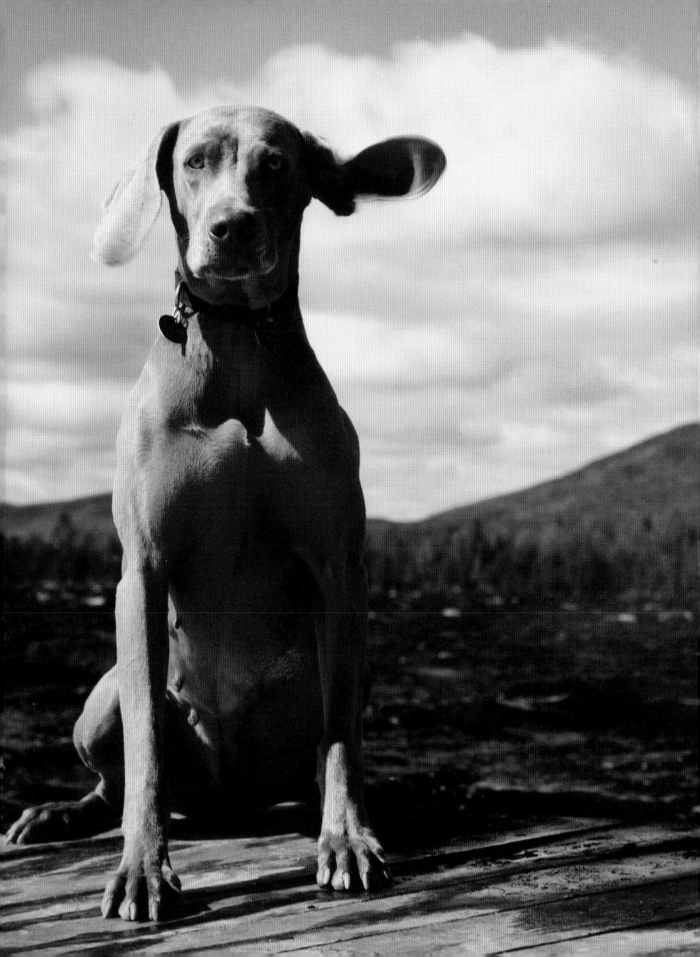

THE Contact Sheet

Edited by Steve Crist

Associate Editor: Maurene Goo
Design: Carrie Worthen and Ben Pope, Thirdthing
Rights and Permissions: Maurene Goo, Lindsay Tunkl,
 Kean O'Brien, Pilar Perez
French Translation: Florence Kircher
German Translation: Daniela Tomas
Spanish Translation: Marian Getino, Carmen Pastor
Copy Editor: Eliani Torres
Production: Reid Embrey, Albert "AJ" Griss
Introduction © 2009 Steve Crist

Acknowledgments for permission to reprint excerpts from the following:

Oral history interview with Imogen Cunningham, 1975 June 9, Archives of
American Art, Smithsonian Institution.

Julius Shulman interview, 1990 Jan. 12 – Feb. 3, Archives of American Art,
Smithsonian Institution.

Oral history interview with Eve Babitz, 2000 June 14, Archives of American Art,
Smithsonian Institution.

ISBN: 9781934429082
Library of Congress Control Number: 2012933607

For more information on AMMO Books, please visit www.ammobooks.com